Digital Anthropology

Digital Anthropology, 2nd Edition explores how human and digital can be explored in relation to one another within issues as diverse as social media use, virtual worlds, hacking, quantified self, blockchain, digital environmentalism and digital representation. The book challenges the prevailing moral universal of "the digital age" by exploring emergent anxieties about the global spread of new technological forms, the cultural qualities of digital experience, critically examining the intersection of the digital to new concepts and practices across a wide range of fields from design to politics.

In this fully revised edition, *Digital Anthropology* reveals how the intense scrutiny of ethnography can overturn assumptions about the impact of digital culture and reveal its profound consequences for everyday life around the world. Combining case studies with theoretical discussion in an engaging style that conveys a passion for new frontiers of enquiry within anthropological study, this will be essential reading for students and scholars interested in theory of anthropology, media and information studies, communication studies and sociology. With a brand-new Introduction from editors Haidy Geismar and Hannah Knox, as well as an abridged version of the original Introduction by Heather Horst and Daniel Miller, in conjunction with new chapters on hacking and digitizing environments, amongst others, and fully revised chapters throughout, this will bring the field-defining overview of digital anthropology fully up to date.

Haidy Geismar is Professor of Anthropology at UCL, UK.

Hannah Knox is Associate Professor of Anthropology at UCL, UK.

Digital Anthropology

Second edition

Edited by Haidy Geismar and Hannah Knox

Routledge
Taylor & Francis Group

LONDON AND NEW YORK

Second edition published 2021
by Routledge
2 Park Square, Milton Park, Abingdon, Oxon, OX14 4RN

and by Routledge
52 Vanderbilt Avenue, New York, NY 10017

Routledge is an imprint of the Taylor & Francis Group, an informa business

First edition published by Bloomsbury 2012

British Library Cataloguing-in-Publication Data
A catalogue record for this book is available from the British Library

Library of Congress Cataloging-in-Publication Data
Names: Geismar, Haidy, editor. | Knox, Hannah, 1977– editor.
Title: Digital anthropology / edited by Haidy Geismar and Hannah Knox.
Description: Second edition. | Abingdon, Oxon ; New York, NY :
 Routledge, 2021. | Revised edition of: Digital anthropology / edited by
 Heather A. Horst and Daniel Miller. London ; New York : Berg, 2012. |
 Includes bibliographical references and index.
Identifiers: LCCN 2020053675 (print) | LCCN 2020053676 (ebook) |
 ISBN 9781350078857 (hardback) | ISBN 9781350078840 (paperback) |
 ISBN 9781003087885 (ebook)
Subjects: LCSH: Mass media and anthropology. | Digital media—Social
 aspects. | Digital communications—Social aspects. | Communication in
 anthropology. | Mass media and culture.
Classification: LCC P96.A56 D54 2021 (print) | LCC P96.A56 (ebook) |
 DDC 302.23/1—dc23
LC record available at https://lccn.loc.gov/2020053675
LC ebook record available at https://lccn.loc.gov/2020053676

ISBN: 978-1-350-07885-7 (hbk)
ISBN: 978-1-350-07884-0 (pbk)
ISBN: 978-1-003-08788-5 (ebk)

Typeset in Times New Roman
by Apex CoVantage, LLC

Contents

Tables

Contributors

Bart Barendregt is Professor (by special appointment) in the Anthropology of Digital Diversity Department at Leiden University, where he lectures on media, Asian studies and digital culture. He is currently exploring how religion and digitalization produce their own futures and how their coexistence may lead to exciting experiments but also moral dilemmas, such as in the case of Islam and artificial intelligence. He is co-editor (with Chris Hudson) of *Global Imaginaries and Performance in Asia* (Amsterdam University Press, 2018) and managing editor of the Brill book series 'Southeast Asia Mediated'.

Tom Boellstorff is Professor in the Department of Anthropology at the University of California, Irvine. A fellow of the American Association for the Advancement of Science, he is the author of many articles and the books *The Gay Archipelago, A Coincidence of Desires*, and *Coming of Age in Second Life*. He is also coauthor of *Ethnography and Virtual Worlds: A Handbook of Method* and coeditor of *Data, Now Bigger and Better!* A former editor-in-chief of *American Anthropologist*, the flagship journal of the American Anthropological Association, he coedits the Princeton University Press book series 'Princeton Studies in Culture and Technology'.

Iris Bull is currently a PhD student in the School of Informatics, Computing, and Engineering at Indiana University. They study notions of work and toxicity in virtual worlds and social networks, and have previously published on notions of 'genderlessness' in the Minecraft universe. Their present work aims to apply Sylvia Wynter's critiques of humanism to contemporary discussions of 'technology ethics', or sociotechnical ethics. In contextualizing toxicity in terms of norms and sociotechnical imaginaries, they hope to attend better to the particular grammars of suffering and marginalization that animate platform politics. You may find them on Twitter @ibull.

Gillian Conquest was a PhD student on the Extreme Citizen Science project (ExCiteS) supervised by Jerome Lewis and Haidy Geismar. She sadly passed away in May 2017, before completing her thesis work. Her research project crossed many disciplinary and international boundaries, as she undertook fieldwork with groups of Indigenous peoples in the Congo Basin and the computer

Global Smartphone (2021, with nine others), *Ageing with Smartphones in Ireland* (2021 with P. Garvey), *The Comfort of People* (2017), *Visualising Facebook* (2017 with J. Sinanan), *How the World Changed Social Media* (2016 with eight others), *Social Media in an English Village* (2016), *Tales from Facebook* (2011), *Stuff* (2010), *The Comfort of Things* (2008), and *The Internet: An Ethnographic Approach* (2000 with D. Slater).

Sarah Pink (PhD, FASSA) is Professor and Director of the Emerging Technologies Research Lab, with a joint appointment in the Faculty of Information Technology and the Faculty of Art, Design and Architecture at Monash University, Australia. She is also a visiting professor at Halmstad University, Sweden and Loughborough University, UK. Her research, which is usually interdisciplinary and interventional, focuses on digital and emerging technologies, futures anthropology and innovation in ethnographic methodology. Recent publications include the collaborative books *Imagining Personal Data*, *Anthropologies and Futures* and *Uncertainty and Possibility* and the fourth edition of her book *Doing Visual Ethnography*.

John Postill (PhD, UCL) is a British-Spanish anthropologist who specialises in the study of media and sociocultural change. To date he has done fieldwork in Malaysia, Indonesia and Spain. He currently lectures at the School of Media and Communication, RMIT University, Melbourne. His books include *The Rise of Nerd Politics* (2018), *Digital Ethnography* (2016), *Localizing the Internet* (2011), *Theorising Media and Practice* (2010) and *Media and Nation Building* (2006). Presently he is researching the rise of woke politics and writing his first novel, a work of social science fiction titled *The School*. He occasionally tweets as @JohnPostill.

Natasha Schüll is a cultural anthropologist and associate professor in the department of Media, Culture, and Communication at New York University. She is the author of *Addiction by Design: Machine Gambling in Las Vegas* (2012), an ethnographic exploration of the relationship between technology design and the experience of addiction. Her forthcoming book project, *Keeping Track*, concerns the rise of digital self-tracking technologies and the new modes of introspection and self-governance they engender. She has published numerous articles on the theme of digital media and subjectivity.

1 Introduction 2.0

Haidy Geismar and Hannah Knox

When the first edition of this book was published nearly ten years ago, it laid out the contours of the emerging subfield of digital anthropology. The original introduction to the book (included in this edition immediately after this chapter, in a shortened and edited form), written by Daniel Miller and Heather Horst, outlined six core themes that they identified as characterising digital anthropology, extending their earlier work on cell phones and the internet (e.g. Miller and Slater 2000; Horst and Miller 2006). Their vision for a nascent digital anthropology drew from broad principles established within material culture studies, outlining how particular digital objects and platforms produce dialectics of normativity within social worlds. Their essay was therefore also a manifesto for a particular kind of social or cultural anthropology, arguing for a holistic focus on the comparative and cross-cultural experience of digital media and celebrating the ways in which digital media could be seen to refract broader cultural and social worlds and identities, and indeed help us to better understand them (see Horst and Foster 2018; Miller et al. 2016).

This approach to both material culture and digital anthropology had a precedent in Miller's influential book *Material Culture and Mass Consumption* (1987), in which he developed a Hegelian understanding of the processes by which subjectivity or identity are produced through practices of consumption. Just as Miller's initial emphasis on material culture moved beyond the prevailing interpretive frames for objects of semiotics, symbolism and signification, so his and Horst's definition of digital technology aimed to move beyond dominant media theories, for instance writing back to detractors of digital media who presented the digital as a radical break with past media traditions (e.g. Turkle 2011) or who understood the digital to be ushering a brave, new and post-human world (Whitehead and Wesch 2012). Miller and Horst argued that digital technologies mediate no more or less than any other cultural expression or communication, noting, "one of the major contributions of a digital anthropology would be the degree to which it finally explodes the illusions we retain of a non-mediated, noncultural, predigital world" (this volume: 26).

Ten years on, debates and discussions within the field of digital anthropology have flourished both within and beyond material culture studies, and within and beyond anthropology. In part this has been the result of a coming of age of

the digital is no longer new or separate but an intrinsic part of most human experiences (Parry 2013). As digital anthropology comes of age, does it just become anthropology again? We suggest not. In this introduction we have argued that a *digital* anthropology remains crucial if we are to stay attentive to the actual everyday implications of technologies in people's lives. The digital is still a powerful marker of modernity and progress, sometimes an empty signifier into which hopes and dreams are put, and at other times is used as an indicator of all that is problematic or dangerous about the world. As long as 'the digital' continues to be manifested in hyperbolic dreams and dystopian fears that drive investment, frame policy and shape technology design, then an anthropological approach that is capable of uncovering the everyday humanness of digital life remains essential.

Moreover, the act of defining, describing and deconstructing 'the digital' as a contemporary part of human experience around the world is only just beginning to make its mark on anthropology as a discipline. We have highlighted in this introduction how digital anthropology is opening up important new avenues for anthropological thought: reposing the central question of what it means to be human; unpacking the role of infrastructures in people's lives; extending and critiquing the analytical utility of concepts like alterity, encounter and difference and the politics of anthropological knowledge. Digital anthropology is also spearheading new developments in methods of research, presentation and dissemination and developing more collaborative, activist forms of ethnographic practice (Miller 2012). As we embark on the next ten years of digital anthropology, we hope that those who pick up and engage with this book – whether they are 'digital' anthropologists or not – will find in it lessons that speak to the question of how to conduct a form of anthropology that can continue to speak with and advocate for voices of people and groups that may often be silenced, marginalised or hidden, acknowledging the fundamental ways in which digital technologies and systems, visible or invisible, are now an unavoidable part of everyday life around the world.

Notes

1 www.wired.co.uk/article/elon-musk-artificial-intelligence-scaremongering www.bbc.co.uk/news/technology-30290540 'Stephen Hawking warns AI could end mankind'.
2 www.bostondynamics.com/
3 See for example Amber Case's TED talk, 'we are all cyborgs now': www.ted.com/talks/amber_case_we_are_all_cyborgs_now?language=en.
4 https://campaignagainstsexrobots.org
5 https://anatomyof.ai
6 These emerged alongside studies of infrastructure within other disciplines – cultural geography, history and media studies and share with these an approach to the study of technical systems that emerges in large part from critical engagement with work in science and technology studies (STS) and urban anthropology and sociology (Mukerji, 2009; Carroll, 2006; Barry, 2002; Mattern, 2017; Graham and Marvin, 2001).
7 Important work in media history (Gitelman 2006, 2013), media archaeology (Parikka 2011), software studies (Kitchin and Dodge 2011, Mackenzie 2006) and format theory (Sterne 2012) act as a palliative to the dominant ways in which 'digital media' is constructed as an academic object of interest.

8 The emergence of technical focused areas of scholarship such as digital humanities has been fraught with some controversy, with critics arguing, "Digital Humanities has played a leading role in the corporatist restructuring of the humanities" and "Digital Humanities as social and institutional movement is a reactionary force in literary studies, pushing the discipline toward post-interpretative, non-suspicious, technocratic, conservative, managerial, lab-based practice" (Allington et al. 2016). Digital humanities detractors see this focus on technical problems and machine-based learning as a direct refusal of critical thinking and also as fundamentally apolitical, chafing against critical enquiry by promoting 'post-critical' machine-focused positivism. Some of this criticism may also be levelled at work clustered under the rubric of 'new materialism', 'object oriented ontology' and speculative realism.

9 www.australiaunlimited.com/society/genevieve-bell

10 See for example digital ethnographic platforms such as The Asthma Files (http://theasthmafiles.org/), Digital Futures (http://vectors.usc.edu/projects/index.php?project=90), Energy and Digital Living (http://energyanddigitalliving.com/) and the UCL Multimedia Anthropology Lab virtual exhibition www.uclmal.com/exhibition-2019. The UCL-based Why We Post project has built on these platforms to create new forms of public anthropology, including open education of digital anthropology through a 'massive open online course' (MOOC), digital open access publication of research monographs and the use of media platforms to engage participants and publics with the findings of the project through photographs, videos and social media, setting a standard for open access within anthropology in which texts are available not just freely, but also in the languages of the research participants (see Miller 2012).

11 See also the IYWTO platform developed by Stefana Broadbent (https://iywto.com/), the #colleeex project run by Eeva Bergland, Tomás Sánchez Criado and Adolfo Estalella and Ana Lisa Ramella (http://xcol.org/in-tra-ventions/collaboratory-for-ethnographic-experiments/), Alberto Corsin-Jimenez's 'Ciudad Escuela' (http://ciudad-escuela.org/), James Holston's DengueTorpedo game (www.denguechat.org/) and Joseph Dumit's anti-fracking game (https://modlab.ucdavis.edu/digitalprojects/frack-the-game/).

References cited

Aiken, Jo. 2015. 'Otherworldly Anthropology: Past, Present, and Future Contributions of Ethnographers to Space Exploration.' In Sheena Nahm and Cortney Hughes Rinker (eds.), *Applied Anthropology: Unexpected Spaces, Topics and Methods* (Routledge: London).

Allington, Daniel, Sarah Brouillette, and David Golumbia. 2016. 'Neoliberal Tools (and Archives): A Political History of Digital Humanities.' *Los Angeles Review of Books*, May 1. https://lareviewofbooks.org/article/neoliberal-tools-archives-political-history-digital-humanities/.

Anand, Nikhil. 2011. 'Pressure: The Politechnics of Water Supply in Mumbai.' *Cultural Anthropology*, 26 (4): 542–64.

Anand, Nikhil, Akhil Gupta, and Hannah Appel. 2018. *The Promise of Infrastructure* (Duke University Press: Durham, NC).

Barry, Andrew. 2002. 'The Anti-Political Economy.' *Economy and Society*, 31 (2): 268–84.

Barry, Andrew, and Georgina Born. 2015. *Interdisciplinarity: Reconfigurations of the Social and Natural Sciences* (Routledge, Taylor & Francis Group: London).

Bateson, Gregory. 1972. *Steps to an Ecology of Mind: Collected Essays in Anthropology, Psychiatry, Evolution, and Epistemology* (Chandler Pub. Co: San Francisco, CA).

Bear, Laura. 2007. *Lines of the Nation: Indian Railway Workers, Bureaucracy, and the Intimate Historical Self* (Columbia University Press: New York; Chichester).

Boellstoff, Tom, Bonnie Nardi, Celia Pearce, and T. L. Taylor. 2012. *Ethnography and Virtual Worlds: A Handbook of Method* (Princeton University Press: Princeton, NJ).

boyd, d., and K. Crawford. 2012. 'Critical Questions for Big Data Provocations for a Cultural, Technological, and Scholarly Phenomenon.' *Information Communication and Society: Special Issue: A Decade in Internet Time: The Dynamics of the Internet and Society*, 15 (5): 662–79.

Bridle, James. 2018. *New Dark Age: Technology and the End of the Future* (Verso: London).

Burrell, Jenna. 2012. *Invisible Users: Youth in the Internet Cafes of Urban Ghana* (MIT Press: Cambridge, MA; London).

Carroll, Patrick. 2006. *Science, Culture, and Modern State Formation* (University of California Press: Berkeley).

Coleman, E. Gabriella. 2015. *Hacker, Hoaxer, Whistleblower, Spy: The Many Faces of Anonymous* (Verso: London).

Crawford, Kate, and Vladin Joler. 2018. 'Anatomy of an AI System.' https://anatomyof.ai. Last Accessed 21 January 2021.

Downey, Gary Lee, Joseph Dumit, and Sarah Williams. 1995. 'Cyborg Anthropology.' *Cultural Anthropology*, 10 (2): 264–69.

Escobar, Arturo. 1996. 'Welcome to Cyberia: Notes on the Anthropology of Cyberculture.' In David Porter (ed.), *Internet Culture* (Routledge: London).

Eubanks, Virginia. 2018. *Automating Inequality: How High-Tech Tools Profile, Police, and Punish the Poor* (St. Martin's Press: New York).

Geertz, Clifford. 1973. *The Interpretation of Cultures: Selected Essays* (Basic Books: New York).

Geismar, Haidy. 2018. *Museum Object Lessons for the Digital Age* (UCL Press: London).

Geismar, Haidy. 2020. 'The New Instrumentalism.' In T. Carroll, A. Walford, and S. Walton (eds.), *Lineages and Advances* (Bloomsbury: London). 75–88.

Geismar, Haidy, and Müller Katja. Forthcoming. 'Postcolonial Digital Collections.' In Elisabetta Costa, Patricia G. Lange, Nell Haynes, and Jolynna Sinanan (eds.), *The Routledge Companion to Media Anthropology* (Taylor and Francis: London).

Gitelman, Lisa. 2006. *Always Already New: Media, History and the Data of Culture* (MIT: Cambridge, MA; London).

Gitelman, Lisa. 2013. *"Raw Data" Is an Oxymoron* (The MIT Press: Cambridge, MA; London, England).

Gluckman, Max. 1940. 'Analysis of a Social Situation in Modern Zululand.' *Bantu Studies*, 14 (1): 1–30.

Graham, Stephen, and Simon Marvin. 2001. *Splintering Urbanism: Networked Infrastructures, Technological Mobilities and the Urban Condition* (Routledge: London).

Gupta, Akhil, and James Ferguson. 1992. 'Beyond "Culture": Space, Identity, and the Politics of Difference.' *Cultural Anthropology*, 7: 6–24.

Haraway, Donna. 1991. 'A Cyborg Manifesto: Science, Technology, and Socialist-Feminism in the Late Twentieth Century.' In *Simians, Cyborgs and Women: The Reinvention of Nature* (Routledge: New York).

Harvey, Penelope, and Hannah Knox. 2015. *Roads: An Anthropology of Infrastructure and Expertise* (Cornell University Press: Ithaca, NY).

Horst, Heather A., and Robert John Foster. 2018. *The Moral Economy of Mobile Phones: Pacific Islands Perspectives* (ANU Press: Acton, ACT).

Horst, Heather A., and Daniel Miller. 2006. *The Cell Phone: An Anthropology of Communication* (Berg: Oxford).

Kelty, Christopher M. 2008. *Two Bits: The Cultural Significance of Free Software* (Duke University Press: Durham, NC).

Kitchin, Rob, and Martin Dodge. 2011. *Code/Space: Software and Everyday Life* (MIT Press: Cambridge, MA).

Knox, Hannah, and Dawn Nafus. 2018. *Ethnography for a Data-Saturated World* (Manchester University Press: Manchester).

Knox, Hannah, Mike Savage, and Penny Harvey. 2006. 'Social Networks and the Study of Relations: Networks as Method, Metaphor and Form.' *Economy and Society*, 35 (1): 113–40.

Larkin, B. 2013. 'The Politics and Poetics of Infrastructure.' *Annual Review of Anthropology*, 42: 327.

Latour, Bruno. 1991. 'Technology Is Society Made Durable.' In John Law (ed.), *A Sociology of Monsters: Essays on Power, Technology and Domination* (Routledge: London).

Latour, Bruno. 1996. *Aramis: Or the Love of Technology* (Harvard University Press: Cambridge).

Lemonnier, Pierre, and Pierre Lemonnier. 1993. *Technological Choices: Transformation in Material Cultures Since the Neolithic* (Routledge, Taylor & Francis Group: London).

Lupton, Deborah. 2016. *The Quantified Self* (John Wiley & Sons: Hoboken, NJ).

Lury, Celia, and Nina Wakeford (eds.). 2012. *Inventive Methods: The Happening of the Social. Culture, Economy and the Social* (Routledge: London).

Mackenzie, Adrian. 2006. *Cutting Code: Software and Sociality* (Peter Lang: New York).

Mattern, Shannon Christine. 2017. *Code and Clay, Data and Dirt: Five Thousand Years of Urban Media* (University of Minnesota Press: Minneapolis).

Meneley, A. 2019. 'Walk This Way: Fitbit and Other Kinds of Walking in Palestine.' *Cultural Anthropology*, 34 (1): 130–54.

Miller, Daniel. 1987. *Material Culture and Mass Consumption* (Blackwell: Oxford).

Miller, Daniel. 2012. 'Open Access, Scholarship, and Digital Anthropology.' *HAU: Journal of Ethnographic Theory*, 2 (1): 385–411.

Miller, Daniel, Elisabetta Costa, Nell Haynes, Tom McDonald, Razvan Nicolescu, Jolynna Sinanan, Juliano Spyer, Shriram Venkatraman, and Xinyuan Wang. 2016. *How the World Changed Social Media* (UCL Press: London).

Miller, Daniel, and Heather A. Horst. 2012. 'The Digital and the Human.' In Heather A. Horst and Daniel Miller (eds.), *Digital Anthropology* (Bloomsbury Publishing: London).

Miller, Daniel, and Jolynna Sinanan. 2013. *Webcam* (Polity Press: London).

Miller, Daniel, and Don Slater. 2000. *The Internet: An Ethnographic Approach* (Berg: Oxford).

Mukerji, Chandra. 2009. *Impossible Engineering: Technology and Territoriality on the Canal du Midi, Princeton Studies in Cultural Sociology* (Princeton University Press: Princeton, NJ; Oxford).

Nafus, Dawn. 2016. *Quantified: Biosensing Technologies in Everyday Life* (The MIT Press: Cambridge, MA; London, England).

Neff, Gina, and Dawn Nafus. 2016. *Self-Tracking* (The MIT Press: Cambridge, MA).

Parikka, Jussi. 2011. *Medianatures: The Materiality of Information Technology and Electronic Waste* (Open Humanities Press: London).

Parry, Ross. 2013. 'The End of the Beginning: Normativity in the Postdigital Museum.' *Museum Worlds: Advances in Research*, 1: 24–39.

Pfaffenberger, Bryan. 1992. 'The Social Anthropology of Technology.' *Annual Review of Anthropology*, 21: 491.

of differentiation. The principle of the dialectic is that it is an intrinsic condition of digital technologies to expand both universality and particularity. Both of these could foster a sense of alienation, and for that reason, in both cases, people strive to humanize and socialize these processes.

Principle 2: culture and the principle of false authenticity

Having made clear what exactly we mean by the term digital, we also need to address what is implied by the term culture. For this we assert as our second principle something that may seem to contradict much of what has been written about digital technologies: people are not one iota more mediated by the rise of digital technologies. The problem was clearly illustrated in a book by Sherry Turkle (2011) which is infused with a nostalgic lament for certain kinds of sociality or humanity deemed lost as a result of new digital technologies ranging from robots to Facebook. The implication of her book is that prior forms of sociality were somehow more natural or authentic by virtue of being less mediated. For example, Turkle bemoans people coming home from work and going on Facebook instead of watching TV. In fact, when it was first introduced, TV was subject to similar claims as to its lack of authenticity and the end of true sociality (Spiegel 1992); yet TV is in no way more natural and, depending on the context, could be argued to be a good deal less sociable than Facebook. Turkle reflects a more general tendency towards nostalgia widespread in journalism and a range of work focusing on the effects of media that view new technology as a loss of authentic sociality. This often exploits anthropological writing on small-scale societies, which are taken to be a vision of authentic humanity in its more natural and less-mediated state.

This is entirely antithetical to what anthropological theory actually stands for. In the discipline of anthropology, all people are equally cultural – that is, they are the products of objectification. Australian aboriginal tribes may not have much material culture, but instead they use their landscape to create extraordinary and complex cosmologies that then become the order of society and the structures guiding social engagement (e.g. Munn 1973; Myers 1986). In anthropology there is no such thing as pure human immediacy; interacting face to face is just as culturally inflected as digitally mediated communication, but, as Goffman (1959, 1975) pointed out again and again, we fail to see the framed nature of face-to-face interaction because these frames work so effectively. The impact of digital technologies, such as webcams, are sometimes unsettling largely because they make us aware and newly self-conscious about those taken-for-granted frames around direct face-to-face encounters.

Potentially one of the major contributions of a digital anthropology would be the degree to which it finally explodes the illusions we retain of a non-mediated, noncultural, predigital world. A good example would be Van Dijck (2007), who uses digital memorialization through photography to show that memory was always a cultural rather than individual construction. Photography as a normative material mediation (Drazin and Frohlich 2007) reveals how memory is not

an individual psychological mechanism but consists largely of that which it is appropriate for us to recall. The foundation of anthropology, in its separation from psychology, came with our insistence that the subjective is culturally constructed. To return to our previous example, Madianou and Miller's (2012) research on Filipina mothers depended on much more than understanding the new communication technologies; at least as much effort was expended upon trying to understand the Filipina concept of motherhood, because being a mother is just as much a form of mediation as being on the Internet. Using a more general theory of kinship (Miller 2008), Madianou and Miller argue that the concept of a mother should be understood in terms of a triangle: our normative concept of what mothers in general are supposed to be like, our experience of the particular person who is our mother, and the discrepancy between these two. Filipina mothers were working simultaneously with regional, national and transnational models of how mothers are supposed to act. The emphasis is not on new media mediating mother–child relationships; rather, it is far more about how the struggle over the concept of being a proper mother mediates how we choose and use polymedia (for which concept, see Madianou and Miller ibid.).

To spell out this second principle, then, digital anthropology will be insightful to the degree that it reveals the mediated and framed nature of the nondigital world. Digital anthropology fails to the degree it makes the nondigital world appear in retrospect as unmediated and unframed. We are not more mediated simply because we are not more cultural than we were before. One of the reasons digital studies have often taken quite the opposite course has been the continued use of the term virtual, with its implied contrast with the real.

This point has been nuanced recently by some important writing on the theory of mediation (Eisenlohr 2011; Engelke 2010). As consistent with Bourdieu's (1977) concept of habitus, we may imagine that a person born in medieval Europe would see his or her Christianity objectified in countless media and their intertextuality. But in those days, the media would have been buildings, writings, clothing accessories, preaching and so forth. Meyer (2011) notes that the critical debate over the role of media in Christianity took place during the Reformation. Catholics fostered a culture of materiality in which images proliferated but retained a sense of mediation such that these stood for the greater mystery of Christ. Protestants, by contrast, tried to abolish both the mediation of objects and of wider cultural processes and instead fostered an ideal based on the immediacy of a subjective experience of the divine. In some respects, the current negative response to digital technologies stems from this Protestant desire to create an ideal of unmediated authenticity and subjectivity. In short, anthropologists may not believe in the unmediated, but Protestant theology clearly does.

As Eisenlohr (2011) notes, the modern anthropology of media starts with works such as Anderson's (1983), which showed how many key terms, such as nationalism and ethnicity, developed in large measure through changes in the media by which culture circulates. There are excellent works on the ways, for example, cassette tapes impact upon religion as a form of public circulation prior to digital forms (Hirschkind 2006; Manuel 1993). But in all these cases, it is not that media

simply mediates a fixed element called religion. Religion itself is a highly committed form of mediation that remains very concerned with controlling the use and consequences of specific media. This is evident when we think about the relationship between Protestantism and digital media. At first we see a paradox. It seems very strange that we have several centuries during which Protestants try to eliminate all objects that stand in the way of an unmediated relationship to the divine while Catholics embrace a proliferation of images. Yet when it comes to modern digital media, the position is almost reversed. It is not Catholics but evangelical Protestants that seem to embrace with alacrity every kind of new media, from television to Facebook. They are amongst the most enthusiastic adopters of such new technologies. This makes sense once we recognize that, for evangelical Christians, the media does not mediate. Otherwise they would surely oppose it. Rather, Protestants have seen media, unlike images, as a conduit to a more direct, unmediated relationship to the divine (Hancock and Gordon 2005). As Meyer (2008) demonstrates, evangelical Christianity embraces every type of new digital media but does so to create experiences that are ever more full-blooded in their sensuality and emotionality. The Apostolics that Miller studied in Trinidad asked only one question about the Internet: Why did God invent the Internet at this moment in time? The answer was that God intended them to become the Global Church, and the Internet was the media for abolishing mere localized religion such as an ordinary church service and instead become globally connected (Miller and Slater 2000: 187–92). More recently the same church has been using Facebook and other new media forms to express the very latest in God's vision for what they should be (Miller 2011: 88–98). This is also why, as Meyer (2011: 33) notes, the less digitally minded religions, as in some versions of Catholicism, try to protect a sense of mystery they see as not fully captured by new media.

In summary, an anthropological perspective on mediation is largely concerned to understand why some media are perceived as mediating and others are not. Rather than seeing predigital worlds as less mediated, we need to study how the rise of digital technologies has created the illusion that they were. For example, when the Internet first developed, Steven Jones (1998) and others writing about its social impact saw the Internet as a mode for the reconstruction of community. Yet much of these writings seemed to assume an illusionary notion of community as a natural collectivity that existed in the predigital age (Parks 2011: 105–9; for a sceptical view, see Postill 2008; Woolgar 2002). They became so concerned with the issue of whether the Internet was bringing us back to community that they radically simplified the concept of community itself as something entirely positive (compare Miller 2011: 16–27). Any and every social fraction or marginal community has an equal right to be seen as the exemplification of digital culture, but this is because, for anthropology, a New York accountant or a Korean games player is no more and no less authentic than a contemporary tribal priest in East Africa. We are all the result of culture as mediation, whether through the rules of kinship and religion or the rules of netiquette and game play.

The problem is with the concept of authenticity (Lindholm 2007). Curiously the earlier writings of Turkle (1984) were amongst the most potent in refuting

these presumptions of prior authenticity. The context was the emergence of the idea of the virtual and the avatar in role-playing games. As she pointed out, issues of role-play and presentation were just as much the basis of predigital life, something very evident from even a cursory reading of Goffman (1959, 1975). Social science had demonstrated how the real world was virtual long before we came to realize how the virtual world is real. One of the most insightful anthropological discussions of this notion of authenticity from this time is Humphrey's (2009) study of Russian chat rooms. The avatar does not merely reproduce the offline person; it is on the Internet that these Russian players feel able, perhaps for the first time, to more fully express their soul and passion. Online they can bring out the person they feel they really are, which was previously constrained in offline worlds. For these players, just as for the disabled discussed by Ginsburg in this volume, it is only on the Internet that a person can finally become real.

Such discussion depends on our acknowledgment that the term real must be regarded as colloquial and not epistemological. Bringing together these ideas of mediation (and religion) with Goffman, Turkle's early work, Humphrey, and the contributions here it should be clear that we are not more mediated. We are equally human in each of the different and diverse arenas of framed behaviour within which we live. Each may, however, bring out different aspects of our humanity and thereby finesse our appreciation of what being human is. Digital anthropology and its core concerns thereby enhance conventional anthropology.

Principle 3: transcending method through the principle of holism

The next two principles are largely a reiteration of two of the basic conditions of anthropological apprehensions of the world, but both require a certain caution before being embraced. There are several entirely different grounds for retaining a holistic approach within anthropology, one of which has been largely debunked within anthropology itself. Many of the theoretical arguments for holism[3] came from either the organic analogies of functionalism or a culture concept that emphasized internal homogeneity and external exclusivity. Both have been subject to trenchant criticism, and today there are no grounds for anthropology to assert an ideological commitment to holism.

While theoretically suspect, there are, however, other reasons to retain a commitment to holism which are closely connected to anthropological methodology, especially (but not only) ethnography. We will divide these reasons to retain a commitment to holism into three categories: the reasons that pertain to the individual, those that pertain to the ethnographic and those that pertain to the global. The first is simply the observation that no one lives an entirely digital life and that no digital media or technology exists outside of networks that include analogue and other media technologies. While heuristically anthropologists will focus upon particular aspects of life, we recognize that the person working at the museum builds social networks and gets involved in politics and that the specifics of any of these three may depend on understanding the other two.

We cannot easily treat each new media independently since they form part of a wider media ecology in which the meaning and usage of any one depends on its relationship to others (also Horst, Herr-Stephenson and Robinson 2010); using e-mail may be a choice against texting and using a social network site; posting comments may be a choice between private messaging and a voice call. Today, when the issues of cost and access have in many places of the world fallen into the background, people are held responsible for which media they choose. In Gershon's (2010) ethnography of US college students, being dumped by boyfriends with an inappropriate media adds much insult to the injury of being dumped. In Madianou and Miller's (2012) work, polymedia are exploited to increase the range of emotional fields of power and communication between parents and their left-behind children.

But this internal holism for the individual and their media ecology is complemented by a wider holism that cuts across different domains. For Broadbent (2011), the choice of media is only understood by reference to other contexts. Instead of one ethnography of the workplace and another of home, we see how usage depends on the relationship between work and home and between very close relationships set against weaker relational ties. This second level of holism is implicit in the method of ethnography. In Coleman's (2010) review of the anthropology of online worlds, it is apparent that there is almost no topic of conventional anthropology that would not today have a digital inflection. Her references range from news broadcasting, mail-order brides, medical services, aspects of identity, finance, linguistics, politics and pretty much every other aspect of life. In essence, the issue of holism relates not just to the way an individual brings together all the dispersed aspects of his or her life as an individual but also how anthropology transcends the myriad foci of research to recognize the co-presence of all these topics within our larger understanding of society.

Another point illustrated clearly in Coleman's review is that there are now more sites to be considered, because digital technologies have created their own worlds. For example, granting Second Life its own integrity matters for people who feel disabled and disadvantaged in other worlds but here find a site where, for example, they can live a full religious life, carrying out rituals they would be unable to perform otherwise (Ginsburg this volume; Boellstorff this volume). Online worlds have their own integrity and their own intertextuality, taking their genres from each other, as was evident in Boellstorff's (2008: 60–5) monograph on Second Life, which includes a spirited defence of the autonomous nature of online worlds as the subject of ethnography.

But if proper ethnography were the sole criteria for holism, it would itself become something of a liability. This is why we require a third holistic commitment. There are not just the connections that matter because they are all part of an individual's life or because they are all encountered within an ethnography. Things may also connect up on a much larger canvass, such as the political economy. Every time we make a debit card payment, we exploit a vast network that exists aside from any particular individual or social group, whose connections would not be apparent within any version of ethnography. These connections are closer

to the kinds of networks discussed by Castells and Latour or to older traditions such as Wallerstein's world systems theory (1980). Anthropology and ethnography are more than method. A commitment to ethnography that fails to engage with the wider study of political economy and global institutions would see the wider holistic intention betrayed by mere method. This problem is exacerbated by digital technologies that have created a radical rewiring of the infrastructure of our world. As a result, we see even less and understand less of these vast networks than previously. For this bigger picture, we are committed to travel those wires and wireless connections and make them explicit in our studies. Anthropology has to develop its own relationship with what has been called Big Data (boyd and Crawford 2011), wherein vast amounts of information are increasingly networked with each other to illustrate behaviour on a massive scale. While we can be critical of their analytical value, if we ignore these new forms of knowledge and inquiry, we succumb to yet another version of the digital divide.

There is a final aspect of holism that anthropologists cannot lose sight of. While anthropologists may repudiate holism as ideology, we still have to deal with the way others embrace holism as an ideal. Postill's (this volume) discussion of the digital citizen reveals how, while democracy is officially secured by an occasional vote, mobile digital governance is imagined as creating conditions for a much more integrated and constant relationship between governance and an active participatory or community citizenship that deals with embracing much wider aspects of people's lives. Often this is based on assuming that previously it was only the lack of appropriate technology that prevented the realization of such political ideals, ignoring the possibility that people may not actually want to be bothered with this degree of political involvement. Political holism thereby approximates what Postill calls a normative ideal. He shows that the actual impact of the digital is an expansion of involvement but is still, for most people, largely contained within familiar points of participation such as elections or communication amongst established activists.

Principle 4: cultural relativism

Cultural relativism has always been another vertebra within the spine of anthropology; indeed, holism and cultural relativism are closely connected. It is worth reiterating with respect to digital anthropology that much debate and representation of the digital is derived from the imagination of science fiction and modernism that predicts a tightly homogenized global world that has lost its prior expression of cultural difference (Ginsburg 2008). As with holism, there is a version of relativism that anthropologists have repudiated (at least since the Second World War) associated with a plural concept of cultures that implied pure internal homogeneity and pure external heterogeneity. These perspectives took cultural differences as essentially historical and a priori based on the independent evolution of societies. By contrast, more contemporary anthropology recognizes that, within our political economy, one region remains linked to low-income agriculture and conservatism precisely because that suits the interests of a wealthier

and dominant region. That is to say, differences are often constructed rather than merely given by history.

For this reason, Miller (1995) argued that we should complement the concept of a priori difference with one of a posteriori difference. In their ethnography of Internet use, Miller and Slater (2000) refused to accept that the Internet in Trinidad was simply a version or a clone of 'The Internet'; the Internet is always a local invention by its users. Miller makes a similar argument here with respect to Facebook in Trinidad, where the potential for gossip and scandal (and generally being nosy) is taken as showing the intrinsic 'Trinidadianess' of Facebook (Miller 2011). In Indonesia, by contrast, Barendregt (this volume) demonstrates that even quite mundane uses of digital communication such as chatting, flirting or complaining about the government become genres quite specific to Indonesia rather than cloned from elsewhere. While in Trinidad the emphasis is more on retained cultural difference, in Indonesia this is overlain by a very deliberate attempt to create a new normativity: the use of digital technologies based on explicit criteria such as their acceptability to Islamic strictures. This may be a response to concerns that if digital technologies are Western, then they are likely to be the Trojan horse that brings in unacceptable cultural practices such as pornography. This produces a highly conscious filtering and transformation to remake these technologies into processes that actually promote rather than detract from Islamic values.

Similarly, Geismar (this volume) argues that homogenization can be imposed most effectively at a level we generally fail to appreciate or apprehend because it occurs within basic infrastructure: the catalogue systems that are used to label and order museum acquisitions. If aboriginal societies are going to find indigenously appropriate forms (Thorner 2010), then it may be through control over things such as the structure of archives, modes of viewing and similar logistical fundamentals that need to properly reflect concepts such as the Vanuatu notion of *kastom*, which is quite distinct from Western tradition.

The cliché of anthropology is that we assert relativism in order to develop comparative studies. In reality, comparison is more usually an aspiration than a practice. Yet comparison is essential if we want to understand what can be explained by regional and parochial factors and what stands as higher-level generalization. For example, Horst and Miller's (2006) study of mobile phones and poverty in Jamaica showed that generalizations about the use of phones for entrepreneurship and finding jobs in other regions may not work for Jamaica, where they found a rather different pattern to economic impact. Karanović (2012) reveals that national differences may remain important even in projects of global conception, such as free software, including the dominance of the English language, a relatively neglected aspect of digital anthropology.

In practice, the legacy of anthropological relativism continues through the commitment to regions and spaces otherwise neglected as well as the concern for the peoples and values of those regions. Many anthropologists have become increasingly concerned with how to give voice to small-scale or marginalized groups that tend to be ignored in academic generalization centred on the metropolitan West. With a few exceptions (see Ito, Okabe and Matsuda 2005; Pertierra et al. 2002),

most of the early work on digital media and technology privileged economically advantaged areas of North America and Europe. Ignoring a global demography where most people actually live in rural India and China rather than in Los Angeles and Paris, the theoretical insights and developments emerging from this empirical base then reflect North American and Northern European imaginations about the world and, if perpetuated, become a form of cultural dominance.

Amartya Sen has argued that a cornerstone to welfare is a people's right to determine for themselves what their own welfare should be. This may demand advocacy and pushing into the groups, such as women migrants who, as noted earlier, matter because of their dependence upon technologies (Madianou and Miller 2012; Panagakos and Horst 2006; Wallis 2008). One version of these discussions has pivoted around the concept of indigeneity (Ginsburg 2008; Landzelius 2006; for an important precedent, see Turner 1992). Where indigenous signified merely unchanging tradition, then the digital would have to be regarded as destructive and inauthentic. But today we recognize that to be termed indigenous is a modern construction and is constantly subject to change. We are then able to recognize the creative usage by all groups, however marginal or deprived.

But these also should include those involved in developing and designing digital technologies (e.g. DeNicola 2012), Drazin (this volume) demonstrates how ethnographers involved in design are also used to give voice to the wider public, such as Irish bus passengers, and increasingly that the public finds ways of being more directly involved. The problem, however, is that this is quite often used more as a form of social legitimacy than to actually redirect design. Many designers report that they are recruited to undertake qualitative and comparative research, but then they see the results of their studies reduced by more powerful forces trained in economics, psychology and business studies to five token personality types or three consumer scenarios, from which all the initial cultural difference has been eliminated. Although there have been alternative interventions, many design anthropologists conclude that they have been used merely to legitimate what the corporation has decided to do on quite other grounds. As digital anthropology becomes more established, we hope to see studies and ethnographies that are more aligned with the actual demographics and realities of our world.

Principle 5: ambivalence and the principle of openness and closure

The contradictions of openness and closure that arise in digital domains were clearly exposed in Dibbell's (1993) early and seminal article, 'A Rape in Cyberspace'. The article explores one of the earliest virtual worlds where users could create avatars, then often imagined as gentler, better people than the figures they represented offline. Into this idyll steps Bungle, whose superior technical skills allows him to take over these avatars, who then engaged in unspeakable sexual practices both with themselves and others. Immediately, the participants whose avatars had been violated switched from seeing cyberspace as a kind of

Principle 6: normativity and the principle of materiality

The final principle of materiality cycles back to the first principle concerning the dialectic. A dialectical approach is premised upon a concept of culture that can only exist through objectification (Miller 1987). As has been argued in various ways by Bourdieu, Latour, Miller and others, rather than privilege a social anthropology that reduces the world to social relations, social order is itself premised on a material order. It is impossible to become human other than through socializing within a material world of cultural artefacts that include the order, agency and relationships between things themselves and not just their relationship to persons. Artefacts do far more than just express human intention. Materiality is thus bedrock for digital anthropology, and this is true in several distinct ways, of which three are of prime importance. First, there is the materiality of digital infrastructure and technology. Second, there is the materiality of digital content, and, third, there is the materiality of digital context.

We started by defining the term digital as a state of material being, the binary switch of on or off, 0 and 1. Kelty's (2008) detailed account of the development of open source clearly illustrates how the ideal of freely creating new forms of code was constantly stymied by the materiality of code itself. Once one potential development of code became incompatible with another, choices had to be made which constrained the premise of entirely free and equal participation. Blanchette (2011), for example, has undertaken a sustained enquiry into the wider materiality of some of our most basic digital technologies, especially the computer. Blanchette explicitly rejects what he calls the trope of immateriality found from Negroponte's *Being Digital* (1995) through to *Blown to Bits* (Abelson, Lewis and Ledeen 2008). His work builds, instead, upon Kirschenbaum's (2008) detailed analysis of the computer hard disk. Kirschenbaum points out the huge gulf between metatheorists, who think of the digital as a new kind of ephemerality, and a group called computer forensics, whose job it is to extract data from old or broken hard disks and who rely on the very opposite property – that it is actually quite difficult to erase digital information.

Blanchette proposes a more sustained approach to digital materiality focusing on issues such as layering and modularity in the basic structure of the computer. What is notable is that at this most micro level, dissecting the bowels of a central processing unit, we see the same trade-off between specificity and abstraction that characterized our first principle of the dialectic at the most macro level – what Miller (1987) called 'the humility of things'. The more effective the digital technology, the more we tend to lose our consciousness of the digital as a material and mechanical process, evidenced in the degree to which we become almost violently aware of such background mechanics only when they break down and fail us. Kirschenbaum states, 'computers are unique in the history of writing technologies in that they present a premeditated material environment built and engineered to propagate an illusion of immateriality' (2008: 135). Objects such as hard disks constantly produce errors but are designed to eliminate these before they impact on what we do with them. We delegate such knowledge as the syntax of a UNIX

file to those we term 'geeks', whom we characterize as antisocial, thereby exiling this knowledge from our ordinary social world, where we find it obtrusive (Coleman 2009).

Another example of this exclusion from consciousness is evident in the topic of e-waste. As with almost every other domain, the digital has contradictory implications for environmental issues. On the one hand, it increases the potential for less tangible information so that music and text can circulate without CDs and books, thereby removing a source of waste. Similarly, the high carbon footprint of long-haul business-class fights can potentially be replaced by video or webcam conferencing. On the other hand, we are becoming aware of a vast detritus of e-waste that often contains problematic or toxic materials that are difficult to dispose of. These are of particular concern to anthropology since e-waste disposal tends to follow the inequalities of global political economy, being dumped onto vulnerable and out-of-sight areas, such as in Africa (Grossman 2006; Park and Pellow 2002; Schmidt 2006).

The second aspect of digital materiality refers not to digital technology but to the content it thereby creates, reproduces and transmits. Dourish and Mazmanian (2011) point out that virtual worlds have made us increasingly, rather than decreasingly, aware of the materiality of information itself as a major component of such content. Coleman (2010) has several references to anthropological and other examinations of the impact of digital technologies upon language and text (Jones, Schiefllin and Smith 2011; e.g. Lange 2007, 2009). Broadbent (2012) highlights how the specific technologies of personal communication is clearly relevant. There are also obvious domains of visual materiality. For example, Miller (2000) used Gell's theory of art to show how websites, just as art works, are systematically designed to seduce and entrap some passing Internet surfers while repelling those they have no reason to attract. In general, digital, and especially online, worlds have greatly expanded the scope of visual as well as material culture studies. Being material in the sense of being merely visible can be transformed into material in the sense of being acknowledged and finally respected. If you will forgive the pun, fundamentally being material means coming to matter.

Third, in addition to the materiality of technology and the materiality of content, there is also the materiality of context. Context refers not just to space and time but also to the various parameters of human interaction with digital technologies, which form part of material practice. Suchman's (2007) studies have led to a greater emphasis upon human–machine reconfigurations that are complemented by the whole development of human–computer interaction as an academic discipline (e.g. Dix 2004; Dourish 2004; Drazin this volume). A good deal of contemporary digital technologies are, in essence, attention-seeking mechanisms (Broadbent 2011), because one of the most common clichés about the digital world is that it proliferates the amount of things competing for our attention so any given medium must, as it were, try still harder. References to speed suggest how important digital technologies have been in shifting our experience of time, and that, instead of creating a timelessness, we seem to be becoming constantly more time aware. We might also note a truism within the

Bourdieu, P. 1977. *Outline of a Theory of Practice*. Cambridge: Cambridge University Press.

boyd, d. 2006. Facebook's 'Privacy Trainwreck': Exposure, Invasion, and Drama. *Apophenia Blog*, September 8. www.danah.org/papers/FacebookAndPrivacy.html.

boyd, d., and K. Crawford. 2011. *Six Provocations for Big Data*. Paper presented at the Oxford Internet Institute Decade in Internet Time Symposium, September 22. www.scribd.com/doc/65215137/6-Provocations-for-Big-Data.

Boyer, D. 2006. Turner's Anthropology of Media and Its Legacies. *Critique of Anthropology* 26: 47–60.

Broadbent, S. 2011. *L'Intimite' au Travail*. Paris: Fyp Editions.

Broadbent, S. 2012. Approaches to Personal Communication. In *Digital Anthropology*, eds. H. Horst and D. Miller, 127–45. London: Berg.

Coleman, G. 2009. The Hacker Conference: A Ritual Condensation and Celebration of a Lifeworld. *Anthropological Quarterly* 83(1): 42–72.

Coleman, G. 2010. Ethnographic Approaches to Digital Media. *Annual Review of Anthropology* 39: 487–505.

DeNicola, L. 2012. Geomedia: The Reassertion of Space Within Digital Culture. In *Digital Anthropology*, eds. H. Horst and D. Miller, 80–98. London: Berg.

Dibbell, J. 1993. A Rape in Cyberspace. *The Village Voice*, December 21, 36–42.

Dix, A. 2004. *Human Computer Interaction*. Harlow: Pearson Education.

Dourish, P. 2004. *Where the Action Is: The Foundations of Embodied Interaction*. Cambridge, MA: MIT Press.

Dourish, P., and M. Mazmanian. 2011. *Media as Material: Information Representations as Material Foundations for Organizational Practice*. Working Paper for the Third International Symposium on Process Organization Studies Corfu, Greece, June. www.dourish.com/publications/2011/materiality-process.pdf.

Drazin, A., and D. Frohlich. 2007. Good Intentions: Remembering Through Framing Photographs in English Homes. *Ethnos* 72(1): 51–76.

Eisenlohr, P., ed. 2011. What Is Medium? Theologies, Technologies and Aspirations. *Social Anthropology* 19: 1.

Engelke, M. 2010. Religion and the Media Turn: A Review Essay. *American Ethnologist* 37: 371–9.

Evans-Pritchard, E. 1937. *Witchcraft, Oracles and Magic Among the Azande*. Oxford: Oxford University Press.

Gershon, I. 2010. *The Breakup 2.0*. Ithaca, NY: Cornell University Press.

Ginsburg, F. 2008. Rethinking the Digital Age. In *The Media and Social Theory*, eds. D. Hesmondhalgh and J. Toynbee, 127–44. London: Routledge.

Goffman, E. 1959. *The Presentation of Self in Everyday Life*. Garden City, NY: Anchor Books.

Goffman, E. 1975. *Frame Analysis*. Harmondsworth: Penguin.

Grossman, E. 2006. *High Tech Trash: Digital Devices, Hidden Toxics, and Human Health*. Washington, DC: Island Press.

Gupta, A., and J. Ferguson. 1997. *Culture, Power, Place: Explorations in Critical Anthropology*. Durham, NC: Duke University Press.

Hancock, M., and T. Gordon. 2005. 'The Crusade Is the Vision': Branding Charisma in a Global Pentecostal Ministry. *Material Religion* 1: 386–403.

Hart, K. 2000. *The Memory Bank: Money in an Unequal World*. London: Profile Books.

Hart, K. 2005. *The Hit Man's Dilemma: Or Business, Personal and Impersonal*. Chicago: University of Chicago Press for Prickly Paradigm Press.

Hart, K. 2007. Money Is Always Personal and Impersonal. *Anthropology Today* 23(5): 16–20.

Hirschkind, C. 2006. *The Ethical Soundscape; Cassette Sermons and Islamic Counterpublics*. New York: Columbia University Press.

Horst, H. 2010. Families. In *Hanging Out, Messing Around, Geeking Out: Living and Learning with New Media*, eds. M. Ito, S. Baumer, M. Bittanti, d. boyd, R. Cody, B. Herr, H. Horst, P. Lange, D. Mahendran, K. Martinez, C. Pascoe, D. Perkel, L. Robinson, C. Sims, and L. Tripp, 149–94. Cambridge, MA: MIT Press.

Horst, H. 2012. New Media Technologies in Everyday Life. In *Digital Anthropology*, eds. H. Horst and D. Miller, 61–79. London: Berg.

Horst, H., B. Herr-Stephenson, and L. Robinson. 2010. Media Ecologies. In *Hanging Out, Messing Around, and Geeking Out: Kids Living and Learning with New Media*, eds. Mizuko Ito, Baumer, M. Bittanti, d. boyd, R. Cody, B. Herr, H. Horst, P. Lange, D. Mahendran, K. Martinez, C. Pascoe, D. Perkel, L. Robinson, C. Sims, and L. Tripp, 29–78. Cambridge, MA: MIT Press.

Horst, H., and D. Miller. 2006. *The Cell Phone: An Anthropology of Communication*. Oxford: Berg.

Humphrey, C. 2009. The Mask and the Face: Imagination and Social Life in Russian Chat Rooms and Beyond. *Ethnos* 74: 31–50.

Ito, M., S. Baumer, M. Bittanti, d. boyd, R. Cody, B. Herr, H. Horst, P. Lange, D. Mahendran, K. Martinez, C. Pascoe, D. Perkel, L. Robinson, C. Sims, and L. Tripp. 2010. *Hanging Out, Messing Around, Geeking Out: Living and Learning with New Media*. Cambridge, MA: MIT Press.

Ito, M., D. Okabe, and M. Matsuda. 2005. *Personal, Portable, Pedestrian: The Mobile Phone in Japanese Life*. Cambridge, MA: MIT Press.

Jones, G., B. Schiefllin, and R. Smith. 2011. When Friends Who Talk Together Stalk Together: Online Gossip as Metacommunication. In *Digital Discourse: Language in the New Media*, eds. C. Thurlow and K. Mroczek, 26–47. Oxford: Oxford University Press.

Jones, S., ed. 1998. *Cybersociety 2.0*. London: Sage.

Karanović, J. 2008. *Sharing Publics: Democracy, Cooperation, and Free Software Advocacy in France*. PhD diss. New York University, New York.

Karanović, J. 2012. Free Software and the Politics of Sharing. In *Digital Anthropology*, eds. H. Horst and D. Miller, 185–202. London: Berg.

Kelty, C. 2008. *Two Bits: The Cultural Significance of Free Software*. Durham, NC: Duke University Press.

Kirschenbaum, M. 2008. *Mechanisms: New Media and the Forensic Imagination*. Cambridge, MA: MIT Press.

Landzelius, K. 2006. *Native on the Net: Indigenous and Diasporic Peoples in the Virtual Age*. London: Routledge.

Lange, P. G. 2007. Publicly Private and Privately Public: Social Networking on YouTube. *Journal of Computer-Mediated Communication* 13(1): article 18. http://jcmc.indiana.edu/vol13/issue1/lange.html.

Lange, P. G. 2009. Conversational Morality and Information Circulation: How Tacit Notions About Good and Evil Influence Knowledge Exchange. *Human Organization* 68(2): 218–29.

Lindholm, C. 2007. *Culture and Authenticity*. Oxford: Blackwell.

Livingstone, S. 2009. *Children and the Internet*. Cambridge: Polity Press.

MacKenzie, D. 2009. *Material Markets: How Economic Agents Are Constructed*. Oxford: Oxford University Press.

3 Rethinking digital anthropology

Tom Boellstorff

'Digital anthropology', once literally unthinkable, at best a contradiction in terms, is well on its way to becoming a full-fledged subdiscipline, alongside formations like legal anthropology, medical anthropology, and economic anthropology, or the anthropologies of migration, gender, and the environment. Undergraduate and graduate courses (indeed entire degree-granting programs) now exist, and a canon is in formation, albeit a canon deeply engaged with scholarship from communications, media studies, sociology, and other disciplines. We are at an opportune time for rethinking what digital anthropology might entail.

With regard to the first term of the phrase – digital – it bears emphasizing that too often it still 'does little more than stand in for "computational" or "electronic"' (Boellstorff 2011: 514). But 'digital' should not act as a mere placeholder, simply marking interest in that which you plug in to run or recharge. Digital technologies are now so globally ubiquitous that from this standpoint all anthropology would be digital anthropology in some way, shape, or form. Just as not all anthropology is medical anthropology despite the fact that all humans have bodies and experience health and disease, so digital anthropology needs a framework – not a precise definition, but flexible parameters that can inform research agendas. Crucially, a framework for the digital can also contribute to the second term of the phrase 'digital *anthropology*'. This is because what *anthropos*, the human, means in terms of embodiment, meaning-making, and practice is being deeply transformed by digital technology and culture.

With all this in mind, in this chapter I seek to contribute to rethinking the digital with regard to digital anthropology. In Part 1, I begin by addressing an issue with foundational implications for digital anthropology: the relationship between the online and the offline.[1] This relation has pivotal ontological, epistemological, and political consequences: it determines what we take the digital to be, what we take knowledge about the digital to entail and what we understand as the stakes of the digital for social justice. I focus on the greatest negative ramification of an undertheorized notion of the digital: the mistaken belief that the online and offline are fusing into a single domain. In Part 2, I engage in the classic anthropological practice of close ethnographic analysis, through case studies drawn from two early days of my research in the virtual world Second Life. In Part 3, I link the theoretical discussion of Part 1 with the ethnographic discussion of Part 2 – another

classical anthropological practice, that of 'tack[ing] between the most local of local detail and the most global of global structure in such a way as to bring them into simultaneous view' (Geertz 1983: 68).

To foreshadow the crux of my argument: I develop a notion of the digital that harkens back to its original meaning of digits on a hand.[2] Rather than a diffuse notion of the digital as that which is merely electronic or online, this opens the door to a radically more robust conceptual framework, one with two key elements. The first is a foundational appreciation for the constitutive role of the gap between the online and offline (like the gaps between 'digits' on a hand). This resonates with the dialectical understanding of the digital developed by Miller and Horst in the previous chapter. The second element of this digital framework, drawing from the etymology of *index* as 'forefinger', is a whole set of theoretical resources for understanding the *indexical* relationships that constantly co-constitute both the online and offline. I thus push toward an indexical theory for understanding how the online and the offline 'point' at each other in social practice. This results in *a theory of the digital that is as imbricated with the human as it is with internet technology as such*. This means that, for instance, even if forms of quantum computing not predicated on binary digits someday become common, digital cultures (and thus digital anthropology) will still exist.

Part 1: challenging the notion of blurring

Before turning to this theory of digital anthropology and the ethnographic encounters that inspired it, it is imperative to first identify the core problem to which a more carefully articulated notion of digital anthropology can respond. This is the idea that we can no longer treat the online and offline as distinct or separate. It lies beyond the scope of this chapter to catalogue examples of scholars framing the study of the digital in this manner, as this is not a review essay or even a critique as such.[3] In an insightful overview of the ethnography of digital media, E. Gabriella Coleman nicely summed up this perspective when noting that with regard to research on virtual worlds, 'the bulk of this work, however, continues to confound sharp boundaries between off-line and online contexts' (Coleman 2010: 492). Coleman's phrasing captured the sense that 'sharp boundaries' are to be avoided – that they are scholarly conceits that falsely separate online and offline contexts, rather than ontologically consequential gaps that constitute the online and offline. In fact, these sharp boundaries are real and therefore vital topics for anthropological inquiry.

While less evident in this particular quotation, the sense that one can no longer see the online and offline as separate – despite the obvious fact that they are, depending on how you define 'separate' – encodes a historical narrative that moves from separation to blurring or fusion. Such presumptions of an impending convergence between the virtual and actual mischaracterize the careful work of earlier ethnographers of the online.[4] For instance, Vili Lehdonvirta has claimed that much virtual-world scholarship is 'based on a dichotomous "real-virtual" perspective' (Lehdonvirta 2010: 2). Lehdonvirta correctly

concluded, 'scholars should place [virtual worlds] side-by-side with spheres of activity such as family, work or golf, approaching them using the same conceptual tools' (2), and 'the point is not to give up on boundaries altogether and let research lose its focus, but to avoid drawing artificial boundaries based on technological distinctions' (9). What needs questioning is Lehdonvirta's assumption that virtual worlds are artificial boundaries, while spheres of activity such as family, work, or golf are somehow not artificial. At issue is that technological distinctions are central to the human condition: artifice, the act of crafting, is a quintessentially human endeavor. To presume otherwise sets the stage for the 'principle of false authenticity', which, as Miller and Horst note, occludes the fact that 'people are not one iota more mediated by the rise of digital technologies' (this volume: 26).

A three-part narrative of movement is embedded in these concerns over authenticity, dichotomies, and blurring: an originary separation, a coming together, and a reunification. This narrative is a teleology insofar as there is a defining endpoint: the impending non-separation of the digital and the physical, often presented in the apocalyptic language of 'the end of the virtual/real divide' (Rogers 2009: 29). Indeed, such contentions of an end times represent not just a teleology but a theology – because they so often appear as articles of faith with no supporting evidence, and because they resemble nothing so much as the dominant Christian metaphysics of incarnation, of an original separation of God from Man in Eden resolved in the Word made flesh (Bedos-Rezak 2000). This speaks to pervasive Judeo-Christian assumptions of 'the antagonistic dualism of flesh and spirit' that have strongly shaped dominant forms of social inquiry (Sahlins 1996: 400).

In place of this dualism, our starting point must be what I have elsewhere termed the digital reality matrix (Boellstorff 2016: 388). This is a four-way distinction between (1) the digital and unreal; (2) the physical and unreal (for instance, acting in a play or wearing a costume for Halloween); (3) the physical and real; but also (4) the digital and real (for instance, learning a language online that you can speak in the physical world, or making a friend online). This provides a rejoinder to conflations of the physical and real, with its implication that the digital is *always* unreal. The persistence of such misrepresentations underscores the urgent need for rethinking digital anthropology.

Some readers may have recognized the homage at play in my phrase 'rethinking digital anthropology'. In 1961, the eminent British anthropologist Edmund Leach published the essay 'Rethinking Anthropology'. In it, Leach chose a fascinating analogy to justify anthropological generalization:

> Our task is to understand and explain what goes on in society, how societies work. If an engineer tries to explain to you how a digital computer works he doesn't spend his time classifying different kinds of nuts and bolts. He concerns himself with principles, not with things. He writes out his argument as a mathematical equation of the utmost simplicity, somewhat on the lines of: $0 + 1 = 1$; $1 + 1 = 10$. . . [the principle is that] computers embody their

information in a code which is transmitted in positive and negative impulses denoted by the digital symbols 0 and 1.

<div align="right">(Leach 1961: 6–7)</div>

Leach could have not have predicted the technological transformations that now make digital anthropology possible. Nonetheless, we can draw two prescient insights from the analysis. First, 39 years after Bronislaw Malinowski established in *Argonauts of the Western Pacific* that 'the essential core of social anthropology is fieldwork' (Leach 1961: 1; see Malinowski 1922), Leach emphasized that anthropologists must attend to the 'principles' shaping everyday life. Second, to illustrate these principles, Leach noted the centrality of gaps to the digital: even a digital computer of nuts and bolts depends on the distinction between 0 and 1.

Leach's observations anticipate my own argument. The persistence of narratives bemoaning the distinction between the physical and the digital miss the point – literally 'miss the point', as my discussion of indexicality in Part 3 will demonstrate. The idea that the online and offline could fuse makes as much sense as a semiotics whose followers would anticipate the collapsing of the gap between sign and referent, imagining a day when words would be the same thing as that which they denote.[5] I will therefore discuss what such a rethought notion of the digital might entail and how, for such a rethinking to apply to digital *anthropology*, questions of theory cannot be divorced from questions of method. First, however, I turn to two case studies: I want the trajectory of this argument to reflect how my thinking has emerged though ethnographic engagement. This is not a detour, digression, or mere illustration: a hallmark of anthropological inquiry is taking ethnographic work as a means to develop theory, not just data in service of preconceived paradigms.

Part 2: two days in my early Second Life

Given the scope of this chapter, I cannot devote much space to background on Second Life.[6] Briefly, Second Life is a virtual world – a place of human culture realized by a computer program through the internet. In a virtual world, you typically have an avatar body and can interact with other persons around the globe who are logged in at the same time; the virtual world remains even as individuals shut their computers off, because it is housed in the 'cloud', on remote servers.

When I first joined Second Life on June 3, 2004, you paid a monthly fee and were provided a small plot of virtual land. In February 2005, I sold the land I had been initially allocated and moved to another area. However, at the time I wrote the first version of this chapter in 2011, to get myself into an ethnographic frame of mind, in another window on my computer I went into Second Life and teleported back to the exact plot of virtual land where my original home once stood in 2004. At that moment – late morning according to my California time – there were no avatars nearby. The large house that once stood here, my first experiment at building in Second Life, disappeared long ago and nary a virtual nail remains of

Figure 3.1 The land where my first home in Second Life once stood

my prior labor. But looking at my old land's little patch of coastline, I think I can still make out the remnants of my terraforming, my work to get the beach to slope into the water just so, in order to line up with the view of the distant shore to the east. Even in virtual worlds, traces of history endure (Figure 3.1).

The current owners of my onetime virtual homestead have not built a new house to replace the one I once crafted; instead, they have made the area into a wooded parkland. To one side, swings rock to and fro with automated animations, as if bearing unseen children. On the other side, at the water's edge, a dock invites repose. In the center, near where the living room of my old home was located, there now stands a great tree, unlike any I have ever seen in Second Life. Its long branches slope gracefully up toward the bright blue virtual sky. One branch, how-ever, snakes out horizontally for some distance; it contains an animation allowing one's avatar to stretch out, arms folded behind one's head and feet swinging in the digital breeze. So here on this branch, where my first Second Life home once stood, my virtual self will sit as I reflect on those first days of virtual fieldwork (Figure 3.2).

In what follows, I recount hitherto unpublished fieldwork excerpts from two concurrent days early in my research. (Second Life at this time had only text communication, which I have edited for concision. As is usual in ethnographic writing, to protect confidentiality all names are pseudonyms.) None of these inter-actions were noteworthy; it is unlikely anyone else bothered to record them. Yet in each case I encountered traces of broader meaning that point toward rethinking digital anthropology.

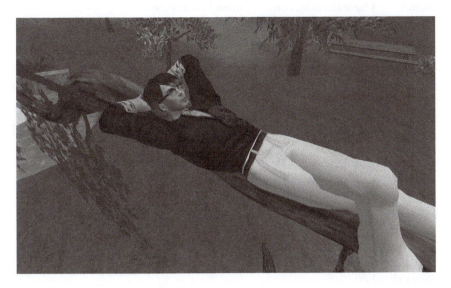

Figure 3.2 At rest in the virtual tree

Day 1: a slow dance for science

At 12:28 p.m. on June 30, 2004, I walked into my home office in Long Beach, California, and turned on my computer. I 'rezzed' into being in Second Life in my recently constructed house, right where my avatar will sit in a tree seven years later as I write this narrative. But on this day, only a month into fieldwork, I left my virtual home and teleported to a dance club at the suggestion of Susan, who was already at the club with their friends Sam, Richard, and Becca. At this point Second Life was quite small and there were only a few clubs. At this club the featured attraction was ice skating; the club had been decked out with a rink, and ice skates were available on the walls to attach to your avatar. In fact you bought the skates and they appeared in a box; if you did not know how to do things correctly, you would end up wearing the box on your head, not the skates on your feet. Most residents were new to the virtual world's workings; Susan was having a hard time getting the skates to work, and Sam and Richard were helping as best they could:

Sam: Susan, take them off your head lol [laugh out loud]
Sam: put them onto the ground
Susan: thanks
Susan: hehe, I'm new to this game
Susan: have I got them on?
Richard: click on the box on your head and choose edit
Richard: then click the 'more' button
Richard: then 'content' and you'll see them

Susan:	I have the skates on . . . I think I do anyway
Richard:	she has the box on her head

Susan (and others) continued to have trouble using the skates. In the meantime, I had managed to figure it out and was soon skating near Becca, who saw from my profile that I was an ethnographer:

Becca:	Tom would you like to slow dance?
Richard:	they [the skates] are still in the box I believe
Susan:	But I can't see it [the box] on my head
Becca:	for science
Tom:	how do you do it?
Becca:	lol
Susan:	hehe
Becca:	um . . . not sure
Sam:	I don't see a box on her head.
Becca:	hehe
Richard:	I do
Susan:	So is it on my head then or not?
Sam:	So Susan . . . you get a set of skates in a box?
Susan:	hehe, I think that might work
Becca:	oh there we go
Becca:	lol
Susan:	Yeah, I got them from the box, moved them into my inventory and then put them on
	IM [instant message]: Becca: just don't put your hand up my skirt . . . hehe

Despite the fact that I have edited this conversation for the sake of brevity, the ethnographic detail in this excerpt alone could take many pages to properly analyze and illustrates the kinds of data obtainable from participant observation that could not be acquired via interviews or other elicitation methods. I will note just six insights we can glean from this fieldwork encounter.

First, residents worked together to educate each other, rather than relying on the company that owns Second Life or some kind of instruction manual.

Second, gender seems to be shaping the interaction: it is largely men advising women. Since everyone knows that physical-world gender might not be aligning with virtual-world gender, this has implications for social constructions of gender.

Third, during this period when Second Life had only text chat (and even after the introduction of voice in 2007, since chat remained common), residents had learned to parse conversations in which there were multiple threads of overlapping talk. For instance, Sam asked Susan, 'you get a set of skates in a box?' and Susan answered three lines later, after first answering 'I think that might work', in reference to a different thread of conversation.

Fourth, when Becca made a slightly risqué comment to me ('just don't put your hand up my skirt'), they switched to an instant message, meaning that this

text was visible to no one besides myself. This apparently trivial practice helped me realize early in my research that I should attend not just to the content of statements, but to their modality of articulation – 'chat', 'shout' (text that, like chat, is publicly visible but to avatars at a greater distance), and instant messages sent both to individuals and groups of residents. This links to longstanding linguistic interest in 'codeswitching', but can also take forms of 'channelswitching' between different technological modalities of communication (Gershon 2010a).

Fifth, these insights (and many more) had precedents and contemporary parallels. Peer education, the impact of gender norms even when physical-world gender cannot be ascertained, and the existence of multiply-threaded and multimodal conversations were not unique to this interaction, to Second Life, or even to virtual worlds. Thus, an awareness of relevant literatures proved helpful in analyzing these phenomena.

Sixth, this encounter underscored how the ethnographer is not a contaminant. The fact that I was participating in Second Life culture without deception was not an impediment; rather, it made the research more scientific. My 'slow dance for science' illustrated the practice of participant observation, online and offline.

Day 2: here and there

On July 1, 2004, one day after my slow dance for science, I logged into Second Life again to conduct fieldwork, appearing as usual in my house. Rather than 'teleporting' instantaneously to another part of the virtual world, I walked down a nearby paved path. In the distance I saw three avatars, Robert, Karen, and Timothy:

Robert: Why, hello!
Karen: Hi Tom
Timothy: Hi tom
Tom: Hello! I'm your neighbor down the road
Karen: Ahh cool
Karen: Sorry for all the mayhem here, I have crazy friends
Robert: Hope the hoopla hasn't been a problem
Tom: What hoopla are you talking about?
Robert: Hee hee
Karen: rofl [rolling on the floor laughing] whew
Robert: just asking for it!
Timothy: whew
Karen: Oh the avie [avatar] launch game we had . . . the explosions, lap dances
Tom: Whatever it is, is hasn't bothered me!
Karen: Very good
Karen: So which way down the road are you?
Tom: To my right
Karen: Ah very good

Karen:	Got a house, or doing something else there?
Tom:	Just got a place for now
Karen:	cool
Karen:	Gonna turn this into a small boutique
Tom:	cool!

Already from the discussion, I had noted how co-presence in a virtual neighbor-hood could help shape online community: place matters when the online context is a virtual world. Karen then changed the subject:

Karen:	wow Tom, reading your profile here.
Karen:	very interesting
Karen:	um . . . Indonesia, really?
Tom:	Yep! Cool place. Not cool really, hot and humid, but fun.
Karen:	lol how'd you end up over there?
Tom:	Random life events, backpacking there after college & meeting people
Karen:	that's gotta be quite interesting I imagine
Tom:	very!
Tom:	is that your glowing dance floor over there to my left?
Karen:	nope, no clue who it's for
Karen:	a little bright
Tom:	there's a lot of building right now in this area! It's cool – every day the landscape is transformed
Karen:	yes, a lot of this land was just released
Timothy:	happens in new areas
Timothy:	finally got a house on one side of mine
Timothy:	mini tower going in behind
Tom:	laugh
Karen:	lol
Timothy:	as long as they don't cut off my view
Karen:	they screwed up my view in Shoki [region]
Robert:	Yeah, it's just sad.
Karen:	even though he said he wouldn't
Timothy:	think I am safe there

After a brief discussion of my positionality as a researcher, the conversation turned once again to virtual place. In my field notes I noted the importance of one's view across a virtual landscape. Encounters like this led me to realize the importance of place to virtual worlds (see Boellstorff 2015: chap. 4). The topic then turned to multiple avatars and I asked about The Sims Online, another virtual world I had briefly explored:

Tom:	do you play more than one avie at the same time? I know people who did that in The Sims Online but it seems that would be hard to do here.
Karen:	no, not here, in TSO [The Sims Online] I did

Robert:	Never saw the Sims, did I miss much?
Timothy:	I never tried TSO
Karen:	Didn't miss shit
Karen:	so you missed There altogether?
Tom:	Yes, I missed There completely. What was it like?
Timothy:	I remember that
Tom:	Was it more like Second Life than TSO?
Karen:	Very much like this, but more cartoonish and everything had to be PG-13
Robert:	Stepford Disney World
Tom:	Is it still around?
Timothy:	and not quite as open
Karen:	yes, Stepford Disney lol
Karen:	but there's still a lot of charm to There
Timothy:	but it has its nice parts
Robert:	Better chat, great vehicles
Timothy:	Meeting Karen being one of em
Robert:	Card games!
Karen:	yes, I met both you guys in There
Karen:	the horizon is clear, not foggy like here

This section of the discussion reveals how understandings of Second Life were shaped by previous and sometimes ongoing interaction in other virtual worlds. This influenced not only how they experienced Second Life, but their social networks (for instance, Karen first met Robert and Timothy in There.com). Yet to learn about how other virtual worlds shaped Second Life sociality, it was not necessary for me to conduct fieldwork in these other virtual worlds. Multi-sited ethnographic research is certainly useful given the appropriate research question – for instance studying a virtual diaspora that moves across several virtual worlds (Pearce 2009). However, it was clearly possible to explore how other places shape a fieldsite without visiting them personally. Indeed, when discussing multi-sited ethnography George Marcus was careful to note the value of 'the strategically situated (single-site) ethnography' (Marcus 1995: 110). This was an unexpected methodological resonance between my research in Second Life and Indonesia: to learn about *gay* identity in Indonesia, it was unnecessary to visit Amsterdam, London, or other places those Indonesians saw as places that influenced their understanding of homosexual desire.

Once again, virtually embodied presence was critical to my ethnographic method. In this one encounter, I gained new appreciation for virtual place, the importance of vision and 'a good view', and the impact of other virtual worlds. I mentioned none of these three topics in my original research proposal, even though they all turned out to be central to my conclusions. The insights were emergent, reflecting how 'the anthropologist embarks on a participatory exercise which yields materials for which analytical protocols are often devised after the fact' (Strathern 2004: 5–6).

place on Facebook cannot be reduced to the physical-world activities and identities of those who participate in it, even though these can have physical-world consequences ranging from a romance's dissolution to a political revolution. It is possible, for example, to become a closer friend with someone on Facebook without meeting that person in the physical world along the way.

The reason why it is possible to rehabilitate the digital so as to transcend its common conflation with 'online' is that the concept is fundamentally linked to indexicality. The etymology of *index* (Latin, forefinger) and *digit* (Latin, finger) both refer to the embodied act of pointing – and this has momentous implications when you can have multiple bodies and multiple fields of reference (even when there is not a clear avatar body involved). Building upon this characteristic of the digital through the framework of indexicality compels attention to the indexical ground of digital culture.[7]

The greatest strength of an indexical perspective is that it avoids the conceptual danger discussed in Part 1: the idea that the gap between the online and offline is headed down a teleological path to a blurring that we might celebrate or rue. It would be nonsensical to contend that the distinction between smoke and fire might someday vanish, that the gap between the word *sun* and the massive orb of gas at the center of our solar system might blur, or that the difference between 1 and 0 might converge into a fog of 0.5s. Yet just such an absurdity is entailed by the idea that the online and offline can no longer be separated. At issue are myriad forms of social practice, including meaning-making, that move within digital contexts but also across the gap between online and offline – from skates on an avatar's feet to embodied views across a virtual landscape, from a friendship in the actual world altered though a text message to a friendship on Facebook between two people who never physically meet.

At a broader level, the online and offline stand in an 'inter-indexical relationship' (Inoue 2003: 327); it is through the general gap between them that the emerging socialities so in need of anthropological investigation are taking form. As online socialities grow in number, size, and genre, the density and rapidity of these digital transactions across this inter-indexical gap between online and offline increase exponentially. Like a pointillist painting, if standing back it appears that the dots have blurred into brush strokes. But no matter how high the resolution, when one looks carefully one sees the discreteness of the dots, as well as the gaps of white space that allow them to convey meaning. This recalls how no matter how fast a computer becomes, no matter how quickly millions of 0s and 1s stream by, millions of gaps will stream by as well, for the computer's functioning depends on the gaps themselves. As noted in the introduction, the digital will exist (albeit in new forms) even in the context of quantum computing not strictly predicated on an opposition between 0s and 1s. This is because rethinking the digital involves recognizing its production through indexicality and the human experience of semiosis in spacetime (Munn 1986), not just through internet technologies per se. Even using a quantum computer, you would go online.

In setting out this idea of an anthropology that is digital by virtue of its attunement to indexicality, I do not mean to imply that online meaning-making is

exclusively indexical in character. At issue is that indexicality provides an empirically accurate and conceptually rich perspective from which to rethink digital anthropology. While a detailed examination of semiotic theory lies beyond the scope of this chapter, we can note in passing that symbols and icons, the other two types of sign in Peirce's analysis, are ubiquitous in online contexts (consider the icons that are so are central to computing cultures). Nor need we limit ourselves to a Peircean approach to language and meaning. But while not all dimensions of culture are like language, this particular aspect of language – the centrality of indexicality to meaning-making – is more indicative of digital culture than the structural-grammatical dimensions of language that 'cannot really serve as a model for other aspects of culture' (Silverstein 1976: 12). What I am suggesting is first, that for digital anthropology to make sense it must mean more than just the study of things you plug in or even the study of internet-mediated sociality, and second, that one promising avenue in this regard involves drawing from the digital's indexical entailments of pointing and constitutive gaps. These entailments have theoretical consequences that suggest research questions and lines of inquiry. They also have important consequences for method, the topic to which I now turn.

Participant observation as the core method for digital anthropology

Digital anthropology typically implies 'doing ethnography'. But ethnography is not a method; it is the written product of a set of methods, as the suffix -*graphy* (to write) indicates. Rethinking digital anthropology must therefore address not just (1) the theoretical frameworks we employ and (2) the socialities we study, but also (3) how we engage in the research itself.

Ethnographers of digital cultures work in a dizzying range of fieldsites (and are not always anthropologists, since ethnographic methods have a long history in sociology and other disciplines). One of the greatest virtues of ethnographic methods is that researchers can adapt them to the contexts of particular fieldsites. Ethnographic research online does not differ in this regard. However, this flexibility is not boundless. A serious threat to the rigor and legitimacy of digital anthropology is when online researchers claim to have 'done an ethnography' when they conducted interviews in isolation, paired at most with the analysis of online texts, images, and video. Characterizing such research as ethnographic is misleading because participant observation is the core method of any ethnographic research project. The reason for this is that methods like interviews and the analysis of online texts, images, and video are *elicitation* methods. They allow interlocutors to speak retrospectively about their practices and beliefs, as well as speculate about the future. But ethnographers combine elicitation methods (like interviews and focus groups) with participant observation, which, as a method not predicated on elicitation, allows us to study the differences between what people say they do and what they do.

The problem with elicitation methods in isolation is that this methodological choice surreptitiously encodes a theoretical presumption that culture is present

to consciousness. It is predicated on the belief that culture is something in peo-ple's heads: a set of viewpoints that an interviewee can tell the researcher or post on a social network site, to appear later as an authoritative block quotation in the published account. Of course, persons can often be eloquent interpret-ers of their cultures; as a result, interviews should be part of any ethnographic project. But what interviews and other elicitation methods can never reveal are the things we cannot articulate, even to ourselves. Obvious cases of this include things that are repressed or unconscious, an insight dating back to Freud. Lan-guage is another example. Consider a basic phonological rule like assimilation, where for instance the *n* in *inconceivable* becomes *m* in *impossible* because *p* is a bilabial plosive (made with the lips) and the nasal *n* assimilates to this place of articulation. Few English speakers could describe this rule in an interview, even though they use the rule hundreds of times a day in the flow of everyday speech.

Such aspects of culture are by no means limited to language and the psyche. In particular, theorists of practice have worked to show how much of everyday social action involves tacit knowledge. Pierre Bourdieu emphasized this point when cri-tiquing anthropologists who speak of 'mapping' a culture: 'it is the analogy which occurs to an outsider who has to find his way around in a foreign landscape' (Bourdieu 1977: 3). Take any route you traverse as part of your daily routine. If there is a staircase in your home or office, do you know how many stairs are there? The peril is to seek a representation of such tacit knowledge via an interview, where the informant's discourse is shaped by the framework of elicitation 'inevi-tably induced by any learned questioning' (Bourdieu 1977: 18).

If there is one thing that ethnographers have shown over the years, it is that 'what is essential *goes without saying because it comes without saying*: the tradi-tion is silent, not least about itself as a tradition' (Bourdieu 1977: 167, emphasis in original). When ethnographers ask interview questions, they obtain representa-tions of social practice. Representations are certainly social facts (Rabinow 1986) and have cultural effects. But they cannot be conflated with culture as a whole. If you ask someone 'what does friendship mean to you?' you will get a representa-tion of what that person takes friendship to be. That representation is socially consequential; it is embedded in (and influences) a cultural context. However, that elicited representation is not identical to friendship in practice.

The methodological contribution of participant observation is that it provides ethnographers insight into practices and meanings as they unfold. It also allows for obtaining non-elicited data – conversations as they occur, but also activities, embodiments, movements though space, and built environments. For instance, in Part 2 I observed Second Life residents teaching each other how to skate on a virtual ice rink, in part by learning how to skate myself. Had I just walked up to an avatar and asked out of the blue, 'how do you learn in Second Life?' I would have likely received a formal response emphasizing things traditionally seen as learning-related; rich detail about a group of avatars learning to skate would not have been in the offing. Participant observation allows researchers to identify cultural practices and beliefs of which they were unaware during the process of research design.

Some persons terming themselves ethnographers may not wish to hear this. On more than one occasion I have counseled scholars who claim to be 'doing ethnography' but use interviews in isolation – in one case, because a colleague told them participant observation would take too long. This does not mean that the norm of the fieldwork year is inviolable; rather, it means that participant observation is never rapid: 'not unlike learning another language, such inquiry requires time and patience. There are no shortcuts' (Rosaldo 1989: 25). You cannot become fluent in a new language overnight, or even in a month or two. Similarly, someone claiming to have conducted ethnographic research in a week or even a month is mischaracterizing their work unless it is part of a more long-term engagement. There is no way they could have *become known to a community* and participated in its everyday practices in such a time frame.

Conclusion: time and imagination

When I consider the exciting possibilities that inhere in rethinking digital anthropology, I find my mind wandering back to an image. A webpage, to be precise, one that has haunted me for years despite its apparent triviality. I think – of all things! – about the original McDonald's home page from 1996, from the early days of the internet's ascendance.[8] Despite its simplicity from a contemporary perspective (basically, the Golden Arches logo on a red background), the webpage represented the best that a major corporation could offer in terms of web presence; it likely involved considerable expense to design and implement.

When I think about what this website represents, I compare it to some contemporary phenomenon like Twitter. Compared to Second Life or many other online phenomena, the basic concept behind Twitter is simple. That simplicity allowed, for instance, former President Trump to disseminate untruths to broad publics. But a website based on the core conceit of Twitter – text messages 280 characters in length – could be implemented with only a dial-up connection, using a 1990s-era computer. In fact, there is no technological reason why something like Twitter could not have existed in 1996, alongside that original McDonald's home page.

Why did Twitter not exist in 1996, coming into being only ten years later? It was not a limit of technology; it was a limit of imagination. In the early years of widespread web connectivity, we did not yet realize the affordances of the technology in question.

From online worlds to wearables, from autonomous vehicles to AI, our digital landscapes in the late 2010s are analogous to that McDonald's web page from 1996. Current uses of these technologies push against the horizon of the familiar: it could not be otherwise. Transformative uses of these technologies certainly exist, but at present are no more conceivable than the idea of a Twitter feed would have been to a user of the McDonald's website in 1996, despite its feasibility from a technical standpoint. It is a matter of time and imagination.

Leach concluded 'Rethinking Anthropology' by emphasizing:

> I believe that we social anthropologists are like the mediaeval Ptolemaic astronomers; we spend our time trying to fit the facts of the objective world

4 The anthropology of mobile phones

Heather A. Horst

Introduction

The mobile phone is one of the most ubiquitous objects around the world. When mobile phones were introduced in 1979 to mass markets, they were an expensive technology available largely to wealthy business people living and working in industrialized contexts. Today, the mobile phone and associated networks are available in every country and have become an everyday consumer object even in some of the world's most remote regions. The cost and capabilities of a mobile phone (increasingly the smartphone) and the quality of the mobile network and associated services to operate varies considerably across countries and contexts. Nevertheless, it has become an aspirational yet attainable consumer object to use and own.

Yet what the mobile phone was, is and can do has also transformed over the past 40 years. Although there have been precursors to the mobile phone since the early 1900s, 1G cellular networks were first made available in Tokyo in 1979 and, shortly thereafter, in Sweden, Norway, Finland and Denmark. The Dyna-TAC mobile phone, the world's first cell phone, launched on the 1G network on March 6, 1983. While the phone was a much-desired consumer item throughout the 1980s, cost and availability was a primary deterrent to widespread adoption. It wasn't until the 1990s with the introduction of 2G networks that mobile phones began to enter into the daily fabric of (largely) urban life around the world. 3G networks followed in 2001 and, at the end of 2019, we were on the cusp of the new standards for 5G networks.

When mobiles entered the mass consumer market, voice was the primary functionality. Phones were often large and cumbersome and, especially in Europe and North America, often doubled as 'car phones' that enabled business persons and others to make calls while driving from point to point. They were also marketed as a useful technology to have in the case of emergencies. 2G networks introduced SMS message functionality, and the first SMS message was sent in Finland in 1993. The shift to 3G in 2001 meant that cellular and mobile networks could move more data at faster speeds, making it possible to send music, videos and other kinds of media over these networks. The demand for these new forms of data prompted the development of 4G. First introduced in Finland in 2010, 4G

has been slowly spreading around the world as telecommunications companies weigh the pros and cons of upgrading their networks. These technological transformations in the mobile phone are important because they highlight the changing meanings of the mobile phone over time and, in turn, the implications of the mobile phone's uneven distribution (Goggin 2011).

Whilst the extraction of minerals that are used to create mobile phones and the growth in mobile phone users and cellular networks were present in many fieldsites (Mantz 2008, 2016), mobile phones did not capture the attention of anthropologists until after the turn of the century. This chapter examines the emergence of the mobile phone and its consequences for research in the subfield of digital anthropology. It begins with a review of mobile phone research, discussing some of the first studies of mobile phones by anthropologists in conversation primarily with scholars outside the discipline. The next section turns to a discussion of key studies and themes that emerged in the second wave of research on the use or consumption of mobile phones in anthropological research in the Global South. More specifically, it explores the role that mobile phones played in elucidating key debates in the field around gender and power dynamics, and the dynamism of the mobile phone as it has transformed into a smartphone and the political economy of the mobile phone. The chapter ends with examples of the ways in which relationships between consumers, companies and state agents are made visible through the moral economy of the mobile phone based upon recent research in the Pacific.

Mobile phone research by anthropologists

When embarking upon a review of the mobile communication literature, it becomes apparent that the formative research in the field has been dominated by disciplinary perspectives from media and communication, informatics, sociology, cultural studies and other fields outside of anthropology. Indeed, what we might view as the first decade of mobile communications research was led by scholars in the US and Europe (e.g. Katz and Aakhus 2002), and it largely focused upon countries in Europe and, to a lesser extent, Asia, who were identified as 'first adopters'. One of the key figures in the field of mobile communication is Rich Ling (1988, 2004), who worked as a communications researcher at the Norwegian telecommunications company Telenor. Drawing upon his training as a sociologist, Ling's early work focused upon how mobile phones were changing social life among families, workers, friends and the broader public in Norway. Perhaps the most important contribution of Ling's initial research involved observations of the ways in which mobile phones shifted relationships to time. In one of his key studies Ling suggests that the mobile phone enables people planning to meet to adapt their meeting times and schedules, what he described as a 'softening of schedules' (Ling and Yuri 2002). Through the concept of micro-coordination, Ling (2004) drew attention to the ways in which people adjusted their meeting times on their way to a meeting, particularly when they were delayed. Other insights emerged through studies of how teenagers used text messaging to save money, the relationship

between mobile phones and fashion, tensions between parents and children over mobile phone use as well as the emergence of changes in communication – even language – with the introduction of mobile phones. Importantly, Ling and others working in fields such as sociology and communications framed much of their work in conversation with key social theorists such as Durkheim and Goffman (e.g. Haddon 2004; Katz and Aakhus 2002; Ling 2008).

While anthropology was generally reticent to claim mobile phones and mobile communication as an object of inquiry in the late 1990s and early 2000s, a number of anthropologists were involved in research and discussion with other scholars outside the discipline. One of the first examples is Raul Pertierra et al.'s (2002) study of mobile phone use in the Philippines, a country widely known as an early adopter of mobile phones. Pertierra and his colleagues in the Philippines examined the ways in which Filipinos were using mobile handsets which, at the time, were largely feature phones with voice and texting capabilities. Among other aspects of the work, Pertierra and colleagues argued that texting – and Filipinos' affinity for it – had less to do with cost and more to do with the ability to maintain social relationships through messages and other forms of communication in both synchronous and asynchronous time. For this reason, the mobile phone, and particularly the capacity to text, enabled the phone to become an extension of self in an unobtrusive way, which reflected broader values of self and personhood in Filipino culture (Pertierra 2006). Such attention to culture and context was not common in mobile communication studies and thus provided a new vantage point for understanding how mobile phones were used and interpreted differently.

A second example of anthropology's engagement with early mobile communication research is Mizuko Ito et al.'s (2005) *Personal, Portable, Pedestrian: The Mobile Phone in Japanese Life*. The edited book, which included Japanese scholars in sociology and communication studies, focused upon mobile phone adoption and change largely in urban Japan. Bringing together Ito's training in cultural anthropology with a broader interest in science and technology studies, Ito et al. (2005) chronicled the ways in which the mobile phone transformed in form and function since the introduction of the mobile phone in Japan in 1992. Attempting to move beyond the techno-orientalism prominent in many studies of technology in Japan, one of the interesting dimensions of their study involved the norms around etiquette and the use of voice technologies, particularly in public spaces such as trains. Rather than voice, many of the Japanese users the research team studied preferred to keep their phone in 'manner mode'. The co-authors' rubric of 'personal', 'portable' and 'pedestrian' defined the relationships that people had with phones. As they described, mobile phones were personal and belonged to the individuals who owned them rather than being a shared device, and phones were often decorated or 'customized' by individuals. Secondly, mobiles in Japanese society were 'portable' in that they are something to carry and contain and are used to communicate with small groups of users, what they described as a full-time intimate community, as they moved throughout their day. Ito et al.'s notion of 'pedestrian' captures the ways through which phones, text messaging and the camera phone had become part of the everyday communication landscape

in Japan. These case studies, and the advances in mobile communication infra-structure available in Japan, were often viewed as examples of what other parts of the world might become.

Finally, the third study is represented in some of my co-authored work with Daniel Miller focused upon the mobile phone in rural and urban Jamaica (Horst and Miller 2006). Emerging out of a broader study of the impact and influence of information and communications technologies (ICTs) in developing countries (Tacchi et al. 2005), the mobile phone – locally called 'the cell phone' – came to dominate the communication landscape over the course of the study. In contrast to countries such as the Philippines, Japan and other places where text messaging replaced voice calls relatively quickly, we found that Jamaicans very rarely used the SMS feature of their mobile phones. They preferred voice calls and, to keep the cost of calls lower, they engaged in 'link-up'. 'Link-up' involved the collec-tion of a large number of names and contact numbers (links) which were then contacted on a relatively regular basis to keep the connection alive. However, most of these calls were quite short, an average of 19 seconds per call. At the time contemporary theories of the network society put forth by Manuel Castells (2004) and others argued that the internet and mobile phone created the conditions for building networks; however, we argued that the logic for link-up as it was expressed in Jamaica revolved around an historical set of practices around build-ing networks in an ego-centred society (Horst and Miller 2005, 2006). In other words, it was not technology but the mix of culture and technology that led to the practice and expression of link-up at this particular moment in time in Jamaica.

In essence, early mobile communication research carried out by anthropolo-gists examined what the mobile phone meant in a broader cultural context. To build conversations, anthropologists emphasized the cultural specificity of mobile phone appropriation and use by introducing more context-specific studies of non-Western societies. Whereas Ito et al.'s (2005) interdisciplinary interlocutors in science and technology studies, media and communication studies, informatics as well as industry leaders often looked to the findings emerging from research in Japan to provide insight into future practices, Horst and Miller's (2006) work was oriented to scholars working in development, especially those concerned with issues such as the digital divide; not surprisingly such work about implications of the mobile in less industrialized contexts focused upon the mobile phone's capac-ity to 'leapfrog' what was viewed as a communication technology's typical trajec-tory, such as landlines (Horst 2006; Jensen 2007; Donner 2008). Anthropological approaches and questions worked to confound studies in Western contexts where mobile phones were viewed, for example, as an extension of the personal, private self; as a fashion accessory that could connote status or an object that created friction between parents and their teenaged children who were seeking autonomy. While anthropologists were more or less mindful not to treat the ontologies and practices of other contexts as always othered or bespoke (e.g. the work on mobile phones and spirituality), anthropological perspectives worked to nuance and chal-lenge the application of Western social theory to other cultural contexts (Bell 2006; Ling and Donner 2009).

The anthropology of mobile communication

Whereas the first phase of research on mobile phones by anthropologists focused upon conversations with scholars outside of the discipline, a second phase of research shifted attention to anthropological questions of power and social change. Despite the initial lack of interest in technology and mobile phones by anthropologists, the spread of mobile phones globally meant that they had quickly become part of the fabric of everyday life as well as a 'must have' technology during fieldwork (Sanjek and Tratner 2016). The increasing pervasiveness of mobile phones in individual researchers' ethnographic sites became the impetus for a series of studies on mobile phones in different national contexts (e.g. Archambault 2011, 2017; Barendregt 2008, 2012; de Bruijn et al. 2009; Kraemer 2017; Doron and Jeffrey 2012; Horst and Taylor 2014; Ito et al. 2009; Lipset 2013; Molony 2008; Stammler 2009; Tenhunen 2008; Wallis 2013). Alongside introducing national and geographical novelty to the interdisciplinary canon of mobile communication literature, anthropologically informed studies enabled a more detailed account of the use and integration of mobile phones for understanding fundamental questions about mobile phone appropriation and its role in everyday sociality. This work highlighted the perspective of people who used mobile phones in relationships and for other ends. While there are a range of issues explored in this second phase of research, this section will concentrate upon three areas where anthropologists studying the mobile phone have focused their attention: the consequences of the mobile for relationships, especially issues of gender; the changing capabilities of the mobile phone and its consequences for how, when and where we use mobile phones; and the broader political and moral economies of the mobile phone in relation to the processes of production, distribution and consumption.

Gender and power

One of the ways in which anthropological perspectives on mobile phones have expanded is through the study of relationships, especially the mobile phone's contribution to the cohesion or disintegration of society. In the US and Europe the focus has largely been upon the ways teenagers use mobile phones to gain autonomy from their parents and families and thus use the phone for peer sociality, in other contexts the use and ownership of an individual or collective mobile phone has had important consequences for gender dynamics and power relations (Horst and Taylor 2014; Kraemer 2017, 2018; Wallis 2013). In Jamaica, for example, women believed that it enabled men's cheating and infidelity, and men contended that women expected mobiles and other forms of support in exchange for sexual relationships (Horst and Miller 2006). In parts of India, some women's use of mobile phones was restricted and/or brokered by male relatives, although there was also evidence of urban young men gifting phones to girlfriends, especially in India's middle class and urban centres, to subvert and gain direct access to women (Doron and Jeffrey 2012; Tenhunen 2018; Tacchi et al. 2012).

Moving beyond mobile phone consumption and appropriation, this section highlights the different ways that mobile phones have become part of the telecommunications ecology in the Pacific island state of Fiji. The research that underpins the material is part of a collaboration with Robert Foster as part of an Australian Research Council Discovery Project, The Moral and Cultural Economy of Mobile Phones in the Pacific (2014–2018). Designed as a comparison of two countries in the region where the same mobile phone company (Digicel Ltd) has entered to disrupt the state-sponsored incumbent, the project developed the framework of the moral economy to account for the ways in which the telecommunications landscape has transformed in each national context in relation to a series of different stakeholders over the last decade. Importantly for us, the moral economy framework takes into consideration the *companies* that offer handsets, airtime and other access to the network, the *consumers* who use the phones, and the state and the *state agents* that provide policies for and regulate the telecommunications companies and the various infrastructures that support mobile phones, ranging from access to international gateways, mobile towers, call rates and other aspects of mobiles (Foster and Horst 2018). To illustrate these changing relationships, and the need to recreate and reinforce them, I focus upon three examples of the ways in which different stakeholders negotiate their relationship with others. The first example focuses upon the *relationship between consumers and the state* through a discussion of online safety and parenting in Fiji. The second example concentrates upon the ways in which *companies in Fiji make consumers* through marketing and branding (Foster 2007, 2011). The final example attends to the ways in which *companies and different kinds of consumers* navigate data plans and infrastructures. Taken together, these provide a wider vantage point on mobile phones across different global contexts. The perspectives offered through an analysis of the changing relationships between these three key actors demonstrates that these patterns and practices cannot be seen as the result of state policies, corporate strategies or creative usage by consumers. They also highlight that the meaning of mobile phones in people's lives reflects a complex configuration of these different components, which are expressed differently across national contexts.

Consumers and the state: smartphones, online safety and parenting

Mobile phones have become part of the everyday communication landscape of people around the world. In Fiji, a multicultural island nation in the Pacific, mobile phone ownership rose to 1,290,000 users in 2018 out of a population of just over 900,000. According to the latest *We Are Social 2018 Report*, most Fijians access the internet and social media using an internet-enabled mobile phone. Whereas only 28% of Fijians accessed the internet and social media through a desktop or laptop computer, 68% of Fijians used a smartphone.

The high rates of smartphone ownership and usage is especially visible in Fiji's capital, Suva, and the greater Suva-Nausori corridor where over half of Fiji's entire population lives. In the greater Suva area, 4G and 3G networks are prevalent.

So, too, is access to vendors where you can buy a smartphone or purchase pre-paid top-up cards for phone and data from one or both of Fiji's two major tel-ecommunications companies: Vodafone and Digicel (Horst 2018). Smartphones have been particularly important for opening up the world of social media. With a smartphone it's much easier to take and edit photos or videos and share them with others. Fijians have, in fact, become expert at posting, commenting, sharing and lurking on social media. According to the *We Are Social 2018 Report*, over 500,000 Fijians used social media, with Facebook being the most popular site by far. Google, YouTube and, to a much lesser extent, Instagram were also popular. In addition, the use of chat and messenger programs such as Facebook Messenger, WhatsApp and other similar apps were on the rise.

Fijian society continues to adapt to this rapidly changing media environment. Fijians are integrating smartphones and social media into their lives, and they are also interpreting their own cultural practices to redefine social media practices. But like other places in the world, Fijians – and Fijian parents in particular – are struggling with the pace of change that smartphones and social media bring into their lives. Many Fijian mothers and fathers grappled with questions such as: When should I give my child a mobile phone or set up a social media account? How much time should my child should spend online? What kind of websites and social media accounts should they use? Should this be different for my sons and daughters? These are questions not only about their children and strategies of digital parenting. They are also about the broader questions of change – and the impact of the smartphone age – for Fijian society.

As we outlined in our documentary film *Parenting in the Smart Age: Fijian Perspectives* (2019), smartphones and social media have created dilemmas about how to manage and monitor the ways that children use media and technology, how this should change as children get older, whether daughters should have different rules than sons and how to cope with a situation when something goes wrong. Most parents in Fiji discussed their efforts to develop rules about when and how their children can use the internet or particular platforms. For example, one parent named Vasiti reflected upon how she started to restrict her six children's use of the internet until the weekend. Once they turned 18, she no longer restricted them and even relied upon the older siblings to help monitor their younger siblings' use of tablets and smartphones. Similar to digital parenting practices in global locations (e.g. Livingstone and Blum-Ross 2020; Ito et al. 2009), other parents restricted mobiles at the dinner table, at church and at key events.

Alongside restricting screen time, parents discussed different ways they tried to monitor and control how their children used technology. It remained common for parents to keep their sons' or daughters' passwords so they could review the content that they were posting, even when their children were over the 13-year minimum age requirement on sites like Facebook. Some parents restricted plat-forms such as Instagram or Snapchat as they were concerned with the kinds of images being shared. Parents such as 40-year-old Natacha developed other, more nuanced rules such as restricting her daughters from friending classmates from school (with a few exceptions) so that issues that occur in school did not impact

Moreover, Vodafone presented itself as part of the fabric of Fijian society, leveraging its long-term presence and commitment to Fiji. Vodafone stressed its role as incumbent and market leader appealing to a sense of belonging, shared history and values during a period of political turbulence and coups (Kelly and Kaplan 2001; Norton 2012). In effect, Digicel, through their marketing strategies and promotions, emphasized the 'consumer' in the consumer-citizen equation. Vodafone, by contract, stressed its relationship with Fijians as consumer-*citizens* through its use of symbols of nation and belonging.

Unlike countries where moves toward privatization disentangled the relationship between the incumbent telecommunications company and the state, in Fiji the state has maintained a different relationship with the telecommunications companies. Given the ownership structure, it also has important relationships with various regulatory agencies such as the Telecommunications Authority of Fiji, Fiji International Telecommunications Limited (FINTEL) and the Consumer Council of Fiji as well as the Fiji National Provident Fund, the local pension scheme that is now majority owner of Vodafone Fiji.

Companies and consumers: how free culture makes consumers

With the solidification of the two key players in Fiji came a shift from what we might think of as culture associated with merchandise and forms of public culture to a second phase of services associated with free services. This is perhaps most visibly noted through the reduction of billboards and newspaper ads and reflects a broader advertising shift to focusing on promotions. Promotions on features and other phones involved free SMS messages or minutes when signing up for particular plans. Indeed, various people in Fiji on pre-paid plans will wait until one of the special promotion days. One of the most popular is a top-up 'Bonanza' which involves receiving free minutes on Vodafone if you top up at least $2 on Tuesday. In fact, virtually everyone on pre-paid services knows the promotion by heart: 2UP on a $7 recharge (double the minutes), 3UP on an $11 recharge (triple the minutes), 4UP on a $15 recharge and 5UP on a $25 recharge. Increasingly there were also free data promotions associated with these services and 'Free Money', which could only be used at particular times during a set period. As an ad in 2018 summarized,

> Get Recharge Bonanza now on $2 n more! 2Up on 2-7, 3Up - 11, 4Up -15 n 5Up on 25 - 100. Free Money on 2-5 expires in 6 days,6-11 in 15 days n 15 n above 30 days. Promotion Ends 26th August. Conditions Apply!

Both networks offered 'freeness', which was part of the broader discourse about what services to use. A 40-year-old woman named Vasiti described her use of promotions on the other network Digicel,

> I usually do $6 a week on Digicel because then I get that total freedom thing that's $4.99 and I get free calls and data and everything for like a week . . . so

I just make sure that I get that $6 a week and then I get that $4.99 and then I'm like set for the whole week.

It is also worth noting here that reminders of these promotions come directly to people's phones, if you have a live service, and are interspersed with a series of other messages for 'deals' and 'specials' for bidding for cars or other vehicles, promotions on downloading free songs for use as the holding music while people ring you, and a range of other activities. Promotions offering free time, free money and free data drives the meaning of free culture in Fiji. The notion of freeness offered by the mobile companies is one that seeks to engage and hold the customer/consumer into the consumer-company relationship. But consumers have little opportunity to escape the telecommunications systems at work unless they were to opt out entirely, leaving them outside of the networks that support other aspects of their lives. As a result, it is not unusual to see someone on a pre-paid plan work their networks for enough credit to get the bonus minutes or 'free money' offered by the mobile companies.

Alongside meeting the demands of promotions by waiting for particular days to recharge or top up their mobile phones and storing the funds to recharge a particular amount and have enough money to buy passes, consumers also find ways to subvert and take advantage of the free culture established by mobile telecommunications companies. This is particularly common for some of our more middle-class users who have stable incomes and access to multiple mobile infrastructures, such as by purchasing multiple SIM cards or dual SIM phones (Horst 2013). Others are able to leverage multiple networks and the increasing availability of Wi-Fi at work and at home. One of our participants, Merelita, described how she navigates between her workplace LAN connection, her pocket Wi-Fi and data on her phone,

> So at the moment I haven't topped up the pocket Wi-Fi so I'm using data (on my smartphone), but when I do top it up – which normally we do monthly because you get the $25 for 8GB or $50 for 50GB, so it's just easier to do that. So if I top it up to that extent then I'm not using data from my phone I'm just using the Wi-Fi. But if that runs out then I'll use data. . . . If I still want to upload stuff . . . I will turn my phone on around lunch time out some updates like a tweet . . . and then turn data off again.

Later Merelita described how access to the internet via a PC at work also made it possible to download music, watch YouTube videos and download bigger files which – given her available infrastructures – she would never think of navigating via her smartphone outside of what she described as "an emergency".

University students discussed similar ways of operating, toggling between the university Wi-Fi (widely acknowledged as slow) to access Moodle and other online platforms and their data on their mobile phones. In a number of our diary studies we found that rather than spend time on the bus chatting on messenger or other apps, quite a few students turned off their data and used the time to listen to music, take photos (largely selfies) or even edit their selfies. They would then go

online when they arrived at the university through using either Wi-Fi (depending upon what they wanted to do) or short bursts of data. A number of students also noted that they used Wi-Fi at home. While it must be stated that Merelita (and most other government and public servants for that matter) was not a high-income earner individually, she operates in a diverse media infrastructure which enabled her to toggle between different data plans – albeit with constraints such as the restriction of social media at work during the day. Certainly students had fewer funds at their disposal than did professionals like Merelita with stable jobs; students moved through the city with their powerbanks (probably more important than data) and a knowledge of the Wi-Fi and other infrastructures available to them to enable moments of 'freeness'. While these infrastructures were not 'free', per se, they defined the ways in which ordinary consumers – especially middle-class consumers in Fiji – leveraged the cultures of free created by mobile operators.

For the many citizens of Fiji who lived outside a system of stable jobs or access to Wi-Fi, Vodafone Fiji and Digicel Fiji Ltd offered day passes where consumers could pre-pay for their 'data bundles' and 'free data' on their smartphones. Theoretically these services were available and easy to use but the experience of taking advantage of freedom passes and free data was not straightforward. A key example of this was Fulori, an 18-year-old woman who lived in her final year of high school about a 30 minutes bus ride away from the informal settlement that she grew up in along the Suva-Nausori corridor. Like other young women at her high school, she loved to go on Facebook to browse what her friends and others were doing. She also liked to watch funny videos on YouTube, though the first time we discussed her use of her smartphone to watch videos on a day pass she noted that she only managed to watch about three videos before her 24-hour pass expired ($FJ 1.49 for 350MB). She mentioned this to a friend and they immediately showed her how to turn off some of the automatic settings that effectively ate up her data.

The next time she saved enough extra money to buy a day pass, Fulori decided to take advantage of Digicel's three-day pass which she used for three blissful days of browsing Facebook, chatting to her boyfriend on Messenger, uploading photos to her Facebook page, joining the group for the informal settlement that she lived in and, of course, watching videos. Fulori felt satiated with her social media use when the three days were up and she decided to try to save up money in another week or two for another social media spree. Two weeks later she went to buy another pass only to discover that the previous pass had 'automatically renewed' and the money she wanted to spend on a new pass was now eaten up by the auto-renew function that she was unaware of when buying the pass. She would have to wait another two weeks before she could save the money to go online, and she would miss out on the news from her friends and family living in other parts of the island. It also meant that she would have to be very careful with the last of the phone credit (voice/SMS).

Fulori's experience with using a day pass was not unusual for most mobile consumers in Fiji accustomed to operating on a pre-paid phone plan, the vast majority of low-income and working-class individuals. With little access to extra money

(she skipped meals to save up for her phone use), Fulori's ability to monitor and manage her usage had been honed through a range of special promotions of buying and adding airtime credit on particular days. The mobile companies use of autopay and automated services effectively disrupt these practices and, as scholars such as Jonathan Donner (2015) and Robert Foster (2018) have been arguing for PNG, require new systems of discipline and practice to emerge to leverage 'free' culture for their own purposes.

Towards a digital anthropology of mobile phones: future directions

This chapter has explored the development of mobile phones as an object of study in the discipline of anthropology. Through a review of the early work on mobile phones by anthropologists in dialogue with other researchers and disciplines to research focused specifically on the growth of an anthropology of mobile phones and mobile communication, it traces how mobile phones – as a global consumer object – became part of the broader research agenda of anthropology. In particular, it examined the ways in which the mobile phone has become integrated into everyday life in different contexts around the world, with particular attention to its role in changing and shaping gender dynamics between individuals and families. Taking into account the materiality of the mobile phone, the chapter then turned to the ways in ways in which the technological capabilities of the mobile phone has started to transform what the mobile phone is and how it is further integrated into relationships. This included reflecting upon the use of the phone for sharing and creating images and videos, sending and receiving money and using a range of other capabilities that further influence social and economic practices. The final section reflected upon the mobile phone as a part of a broader political economy that relies upon minerals, factories of production as well as regulatory and marketing frameworks established by governments and companies.

As the review and three case studies based on recent research exploring the relationship between consumers, companies and state agents suggest, the mobile phone is one of the most important consumer items of the early 21st century. But it is also a nebulous object that is not easily confined as having particular capabilities and affordances. It remains, at least in part, a communication technology that people use for talking and typing messages. But once linked to data infrastructures, it becomes a device through which a variety of other applications can be downloaded and used. In the mobile only or mobile primary regions of the world where many anthropologists continue to carry out research, the merging of the smartphone with social media and apps can be used for education and learning, health and wellbeing, economic transactions and activities. The widespread prevalence of the mobile phone, coupled with the specificity of the contexts of use, production and circulation, places the mobile phone at the center of the subfield of digital anthropology.

References cited

Anderson, Barbara. 2013. "Tricks, Lies, and Mobile Phones: 'Phone Friend' Stories in Papua New Guinea." *Culture, Theory and Critique*, 54(3): 318–334.

Archambault, Julie Soleil. 2011. "Breaking Up 'Because of the Phone' and the Transformative Potential of Information in Southern Mozambique." *New Media & Society*, 13(3): 444–456. doi: 10.1177/1461444810393906.

Archambault, Julie Soleil. 2017. *Mobile Secrets. Youth, Intimacy and the Politics of Pretense in Mozambique*. Chicago: University of Chicago Press.

Barendregt, Bart. 2008. "Sex, Cannibals, and the Language of Cool: Indonesian Tales of the Phone and Modernity." *The Information Society*, 24(3): 160–170.

Barendregt, Bart. 2012. "Diverse Digital Worlds." In H. Horst and D. Miller (eds.), *Digital Anthropology*, 203–224. New York and London: Berg.

Bell, Genevieve. 2006. "No More SMS from Jesus: Ubicomp, Religion and Techno-spiritual Practices." In P. Dourish and A. Friday (eds.), *UbiComp 2006: Ubiquitous Computing. UbiComp 2006. Lecture Notes in Computer Science*, vol. 4206. Berlin, Heidelberg: Springer. doi: 10.1007/11853565_9.

Bell, Joshua A., Briel Kobak, Joel Kuipers, and Amanda Kemble. 2018. "Unseen Connections: The Materiality of Cell Phones." *Anthropological Quarterly*, 91(2): 465–484.

Bell, Joshua A., and Joel Kuipers. (eds.). 2018. *Linguistic and Material Intimacies of Cell Phones*. London: Routledge.

Castells, Manuel. 2004. *The Rise of the Network Society*. London: Wiley Blackwell.

Costa, Elisabetta. 2019. "Location as Conspicuous Consumption: The Making of Modern Women and Consumer Culture in South-East Turkey." In Rowan Wilken, Gerard Goggin, and Heather Horst (eds.), *Location Technologies in International Context*. London: Routledge.

Couldry, Nick. 2004. "The Productive 'Consumer' and the Dispersed 'Citizen'." *International Journal of Cultural Studies*, 7(1): 21–32.

Cruz, Edgar Gomez and Asko. Lehmuskallio. 2016. *Digital Photography and Everyday Life Empirical Studies on Material Visual Practices*. Abingdon: Routledge.

de Bruijn, Mirjiam, Francis Nyamnjoh, and Ingrid Brinkman (eds.). 2009. *Mobile Phones: The New Talking Drums of Everyday Africa*. Yaoundé/Leiden: Langaa/Afrika Studiecentrum.

Deger, Jennifer. 2018. "Phone-made Poiesis: Towards an Ethnography of Call and Response." In J. Bell and J. Kuipers (eds.), *Linguistic and Material Intimacies of Cell Phones*, 128–147. London: Routledge.

Donner, Jonathan. 2008. "Research Approaches to Mobile Use in the Developing World: A Review of the Literature." *The Information Society*, 24(3): 140–159.

Donner, Jonathan. 2015. *After Access: Inclusion, Development, and a More Mobile Internet*. Cambridge: MIT Press.

Doron, Assa, and Robin Jeffrey. 2012. *The Great Indian Phone Book: How the Cheap Cell Phone Changes Business, Politics and Everyday Life*. Cambridge, MA: Harvard University Press.

Foster, Robert J. 2007. "The Work of the New Economy: Consumers, Brands, and Value Creation." *Cultural Anthropology*, 22(4): 707–731.

Foster, Robert J. 2011. "The Uses of Use Value: Marketing, Value Creation, and the Exigencies of Consumption Work." In D. Zwick and J. Cayla (eds.), *Inside Marketing: Practices, Ideologies Devices*, 42–57. Oxford: Oxford University Press.

Foster, Robert J. 2018. "Top Up: The Moral Economy of Prepaid Mobile Phone Subscriptions." In *Robert J. Foster and Heather Horst's the Moral Economy of Mobile Phones: Pacific Island Perspectives*. Canberra: ANU Press.

Foster, Robert J., and Heather A. Horst (eds.). 2018. *The Moral Economy of Mobile Phones: Pacific Islands. Perspectives*. Canberra: ANU Press.

Gershon, Ilana. 2010. *The Breakup 2.0: Disconnecting over New Media*. Ithaca, NY: Cornell University Press.

Goggin, Gerard. 2011. *Global Mobile Media*. London: Routledge.

Gurrumuruwuy, Paul, Jennifer Deger, Enid Gurungulmiwuy, Warren Balpatji, Meredith Balanydjarrk, James Ganambarr Kayleen Djingadjingawuy. 2019. *Phone & Spear: A Yuṯa Anthropology*. London: Goldsmith Press.

Haddon, Leslie. 2004. *Information and Communication Technologies in Everyday Life*. Oxford: Berg.

Hjorth, Larissa. 2009. *Mobile Media in the Asia-Pacific: Gender and the Art of Being Mobile*. London: Routledge.

Hjorth, Larissa, and Michael Arnold. 2013. *Online@Asia-Pacific: Locative, Social and Mobile Media in the Asia– Pacific Region*, Asia's Transformation Series. London: Routledge.

Hobbis, Geoffrey. Forthcoming, April 2021. An Ethnography of Deletion: Materializing Transience in Solomon Islands Digital Cultures. *New Media & Society*.

Horst, Heather A. 2006. "The Blessings and Burdens of Communication: Cell Phones in Jamaican Transnational Social Fields." *Global Networks*, 6(2): 143–159.

Horst, Heather A. 2013. "The Infrastructures of Mobile Media: Towards a Future Research Agenda." *Mobile Media and Communication*, 1(1), January: 147–152.

Horst, Heather A. 2014. "From Roots Culture to Sour Fruit: The Aesthetics of Mobile Branding Cultures in Jamaica." *Visual Studies*, 29(2): 191–200.

Horst, Heather A. 2018. "Creating Consumer-Citizens: Competition, Tradition and the Moral Order of the Mobile Telecommunications Industry in Fiji." In R. Foster and H. Horst (eds.), *The Moral Economy of Mobile Phones: Pacific Perspectives*. Canberra: ANU Press. http://press-files.anu.edu.au/downloads/press/n4253/html/ch04.xhtml?referer=&page=9#.

Horst, Heather A., and Erin B. Taylor. 2014. "The Role of Mobile Phones in the Mediation of Border Crossings: A Study of Haiti and the Dominican Republic." *The Australian Journal of Anthropology*, 25(2): 155–170.

Horst, Heather A., and D. Miller. 2005. "From Kinship to Link-Up: Cell Phones and Social Networking in Jamaica." *Current Anthropology*, 6(5): 755–778.

Horst, Heather A, and D. Miller. 2006. *The Cell Phone: An Anthropology of Communication*. London: Berg.

Ilahiane, Hsain. 2019. "The Berber House or the World Leaked: Mobile Phones, Gender Switching, and Place in Morocco." In Rowan Wilken, Gerard Goggin, and Heather Horst (eds.), *Location Technologies in International Context*. London: Routledge.

Ito, Mizuko, Sonja Baumer, Matteo Bittanti, danah boyd, Rachel Cody, Rebecca Herr-Stephenson, Heather A. Horst, Patricia G. Lange, Dilan Mahendran, Katynka Z. Martinez, C. J. Pascoe, Dan Perkel, Laura Robinson, Christo Sims, and Lisa Tripp. 2010. *Hanging Out, Messing Around, and Geeking Out: Kids Living and Learning with New Media*. Cambridge: MIT Press. ISBN: 0262013363 [Second edition published 2020].

Ito, Mizuko, Daiske Okabe and Ken Anderson. 2009. "Portable Objects in Three Global Cities: The Personalization of Urban Places." In Rich Ling and Scott Campbell (eds.), *The Mobile Communication Research Annual Volume 1: The Reconstruction of Space and Time Through Mobile Communication Practices*, 67–88. New Brunswick: Transaction Books.

and Development Communities in the New South." Final Report prepared for the Department for International Development (UK).

Tenhunen, Sirpa. 2008. "Mobile Technology in the Village: ICTs, Culture, and Social Logistics in India." *Journal of the Royal Anthropological Institute* (14): 515–534.

Tenhunen, Sirpa. 2018. *A Village Goes Mobile*. Oxford: Oxford University Press.

Thompson, E. P. 1991. *Customs in Common*. New York: New Press.

Tomlinson, Matthew. 2002. "Religious Discourse as Metaculture." *European Journal of Cultural Studies*, 5(1): 25–47.

Tomlinson, Matthew. 2009. *In God's Image: The Metaculture of Fijian Christianity, the Anthropology of Christianity (#5)*. Berkeley: University of California Press.

Vodafone Fiji Bati Song. MaiTV Uploaded on October 21, 2008. www.maitv.com.fj. www.youtube.com/watch?v=R0W6HyJjjYs, Accessed 1 September 2015.

Wallis, Cara. 2013. *Technomobility in China: Young Migrant Women and Mobile Phones*. New York: NYU Press.

Wardlow, Holly. 2018. "HIV, Phone Friends and Affective Technology in Papua New Guinea." In R. J. Foster and H. A. Horst (eds.), *The Moral Economy of Mobile Phones: Pacific Perspectives*. Canberra: ANU Press. https://press-files.anu.edu.au/downloads/press/n4253/html/ch02.xhtml?referer=&page=7.

We Are Social. 2018. Digital in 2018 in Oceania: Essential Insights into Internet, Social Media, Mobile and Ecommerce Use Across the Region. Published 29 January 2018. https://www.slideshare.net/wearesocial/digital-in-2018-in-oceania-part-1-west?from_action=save, Accessed 7 January 2019.

Wilken, Rowen, Gerard Goggin and Heather Horst. 2019. *Location Technologies in International Context*. London: Routledge.

5 The anthropology
of social media

Daniel Miller

Introduction

In the first edition of this book what are now called social media were termed social networking sites (boyd and Ellison 2007). Within the last few years that term has become redundant, and there are grounds for thinking that the term social media may also have already served its time. These were always a global phenomenon. The first mass usage of SNS was probably that of Cyworld in Korea in 2005 (Hjorth 2009), but the best known is the rise of Facebook, which evolved from an instrument for connecting American students at Harvard University to a platform used by over two billion people, replacing rivals such as Orkut which had spread rapidly in Brazil and India, Friendster in Southeast Asia and Myspace in the US and Europe. Other platforms that contribute to this sense of vast usage would include QQ and WeChat in China, LINE in Japan and WhatsApp, which is now owned by Facebook. At the time of writing (2019), Facebook is clearly declining in popularity amongst young people and new platforms continue to arise.

This chapter will make considerable reference to the Why We Post project, a comparative research project funded by the European Research Council that I ran between 2012 and 2017 which consisted of nine ethnographies of social media. One of the tasks of this project was to develop an anthropologically inflected definition of social media. Our definition comprised the term 'Scalable Sociality' (Miller et al. 2016: 1–6). In our offline worlds sociality has always been scalable to some degree. We can talk with one other person, meet a few friends for a meal or address a crowd. But this had not been true to the same extent for mediated communication. Prior to social media there were two primary forms of media. Public broadcast such as radio, TV and newspapers, which transmitted to whoever chose to be part of the audience, or private dyadic media such as telephone calls and letters. Even before social media there were some digital communications, such as email and web forums, that started to populate the field of group discussion and that lay in between the dyadic and the public. Social media continued this process. Some platforms created forms of semi-public broadcasting such as Facebook friends, Twitter or Instagram followers and online chat groups. More recently this process of scaling down to smaller groups from public broadcasting was matched by a complementary shift. Recently we have seen the rise of

platforms such as WeChat and WhatsApp which started from messaging services and then scaled such texting upwards to larger groups. Putting these two trends together, the result was that the original division of public as against private has been replaced by scales. Today we can select a particular platform because it is suited to smaller or larger groups, and we may also select on the basis of wanting a more private or more public platform. Indeed at this point the ability to scale our sociality has surpassed that which existed previously in our offline communication. This is not the only definition one could use for understanding social media, but it is a definition that shows how social media help us understand one of the core constituent parts of anthropology, the study of sociality.

This situation continues to evolve, with some rapidity. By 2019 it is no longer clear that social media are themselves a discrete body of platforms. Increasingly they are employed through smartphones, rather than computers, in which case they are more naturally understood as simply part of the wider array of smartphone apps, fitting alongside the voice calls and messenger services that already existed on phones. In recognition of this, the conclusion of this chapter, which is concerned with the future of such studies, will shift from a focus upon social media to an emphasis upon the anthropology of the smartphone.

Given their ubiquity and significance, social media are subject to study by many academic disciplines. There are journals with titles such as *Social Media + Society* that arise from communication studies. In this chapter the predominant concern is to delineate the specific contribution of digital anthropology to this research. The body of this chapter will consist of two such contributions. The first is a concern with the consequences of social media for migrants, refugees and diaspora; groups that have already loomed large on the anthropological radar partly because of the welfare issues that the discipline naturally wishes to address. The second, which is more specific to anthropology, will be the comparative study of social media.

There are, however, other areas where it is important that anthropology makes clear its particular contribution. For example, partly assisted by the original nomenclature of *social networking sites*, the dominant trend in sociology has been to argue that these platforms reflect a wider transformation in the world from society based on groups, such as kinship and tribes, which was a characteristic of anthropological analysis, towards society based instead on networked individualism, which comes closer to the way sociology itself has tended to characterise society.

The phrase 'social networking sites' suggested a strong affinity with the discipline of anthropology itself. Indeed, the term 'social networking' could have been a definition of the anthropological perspective. Traditionally anthropologists refused to study persons as mere individuals but, as in the study of kinship, an individual was regarded as a node in a set of relationships, a brother's son or sister's husband, where kinship is understood to be a social network. In contrast to anthropology, sociology was principally concerned with the consequences of an assumed decline from this condition. Many of the most influential books in sociology such as Putnam's (2001) *Bowling Alone* and Sennett's (1977) *Fall of Public*

Man, along with works by Giddens, Beck and Bauman, reflect the proposition that as a result of industrialisation, capitalism and urbanism older forms of tight social networking colloquially characterised by words such as *community* or *neighbour-hood* are increasingly replaced by individualism. Particularly influential has been the work of Castells, who made dramatic claims about how 'Our societies are increasingly structured around a bipolar opposition between the Net and the Self' (1996: 3) (see also Knox, this volume). Another major influence has been the work of Barry Wellman (see especially Rainie and Wellman 2012) who see this shift from group to network as the primary consequence of the rise of the internet.

These sociological arguments are reflected in a rather more nostalgic and romantic perspective in popular writing, where the question of whether you can have a genuine online community tends to have the effect of simplifying as rela-tively unproblematic the question of whether people lived in communities prior to the internet. Postill (2008) provided an early anthropological critique of this work, urging caution in using the older terminology of community and neighbourhood, but also noting the increasing fetishism in the term 'network' arising from this new sociological sub-discipline of social network analysis. Instead he favoured a more nuanced and contextualised ethnography of the many different social fields in which people engage, for example short-term more activist-related political collections that emerged from his fieldwork in a Malaysian suburb (see Postill, this volume). This view was supported by Miller and Slater (2000), who had also criticised Castells and argued that the various networks found on the internet were too dispersed and partial to equate with anthropological approaches to older forms of sociality.

Later in this chapter we will consider whether ethnographic studies support the proposition of a move towards networked individualism. But the wider problem this raises is the tendency to see social media as the 'cause' of almost every-thing that is happening today, and more particularly to 'blame' social media for all trends assumed to represent a decline from some preferable past, such as the time when we all lived in real communities. This is particularly prominent in newspaper coverage, reflecting the way the business models of the newspaper industry have been decimated by social media and that nostalgia-based anxiety sells papers. For example, a host of deleterious political trends are blamed on 'fake news' promulgated by social media, as though the Zinoviev letter, a fake news item often thought to have brought down the UK Labour government in 1924, could not have happened in prior times and that the tabloid newspapers previously only published on the basis of verifiable information.

In response to this, anthropology needs to take a less adjudicatory and less nostalgic tone. Digital anthropology must constantly avoid the temptation to simplify or romanticise the predigital world. Instead of trying to decide if social media is 'good' or 'bad', when actually it is almost always both of these things simultaneously, anthropology should provide a more scholarly understanding of the rise of social media in the context of social change more generally. For example, Miller (2017a) examined the use of the term 'to friend' that arose with platforms such as Friendster and Facebook. He argued that anthropologists can

discern a much longer-term trend from when kinship was the dominant idiom for social relationships, reflected in the phenomenon of fictive kinship, addressing friends as 'Auntie' or 'Uncle'. There is a marked shift towards our contemporary world where it is friendship, understood as a relationship we choose to enter into, that now dominates kinship viewed as a relationship of obligation. So today, instead of fictive kinship, we have fictive friendship, when we introduce someone as 'my mother – but also my best friend'. Seen from that perspective, social media and its terminology of friending appears less as the cause of these developments and rather more as the manifestation of larger and longer-term changes in society.

To summarise, the contribution of digital anthropology to the study of social media is to insist on the value of traditional ethnographic scholarship, which ensures that we come to understanding these phenomena grounded fully in context as part of wider transformations and continuities in sociality and in communication. However important social media, no one lives only online, and the best way we can understand online behaviour is by grounding it in patient comprehension of the wider offline world. This point will now be illustrated through two examples, that of comparative analysis, but first a focus upon populations where social media might be of particular consequence, such as migrants and diasporic populations.

Case one: migrants, refugees and diaspora

Social media has become one of the most conspicuous examples of the internet as representing 'the death of distance' (Cairncross 1997). As such, a prime concern for anthropologists has been the use of social media in relation to migration, diaspora and refugees. An initial interest was with the potential use by migrant populations who are separated from their families (e.g. Horst and Miller, 2006; Horst and Panagakos 2006). But from early on it was clear that the internet could be more than a mode of reconnection and instead represent a kind of home or place in its own right, as echoed in the title of Greschke's (2012) volume on South American migrants *Is There a Home in Cyberspace?* Social media could become the effective site which linked diasporic populations settled across various offline locations. For example Oosterbaan (2010a, 2010b) examined the way Orkut established the connections between diasporic Brazilian populations based in various European cities such as Barcelona and Amsterdam.

It is reasonable to suggest that social media can effectively become the primary 'home' for an individual. A Filipina worker in London I knew well made no use of any of the local facilities, never going out to pubs or films. Apart from working, sleeping and eating, she spent her entire time on social media in the company of friends and kin. In *Tales from Facebook* (Miller 2011) we find the story of Dr Karamath who is disabled and so never steps out of his house in Trinidad, living as much as possible in Facebook instead, which is where he works, aggregating activist information on human rights, and socialises with a group of new friends from the wider South Asian diaspora.

Social media may form just one part of larger online projects. In many instances diaspora populations are trying to relate back to an original homeland that may have been destroyed, and part of their reconstruction as a community consists of the virtual reconstruction of their place of origin (Walton 2016). Equally important may be the tension between the diaspora and the homeland. Bernal has examined the public sphere of diasporic Eritreans and how this shifted from the affirmation of the nation to the critique of the governing regime (Bernal 2014). Hegde (2016) illustrates the multiple ways in which diasporic populations use new media as part of the complex and contradictory strategies by which they seek to create legitimacy and understand their situation with respect both to the dominant population of their new homeland and to the reconfiguration of their relationships with the original homeland.

Anthropologists alongside academics in other disciplines are also investigating the role of social media in situations of forced migration and displacement. For example, the situation of refugees from Syria and elsewhere who have been desperate to find a way of migrating to Europe but can end up spending extensive periods in refugee camps (see Leurs and Smets 2018) has also been the experience of Palestinians and others over many decades now. Today social media has become integrated into the wider use of the smartphone. As a result Syrian refugees are now giving considerable attention to problems such as keeping their phones dry at sea or finding a docking station for recharging (Gillespie, Osseiran, and Cheesman 2018). If you are in a holding camp in Lesvos or indeed in Calais, hoping to get to the UK, the smartphone is now crucial to one's ability to remain connected to the wider world. So for Syrian refugees the route is also seen in terms of where they can recharge batteries or find Wi-Fi, since the phones are a major source of comfort and connection with families and friends on their perilous journeys.

Anthropologists often work with diaspora populations and have found that social media are just as important for longer-term sustained connectivity. One of the most extensive studies has been that of McKay (2016: 51–69, 92–94) focusing on the use of Facebook amongst Filipino migrants in London. These migrants use Facebook so that they can follow each other's social lives in detail: where someone has visited, what they wore, whom they were with and so forth. Some might belong to the same church network which itself runs a Facebook group, and they enthusiastically examine photos from church events. The bulk of photographs posted are essentially domestic and quotidian. Shared activities may range from rituals of blessing a new vehicle to dealing with ancestral ghosts, to commenting on one's employers (ibid. 51–69). McKay describes what she calls prosthetic citizenship. Since social media is the main place where you are viewed by others, they will increasingly judge you and the way you conform to social responsibilities according to how you perform on Facebook.

This is a much more nuanced portrait than bland images of community, since it also shows competition and hierarchy, where the use of social media can be as much about cutting people off as including them in. Individuals can be cropped out of photographs or accused of witchcraft, all of which activity is followed as

The first key finding, as might be expected, was evidence to support differences in both use and consequence. The team employed digital communication to remain in close contact throughout the research, so comparison was carried out during rather than after fieldwork. For example, the Brazilian fieldsite (Spyer 2017) reported that low-income people don't post photos on Facebook about where they really live – the half-built brick walls and the poverty. They post photos posed next to swimming pools or near the gym, to show their aspirations. But then the anthropologist working in low-income Chile (Haynes 2016) countered that her informants are trying to form community based on honesty in opposition to metropolitan elites. They would never post an image of themselves next to a swimming pool because everyone knows that they couldn't possibly afford to go there. They post modest and unpretentious images.

One advantage of studying social media is that because so much posting is visual, these points of difference can be clearly illustrated. The book *Visualising Facebook* (Miller and Sinanan 2017) includes hundreds of images, which contrasts posts from the Trinidad and the English fieldsites. For example, what happens to posting online when people become mothers? In the English fieldsite, soon after the baby is born, the mother almost disappears from her own Facebook profile, being displaced by her baby whose image becomes her own profile picture. In Trinidad, it is quite the opposite. The new mother will make a considerable effort to post images that demonstrate that she continues to be a glamorous individual and no one should imagine that just because she has become a mother that is all that she now is.

The unit of comparison was a fieldsite, not a nation, even though we refer to national identity in the titles of our books. Some of the strongest contrasts were between the two Chinese fieldsites. In the rural case, social media confirms the degree of dedication to education (McDonald 2016), while in the factories, education was of very little importance since it would not contribute to their labour (Wang 2016). In some fieldsites social media is regarded as the death of privacy, while for those who had previously lived within extended families in rural settings, this was almost their first experience of modern privacy. To conclude, social media was generally seen more as an expression, than a suppression, of cultural differences, and very few claims would apply equally to all nine fieldsites. While within any given fieldsite we see differences based not only on familiar social parameters such as gender and class, but also parameters that relate to the consequences of these new media. For example, because many basic tasks depend on the ability to use the internet, an increasingly important distinction is between those who are digitally excluded and those who embrace and feel comfortable with the new technologies. Anthropology needs to deal with a posteriori cultural differences and not just a priori distinctions.

The Why We Post project was in an ideal position to assess the claims made in sociology for the internet and social media as just one more step in the collapse of traditional group-based society and its replacement by individualised networks. In general, the evidence from this project went against this assumption. We found that in most of the fieldsites people felt that modern life had already become too

fragmented and, if anything, they use social media to try to repair the traditional groups that had previously existed. So when families have become divided, they will use social media to try to reconnect and become more like the family they used to be. Costa has shown how Kurdish people reconstruct their traditional lineage organisation when the families themselves have become dispersed as a result of decades of conflict in Eastern Turkey. A young male may have 200 friends on Facebook of which all but around 20 will be relatives (Costa 2016). Equally there was evidence that caste in India may be strengthened by social media (Ventkatraman 2017).

This is not the only way in which social media can become quite conservative. Women in the Turkish fieldsite (Costa 2016) wouldn't show themselves out having tea because of the gossip about the people who might appear near them in the photograph. They preferred to post images of food nobody can gossip about. Life portrayed online would then be a more conservative version than what could be seen offline. On the other hand, before social media it was impossible for young men and young women to be in much contact without their parents knowing about it, while now a young woman can send 500 WhatsApp messages a day to her secret boyfriend, though they still can't meet offline. Two important points follow. The first is that just because there are new possibilities and freedoms online doesn't mean this is also true offline. The second is that the overall impact of new media can be to enhance conservatism, not necessarily to facilitate a movement to what people regard as modernity.

Social media is so vast that it is possible to find material around almost any topic. Much of the discussion of politics is based on researchers seeking out what they are interested in. Why We Post took the more ethnographic stance of trying to assess every topic simply as it emerged from everyday usage. The project found, generally, that there was much less political posting than we had expected. This applied to areas where politics is relatively innocuous, as well as in areas of intense political violence, so it was not just a question of fear. Our conclusion was that the reason had little to do with politics itself; it was rather that people saw this as *social* media, while they see politics as relatively divisive. When they are in conversation with relatives and friends, they try to avoid topics that might cause division. We need to appreciate the social aspects of posting in order to account for the politics of posting, rather than seeing topics in isolation from each other.

To balance the emphasis upon cultural relativism, comparative studies can also be used as a firm base for making general, sometimes global, claims as well as contributions to theory. An example would be the way social media represents a change in human communication. Up to now we have tended to use either oral communication, as in speaking on the phone, or textual communication, as in writing. But with social media the visual becomes an integral part of communication. *Snapchat* means to chat with photographs. We previously used emoticons and emojis, but now a person can take images of their face to show their changing moods all day long.

An example of a new form of visual communication that has arisen in direct reference to social media is the meme. The Why We Post project understood memes

more on apps used constantly such as Googling for health information and using WhatsApp for organising the care of patients. We found that these have far more significant consequences than either specialist health apps or topics that had previously been emphasised by academics such as self-tracking and the quantified self (Lupton 2016; Neff and Nagus 2016). The project is committed to developing health interventions, not just observations. For example, we have created an extensive manual on how to use WhatsApp for health and are becoming involved in 'social prescribing' (Thomson, Camic, and Chatterjee 2015).

This raises a more general question for digital anthropology. Given that anthropologists are in an ideal position to observe the use and consequences of new technologies, how far does this impose a responsibility to becomes involved, using their knowledge to further the positive consequences and avoid the negative? For example, based on a previous study of patients mostly with a terminal diagnosis, work by Miller (2017b) has influenced the hospice movement to suggest that the family and friends of patients develop WhatsApp groups to help coordinate the care activities involved in looking after terminal patients. In recent decades, most anthropologists have retreated to a position of critical reflections on other people's interventions, but perhaps the time has come for stepping forward towards an active involvement. This could also include a wider integration of those trained in digital anthropology who are then employed in welfare or commercial services and incorporating them within the academic dialogue that constitutes digital anthropology.

If we see this as digital anthropology spreading its wings, then if more engaged anthropology represents one wing, the other wing might be viewed as the potential for a more philosophical engagement with the way anthropology and indeed humanity are impacted by the rise of digital technologies such as smartphones and social media. One of the problems faced by digital anthropologists is that every time a new technology is developed, it typically elicits two opposed reactions. The first tends to a nostalgic tone, which implies that proper human beings are those who communicate face to face. When people replace these face-to-face encounters and instead seem to be constantly staring at screens, this means that we have lost our true humanity (e.g. Turkle 2011). At the same time an entirely different response suggests that these new technologies have revolutionised our basic capacities such that we are no longer merely the form of human beings that we were in the past. Instead we should not be regarded as in some way post-human or trans-human or cyborg (e.g. Whitehead and Wesch2012).

These stances have become quite repetitive. In response, the Why We Post project (see also Miller and Sinanan 2014: 4–15) proposed a 'theory of attainment'. The premise is that our concept of humanity is just too conservative. Typically, we use the term humanity to mean simply that which we have always been up to now. Instead, we should perhaps use the word humanity to mean all of those things that we also have the capacity to be in the future. Things we will only attain through some new technology. Human beings couldn't fly, but now with aeroplanes they can. We have attained the ability to fly. But we are still just ordinary human beings, no more or no less human.

Similarly, we need a radical solution to understanding the impact of the smart-phone. In many ways this supersedes the way society has understood the problem of the robot. The robot is the more superficial face of the anthropomorphic machine, because the emphasis is on alterity – something that may look like us but is other than us. By contrast, a smartphone looks not one iota like a human being. It has no arms and no legs. The smartphone has no need of limbs, since it achieves mobility through its placement in trouser pockets or handbags. Anthropomorphism is advanced through processes such as complementarity and prosthetics. There is increasing concern in digital anthropology with the potential impact of algorithms and artificial intelligence, but the smartphone, with its integrated social media, may help us to achieve a more anthropological and nuanced view of these developments. The apps on a smartphone use AI to study the user, but this is not to create a separate AI-based entity. Since the machine is learning the user's habits, the result is unique, as much a movement of machine to person as person to machine.

This is important because currently the main focus on the rise of AI and algorithms is on how corporations and states may use these as forms of control that potentially alter persons and reduce our humanity. But the material in this chapter has suggested that a far more complex story is in the offing. Smart-phones and social media are one of the main areas in which algorithms and AI are already employed. Our use of Google Translate or Google Maps, the targeting of advertising, and the creating of digital assistants such as Siri and Alexa all involve AI so that our phones can learn more about us. In the ASSA project, the ethnographies study the way this creates digital technologies that manifest an externalised aspect of their user. As soon an individual buys a phone, they start to configure a particular constellation of apps and alter settings, while AI in turn makes those apps more responsive to their unique personality. For example in my current fieldsite in Ireland, a retired fisherman uses the phone to express his rugged and practical self-sufficiency. For him all usage must be justified by clear canons of function, and superfluous usage is banned. He mentions more than once how, now that his daughter is no longer in Australia, he will never use Skype. By contrast, a woman aged 69 has always been the consummate professional. Her iPhone is a marvel. There are no individual app icons, since these are all nested into groups with labels such as finance, sports, news and utilities. Her calendar states each task, such as paying a particular utility bill. But that is then linked to files organised through her notebook, which include a detailed step-by-step account about how each particular kind of utility bill has to be paid, including the password and website address that would be involved. Her phone has become a kind of life manual of several hundred pages. A younger woman finds that her phone use has become dominated by her role as mother. She has grown to detest WhatsApp since whenever one of her children win at a team sport such as hurling or football every adult feels obliged to send them congratulation messages, which result in endless trivial notifications on her phone. So the phone is becoming more anthropomorphic than any robot but one that corresponds to its individual user. We are used to thinking of clothing

as an external expression of the person, and the Why We Post project argued for a similar capacity in social media, but thanks to AI and algorithms this has become a more refined and two-way process, as clothing had no capacity to learn from the experience of being worn, while smartphones do. So the idea of an expressive material culture becomes still more profound when it comes to understanding the smartphone.

Digital anthropology, as reflected in the study of social media and smartphones, embodies the philosophical approaches that have been developed in the more general study of material culture (Carroll, Walford, and Walton (eds) 2020). Online as well as offline, we see a constant dialectic between how machines configure us and we configure the machine, with no clear boundaries between the person and their material and their online world. This remains hugely important for anthropology because it is also the foundation for the second case study of this chapter, which focuses upon the comparative. It is not just individuals who play out this dialectic, but also populations, which is why these new developments in digital communication often manifest and extend cultural difference, rather than appear to us as simple universals dictated by machine affordances. Anthropology is the only discipline that seeks to constantly assert the rights of all populations to be considered equally as users. A smartphone is what its owner in Kampala creates, not just what Samsung creates. With this comes also a sense of responsibility, which was reflected in the first case study in which attention was drawn to populations such as migrants and refugees where we believe these developments are particularly important in relation to people's welfare. All of this may contribute both to anthropology's long-term quest to better understand the nature of humanity and anthropology's short-term responsibility to make our findings accessible and instrumental in support of those welfare goals.

Notes

1 Funding for the Why We Post project was from the European Research Council grant 2011-AdG-295486 Socnet.
2 The ASSA project can be found at https://www.ucl.ac.uk/anthropology/assa/.

References cited

Archambault, J. 2017 *Mobile Secrets: Youth, Intimacy, and the Politics of Pretense in Mozambique*. Chicago: Chicago University Press.

Bernal, V. 2014 *Nation as Network*. Chicago: University of Chicago Press.

boyd, D. M. and Ellison, N. B. 2007 Social Network Sites: Definition, History, and Scholarship. *Journal of Computer-Mediated Communication*, 13(1), article 11. http://jcmc.indiana.edu/vol13/issue1/boyd.ellison.html.

Cairncross, F. 1997 *The Death of Distance*. Orion Business Books.

Carroll, T., Walford, A. and Walton, S. (Eds). 2020. *Lineages and Advancements in Material Culture Studies: Perspectives from UCL Anthropology*. London: Routledge.

Castells, M. 1996 *The Rise of the Network Society, The Information Age: Economy, Society and Culture*. Oxford: Blackwell.

Chua, L. 2018 Small Acts and Personal Politics: On Helping to Save the Orangutan Via Social Media. *Anthropology Today*. https://doi-org.libproxy.ucl.ac.uk/10.1111/1467-8322.12432.

Coates, J. 2017 So Hot Right Now: Reflections on Virality and Sociality from Transnational Digital China. *Digital Culture and Society*, 3(2): 77–98.

Costa, E. 2016 *Social Media in Southeast Turkey*. London: University College London Press.

Costa, E. 2018 Affordances-in-Practice: An Ethnographic Critique of Social Media Logic and Context Collapse. *New Media and Society*. https://doi.org/10.1177/1461444818756290.

Gershon, I. 2010 *The Breakup 2.0: Disconnecting Over New Media*. Ithaca, NY: Cornell University Press.

Gershon, I, 2017 *Down and Out in the New Economy*. Chicago: Chicago University Press.

Gillespie, M., Osseiran, S. and Cheesman, M. 2018 Syrian Refugees and the Digital Passage to Europe: Smartphone Infrastructures and Affordances. *Social Media + Society*, 4(1). https://doi.org/10.1177/2056305118764440.

Greschke, H. 2012 *Is There a Home in Cyberspace? The Internet in Migrants' Everyday Life and the Emergence of Global Communities*. London: Routledge.

Haynes, N. 2016 *Social Media in Northern Chile*. London: UCL Press.

Hegde. R. 2016 *Mediating Migration*. Cambridge: Polity Press.

Hjorth. L. 2009 Gifts of Presence: A Case Study of a South Korean Virtual Community, Cyworld's Minihompy. In *Internationalising the Internet Anthology*, eds. G. Goggin and M. McLelland. London: Routledge, pp. 237–251.

Horst, H. and Miller, D. 2006 *The Cell Phone: Anthropology of Communication*. Oxford: Berg.

Horst, H. and Panagakos, A. Eds. 2006 Return to Cyberia: Technology and the Social Worlds of Transnational Migrants. *Global Networks*, 6.

Hromadžić, A. and Palmberger, M. Eds. 2018 *Care Across Distance; Ethnographic Explorations of Aging and Migration*. London: Berghahn.

Kaiser-Grolimund, A. 2018 Healthy Ageing, Middle-Classness, and Transnational Care between Tanzania and the United States In *Care Across Distance; Ethnographic Explorations of Aging and Migration*, eds. A. Hromadžić and M. Palmberger. London: Berghahn, pp. 32–54.

Leurs, K. and Smets, K. 2018 Five Questions for Digital Migration Studies: Learning from Digital Connectivity and Forced Migration In(to) Europe. *Social Media + Society*, 4(1): 1–18. https://doi.org/10.1177/2056305118764425.

Lupton, D. 2016 *The Quantified Self*. Cambridge: Polity Press.

Madianou, M. and Miller, D. 2012 *Migration and New Media*. London: Routledge He Polymedia Revolution.

McDonald, T. 2016 *Social Media in Rural China*. London: UCL Press.

McKay. D. 2016 *An Archipelago of Care Filipino Migrants and Global Networks*. Bloomington: Indiana University Press.

Miller, D. 2011 *Tales from Facebook*. Cambridge: Polity.

Miller, D. 2017a The Ideology of Friendship in the Age of Facebook. *Hau*. www.hau journal.org/index.php/hau/article/view/hau7.1.025

Miller, D. 2017b *The Comfort of People*. Cambridge: Polity Press.

Miller, D., Abed Rabho, L., Awondo, P., de Vries, M., Duque, M., Garvey, M., Haapio-Kirk, L, Hawkins, C., Otaegui, A., Walton, S. and Wang, X. 2021 *The Global Smartphone; Beyond a Youth Technology*. London: UCL Press.

Miller, D., Costa, E., Haynes, N., McDonald, T., Nicolescu, R., Sinanan, J., Spyer, J., Venkatraman, S. and Wang, X. 2016 *How the World Changed Social Media*. London: University College London Press.

Miller, D. and Sinanan, J. 2014 *Webcam*. Cambridge: Polity Press.

Miller, D. and Sinanan, J. 2017 *Visualising Facebook*. London: UCL Press.

Miller, D. and Slater, D. 2000 *The Internet: An Ethnographic Approach*. Oxford: Berg.

Morris, J. and Murray, S. Eds. 2018 *Appified – Culture in the Age of Apps*. Ann Arbor. University of Michigan Press.

Neff, G. and Nagus, D. 2016 *Self-Tracking*. Cambridge, MA: MIT Press.

Nicolescu, R. 2016 *Social Media in Southern Italy*. London: UCL Press.

Oosterbaan, M. 2010a Virtual Migration. Brazilian Diasporic Media and the Reconfigurations of Place and Space. *Revue Européenne des Migrations Internationales*, 26(1): 81–102.

Oosterbaan, M. 2010b Virtual Re-evangelization: Brazilian Churches, Media and the Postsecular City. In *Exploring the Postsecular: The Religious, the Political, the Urban*, eds. J. Beaumont, B. Molendijk and C. Jedan. Leiden: Brill, pp. 281–308.

Postill, J. 2008 Localizing the Internet Beyond Communities and Networks. *New Media Society*, 10: 413.

Putnam, R. 2001 *Bowling Alone*. New York: Simon and Schuster.

Pype, K. 2016 "[Not] Talking Like a Motorola": Mobile Phone Practices and Politics of Masking and Unmasking in Postcolonial Kinshasa. *Journal of the Royal Anthropological Institute*, 22(3): 633–652.

Rainie, L. and Wellman, B. 2012 *Networked: The New Social Operating System*. Cambridge, MA: MIT Press.

Sennett, R. 1977 *The Fall of Public Man*. New York: Knopf.

Spyer, J. 2017 *Social Media in Emergent Brazil*. London: UCL Press.

Strathern, M. 1996 Cutting the Network. *Journal of the Royal Anthropological Institute*, 2: 517–535.

Tenhunen, S. 2018 *A Village Goes Mobile*. Oxford: Oxford University Press.

Thomson, L. J., Camic, P. M. and Chatterjee, H. J. 2015 *Social Prescribing: A Review of Community Referral Schemes*. London: University College London.

Turkle, S. 2011 *Alone Together*. New York: Basic Books.

Ventkatraman, S. 2017 *Social Media in South India*. London: UCL Press.

Walton S. 2016 Abadan's Digital Afterlife: Past Images and Present Pasts in Abadani Virtual Communities. www.abadan.wiki/en/abadans-digital-afterlife-past-images-and-present-pasts-in-abadani-virtual-communities/.

Wang, X. 2016 *Social Media in Industrial China*. London: UCL Press.

Whitehead, N. L. and Wesch, M. 2012 *Human No More*. Boulder, CO: University of Colorado Press.

Wilding, R. and Baldassar, L. 2018 Ageing, Migration and New Media: The Significance of Transnational Care. *Journal of Sociology*. https://doi.org/10.1177/1440783318766168.

6 Diverse digital worlds

Bart Barendregt

I An anthropology of digital diversity

Digitalization, the great leveller?

In this anthropocentric era diversity, ecological and cultural, is under threat, and digital technology apparently does little to help. Authors like Fuchs (2017) recount how the ideal of a cheaply accessible, efficient and clean informational society ignores hidden costs elsewhere. Mountains of discarded electronic equipment have appeared in southern China as ugly material consequences of the digital transition; cruel civil wars were fought in 1990s Congo over the minerals richer nations needed to produce telephones and games consoles. Meanwhile Carruth (2014) has shown how industry-sponsored 'word clouds' and 'white papers' both simplify and 'greenwash' the transition, how 'data flows', 'mountains of data' and 'cloud-based' services – fine ecological metaphors all – obscure critical perspectives on potentially damaging effects of the digital infrastructure, however non-material it seems. However, in its sheer diversity the digital transition sets other challenges for 'planet Earth'. Climate change will probably accelerate extinctions; there is already mass degradation of habitat, while 75% of people now subsist on three staple foods (Srinivasan 2017: 8). We sense a steady loss of cultural practices and expression, including languages. Even the technology meant to preserve seems only to make things worse.

Dor (2004) offers an early account of presumed loss of diversity in the digital age, interrogating predictions that Internet-driven Americanization of language would obliterate other languages. English was not surprisingly the major language of the early Internet, and between 50% and 60% of all indexed content is still in English (W3Techs 2020). However, far fewer than half the four billion Internet users have English as their main language, so it seems that the expected hegemonic role of English on the Internet has not materialized. Today about 400 major languages continue to survive and even thrive online, and digital language materials now form a global market, a reminder that the Internet's impact on diversity is as difficult to predict as it is ambiguous. Standard keyboard designs for Urdu and Mandarin, for example, have transformed creative calligraphy and a range of dialects into standardized formulae, effectively constraining speakers. Language standardization is no longer the exclusive privilege of nation-states but is instead

Others describe globalization as, at most, patchy. In *The Information Age*, Castells (1997) refers to 'black holes' of informational capitalism, and better connected digital 'haves' and poorly connected 'have-nots'. Accordingly, anthropologists like Tsing (2005) and Ferguson (1999) call not just for focus on globalization's increased interconnectedness but on how it might actually be disconnecting people. While admiring the privileged centres with their cutting-edge technology and fashionable informational avant-garde, we must not ignore people and places that find it difficult to connect as globalization progresses into the digital future.

Globalizing the digital

Studies of diverse digital worlds could benefit from work showing how global cultural dynamics are not the exclusively Western project so often imagined. Correctives are needed to the cultural imperialism thesis popular in the late 1970s and 1980s and still believed by critics like Barbrook (2007). Undeniably, Western culture and ideas are today flowing from the centre for replication in all corners of the world, as exemplified by the impact on the 'logic of script' exerted on many vernacular languages by Microsoft Word (Dor 2004). Furthermore, linguistic anthropologists have studied television, mobile and social media to see how they produce new communicative environments in which multiple languages and channels of interaction are instantaneously evoked by users who no longer feel bound by national languages. The new term 'superdiversity' refers to 'the vastly increased range of linguistic, religious, ethnic, and cultural resources characterizing late modern societies' (Jacquemet 2016: 341).

Inda and Rosaldo (2008) summarized three other critiques of the still-current cultural imperialism thesis. First, despite the dominant flow of all things digital from the wealthy North to the poorer South, its recipients are never passive. Many studies have shown other consumers of Western digital technologies reinterpreting and customizing them to their own cultures. Heeks (2008, 2018) showed that online role-playing games like World of Warcraft offer their young Chinese players financial benefits and even education. Click-farming, scamming and other forms of 'grey and black digital economy' may be viewed similarly, although digital labour in the developing world is framed as illegal and immoral and as reinforcing existing inequalities and asymmetrical power relations (Arora 2019: 23).

The second critique is of the supposedly one-way view of globalization, with anthropologists highlighting reverse cultural flows and mutual imbrications. An example is Grameen's successful and multi-award-winning Village Pay Phone programme which helped Bangladeshi 'phone ladies' start their own pay-phone services to non-connected villagers (Sullivan 2007). Offshoots were inspired like Kenya's M-Pesa mobile telephone banking project to bypass banks (Kusimba et al. 2016), so successful that Vodafone experimented with allowing international remittances to be sent from the UK to Kenya by mobile telephone.

Lastly, adherents of the cultural imperialism thesis have traditionally tended to ignore global circuits of exchange outside the West, neglecting for example

increasing South-to-South contact such as the international free and open-source software (FOSS) movement in places like South Africa and Brazil. More recently others, under the banner of 'data justice', have advocated recognition of 'non-mainstream ways of knowing the world through data' and the exploration of ways of thinking and using 'data from the margins', thereby understanding 'the South as a composite and plural entity' not necessarily geographically anchored (Milan and Treré 2019).

Intersectionality on the Internet

The dominance of Californian 'big tech' and East Asian responses to it, fear of unbridled 'surveillance capitalism' and increased alienation, and a sense of minimal control over design of digital technology and its lack of diversity all have led to increasingly vocal disquiet by those advocating a more critical reflection on how much technology to let into our lives, not only on the digital fringes but in the very heart of the information society. Almost precisely coincidentally with the popularization of the Internet, and for more than two decades now, insider dissidents have unceasingly highlighted the information society's shortcomings.

Many have claimed that the very technology intended to connect actually disconnects (Turkle 2012), insisting we should be able to regain control over our own lives. Even future-orientated magazines like *Wired* seem to have had a soft spot for cults of the Information Age, like 2005's 'Hipster PDA', or the 'Getting-Things-Done' movement inspired by David Allen's 2001 book, while others lately find solace in digital sabbaticals, 'detox' or 'sacred zones' (Syvertsen and Enli 2019). Dissidents have tried to envisage an alternative future in which digital technology must embrace wider spiritual values rather than destroy them, in fact reiterating an important element of the original conception of the 'digital revolution'. Both Turner (2006) and Zandbergen (2011) described a spiritual undercurrent in San Francisco's 'Bay Area Geekdom', ranging from Stewart Brand's *Whole Earth Catalog* to today's 'New Edge' movement. Others write of cybergnosis's blending of secular technology with a quest for a spiritual experience of ultimate reality (Aupers et al. 2008). Mosco (2005) asks if the 'digital sublime' advocated by atheist technologists amounts to a new religion, or reinvigorates religious conviction. Scholars studying the world's religions have commented on the convenient – or perhaps inconvenient – marriage of modern-day technology and religious tradition even in Western capital hubs, yet scholarly debate on technological futures remains distinctly secular and implicitly modelled on the global North, although even then digital diversity and the need for is often overlooked (see for just a few examples Bunt 2018; Campbell 2010; Fader 2017, and also the second half of this chapter).

'Intersectionality', a term coined in 1989 by civil rights advocate Crenshaw, is now popularly used to describe how power relations of race, religion, class and gender are never discrete or mutually exclusive, but probably augment each other and frequently combine to oppress individuals and even whole communities (Collins and Bilge 2016). A rich body of literature has appeared in the last year or two,

mostly in fields adjacent to anthropology such as gender or critical race studies, much of it advocating more diverse design, use and control of digital technology.

Although commentators have long cherished their belief in an online world free of old ills like sexism or racism, Nakamura's early study (2002) warned against utopianism, for even where no users of colour are present, race ideologies tend to prevail online. Many of the identities assumed by Internet gamers, for example, are stereotypically derived, while *Cybertypes* are images of race scripted into digital environments apparently privileging Western white males (Nakamura 2002: 6). Online racism is disembodied and considered part of the virtual world that 'can be turned off or walked away from', yet is symptomatic of larger social norms (Nakamura 2010: 337). Marginalized groups are still often represented as lacking understanding of technology, although apparently ignoring the fact that many such groups anyway lack access to or literacy in technology, and downplaying the many ways in which they contrive against all odds to engage with such technologies after all (Benjamin 2019). Tech designers encode their own judgement and social bias, yet any racist results are blamed on user input rather than on structural inequalities within the industry (McIlwain 2020). Racism as encoded into technological systems is then buried under what Benjamin (2019: 6) calls 'digital denial'. Like 'race' itself, technology is marketed as diverse and inclusive, but it too produces patterns of social relations seen as natural, inevitable and logical. Anthropologists must deconstruct those arguments to determine what diversity and inclusivity are really being achieved, whether positively or negatively (Benjamin 2019: 15).

We need therefore to study global digital flows and intersectionality to see the highly diverse and local responses of those who might provide tactical alternatives to an otherwise seemingly homogeneous and hegemonic information society. Clearly, scholars can profit here from earlier anthropological work on the global by scholars who have traditionally highlighted processes by noting customization practices in places outside the world's digital centres (Ferguson 1999; Tsing 2005). Indeed, this chapter's case study is of a particular instance in which the Western neoliberal origins of the information society – and their contribution to digital anthropology more generally – have been increasingly contested, along with hegemonic values of race, religion and gender.

II Extended case study: Indonesia

This section offers a brief introduction to digital transitions in the Indonesian context with which I am most familiar from my own research. More specifically, I shall ask why certain digital practices have found fertile ground there and why they seem to be preferred over others. I shall present three examples showing not only how certain new digital practices have been given genuinely Indonesian characters and how they extend previous configurations and practices, but particularly, and in line with the previous section's arguments, how prevailing ideologies of class, gender and religion within one country multiply our descriptions of digital social life.

From digital revolution to aspirational consumption

From the outset, nation-builders in developing Southeast Asian states like Indonesia have been obsessed with all things modern, especially iconic information technology. Anderson (1983) noted that in the 1945 independence struggle, Indonesian nationalists fought over postal and radio communication, and that postwar an archipelago-wide radio and television network was the result. Indonesia's home-grown satellite system was launched in 1976, eventually proving instrumental in creating a modern-day variant of Anderson's national audience (Barker 2005). However, the new dynamic media landscape was driven by consumerist not political ideology, and the Indonesian regime eventually lost control of it. In May 1998, foreshadowing much-celebrated online revolts elsewhere, ICT-literate foreign-educated Indonesian students occupied their country's parliament and called for democracy and freedom (Hill and Sen 2005). Given that digital technology had been used to support political causes as early as the late 1990s and early 2000s, it is no surprise that many later studies of the Indonesian Internet included matters affecting civil society, activism and the political potential of the Internet (Lim 2013 and more recently, Seto 2017).

Official powers soon saw the value of ICT, recognizing its potential to reach the masses and mobilize them as citizens. In early 2005 'open letters to the president' appeared in Indonesian national newspapers, allowing people to send text messages to the Indonesian president, Susilo Bambang Yudhoyono, to comment on his first 100 days in office. Later that year, he advised citizens to send him their thoughts directly, to which end he revealed his private mobile phone number. Later, President Joko Widodo made strategic use of the then burgeoning social media to address young voters although, as often popularly acknowledged, he had significant support from the oligarchic mainstream media (Tapsell 2015). Perhaps riding the waves of optimism triggered by 1998's regime change and typical of government hopes of both facilitating and nationalizing the global digital revolution, the new Jokowi government is investing in innovative e-governance applications (Nugroho and Hikmat 2017) in the hope of stimulating the sort of well-developed e-citizenship that has become the hallmark of nationalist modernity elsewhere (for instance in Estonia, Tammpuu and Masso 2018).

In practice, official attempts to promote digital citizenship have been complemented by others probably not officially envisioned. In the early 2010s there was a steady rise in citizen journalism, with social media platforms such as Facebook, Twitter and Instagram all being used by Indonesians passionately fighting injustice. With many quick to point out the new media's somewhat dubious reputation for 'one-click activism', the organizational potential of blogs and network sites received a fillip when, in October 2009, a 'one million Facebookers' support movement was launched to protest the arrest of two senior members of the national Corruption Eradication Commission (Lim 2013). The movement would rise again in 2015 as part of a 'creative grassroots campaign' on Facebook and Twitter by Indonesian activists wishing to 'Save KPK' (Suwana 2020).

However, post-authoritarianism cannot fully explain the uptake of digital technology, for in post-1998 Indonesia, as elsewhere, the Internet was predominantly used to embrace consumer fads, many imported from abroad and increasingly promoted by local lifestyle gurus, online magazines and a blossoming creative industry based in Jakarta and other centres of fashion. Since the early 2000s a rapid succession of social media have come and gone, but now mobile phones are the ultimate Internet platform, initially used and reconditioned BlackBerries as the only remotely affordable types. Since then, Indonesians have transformed chatting, blogging and other forms of self-publishing into a national pastime. Indeed, Twitter for example became so rapidly popular that by late 2010 Indonesia was said to be the world's most Twitter-addicted nation on the planet (Lim 2013).

Class, sexual mores and religiously inspired sentiments

To address now the larger questions of Indonesia's digital future, we must consider three contexts. First, strategically positioned between West and East, Indonesia has the world's largest Muslim population. Ever since the Islamic revival of the early 1970s, various groups and spokespeople in Indonesia have used Islam to contest Western values and to call for a genuine Muslim resurgence. Alongside plans for Islamic science, economy and environmentalism, information technology has been instrumental in revitalizing religion and readying it for the twenty-first century. Second, we must consider the sheer speed with which a country barely penetrated by information technology infrastructure became one of the region's fastest-growing markets, where new and mobile media are sometimes peddled for the first time. Nonetheless, the spread of and access to the latest technology is very uneven. Third, early use of digital media for political action perhaps led to wider ideas of digital revolution. Despite often-unrealistic hopes, fear of the more sinister possibilities of the digital revolution has grown over the years. Mobile telephones, once used to micro-engineer mass protests, were detonating bombs, most notoriously in Bali in 2002. Mobile phones and new social media nowadays offer platforms for digital arts, accessible health care and financial inclusion, although they are commonly associated too with piracy, pornography, populism and political violence, prompting thoughts of the security question.

Any anthropologist will note that new and mobile media immediately both inspired and expressed new forms of intimacy among Indonesian youth and encouraged experimentation with new possibilities for cyber-ad phone sex or queer sexuality. Skype was used in Internet cafés to circulate images of the private parts of even veiled girls, and one might reasonably presume that ever more Indonesians are viewing sexual content using increasingly cheap access to privately owned digital devices. In Indonesia, new media and especially anonymous sharing mechanisms have become associated with pornography as a Western perversion, and increasingly as betraying lack of religious morality (Strassler 2020). In a recently authoritarian country, censorship seems the least popular solution so that more optimistic ways have been sought to facilitate, embrace and actively stir and reorient the Indonesian information society.

Indonesia's position within the Islamic world, its uneven access to information technology and the coincidence of social and technical revolutions all suggest more than one vision of how Indonesian information society might appear a decade hence. I shall now refer to three religiously inspired digital practices and widespread information ideologies, ranging from hardware to content. I shall bear in mind the previous observations on the Internet and intersectionalities to address questions of class and consumption, gender stereotypes and newfound religious sentiment that have caught public attention over the last fifteen or twenty years.

Example 1: reconditioned phones, cannibals, and pocket Muslims

Today, the global South leads the world in accessing the Internet and other electronic information through mobile telephones rather than personal computers. A burgeoning literature on mobile phones (see Horst this volume) shows how use of mobile phones in various non-Western cultural contexts has led not only to genuine customization of technology and associated practices but to different expectations of what being mobile and connected means. Indonesian mobile telephone use illustrates both perfectly and serves here as a first case study.

The December 2004 issue of *Tren Digital* magazine described how camera phones were rapidly and constantly improving. But it included something even phone companies had not dared to think about: the X-ray camera phone. Ryan Filbert, an independent mobile phone technician from Jakarta, had managed to build one using Nokia mobile phone parts and a 'night vision' infrared chip from a digital video camera. The *Tren* article included pictures showing the camera's ability to 'see through' people's clothes, and concluded with a quotation from a Nokia spokesman saying that company was legally powerless to prevent such goings-on, 'as Indonesia at present still lacks a law covering such activities'.

'Cannibal phones', for which parts of broken phones are reused with better, more prestigious ones 'devouring' inferior ones, were just one among many tactics enabling Indonesian 'geeks' and the digitally less well-off to participate in a future that was, according to discourse in the global North, not supposed to be theirs. However, since 1990 Indonesia's rapidly growing middle class has been among the keenest users of new and mobile media, and while they still account for only a small proportion of the country's population of 267 million people, their lifestyles and social and physical mobility are exemplary for other Indonesians and were reflected in the 'mobile phone craze' that swept Indonesia.

However, mass mobile telephone ownership could be realized only by addressing each social class differently. While Jakarta's upper class prided itself on its ability to afford the latest fashionable Nokia models – or BlackBerry in those days – the defining feature of the Indonesian mobile phone market was actually its division into various submarkets, with the less well-off habitually buying phones semi-legally.

Fast forward to the mid-2010s as much of Southeast Asia, with Indonesia upfront, has developed from dumping ground for the global North's recycled hardware to test bed for new digital commodities and infrastructures. However,

Indonesia's increasingly aspirational and wealthy citizens have confounded many secularization theorists by joining the middle class in preferring a modern, but otherwise very orthodox, lifestyle. A folder from 2007 thus shows a young Muslim woman holding a digital device. The earplugs are hidden under her veil, and from the device itself hangs a small prayer compass. Sold as the 'first Muslim iPod', the device was among the first to target fashionable young Muslims nationwide, with other 'pocket Muslims' – handheld devices with all sorts of Islamic multimedia features and many offering or focusing on phone functionality – soon following suit. Among their functions are an authorized digital Koran, various other Islamic books and an animated preparation for the pilgrimage to Mecca. Most such devices are produced abroad, some proudly bearing the certificate 'Made in Mecca'. Although never quite as successful as hoped, they clearly paved the way for a range of popular Islamic apps (Fakhruroji 2019).

The growth of a Muslim middle class in Indonesia and neighbouring countries coincided with a shift from an earlier Islamic revival in the early 1970s, in which religion was widely seen as the antidote to Western colonization. Bayat (2013) defined it as 'post-Islamism' – addressing all details of everyday life. Obviously borrowing the imagery of its opponents, post-Islamist lifestyles use public expressions of religiosity to challenge simultaneously modern secularism and religious orthodoxy as 'contaminated' by Western consumerism.

New media have regularly been subject to *fatwa*, with Islamic hardliners quick to call for bans on, for example, bets placed via text and condemning the use of excerpts of the Koran as ring tones. Others, more pragmatically, have categorized technology as *sunnatulah* – God-given – blaming not the technology but its users when things go wrong and noticing how new media can be used to help combat the radicalization of Muslim youth (Schmidt 2018). However, the import of what is dubbed dismissively as 'Western technology' has led many modern Muslims to lament the fact that even postcolonial Muslim countries are still subject to Western technology which, however superior, lacks any spiritual element. Clearly, the challenge is how to remind Muslim users of modern information technology of Allah's greatness and to encourage them to abide by his laws.

Example 2: modest bloggers and online saints

The second case study, inspired by earlier work by my colleagues, exemplifies how digital technology and social media especially have helped facilitate newly styled gender performances among young religious Indonesians. Chatting and sharing in different forms remain easily the most popular uses of digital media in Indonesia. Slama (2010) describes how shortly after its introduction in the mid-1990s chatting became part of urban youth culture. Anonymity and other advantages offered by communication software such as mIRC or successful dating sites such as match.com and later Friendster allowed young Indonesians to experiment safely with romance in a society that otherwise disapproves of intimate public contact between the sexes. However, while seemingly unprecedented and providing teenaged girls especially with exciting new opportunities, the performative

style of such amorous and at least relatively anonymous chit-chat can be traced to earlier Indonesian phenomena such as call-and-response singing in fields or during festivities, when prefabricated constructions were instrumental in creating an atmosphere of good-natured teasing and flirtation. Indeed, a good number of the texts initially circulated by Indonesian mobile phone users or some of the more intimate exchanges in chat sessions seemed to echo those older traditions. Over the years, compilations have been published of text messages and Twitter poetry spiced up with emoticons, English abbreviations and other forms of digital communication fashionable among the young.

If the new private possibilities afforded by chat rooms and networking sites build upon certain Indonesian traditions, so too do more public uses of Indonesia's Internet. Much public discussion on mailing lists, YouTube posts, and more recently WhatsApp, Line or Instagram resembles earlier forms of *warung* ('street stall') talk; the humorous, often engaged but otherwise very ordinary conversations to be heard in small shops, half-jokingly referred to as 'the people's parliament'. Such conversations form a mixed modality, with stories intended to communicate something increasingly meant to be overheard (see Baym 2010: 63). New media language – including an increasing number of Indonesian blogs and Facebook pages using modern languages including English – is part of a wider funky lifestyle meant for socializing and talking about the 'right things' often through punning and wordplay.

So far, two different although not mutually exclusive scenarios have emerged in response. The first relates to exploiting ICTs' outwardly hypermodern appearance to Islamize modernity, shaping new media technologies to existing preferences while attempting to give them a conspicuously Islamic feel. The second scenario is potentially more revolutionary, focusing on how Islamic practice can truly benefit from technological advances, thereby modernizing Islam. The first approach includes new media practices adapted to Islamic taste. Following Campbell's (2006) description of the 'kosher telephone' or Ellwood-Clayton's (2003) Catholic texting practices in the Philippines, most such practices have equivalents in other world religions. Some, however, are used only by Muslims, such as Mobile Sharia Banking or validated added text services such as the Al Quran Seluler, initiated in 2002 by televangelist Aa Gym. Although not exclusively Indonesian, one of the most interesting efforts to create conspicuously Islamic software or social media content is an open-source project called *Sabily* popular until the late 2000s. Somewhat similar and more recent efforts are the Dubai-based *Salam web*, dubbed 'the World's First Browser for Muslims', or the Malaysian 'edutainment' platform, *Islamic Tunes* which also streams Indonesian Muslim acts.

All the Islamic software described here is subject to religious rules and to rapidly changing commercial tastes and users' allegiances and ages. It might therefore be more fruitful to look at actual use and what Muslims believe is gained or lost from religiously inspired technology – which brings me to the second approach, which concerns not so much Islamization of the modern, but rather modernization of Islam.

Seen from that perspective and stressing function over form, many Indonesian Muslims, while not objecting to Muslim mobiles or other religious hard- and software, fail to see much added value. Why buy a digital Koran if the book is at home? Why pay for an expensive telephone with a 'call-to-prayer' function if mosques are everywhere? Whereas in the first approach new media practices are conspicuously shaped by religious preference, in other instances Islamic practice has clearly been extended by the affordances of new technology which, furthermore, play out along heavily gendered lines.

Early Indonesian Internet and social media interaction may be characterized essentially as heart-to-heart conversations (*curhat*), and continual Islamization of the public sphere has made of the Internet an arena to 'recharge one's heart' (*ngecharge hati*). As Slama (2017a) has put it:

> the *curhat* between peers in the chat rooms of the past suggested a one-way emptying of emotion to one's peers, that has been absorbed by a more technical metaphor of recharging a battery, a process which requires a more powerful source to supply energy.

According to Slama and others, that explains why middle-class women have increasingly sought guidance in their own Quranic reading groups (see Nisa 2018 on ODOJ) or from charismatic online preachers available round the clock to listen, which husbands and friends often fail to do (Slama 2017b). Many online preachers lack traditional religious education or even command of the Arab language, so claim 'godliness' derived from pop culture and digital technology. They try to attract followers – most of them women – using a certain air of soft masculinity as 'charisma', with a healthy dose of pop-psychology thrown in.

Does that leave female users without romantic agency? By no means: studies by Beta (2019) and Baulch and Pramiyanti (2018), for example, mention the *hijabers*, a so-called 'modest fashion' bloggers movement which combines a visually pleasing aesthetic and positive, motivational quotations from authoritative sources like the Quran or *hadith* (the sayings of the Prophet Muhammad) with 'hard sell' on Instagram the favoured platform. Advertising sharia-compliant headgear among followers has as a result become a form of *hijrah* or 'cultivation of the virtuous self' and a major 'cultural genre of content' on the Indonesian Internet (Miller et al. 2016: 8).

III Comparing digital worlds

How, then, should we study the information society as an ideal? This last section uses the previous Indonesian materials to suggest how a digital anthropologist might conduct further research on plural digital worlds. I shall refer first to studies of globalization, media and material culture, especially those dealing with customization and other localizing practices. Second, I shall offer a close reading of the Indonesian digital world, especially its transnational religious aspirations, to scrutinize more closely how digital technologies themselves are used increasingly

to imagine specific futures, which we might consider central to our understanding of other people's digital worlds.

Much of the anthropological study of the global focuses on processes of localization, vernacularization, creolization or, more generally, customization, by which formerly separate but not necessarily pure cultural traditions – for our purposes here meaning the 'Western digital' and local readings of it – can be variously combined to create new hybrid forms. Classical media and material studies too can suggest ways of studying creative appropriations of dominant digital culture in places removed from its centre. Sprague's (1978) study of Yoruba analogue photography described how African people might or might not use modern technology to shape their own figurative traditions, eventually concluding that 'photographs are actually coded in Yoruba'. Sprague's and others' findings inspired those studying new media's 'indigenous poetics', referring to culturally recognizable styles and to how distinctive cultural ideals, logic and knowledge are organized and expressed (Wilson and Stewart 2008). Hjorth (2009) describes 'techno-cute practices' among mobile phone camera users in many Asian societies, such as 'feminine' customization ranging from pink casings or characters hanging from one's phone to the cute aesthetics of holding the cell phone camera in such a way that 'eyes look big and bodies small'. Writing on media use of first people groups, Ginsburg (2002: 220) described the Tanami Network, an early video-conferencing network established by the Warlpiri communities in Australia's Northern Territory. Tanami was designed purposely to break from 'white people's' use of information technology, to prioritize decentralization and interactivity. In similar vein, Srinivasan (2017) calls for a more indigenous-friendly approach to digital technology, and especially digital rights management. Those and other creative appropriations perhaps contain the key to further anthropological ventures into the digital.

Technological drama

In certain respects, the Indonesian case in the previous section echoes a longstanding tradition in the anthropology of technology by which, following Bryan Pfaffenberger (1992), the emphasis is on the sociality of human technological activity. Today's information society is one of a number of much wider systems incorporating questions of regularization, adjustment and reconstitution. Southeast Asian governments, including Indonesia's, are eager to regularize, hoping to engage their citizens actively in this digital era and providing them with the requisite equipment and infrastructure. Early satellite technology, as Barker (2005) illustrated, was most used to spread dominant Javanese values to the outer Indonesian islands, to strengthen a nationalist-military vision of the thousand-island archipelago. And while the Internet has allowed Indonesians into global capitalism, fashion and consumerism, the success of new, mobile and social media continues to be measured by their contribution to national and international economic growth – much in line with what critics such as Barbrook and Cameron (1996) designate 'the Californian ideology'.

Our second scenario illustrates Pfaffenberger's notion of 'adjustment' strategies to compensate 'the loss of self-esteem, social prestige, and social power caused by the technology' (1992: 506). The models are the 'cannibal phone' and, to a certain extent at least, the conspicuous consumption of 'religious' hardware like the 'pocket Muslims'. In the Indonesian setting the use of creole technology, piracy and other forms of cheap globalization are means to gain access to a dominant system otherwise impenetrable by the digitally less well off. That leaves us with reconstitution, Pfaffenberger's third process (1992: 506) said to consist of the fabrication of counter-artefacts, 'believed to negate or reverse the political implications of the dominant system': Islamic software and hardware might feel different, but work almost identically to secular counterparts.

Example 3: the Islamic information society

The experience of the Amish (Wetmore 2007) shows that resistance to technology for religious reasons has tended to be more about adopting technology if appropriate rather than blanket rejection of anything new. In practice, formal religions have been very successful in using new digital affordances to their own advantage (see Campbell 2006; Bunt 2018). There is now plenty of research on how new media technology has affected and extended traditional religiosity, but relatively few publications focus on how religion itself affects dominant ideas of the digital revolution or, for that matter, how religion has sought to intervene in the information society. In Indonesia, new media technology has been used to show not only how modern Islam can be, but also to trigger discussion of how Islam should embrace modernity, as the following case study attests.

Indonesian Muslim ICT use is interesting for its increasingly transnational reach. This is not just a question of techno-savvy radical groups proselytizing for the cyber caliphate or Southeast Asian Muslim celebrities making the worldwide *ummah* their market (Barendregt 2017). More progressive thinkers promote the concept of tomorrow's *ummah*, first mentioned by Muslim intellectuals like Ziauddin Sardar and endorsed by Malaysian opposition leader Anwar Ibrahim (1991). They believe it can compete with both the mass appeal of cyberfundamentalism and the Western-style liberal information society, either of which might shape post-postmodern Muslim society. Private sector initiatives, including transnational telecommunications, allow today's Indonesian pilgrims to use their own telephones in the Holy Land, while Malaysian money and expertise has built a digital growth centre in Medina.

Similarly, social networking sites like Facebook and YouTube contribute to religious exchange among Indonesian youth and their Muslim peers abroad, like the *Sabily* project mentioned earlier. Initially launched by a Tunisian programmer in Paris and hosted on a Kuwaiti server, it was for some time particularly popular in Malaysia and Indonesia. *Sabily*, *Salamweb* and content platforms like *Islamic Tunes* not only show that much of today's ICT use is transnational rather than global, but also represent the lingering urge for so-called South-to-South software first articulated in 2000 at the Tunis Forum on ICTs and Development

in the Islamic World and by the Organization of the Islamic Conference (OIC). In 2003, at its biennial congress in Malaysia, the OIC unfolded its Vision 1441 (2020 in the Western calendar). It urged its fifty-six member countries to focus on strengthening the knowledge-based 'K-economy' and fight the deepening divides threatening much of the Islamic world. Many international Muslim academics have been fully involved in the movement, which has been dubbed 'information and communication technology for the Muslim world', or ICT4M.

A few years ago, Islamic-world.net, the site of the Malaysia-based Khalifah Institute, came up with a 'Web Plan' for a pre-eminent Islamic web portal providing positive information about Islam and giving daily commentary on international news events from an Islamic perspective. Other strategies following on from the interactive Web 2.0 hype included polls to assess the opinions of Muslims worldwide on various matters of import to Islam, whereas web 3.0 and the Internet of Things now offers smart halal tourism, plus bots and apps as tools for ethical self-governance (Bahardeen and Ayunni 2019). Turning to new media, the worldwide *ummah* seems to have awakened and become increasingly self-aware. One in five of the world's population – the majority of whom, as Bunt (2009) warns, are not yet online – are dreaming new technological dreams that might easily influence the course of our current vision of an information society.

Islam is therefore a thought-provoking case, not only because it is a major world religion but also as the 'liberation theology' of the global South. The ideal of an Islamic information society spearheading the latest technology offers an alternative to Californian 'big tech', European regulation or the Chinese social credit system as the dominant pathways of digital transition. Anthropologists have discussed moral and social dimensions of digitalizing societies, but scholarly debate on technological futures is distinctly secular and implicitly modelled on the global North. Building on cultural studies of digital design (Escobar 2018), anthropologists might wish to consider the production and use of digital technologies and emergent ethical dilemmas from the viewpoint of Muslim Southeast Asia, specifically as they are already appearing in newer digital technologies including machine learning, algorithmic curation and big-data governance.

In praise of diversity

This chapter has touched on how the current digital transition threatens but might also enrich cultural diversity both within and between societies. As Miller (2018) has argued, anthropology, with its participatory and longitudinal research toolkit, is the discipline most likely to situate emergent technologies within a broader comparative cultural and social context. Anthropology has the potential and the mission to show that there are always multiple directions and different solutions to the challenges posed by the digital transition.

Why should we care about digital diversity? And why focus on the malcontents in today's information society? The simple answer is because that is what anthropologists do; they show that there are always various ways to address a problem and that the problem can vary between societies. Most studies of digital

culture still focus on the powerful centres of the information society, zooming in on research labs, geeks and youth culture in the global North, seeing the rest of the world as digitally undeveloped and therefore the focus of information and communication technology for development (ICT4D) studies. If the Islamic South's interest in information technology shows anything, it is how digital technologies are used to imagine specific futures and cultural styles. Increasingly the digital itself is a prominent building block for people's futures. One important task for anthropologists of the digital is to compare digitally diverse futures; the digital revolution and Western information society are but two possible metanarratives among many others.

There have been too few ethnographic equivalents to popular books on places where these digital futures are actually shaped: the local boardrooms of multinationals involved in formulating a digitally diverse future. Again, this is only half the picture, and digital anthropologists would do well to incorporate more awkwardly connected places. Anthropological fieldwork has shown that it is one thing to have an affluent dream about tomorrow's possibilities but something entirely different to consider how such dreams affect the present or those apparently left voiceless in such matters. Possible trajectories to the future might begin from small acts of resistance, such as a Muslim version of Facebook or a cheaply restyled telephone. With other parts of the world adopting information technology and appropriating, reconstituting and embedding digital practice to their own culture, an exciting new era for anthropologists is dawning. Now, as the parts of the world traditionally associated with anthropological research adopt technology, our job is to show how they might reshape our own sociotechnical systems and our dreams for tomorrow's technology.

Note

1 See the Google Translate homepage, https://translate.google.com/intl/en/about/contri bute/, last accessed September 18, 2020.

References cited

Allen, D. 2001. *Getting Things Done: The Art of Stress-free Productivity*. London: Penguin Books.

Anderson, B. R. O'. G. 1983. *Imagined Communities: Reflections on the Origin and Spread of Nationalism*. London: Verso.

Arora, P. 2019. *The Next Billion Users: Digital Life Beyond the West*. Cambridge, MA: Harvard University Press.

Aupers, S., Houtman, D., & Pels, P. 2008. Cybergnosis: Technology, Religion and the Secular. In *Religion: Beyond a Concept*, ed. H. De Vries, 687–703. New York: Fordham University Press.

Bahardeen, F., & Ayunni, N. 2019. *Halal Travel Frontier 2019 Report*. Singapore: Mastercard CrescentRating. Retrieved from the Crescentrating website, accessed April 24, 2020.

Ballatore, Andrea, Graham, M., & Sen, S. 2017. Digital Hegemonies: The Localness of Search Engine Results. *Annals of the American Association of Geographers*, 107(5): 1194–1215. DOI: 10.1080/24694452.2017.1308240.

Barbrook, R. 2007. *Imaginary Futures: From Thinking Machines to the Global Village*. London: Pluto.

Barbrook, R., & Cameron, A. 1996. The Californian Ideology. *Science as Culture*, 6(1): 44–72.

Barendregt, B. 2017. Princess Siti and the Particularities of Post Islamist Pop. In *Vamping the Stage Voices of Asian Modernities*, eds. Andrew Weintraub & Bart Barendregt. Honolulu: University of Hawaii Press.

Barker, J. 2005. Engineers and Political Dreams: Indonesia in the Satellite Age. *Current Anthropology*, 46(5): 703–727.

Baulch, E., & Pramiyanti, A. 2018. Hijabers on Instagram: Using Visual Social Media to Construct the Ideal Muslim Woman. *Social Media+ Society*, 4(4). DOI: 10.1177/2056305118800308.

Bayat, A. 2013. *Post-Islamism: The Changing Faces of Political Islam*. Oxford: Oxford University Press.

Baym, N. K. 2010. *Personal Connections in the Digital Age*. Cambridge: Polity.

Benjamin, R. 2019. *Race After Technology. Abolitionist Tools for the New Jim Code*. Cambridge: Polity.

Beta, A. R. 2019. Commerce, Piety and Politics: Indonesian Young Muslim Women's Groups as Religious Influencers. *New Media & Society*, 21(10): 2140–2159.

Bunt, G. R. 2009. *iMuslims: Rewiring the House of Islam*. Chapel Hill: University of North Carolina Press.

Bunt, G. R. 2018. *Hashtag Islam: How Cyber-Islamic Environments Are Transforming Religious Authority*. Chapel Hill: University of North California Press.

Campbell, H. A. 2006. Texting the Faith: Religious Users and Cell Phone Culture. In *The Cell Phone Reader: Essays in Social Transformation*, ed. A. P. Kavoori & N. Arceneaux, 139–154. New York: Peter Lang.

Campbell, H. A. 2010. *When Religion Meets New Media*. London and New York: Routledge.

Carruth, A. 2014. The Digital Cloud and the Micropolitics of Energy. *Public Culture*, 26(2): 339–364. DOI: 10.1215/08992363-2392093.

Castells, M. 1997. *The Information Age: Economy, Society and Culture*. Malden, MA: Blackwell.

Collins, P. H., & Bilge, S. 2016. *Intersectionality*. Hoboken, NJ: John Wiley & Sons.

Dor, D. 2004. From Englishization to Imposed Multilingualism: Globalization, the Internet, and the Political Economy of the Linguistic Code. *Public Culture*, 16(1): 97–118.

Ellwood-Clayton, B. 2003. Texting and God. The Lord Is My Textmate – Folk Catholicism in the Cyber Philippines. In *Mobile Democracy: Essays on Society, Self and Politics*, ed. K. Nyíri. Vienna: Passagen. www.socialscience. t-mobile.hu/dok/8_Ellwood.pdf.

Escobar, A. 2018. *Designs for the Pluriverse: Radical Interdependence, Autonomy, and the Making of Worlds*. Durham, NC: Duke University Press.

Fader, A. 2017. Ultra-Orthodox Jewish Interiority, the Internet, and the Crisis of Faith. *HAU: Journal of Ethnographic Theory*, 7(1): 185–206.

Fakhruroji, M. 2019. Digitalizing Islamic Lectures: Islamic Apps and Religious Engagement in Contemporary Indonesia. *Contemporary Islam*, 13(2): 201–215.

Ferguson, J. 1999. *Expectations of Modernity: Myths and Meanings of Urban Life on the Zambian Copperbelt*. Berkeley: University of California Press.

Tapsell, R. 2015. Indonesia's Media Oligarchy and the "Jokowi Phenomenon". *Indonesia*, 99: 29–50.

Tsing, A. L. 2005. *Friction: An Ethnography of Global Connection*. Princeton, NJ: Princeton University Press.

Turkle, S. 2012. *Alone Together: Why We Expect More from Technology and Less from Each Other*. New York: Basic Book.

Turner, F. 2006. *From Counterculture to Cyberculture: Stewart Brand, the Whole Earth Network, and the Rise of Digital Utopianism*. Chicago: University of Chicago Press.

W3Techs. 2020. Usage Statistics of Content Languages for Websites. https://w3techs.com/technologies/overview/content_language.

Welles, B. Foucault. 2014. On Minorities and Outliers: Making Big Data Small. *Big Data & Society*, 1(1): 1–2.

Wetmore, J. 2007. Amish Technology: Reinforcing Values and Building Community. *IEEE Technology and Society Magazine*, 26(2): 10–21.

Wilson, P., & Stewart, M. 2008. *Global Indigenous Media: Cultures, Poetics, and Politics*. Durham, NC: Duke University Press.

Zandbergen, D. 2011. *New Edge, Technology and Spirituality in the San Francisco Bay Area*. PhD thesis, Leiden University, Leiden.

7 Disability in the digital age

Faye Ginsburg

The following excerpt is an example of the work of the late Mel (formerly Amanda) Baggs, from their[1] audio track *In My Language* (2007b):

> *It is only when I type something in your language that you refer to me as having communication. I smell things, I listen to things, I feel things, I taste things, I look at things. It is not enough to look and listen and taste and smell and feel, I have to do those to the right things, such as look at books, and fail to do them to the wrong things, or else people doubt that I am a thinking being, and since their definition of thought defines their definition of person-hood so ridiculously much, they doubt that I am a real person as well. I would like to honestly know how many people if you met me on the street would believe I wrote this. I find it very interesting by the way that failure to learn your language is seen as a deficit but failure to learn my language is seen as so natural that people like me are officially described as mysterious and puzzling rather than anyone admitting that it is themselves who are confused, not autistic people or other cognitively disabled people who are inherently confusing. We are even viewed as non-communicative if we don't speak the standard language but other people are not considered non-communicative if they are so oblivious to our own languages as to believe they don't exist. In the end, I want you to know that this has not been intended as a voyeuristic freak show where you get to look at the bizarre workings of the autistic mind. It is meant as a strong statement on the existence and value of many different kinds of thinking and interaction in a world where how close you can appear to a specific one of them determines whether you are seen as a real person or an adult or an intelligent person.*

On January 14, 2007, Mel, a then 26-year-old autistic neurodiversity activist,[2] launched this video on YouTube.[3] The nine-minute work was shot in their apartment in Vermont in the "DIY" style typical of many user-generated video works shared on that platform. For some viewers, the unusual combining of sight and sound, and the sense of an alternative aesthetic, suggests experimental video of the sort seen in museum galleries. In any case, *IML* offers a riveting glimpse into Baggs' life, immersing the audience virtually into how they experience the world

differently from "neurotypicals." Explaining their work in a way that clearly anticipates and invites non-autistic viewers, Baggs writes,

> The first part is in my "native language," and then the second part provides a translation, or at least an explanation. This is not a look-at-the-autie gawking freakshow as much as it is a statement about what gets considered thought, intelligence, personhood, language, and communication, and what does not.
>
> (2007b)

The first part shows us Baggs engaged in a variety of repetitive gestures around their apartment – playing with a necklace, typing at a keyboard, sitting on their couch, moving their hand back and forth in front of a window – to the sound of a wordless tune they hum off camera, creating a meditative, almost mesmerizing effect. Baggs, who stopped speaking verbally altogether in their early 20s, provides the "translated portion" of the piece from which the earlier quote is taken at a little under four minutes into the video (Baggs 2007b). Their spoken voice is rendered via an augmentative communication device, a DynaVox VMax computer.[4] When feeling well, Baggs was able to type on it at a rate of 120 words a minute. Their typed words emerge into spoken speech – as well as in yellow subtitles – via a synthetic voice that (as one interviewer remarked) "sounds like a deadpan British schoolteacher" (Wolman 2008).

I begin my contribution to a book on "digital anthropology" with this particular case because *In My Language* makes stunningly clear how interactive digital technologies can provide unanticipated and powerful platforms for those with disabilities to communicate to a broad range of publics. These media enable first-person discussion of their world and experience – often asserting an alternative sense of personhood, as does Baggs – without requiring typical others to interpret for them. Moreover, the accessibility of social media forms such as YouTube have dramatically enhanced the possibilities for forming community for those who have difficulty speaking or sustaining face-to-face conversation. As Baggs explained in an interview on National Public Radio in 2010, "A lot of us have trouble with spoken language, and so find it easier to write on the Internet than to talk in person. There's a lot of us where we might not be able to meet anywhere else but online." In 2020, after Baggs' death at the age of 39 on April 11 (Genzlinger 2020), *In My Language* continues to be influential, with over a million and a half views, a work that still inspires disability activists worldwide, as well as a famous homage, *Shape of a Right Statement* (Electronic Arts Intermix, 2008), by trans performance/media artist and MacArthur Awardee Wu Tsang.[5]

Since posting *In My Language*, Mel not only had a name change, but also created an influential blog, *ballastexistenz*. In all Baggs' digital work, we see distinctive understandings of communication, empathy, self-reflection – core elements of the human experience that have at times been used to define American personhood, reflexively showing how the digital can help us rethink the cultural parameters of humanity and the deeper discriminations of the social along the lines of ability.

In this chapter, I discuss several cases that illustrate how, in the 21st century, people with disabilities (and their supporters) are developing emergent forms of digital media practices that enable their own self-representation in ways that slowly but surely are expanding our collective sense of personhood and publics.[6] The social media platforms I am focusing on here are only a small part of the remarkable embrace of digital media by many of the nearly 26% of the American population who live with some kind of disability.[7] The cases I discuss are exemplary of the enhanced capacity of these media to provide counter-discursive sites of representation for cultural actors who rarely have had opportunities to enter the public (or counter-public) sphere. While the question of accessible design is less frequently discussed than are issues of representation on the screen, work on this crucial aspect of digital media demonstrates how the very materiality of digital media builds in assumptions about embodiment, personhood, and even citizenship. In their groundbreaking 2003 work, *Digital Disability: The Social Construction of Disability in New Media*, Gerard Goggin and Christopher Newell rightly remind us that questions of access and new media are cause to "curb our digital enthusiasm." They write:

> As we interrogate our technologies, and see them as reflecting the values and lived social policy, we propose that society dare to ask: whom do I count as a member of my moral community, and whom do I exclude in the everyday taken-for-granted technology and its uses? Whom do we disable in the scramble to the networked digital society? Or, more hopefully, how can we bring about a future in which disability in its digital incarnations may unfold in new, unexpected, and fairer ways to the genuine benefit, and with the assured, ubiquitous participation every day, individually and collectively, we engage with a pressing reality: disabling new media.
>
> (154)

The battles that were fought for ramps, elevators, Braille signage, and visual signals for the hearing impaired, to name a few of the more well-known efforts of disability activists to make public space available to all citizens, are now being extended to the digital media world. The essential question that Goggin and Ellis raise when discussing the consequences of inaccessible digital technology – whom do I count as a member of my moral community? – reminds us that issues of digital design concern more than political economy or tweaking technology; they reflect the politics of recognition and the need to include the full range of people who constitute our body politic (Ellis and Kent 2011; Ellul 1964 [1954]; Goggin and Newell 2003).

The publication of a number of recent works is raising the volume and visibility of these issues. For example, the *Routledge Companion to Disability and Media* (2020), edited by media/disability scholars Katie Ellis, Gerard Goggin, Beth Haller, and Rosemary Curtis, includes pieces that concern circumstances encountered in diverse locations, addressing sensory, cognitive, and physical disability as these body/minds intersect questions of representation, agency, appropriate

casting, accessibility, and the possibilities and foreclosures presented by new technologies. The wide-ranging writings that the editors have gathered open up new and exciting horizons that build on important earlier work: Beth Haller's *Representing Disability in an Ableist World: Essays on Mass Media* (2010) and Katie Ellis and Gerard Goggin's *Disability and the Media* (2015). By 2017, media scholars Elizabeth Ellcessor and Bill Kirkpatrick argued for the significance of the emerging field of *Disability Media Studies*, the name of their volume published that year. Many of the articles in the collection fulfill the call generated by media scholars Jonathan Sterne and Mara Mills in their afterword, suggesting that we use the neologism "dismediation," which

> centers disability and refuses universal models of media and communication. . . . dismediation appropriates media technologies and takes some measure of impairment to be a given, rather than an incontrovertible obstacle or a revolution.
>
> (Mills and Sterne 2017: 366)

The burgeoning of digital technologies has spurred the growth of this work. While interdisciplinarity has been foundational, the lack of attention to work emerging from anthropology suggests the need for a further widening of the scholarship.

Mediated kinship and digital worlds

My interest in this question of the impact of media – digital or otherwise – on the experiences and categorical understandings of disability grows from several sources. First is my enduring interest in transformations in media worlds (Ginsburg et al. 2002) as a form of cultural activism, a central focus in my long-standing work on the development of indigenous media worldwide (Ginsburg et al. 2002). Second, is the two decades plus that I have spent raising a child with a rare and debilitating Jewish genetic disorder, familial dysautonomia. This circumstance has, since 1989, profoundly changed my understanding of disability and its consequences and turned me into an advocate, activist, and a daily observer of the difference that media make in the lives of those who routinely face challenges of communication, mobility, chronic illness, and discrimination. I watched as my daughter Sam grew increasingly frustrated at the stunning lack of visibility of kids with disabilities on any of her favorite forms of popular media, eventually managing to tell her own story on television at age 10 and starting a blog at age 11. It was her encounter with this form of prejudice – the sense that one's experience and body are virtually invisible – and the growing range of available digital media since then that have taught me where and how to pay attention. Over the last two decades, I followed the uneven expansion of what I call the "disability media world" through participating in and running disability film festivals and screenings, as well as getting involved in online communities on a variety of platforms (Ginsburg and Rapp 2013).

The impact of disability in digital media is increasingly evident in the growth of digital photographic and video work and of course 2.0 social media including interactive websites, Facebook groups, virtual worlds, blogging, and YouTube, all of which have dramatically expanded the range of locations for the mediation of disability to a variety of publics. New scholarship in disability studies, visual culture, and media has opened lively discussions on how such media are deeply implicated in the creation of a more inclusive sense of citizenship for nonnormative social actors. Scholars Kate Ellis and Mike Kent point out,

> Technological advancement does not occur as something separate from ideology and stigma, and web 2.0 has been developed in and by the same social world that routinely disables people with disability. However, a resistance has emerged in an attempt to reverse this trend in the form critical disability studies, a discipline which seeks to reveal the workings of a disabling social world.
>
> (2011: 3)

Rosemarie Garland-Thomson's 2009 book *Staring* provides a valuable discussion of "visual activism," a term she deploys to describe how people with disabilities are increasingly putting themselves in the public eye, saying "look at me" instead of "don't stare."[8] Their public presence as powerful social actors, she argues, "stretches our shared understanding of the human variations we value and appreciate and invites us [instead] to accommodate them" (195).

Disability scholars and filmmakers Sharon Snyder and David Mitchell interpret the potential for transformation that occurs via encounters with self-determined disability films. They suggest that exposure to a broad range of disabilities such as occurs in utopian spaces like disability film festivals can produce "aesthetic reprogramming" (Snyder and Mitchell 2008) for audiences who encounter works that reframe the everyday experience of visual doxa – the taken-for-granted aspects of the social world (Bourdieu 1977).

New York City's ReelAbilities Film Festival (for which I serve as an advisor) is now in its 14th year. It has shown outstanding films from all over the world dealing with topics from brain injury and autism to mental illness and Down's syndrome. These are not what some politely call "awareness" films but rather show people with disabilities as agents of their own creative interventions. Audiences are extremely diverse and include a very wide range of New Yorkers from the temporarily able-bodied to people with a remarkable range of disabilities. The kind of "aesthetic reprogramming" that Mitchell and Snyder discuss occurs not only because of what is on the screen, but also through the experience of being in a truly inclusive screening space. The film *Wretches and Jabberers: Stories from the Road* (Wurzburg, 2010), for example, was sitting and standing room only, with the requisite off-screen adaptations for "cripping" the viewing space: audio description for those with visual impairments, signing for deaf audience members, seating that allowed for at least 10 power chairs in the room, a few guide dogs, a high tolerance for audience unruliness, and a high percentage of people on the

autism spectrum using assistive communication devices. The documentary features Tracy Thresher and Larry Bissonnette, two men with autism who have limited oral speech but much to say. As young people, both faced lives of isolation. It was not until adulthood when each learned to communicate with the help of digital assistive technology that their lives changed dramatically, finally providing them with a way to express their thoughts, needs, and feelings. Through an outreach campaign conducted via website, Facebook, YouTube, and email, the film has spread virally across the globe across a densely connected autism network.

The circulatory reach of electronic media is the key factor in the creation of what Rayna Rapp and I have called *mediated kinship*. Emerging as a neighboring – and sometimes overlapping – field to the formal, institutionalized discourse of disability rights, mediated kinship offers a critique of normative American family life that is embedded within everyday cultural practice. Across many genres – documentaries talk shows, online disability support groups, websites, Second Life communities, and so on – a common theme is an implicit rejection of the pressure to produce "perfect families," objectified through the incorporation of difference under the sign of love and intimacy in the domain of kinship relations. We suggest that these mediated spaces of public intimacy are crucial for building a social fund of knowledge more inclusive of the fact of disability. Such media practices – increasingly digital – provide a counter-discourse to the stratification of families that for so long has marginalized those with disabilities. It is not only the acceptance of difference within families, but also the embrace of relatedness that such models of inclusion present to the body politic. As groups of people with similar diagnoses – autism, down syndrome, ADHD – begin to recognize each other through these practices, their emergent sense of kinship and identity makes these spaces potentially radical in their implications for an expanded understanding of personhood (Rapp and Ginsburg 2001: 550).

Found in digital translation

Baggs' video – one of many they made – is exemplary of this kind of mediation. They uploaded it approximately two years into the life of YouTube, the digital social media platform for uploading and sharing video of all kind. Perhaps because YouTube was relatively young as a medium in 2007, possibly because of the novelty of Baggs' video as an intervention into the presumptions of typicality exhibited by most other videos on that site, and certainly due to the rising interest in the nature and diagnosis of autism spectrum disorders in the early 21st century (Grinker 2007), *In My Language* provoked considerable response and some controversy, with over 300,000 views in the first three weeks of its posting and over one million and a half by 2019 (Gupta 2007).[9]

Within a month of its launch, CNN ran a story on Amanda (now Mel) Baggs and the video; two days later they guest-blogged with Anderson Cooper, the well-known American CNN television journalist (Cooper 2007). A year later, Baggs was the subject of an article in *Wired* magazine[10] entitled *The Truth about Autism:*

Scientists Reconsider What They Think They Know. In April 2008, CNN's celebrity medical expert and neurosurgeon Dr. Sanjay Gupta visited and interviewed Baggs at their Vermont home (April 2008). After Gupta met Baggs and saw the remarkable access that was opened by media platforms such as YouTube and blogs, he quipped,

> The Internet is like a "get out of jail for free" card for a new world of autistics. On the Internet, Amanda can get beyond names and expectations. She can move at her own pace, live life on her own terms.
>
> (Gupta 2008)

Baggs' use of digital platforms illustrates the striking benefit that this kind of technology holds, potentially, for certain groups of people with disabilities – especially those with autism and related communicative disorders. This is due in large measure to the capacity of such media to reach beyond the local and constitute networks organized along other modes of recognition rendered intimate or at least available because of the rapid and democratizing (if unequal) spread of social media. Daniel Miller's case of "Dr. Karamath" in his recent book, *Tales from Facebook*, makes this point poignantly clear (Miller 2011: 28–39). Another autistic activist, the Canadian researcher Michelle Dawson, also finds face-to-face interaction an ordeal. She is an avid blogger, especially with "scientists, parents' groups, medical institutions, the courts, journalists, and anyone else who'll listen to their stories of how autistics are mistreated" (Wolman 2008: 10).

Not being able to talk doesn't mean you don't have anything to say

People like Mel Baggs, who present to neurotypicals as if they have no language because they don't speak, are able to communicate – can be stunningly articulate through a keyboard and augmented communication technologies, and most recently, via interactive tablet technologies such as the iPad.[11] As Baggs remarked regarding their own situation, "Not being able to talk doesn't mean you don't have anything to say."

The 30 or more videos they posted on YouTube showing Baggs' everyday activities are testimony to that; they range from angry manifestos against the inhumanity shown to those with disabilities or other forms of "unacceptable" difference (*Being an Unperson, About Being Considered "Retarded"*) to the wry yet revelatory *How to Boil Water the EASY Way* (2007a). The piece is introduced with a series of title cards that explain:

> This is meant to explain why it takes me five hours or longer to boil water sometimes. This is a shortened version of what goes on. Feel free to laugh as long as it's not to make yourself feel superior or something. But even though

it can be funny, be aware this is a serious and real situation for a lot of autistic people among others.

(Baggs, 2007a)

A quick unscientific read of many of the 30,000 responses to this particular video in the comments section (only 20 "dislikes") gives a sense of how this digital self-presentation strikes viewers. The comments of "Suzanne, Mother of an autistic 3 (almost 4) year old" expressed the sentiments of many:

You are amazing:) Brilliant video! I am thankful for the videos you produce. Sincerely, Suzanne, Mother of an autistic 3 (almost4) yr old. p.s. and I'd like to give you a cyber (((hug))) =). maybe I can meet up with you some day in Second Life and give you a hug there. Hehe.

(accessed 7/16/2011)

Suzanne is clearly aware that in addition to the use of video platforms such as YouTube and blogging, Amanda Baggs was an avid user of the virtual immersive community of Second Life. There they created an avatar who looks and acts like Baggs, typing and rocking back and forth – but who can fly to different destinations and attend autism meetings with far less anxiety than in real life (IRL).

In real life, according to Dan Wollman from *Wired* magazine who interviewed them in 2008,

Baggs lives in a public housing project for the elderly and handicapped near downtown Burlington, Vermont. She has short black hair, a pointy nose, and round glasses. She usually wears a T-shirt and baggy pants, and she spends a scary amount of time – day and night – on the Internet: blogging, hanging out in Second Life, and corresponding with her autie and aspie friends. (For the uninitiated, that's *autistic* and *Asperger's*.) On a blustery afternoon, Baggs reclines on a red futon in the apartment of her neighbor (and best friend) . . . Autistics like Baggs are now leading a nascent civil rights movement. "I remember in'99," she says, "seeing a number of gay pride websites. I envied how many there were and wished there was something like that for autism. Now there is." The message: We're here. We're weird. Get used to it.

(Wolman 2008: 4–5)

While their "celebrity crip" status is unique, Ms. Baggs' creative and interventionist uses of YouTube, blogging, and Second Life are metonymic of a broader change in the zeitgeist, at least in the first world. The rise of the global movement for disability rights since the 1980s and the simultaneous emergence of enabling digital technologies for people with a wide range of disabilities have created a modest but nonetheless transformative effect, a historical moment when various interests within a field intersect in ways that lead to paradigmatic change.

If one of the goals of the contemporary disability rights movement worldwide is self-determination, then there is no question that being able to represent oneself

in digital public (or counter-public) spheres on one's own terms is consistent with that project (Charlton 1998). As Mel Baggs' case illustrates, this kind of self-determination might include:

1 either "passing" as typical or "coming out" as a person with a disability;
2 having control over channels of communication in ways that are suitable for particular issues faced by those who are not "neurotypicals"; and
3 locating and developing relationships with others with similar circumstances as well as supportive fellow travelers in the broad non-local world of the internet.

The growing literature on the impact of digital media for people with disabilities suggests that these new forms of digital access provide distinctive possibilities for virtual sociality and self-determined recognition, a fundamental aspect of personhood. As Morton Ann Gernsbacher, a cognitive psychologist who specializes in autism at the University of Wisconsin-Madison notes, "The Internet is providing for individuals with autism, what sign language did for the deaf," she says. "It allows them to interact with the world and other like-minded individuals on their own terms."[12] In the US, it was only four decades ago that the longstanding so-called ugly laws were abolished; for over a century, this legislation had made it illegal for persons with "unsightly or disgusting disabilities" to appear in public in most American cities, laying the groundwork for the widespread acceptance of eugenics and institutionalization in the 19th and 20th centuries, as disability scholar Susan Schweik has taught us (2009).

In addition to the alternative but clearly indexical representation of their life offered by Mel Baggs, another corner of the digital media world – the virtual immersive world of Second Life – has been home to a growing but robust presence of participants. A remarkable number of avatars created by people with disabilities live fully social lives in ways not otherwise available to them IRL. At the same time, a number of disability activists joined together to create Virtual Ability, a site that provides support for those with disabilities both in Second Life – including how to gain access if one has difficulty using standard software and hardware – and IRL, with counseling and support provided in ways that demonstrate the difficulty of rendering on- and offline worlds fully separable.

Getting a (second) life

At a Friday afternoon workshop about Jewish religious practice in the online world, at New York University's Center for Religion and Media, a virtual lighting of the Shabbat candles was about to take place in the Jewish section of the online world of Second Life.[13] The assembled group waited eagerly, watching a projected screen while a group of online avatars (or "javatars" as some call those virtual representatives who identify as Jewish) gathered for the first set of candles to be lit (virtually) based on Israeli time, seven hours ahead of New York City. As the avatar named Namav Abramovitch carried out the ritual, the

scholar who was conducting the workshop as part of a demonstration of her research asked him if he would be leaving soon to go light candles IRL. To the group's astonishment, he wrote back, "No, I can't light candles IRL because I am disabled. Second Life is the only space where I can be a practicing Jew." (Note – voice software was not yet an option at that time.) In actual life, Namav is (the late) Nick Dupree, a Medicaid reform activist with muscular dystrophy who uses a ventilator to breathe. He had only been active on SL a few months prior to the encounter I just described. He became interested after reading an article in *The Washington Post* about how people with disabilities creatively use Second Life and other social media (Stein 2007). Nick can't use a keyboard or lift his hands; he types with a thumb on a trackball mouse, creating text by hitting letters using onscreen keyboard software. As he explains, "I had run a support group online in the past, and am interested in using virtual community to support people with disabilities . . . and now have founded Open Gates, a project to provide 24/7 peer support in Second Life."[14]

Namav's story offers a kind of parable of digital possibility for those who find RL less than accommodating of their impairments. Participation in the virtual world of Second Life offers a "second chance" to participate in a variety of social practices that previously might not have been available. Research on the impact of this virtual activity on offline lives suggests that these are "existentially therapeutic." Rob Stein, in his influential *Washington Post* article, "Real Hope in a Virtual World," described a number of such cases. One woman had a devastating stroke that left her in a wheelchair with little hope of walking again; she has since regained use of her legs and "has begun to reclaim her life, thanks in part to encouragement she says she gets from an online 'virtual world' where she can walk, run and even dance". Another SL participant who had severe agoraphobia gained the confidence to start venturing outdoors after exploring the world of Second Life. Stein suggests that these effects are so powerful in part because of "the full-color, multifaceted nature of the experience offers so much more 'emotional bandwidth.'"

Clinical research confirms these reports of the practical and existential effect of participating in virtual worlds for disabled subjects.[15] These range from disabled users gaining a sense of control over their environment and their interactions with others (Alm et al. 1998; Stevens 2004; Williams and Nicholas 2005) to developing an enhanced spatial awareness, eye/hand coordination, and fine motor skills, finding sources of social support and medical information (Kalichman et al. 2003; Hill and Weinert 2004), and achieving greater independence, communication, and learning for those with mobility impairments (Anderberg and Jönsson 2005) and traumatic brain injury (Thornton et al. 2005). For those with cognitive impairments, participation in virtual reality has been shown to help subjects focus attention and promote learning of life skills such as shopping and food preparation (Alm et al. 1998; Christiansen et al. 1998). People with autism spectrum condition often find VR communication more comfortable than that in real life (Biever 2007; Parsons and Mitchell 2002).

In his ethnography of Second Life, based on fieldwork that took place from June 3, 2004, to January 30, 2007, anthropologist Tom Boellstorff talks about

the consequences that actual-world embodiment has for virtual participation on this online world. While Second Life is no longer as active as it was when he did his research in the rapidly changing digital mediascape, his writing nonetheless draws attention to the ways that the design of digital media can be "disabling." However liberating life as an avatar might be, creating that version of the self requires that "one saw or heard with actual eyes and ears, typed on a keyboard and moved a mouse with actual hands and fingers" (2008: 134–135). Boellstorff notes the frequent comments he heard regarding the lack of consideration for "universal design" that might accommodate users with a variety of disabilities. Complaints included the difficulty of reading small fonts for those with visual impairments, the impact of seizure-inducing flash effects for those with epilepsy, difficulties managing avatars with a track ball, and problems with abstract reasoning required for scripting. Boellstorff also found that many people who self-disclosed created avatars that did not reflect their impairments – an online practice of "passing" noted since the days of text-only chatrooms (Van Gelder 1991: 366). As one resident in his study explained, having virtual capacities in SL that otherwise are not available "allows you to be free to explore yourself" (137). Others create embodied representations that reflected their RL disabilities.[16]

Boellstorff's fieldwork ended in January 2007, six months before a remarkable community of support for people with disabilities on SL emerged, largely due to the efforts of disability activist Alice Krueger and fellow travelers who have joined her. The community that Ms. Krueger/Gentle Heron founded with two other disabled friends began in June 2007 when they began thinking about how important the concept of community was for those who faced barriers to participation in the physical community in which they lived. They began asking other disabled people what their idea of "community" was and what they expected from being a member of a community. So the three friends decided to explore virtual reality as a setting within which to build a supportive community and chose Second Life as the one to colonize first, since it seemed to be the richest cultural environment and the most fully developed (Whiteberry 2008).

Within its first eight months, the community grew to 150 subjects, quickly earning a reputation as the primary group supporting people on SL with real-world disabilities. After discussion with these members, they became Virtual Ability, Inc., in January 2008, a nonprofit corporation based in Colorado, where Ms. Krueger lives.[17] Virtual Ability continues to be active and has six SL properties that together reflect the concerns first articulated by the founders.[18] Their goal – to provide a support community for people with disabilities and their fellow travelers – is a serious project that does not regard the boundary between virtual and "real" life as significant in the making of the kind of the "moral community" that Goggin and Newell imagine.[19] While examples from Second Life are engaging and a reminder of the affordances necessary to access virtual worlds for people with different kinds of impairments, the number of people – with or without disabilities – involved in this virtual world is quite small.

#Cripthevote[20]

What of the estimated 26% of the population with disabilities? This social category comprises the largest minority in America – a demographic fact of political arithmetic that is rarely recognized. In the current neoliberal zeitgeist, public expenditures providing crucial disability support across the life cycle are constantly at risk. In the turbulent 2016 American presidential race, disability rights groups found new ways to use digital media to get political, responding to the specter of a collapsing social contract. Disability activists launched the online platform RespectAbility,[21] a remarkable nonpartisan effort to urge candidates to address disability issues. Additionally, using the reach of social media, the newly created #cripthevote campaign created a national conversation about disability rights with a view to mobilizing voters (Ginsburg and Rapp, 2016).

The need for these initiatives erupted when Donald Trump maliciously imitated a disabled *New York Times* reporter, Serge Kovaleski. As head of the National Organization on Disability commented, "Considering there are fifty-six million Americans living with a disability, you would think a candidate for president would be looking for opportunities to highlight their remarkable contributions to society, not mock them."[22] In June, Priorities USA, a Democratic political action committee, aired a 30-second anti-Trump advertisement focusing on the impersonation, featuring a 17-year-old African American Dante Latchman criticizing Trump for his bigotry.

One month later, at the Democratic National Convention, disability issues became central to a presidential campaign for the first time in American history. This was most notable in the speech by activist Anastasia Somoza, a young woman with cerebral palsy and quadriplegia. Her impassioned declaration of the need to recognize people with disabilities generated considerable publicity and conversations in the disability blogosphere. Beyond the affective spectacle featuring disability advocates at the convention, careful attention to inclusive infrastructure relying on digital technologies was evident at the convention, including accessible screen readers, large print, live captions, American Sign Language, assisted listening devices, audio descriptions for convention-hall proceedings, and a texting system for requesting assistance.[23]

The efforts of disability activists in the 2016 and 2020 elections rapidly evolved in terms of both political and technological savvy. Hashtags and other forms of online activism are building ties and awareness, encouraging disabled Americans to make their votes count. These efforts by #cripthevote signal the maturation of a social movement flexing its political muscle, enabled by the affordances of digital and social media, while pushing against the neoliberal erasure of recognition and the erosion of public services.

Conclusion

There is still considerable ground to cover before we truly achieve "digital doxa" in which "disability in its digital incarnations may unfold in new, unexpected, and

fairer ways to the genuine benefit . . . of people with disabilities" (Goggin and Newell 2003: 154). My daughter, at age 32, still finds it hard to find actual characters with disabilities on television or at the movies, although that is finally starting to change with the advent of very successful shows such as *Speechless* and most recently *Special*.[24] Nonetheless, the cases discussed here suggest a sea change is occurring, as the capacities of digital media enable significant interventions in our everyday understandings of what it means to be human for the estimated one-fifth of the world's population that live with disabilities, a category that anyone of us might join in a heartbeat.

Notes

1 Baggs' insisted that they were genderless, and over time switched to plural pronouns until their death in April 2021. Out of respect for Baggs' practice, I will use plural pronouns for Baggs in this chapter although some earlier writing on Baggs that I quote uses she/her pronouns.

2 The status of Amanda/Mel Baggs' diagnosis has been the subject of some debate. I have found Amy Lutz's piece in Slate, *Is the Neurodiversity Movement Misrepresenting Autism?* to be the most helpful. In short, diagnoses are often very difficult. https://slate.com/technology/2013/01/autism-neurodiversity-does-facilitated-communication-work-and-who-speaks-for-the-severely-autistic.html. Accessed June 16, 2019.

3 Amanda (Mel) Baggs. In my language. *YouTube*. Accessed July 18, 2011.

4 Since then, technologies such as Tobii Dynavox Speech Case and Speech Case Pro can be integrated with iPad cases designed specifically for augmentative and alternative communication (AAC), displacing older longstanding technologies such as the Dyna-Vox visible in Ms. Baggs' video.

5 In her 2008 video, *The Shape of a Right Statement*, Wu Tsang stages a one-to-one vocal performance *In My Language*. As one critic wrote, "Tsang's 'full-body quotation' of Baggs speaks to several major issues at the heart of her practice. Foremost is her endeavor to communicate the impossibility of communication, the ways we can never fully understand other people." www.culturedmag.com/wu-tsang/

6 What "counts" as digital is a vast array of technologies; by necessity, this chapter will be limited to only a few of these forms.

7 According to the US Census Bureau, 19% of the population has some kind of disability. www.census.gov/newsroom/releases/archives/miscellaneous/cb12-134.html. Accessed June 2, 2019. By 2020, it was 26%, according to the CDC. https://www.cdc.gov/ncbddd/disabilityandhealth/infographic-disability-impacts-all.html

8 The ocular-centrism of the title *Staring* and the idea of "visual activism" are worthy of more commentary than this article permits.

9 David Wolman from *Wired* magazine wrote the following in his 2008 article on Ms. Baggs about the status of her video. "I tell her (Amanda Baggs) that I asked one of the world's leading authorities on autism to check out the video. The expert's opinion: Baggs must have had outside help creating it, perhaps from one of her caregivers. . . . After I explain the scientist's doubts, Baggs grunts, and her mouth forms just a hint of a smirk as she lets loose a salvo on the keyboard. No one helped her shoot the video, edit it, and upload it to YouTube. . . . ' 'My care provider wouldn't even know how to work the software,' she says" (Wolman 2008: 4).

10 *Wired* magazine reports on how new and developing technologies – especially digital technologies – affect culture, the economy, the body, and politics.

11 Zoe Fox, Four Ways iPads Are Changing the Lives of People with Disabilities. http://mashable.com/2011/07/25/ipads-disabilities/. Accessed July 25, 2011.

12 http://edition.cnn.com/2007/HEALTH/02/21/autism.amanda/index.html
13 Second Life (SL or 2Life) is a virtual world launched in 2003 and is accessible via the internet.
14 http://virtualability.org/vanamav.aspx. Accessed July 15, 2011.
15 http://virtualability.org/va_medical_benefits.aspx. Accessed July 20, 2011.
16 Wagner James Au reports the case of a single avatar controlled by nine people with disabilities (2004a).
17 http://wiki.secondlife.com/wiki/Virtual_Ability. From 2006 to 2010, Wellness Island, founded by AL counselor Avalon Bike, provided a support center on Second Life, one of the first to offer mental health resources, counseling, and education. It closed after 3.5 years because of time and money. Wellness Island http://slhealthy.wetpaint.com/page/Wellness+Island.
18 Virtual Ability Island (VAI) provides new resident orientation and training for people with disabilities or chronic illnesses; (2) HealthInfo Island, attached by a drawbridge to VAI, offers information on physical, emotional, and mental health through interactive displays, links to outside resources, events, and personalized assistance as well as an Accessibility Center with floors that each focus on different aspects of accessibility: vision, hearing, mobility and dexterity, and learning impairments; (3) Cape Able is for those who are deaf or have hearing impairments; (4) Cape Serenity is a kind of haven featuring a library with books written by people with disabilities, as well as a patio for storytelling and poetry readings; (5) Wolpertinger property offers 23 inexpensive apartments; and (6) AVESS (Amputee Virtual Environment Support Space) was built to establish best practices and protocols for the provision of online peer-to-peer support services for military amputees and their families. https://virtualability.org/. Accessed June 16, 2019.
19 Consistent with their interest in disability rights both on- and offline, their most recent project was the organizing and hosting of a "virtual world conference about real world rights": The International Disability Rights Affirmation Conference took place July 23/24, 2011, at Sojourner Auditorium on Virtual Ability Island.
20 Portions of this section are drawn from a 2016 piece I wrote with Rayna Rapp, "#cripthevote: What's the Crisis of Liberalism Got to Do With It?"https://culanth.org/fieldsights/cripthevote-whats-the-crisis-of-liberalism-got-to-do-with-it. Accessed June 16, 2019.
21 See www.respectability.org/. Accessed June 16, 2019.
22 www.thedailybeast.com/donald-trumps-war-on-people-with-disabilities. Accessed June 16, 2019.
23 www.demconvention.com/app_news/app_news_press_releases/2016-democratic-national-convention-announces-plans-make-accessible-convention-ever/. Accessed June 16, 2019.
24 The TV series *Speechless* ran for three seasons, completing its run in April 2019. The last episode of this trailblazing show was followed by the disappointing announcement of its cancellation, a blow for fans of this thoroughly cripped sitcom. However, a new Netflix series, *Special*, hit the news cycle the same month, publicized as an unconventional comedy headlining Ryan O'Connell, a young gay comedian with cerebral palsy playing himself. This new show received widespread and positive press coverage.

References cited

Alm, N., J. L. Arnott, I. R. Murray, and I. Buchanan, I. 1998. Virtual reality for putting people with disabilities in control. *Systems, Man, and Cybernetics*, 2, 1174–1179
Anderberg, P., and B. Jönsson. 2005. Being there. *Disability & Society*, 20(7): 719–733
Baggs, Amanda. 2007a. How to boil water the EASY way. *YouTube*, June 17. https://www.youtube.com/watch?v=9fUi1EYq6Rs. Accessed 31 January 2021

Baggs, Amanda. 2007b. In my language. *YouTube*, January 14. www.youtube.com/watch? v=JnylM1hI2jc. Accessed 18 August 2007

Biever, C. 2007. Let's meet tomorrow in second life. *New Scientist*, 2610, June: 26–27

Boellstorff, Tom. 2008. *Coming of Age in Second Life: An Anthropologist Explores the Virtually Human*. Princeton: Princeton University Press

Bourdieu, Pierre. 1977 [1972]. *Outline of a Theory of Practice*. R. Nice, trans. Volume 16. Cambridge: Cambridge University Press

Charlton, James. 1998. *Nothing About Us Without Us: Disability Oppression and Empowerment*. Berkeley: University of California Press

Christiansen, C., B. Abreu, K. Ottenbacher, K. Huffman, B. Masel, and R. Culpepper. 1998. Task performance in virtual environments used for cognitive rehabilitation after traumatic brain injury. *Archives of Physical Medicine and Rehabilitation*, 79(8), August: 888–892

Cooper, Anderson. 2007. Why we should listen to 'unusual' voices. Wednesday, February 21, 2007. www.cnn.com/CNN/Programs/anderson.cooper.360/blog/2007/02/why-we-should-listen-to-unusual-voices.html

Electronic Arts Intermix. 2008. Shape of a right statement. https://www.eai.org/titles/shape-of-a-right-statement. Accessed 25 January 2021

Ellcessor, Elizabeth, and Bill Kirkpatrick, eds. 2017. *Disability Media Studies*. New York: NYU Press

Ellis, Katie, and Gerard Goggin. 2015. *Disability and the Media*. Basingstoke, UK: Palgrave Macmillan

Ellis, Katie, and Mike Kent. 2011. *Disability and New Media*. New York and London: Routledge

Ellis, Katie, Gerard Goggin, Beth Haller, and Rosemary Curtis, eds. 2020. *The Routledge Companion to Disability and Media*. New York and London: Routledge.

Ellul, Jacques. 1964 [1954]. *The Technological Society*. Robert K. Merton, trans. John Wilkinson, Intro. New York. A. A. Knopf

Garland-Thomson, Rosemarie. 2009. *Staring: How We Look*. New York: Oxford University Press

Genzlinger, Neil. 2020. Mel Baggs, blogger on autism and disability, dies at 39. *The New York Times*, April 28. https://www.nytimes.com/2020/04/28/health/mel-baggs-dead.html. Accessed 31 January 2021

Ginsburg, Faye, Lila Abu Lughod, and Brian Larkin. 2002. *Media Worlds: Anthropology on New Terrain*. Berkeley: University of California Press

Ginsburg, Faye, and Rayna Rapp. 2013. Disability worlds. *Annual Review of Anthropology*, 42: 53–68

Ginsburg, Faye, and Rayna Rapp. 2016. #cripthevote: What's the crisis of liberalism got to do with it? In *Cultural Anthropology*. Editor's Forum Hot Spots. Crisis of Liberalism Series. https://culanth.org/fieldsights/cripthevote-whats-the-crisis-of-liberalism-got-to-do-with-it. Accessed June 16, 1019

Goggin, Gerard, and Christopher Newell. 2003. *Digital Disability: The Social Construction of Disability in New Media*. New York: Rowman & Littlefield

Grinker, Roy Richard. 2007. *Unstrange Minds: Remapping the World of Autism*. New York: Basic Books

Gupta, Sanjay. 2007. Behind the veil of autism. February 20. www.cnn.com/HEALTH/blogs/paging.dr.gupta/2007/02/behind-veil-of-autism.html. Accessed 18 August 2011

Gupta, Sanjay. 2008. Finding Amanda. April 2. http://thechart.blogs.cnn.com/2008/04/02/

Haller, Beth. 2010. *Representing Disability in an Ableist World: Essays on Mass Media*. Louisville, KY: Advocado Press

Hill, W. G., and C. Weinert. 2004. An evaluation of an online intervention to provide social support and health education. *Computers, Informatics, Nursing*, 22(5), August: 282–288

Kalichman, S. C., E. G. Benotsch, L. Weinhardt, J. Austin, W. Luke, and C. Cherry. 2003. Health-related Internet use, coping, social support, and health indicators in people living with HIV/AIDS: Preliminary results from a community survey. *Health Psychology*, 22(1): 111–116

Mauss, Marcel. 1935. Body techniques. In *Sociology and Psychology: Essays by Marcel Mauss*. Ben Brewster, trans., 95–123. London: Routledge and Kegan Paul

Miller, Daniel. 2011. *Tales from Facebook*. Cambridge, UK: Polity Press

Mills, Mara, and Jonathan Sterne. 2017. Afterword II: Dismediation – Three proposals, six tactics. In *Disability Media Studies*. Elizabeth Ellcessor and Bill Kirkpatrick, eds., 365–378. New York: NYU Press

Parsons, S., and P. Mitchell. 2002. The potential of virtual reality in social skills training for people with autistic spectrum disorders. *Journal of Intellectual Disability Research*, 46 (Pt. 5), June: 430–443

Rapp, Rayna, and Faye Ginsburg. 2001. Enabling disability: Rewriting kinship, reimagining citizenship. *Public Culture*, 13 (3): 533–556

Rapp, Rayna, and Faye Ginsburg. 2010. The human nature of disability. Vital topics column. *American Anthropologist*, 112 December

Schweik, Susan M. 2009. *The Ugly Laws: Disability in Public*. New York: NYU Press

Snyder, Sharon L., and David T. Mitchell. 2008. "How do we get all these disabilities in here?" Disability film festivals and the politics of atypicality. *Canadian Journal of Film Studies*, 17(1), Spring: 11–29

Stein, Rob. 2007. Real hope in a virtual world. *The Washington Post*, October 6. www.washingtonpost.com/wp-dyn/content/article/2007/10/05/AR2007100502391.html. Accessed 18 August 2011

Stevens, L. 2004. Online patient support: Mostly a boon, but challenges remain. *Medicine on the Net*, 10(3): 1–6

Thornton, M., S. Marshall, J. McComas, H. Finestone, A. McCormick, and H. Sveistrup. 2005. Benefits of activity and virtual reality based balance exercise programmes for adults with traumatic brain injury: Perceptions of participants and their caregivers. *Brain Injuries*, 19(12), November: 989–1000

Van Gelder, Lindsey. 1991 [1985]. The strange case of the electronic lover. In *Computerization and Controversy: Value Choices and Social Conflicts*. Charles Dunlop and Rob Kling, eds., 364–75. Boston: Academic Press

Whiteberry, Widget. 2008. The story of the heron sanctuary. *The Imagination Age*, January 24. www.theimaginationage.net/2008/01/story-of-heron-sanctuary.html. Accessed 18 August 2011

Williams, P., and D. Nicholas. 2005. Creating online resources for the vulnerable. *Library & Information Update*, 4(4): 30–31

Wolman, David. 2008. The truth about autism: Scientists reconsider what they think they know. *Wired*, 16(3), February 25. Accessed 18 August 2007

Wurzburg, Gerardine. 2010. Wretches and Jabberers: Stories from the Road (93 min.). Area 23A

8 Devices and selves

From self-exit to self-fashioning

Natasha Schüll

Popular and academic writings on digital technology tend to characterize the effects of its distinguishing properties – abstraction, binarism, and the "reduction of quality to quantity" (to quote from Miller and Horst's introduction to the first edition of this volume) – in one of two ways. Dominating the debate are accounts that warn of the increasing levels of distraction, alienation, and addiction that it produces, while an opposing set of writings articulate hopeful vistas on digital solutions for a freer, happier, more equitable future – one of amplified social connectivity across time and space, novel collaborative activisms, and liberatory self-transformations.

The premise of this chapter is that close, empirical attention to the experiences, practices, and design logics at work in specific human-digital encounters can enliven the polemical debate over digital technology with ethnographic particulars, moving beyond the question of whether digital technology is toxic or enabling to the more interesting questions of *in what ways* and *under what conditions* technologies might be toxic, enabling, or both. The two case studies that follow address both ends of this spectrum. The first, drawn from my research among the designers and players of digital slot machines (Schüll, 2012), examines the *self-suspending, desubjectifying affordances* of human-digital encounters. The second, drawn from my research among members of the group Quantified Self (Schüll, 2016, 2019), examines the *self-cultivating, subjectifying affordances* of digital self-tracking devices and algorithms. In both cases, digital artifacts and software serve as media for self-modulation, yet with critical differences in their design as well as the aims of their users. My goal is to show how an ethnographic parsing of these differences – as well as a recognition of their shared predicament – can render a more precise and powerful critique of contemporary economic, political, and social pressures on the self.

The inductive orientation and fieldwork-based methodologies of anthropology, proceeding from observation to analysis and privileging particular cases over general frameworks, have much to contribute to understanding the effects of digital technology on everyday human experience. Rather than provide a comprehensive review of the anthropological literature in this area, before proceeding I touch upon a number of recent ethnographic inquiries into human-digital encounters, clustering these under three driving questions that scholars have posed around (a) online platforms; (b) networked communication technology; and (c) algorithmically driven interactive devices, the focus of this chapter's two case studies.[1]

(a) Do online platforms support or undermine self-expression and identity formation?

Turkle's early investigations into the subjective dimensions of online interactions in the context of multi-user domains (1995) portrayed such platforms as potentially liberating, expressive vehicles. Ethnographers have continued to find in online gaming cultures a rich ground for exploring digitally mediated modes of selfhood such as avatar and character creation in virtual worlds (Humphrey, 2009; Shaw, 2014; Nardi, 2010; Boellstorf, 2008; Taylor, 2006) and the ways in which these aspire to, depart from, or replicate the offline identities of players.

Another rich area of inquiry concerns "selfie culture" (Rettberg, 2014) and the various online sites through which individuals can present, perform, and curate themselves, including Facebook (van Dijck, 2013; Goodwin et al., 2016), Instagram (Lavrence & Cambre, 2020), blogs (Reed, 2005), and webcamming (Taylor, 2018; Wesch, 2009; Senft, 2008). Ethnographers of online gaming and selfie culture have also been attentive to "the paradoxical dynamics of exploitation and empowerment" (Zhongxuan, 2018; Majamäki & Hellman, 2016) into which participants can be drawn, as in various forms of addiction (Golub & Lingley, 2008; Chan, 2008) and digital labor (Calvão, 2019; Dibbell, 2007, 2008; Chen & Sun, 2020; Roberts, 2019, Raval, 2020), including self-branding and self-promotion (Petre, 2018; Kuehn, 2016; Duguay, 2019).

Scholars have also considered how individuals use social media to perform and narrate identities around illness and health practices (Kent, 2020; Tembeck, 2016), while others have focused on the ways in which telecare technologies redefine patient identities and roles (Oudshoorn, 2011). Some show how direct-to-consumer genetic testing sites serve as avenues to new ancestral and ethnic identifications (Lee, 2013) and portals of access to raw genetic code that individuals can probe for personal details with open-source tools (Ruckenstein, 2017) or use to construct "autobiologies" (Harris et al., 2014). In an online ethnography of videos posted to the website for the Quantified Self (QS), an international collective that seeks "self-knowledge through numbers" (as its website tagline reads), Smith and Vonthethoff explore how members "narrate personal experiences and stories in a public forum via the 'companion' medium of their data" (2017, p. 12), while Sharon and Zandbergen describe participants' self-quantification practices as a "continuous process of identity construction" (2016, p. 1700).

More than a process of personal identity construction, the open-ended communications that transpire between individuals exploring their digitally sourced self-data constitute a kind of "datasociality" (Ruckenstein & Schüll, 2017, p. 266), a theme to which we will return in Case 2 of this chapter.

(b) Do networked communication technologies amplify or diminish social ties?

Ethnographers have documented the robust sense of community that can unfold in computer-accessed game worlds, resulting in affiliations that in some

cases transcend or escape the strictures of offline social dynamics and, in other cases, recreate or even amplify them (Boellstorf, 2008; Taylor, 2006; Pearce, 2009, Shaw, 2014).

Likewise, anthropologists have explored how networked forms of communication such as email, mobile telephony, and social media affect social ties,[2] including friendship and interpersonal connections (Ito et al., 2005; boyd, 2014; Baym, 2010; Burrell, 2012; Turco 2016; Venkatraman, 2017; Costa, 2018; Watkins & Cho, 2018; Sutton, 2020), romantic intimacy (Ansari & Klinenberg, 2015; Gershon, 2010, 2018; Frampton & Fox 2018; Hellman et al. 2017; McVeigh-Schultz & Baym, 2015; Kenny, 2016; Doron, 2012), and familial and care relationships (Wilson & Chivers, 2017; Madianou & Miller, 2011; Miller & Slater, 2000; Gregg, 2011; Barassi, 2020). Recent ethnographic studies have examined how networked devices sustain hope and emotional togetherness for migrants and refugees coping with the anxieties of prolonged cultural separation (Twigt 2018; Alinejad, 2019; Udwan et al., 2020).

While much of this literature emphasizes the enrichment or intensification of social ties that mobile communication technology grants, it acknowledges the ways in which this technology can diminish social ties as well as a sense of self. "Cyberintimacies slide into cybersolitudes," writes Turkle (2011, p. 16). "With constant connection comes new anxieties of disconnection."

(c) Do algorithmically driven devices restrict or enable human agency?

Schüll (2012) has explored this question in her account of the design and play of digitally networked slot machines, showing how the devices' audiovisual and algorithmic features draw players into what they call the *machine zone*, "a state in which alterity and agency recede" (2012, p. 175; see Case 1, this chapter). Ito's (2009) research on children's software likewise takes up the question of how design can format user agency in ways that are at once enabling and restrictive, as does Jablonsky's (2020) ethnography of meditation apps. A number of ethnographic studies have examined financial investing and trading in computer-mediated environments, finding that video screens and automated processes create a "postsocial" relationship between traders and the market (Knorr-Cetina & Bruegger, 2002), engendering new experiences of agency and practices of self-regulation (Zaloom, 2006; Zwick, 2012; see also Schüll, 2016b, on the affective self-management of high-stakes online poker players via an array of algorithmic tools and automated processes).

The question of how human agency might be altered by digital technology is also salient in anthropological work on self-quantification devices.[3] Viseu and Suchman note that wearable computing engineers imagine the human body as "continually emitting signs, albeit in forms inaccessible to the self that might act to maintain it" (2010, p. 175; see also Berg, 2017). Drawing on research conducted among technology developers and marketers of personal health technology, Schüll (2016a) considers how they "design self-care" into their products

in the form of motivational feedback loops and "micronudges" that reinforce certain behaviors and discourage others. As normative social expectations are embedded in tracking devices' target numbers, presentation of scores, and gami-fied incentives (Depper & Howe, 2017; Whitson, 2013), a "numerical ontology" comes to suffuse everyday practices and "the ways in which people relate to their own bodies" (Oxlund, 2012, p. 53). Smith and Vonthethoff (2017, p. 18) find it troubling that "bodily intuition is being outsourced to, if not displaced by, the medium of unbodied data." In the rhythms and temporalities of self-tracking technologies and practices, ethnographers have discerned anxiety, a loss of autonomy, and even addiction (Schüll, 2018; Lomborg et al., 2018; Pink et al., 2018).

But alongside accounts of algorithmic nudging, hooking, and dressage, anthro-pologists and the self-trackers they study insist that self-quantification can also be a generative source of agentic experience (Schüll, 2019; Jablonsky 2020). In their ethnographic study of hypoglycemia, Mol & Law (2004, p. 48) describe "the use of measurement machines to train inner sensitivity" to blood sugar levels, which they call "intro-sensing." In a more recent study, Mialet (2019, p. 379) explores the intensively mediated lives of diabetics who must cultivate the ability "to read and interpret numbers, sensations, and signs of all kinds that display information about the state of the body." Observing personal data charts and visualizations can trig-ger critical reflection and raise new questions to pursue; the data does not displace or freeze but, rather, enlivens self-narratives (Ruckenstein, 2014, p. 80), inspir-ing novel forms of self-curation (Weiner et al., 2020; Dudhwala & Larsen 2019). Schüll has emphasized how device-enabled, extended time-series analysis of self-data frees trackers from a sense of fixed, essential identity (2016a), while Sherman (2016) has described self-tracking as an aesthetic practice in which bits of the self, extracted and abstracted, become material for differently seeing and experiencing the self. Sensory ethnographers Pink and Fors (2017, p. 2) observe that the digital materiality of self-tracking technologies intimately mediates "people's tacit ways of being in the world." Neff and Nafus (2016, p. 75) describe data as a "prosthetic of feeling [that can] help us sense our bodies or the world around us." Berson (2015) shows how contemporary bodily experience is increasingly folded into digital data, and how digital data – as a particular kind of abstraction of experience – increas-ingly shapes experience and mediates human agency. "Some aspects of the self are amplified while others become reduced or restructured" (Kristensen & Ruckenstein, 2018, p. 2) – but not necessarily in a negative fashion. As will become evident in the second case of this chapter, "devices and data contribute to new ways of seeing the self and shaping self-understanding and self-expression" (p. 3).

Case I: devices of self-suspension

Since the mid-1980s in the United States, there has been a dramatic turn away from social forms of gambling, played at tables, to asocial forms of gambling, played at video terminals. Slot machines, formerly relegated to the sidelines of casino floors, today generate twice as much revenue as all "live games" put together. When machine gamblers began to present themselves in growing numbers for addiction

treatment, clinicians proposed the term "escape gambling" (as opposed to "action gambling") to characterize their experience. As players describe it, machine gambling is a solitary, absorptive activity in which they enter a dissociative state – a "zone," as they call it – in which a sense of time, space, monetary value, social roles, and sometimes even their very sense of existence dissolves. "The zone is like a magnet, it just pulls you in and holds you there," one gambler told me. "You can erase it all at the machines – you can even erase yourself," said another.

Figure 8.1 Woman playing video poker at a drugstore in Las Vegas
Source: Photo by the author.

Suspending the self

Gamblers most readily enter the zone at the point where their own actions, typically swift and repeated, become indistinguishable from the functioning of the machine. They explain this point as a kind of coincidence between their intentions and the machine's responses. "My eyes feel like they're lining up the bars on the screen – I see them turning, and then stop, like they're under my influence," said one gambler of a machine's video reels; "it's like you go around in them and you decide where to stop." Randall, a middle-aged electronics engineer, likened the experience to being "in tune" with the device, harmonically synchronized to a common beat as with a musical instrument. Another spoke of a communicative vibration: "Sometimes I feel this vibration between what I want and what happens." Although the decisive act of a gambler starts the reels spinning or the cards

flipping, the immediacy of the machine's response joins human and machine in a hermetically closed circuit of action such that the locus of control – and thus, of agency – becomes indiscernible. What begins as an autonomous act thus "becomes part of the automatic actions and reaction of the doer," as game scholar Calleja (2007, pp. 244–245) writes in his study of online digital games, resulting in "a loss of the sense of self."

In her research on children's game software, Ito (2009) explores the counterintuitive association that arises between features that give "the experience of being able to control and manipulate the production of the effect" (p. 127) and a sense of losing oneself in the game. Although such effects would seem to invite active rather than passive participation, they tend to bring about states of absorptive automaticity, blurring boundaries between players and the game. Their "unique responsiveness," she argues, "amplifies and embellishes the actions of the user in so compelling a way that it disconnects him from others and obliterates a sense of difference from the machine." As Turkle (1984) writes in her landmark study of early video games, "the experience of a game that makes an instantaneous and exact response to your touch, or of a computer that is itself always consistent in its response, can take over" (p. 87). "Conversation gives way to fusion," she comments (p. 70).

The control-lending features and interactive rhythm of the modern gambling machine endow it with a "computational specificity," to use Turkle's phrase, that makes it a particularly expedient vehicle for retreat. The clean, stripped-down circuit formed by the pulse of the random number generator, the win-or-lose binary of its determinations, the rise and decline of the credit meter that registers those determinations, the gambler's apprehension of that oscillating variation, and the rhythm of her tapping finger reduce the gambling activity to its mathematical, cognitive, and sensory rudiments. Inside the machine, payout schedules are driven by carefully calibrated algorithms that mask the disjunctive events of chance with a steady blur of small wins. At a fast enough speed, repeat players cease to register these events as discontinuous or even to distinguish them from their own inclinations. "I'm almost hypnotized into *being* that machine," a gambler named Lola told me. "It's like playing against yourself: You are the machine; the machine is you." A sense of difference from the machine is so effectively banished that the gambler's absorption becomes, for limited stretches of time, almost total.

"The key to the magic," observed the vice president of innovation for Harrah's gaming company during a presentation at a 2006 gaming expo, "is figuring out how to leverage technology to act on customers' preferences [while making] it as invisible – or what I call auto-magic – as possible, to enable experience." Designers, he elaborated, are in the business of "auto-magically making something happen by some inbound-outbound channel." When the flow of play is encumbered by extraneous or excessive stimuli, gamblers become too aware of the mechanisms operating upon them and the immersive magic of the zone is broken. Thus the most effective designs manage to minimize gamblers' awareness of the machinery that mediates their experience. "I get to the point where I no

longer feel my hand touching the machine," Randall told me. "I feel connected to the machine when I play, like it's an extension of me, as if physically you couldn't separate me from the machine."

Departing from Randall's narrative of extension, the most extreme of machine gamblers speak in terms of *exit*. An insurance agent named Isabella likened her entry into the zone to the way that characters on a science fiction television program are sucked into video screens: "On TV they express it by pulling – the bodies actually disappear into the screen and go through the games of the computer. That's what gambling on the machines correlates to: for the time that I was there, I wasn't present – I was gone." Lola likewise spoke of exiting her body and entering the machine through a kind of pulling. "You go into the screen, it just pulls you in, like a magnet. You're over there in the machine, going around in the cards." Ironically, the heightened attention that player-centric design pays to gamblers' senses and bodies – ergonomic seating and consoles that mold to natural human posture, immersive audio effects, capacitive touchscreens that respond to fingers with transactional confirmation – has the effect of diminishing their sensory and bodily awareness, suspending them in a zone where the continuity of electronic play supersedes the physical and temporal continuity of organic being.

It is not just the body of the player but also the body of the *machine* that withdraws into the background during play, even as its console, screen, and game processes continue to enable the zone state. "The machine isn't even really there," Julie explained. "It starts out the machine and then it's the cards – choosing which cards to keep – and then it's the game, just playing the game." The initial alterity of the machine, along with the initial agency of the card-choosing player, dissipates in the zone of play. "The physical machine and the physical player do not exist," writes Turkle (1984, p. 70); players do not act on the game, but *become* the game. The moment when this happens is the moment when gamblers enter the zone – a state in which alterity and agency recede.

Suspending social exchange

The tuning out of our worldly choices, contingencies, and consequences in the zone of machine gambling depends on the exclusion of other people. "In live games," Julie observes, "you have to take other people into account, other minds making decisions . . . you can't get into their minds, you can't push their buttons – [you can only] sit back and hope and wait." As in life, in "live" card play she occupies a position of dependent uncertainty towards others. By contrast, the immersive zone of machine play offers a reprieve from the nebulous and risky calculative matrix of social interaction, shielding her from the monitoring gaze of others and relieving her of the need to monitor them in return. Lola, who is a buffet waitress and mother of four, describes this reprieve as a kind of vacation:

If you work with people every day, the last thing you want to do is talk to another person when you're free. You want to take *a vacation from people.*

> With the machine there's no person that can talk back, no human contact or involvement or communication, just a little square box, a screen.

Machine gamblers frequently associate their preference for the asocial, robotic procedure of machine play with the hypersociality demanded by their jobs – in real estate, accounting, insurance, sales, and other service fields. An accountant named Josie told me,

> All day long I have to help people with their finances and their scholarships, help them be responsible. I'm selling insurance, selling investments, I'm taking their money – and I've got to put myself in a position where they will believe what I'm selling is *true*. After work, I have to go to the machines.

There, she finds respite from the incessant actuarial practices and interpersonal pressures that her vocation entails: "I was safe and away – nobody talked to me, nobody asked me any questions, nobody wanted any bigger decision than if I wanted to keep the king or the ace."

"The machines were like heaven," remembers Patsy, a welfare officer, "because I didn't have to talk to them, I just had to feed them money." In the simplified, mechanical exchange with gambling machines, she removes herself from the complicated and often insurmountable needs and worries of others, to a point where she herself becomes robotlike, impervious to human distress and her own ability – and inability – to assuage it. "The exchange wasn't messy like a human relationship," Sharon tells me of her video poker play in the course of recounting a difficult romantic breakup.

> The machine got my money, and in return I got isolation and a chance to make hands. The interaction was clean cut, the parameters clearly defined – I decided which cards to keep, which to discard, *case closed*. All I had to do was pick YES or NO, and I knew, when I pressed those buttons, that I would get the desired response that I needed.

Addicts of gambling machines invariably emphasize their desire for the uncomplicated, "clean cut" exchanges machines offer them – as opposed to relationships with other humans, which are fraught with demands, dependencies, and risks. "At the machines I felt safe," Sharon remembers, "unlike being with a person. I may win, I may lose; if I lose, that's the end of the relationship. It's understood, part of the contract. Then it starts again, fresh." Machine gamblers enter a kind of safety zone in which choices do not implicate them in webs of uncertainty and consequence; digitally formatted, choices are made without reference to others and seemingly impact no one. This mode of choice making at once distills the autonomy of the responsible, entrepreneurial self and unravels it, for behavior is no longer self-maximizing, risk-taking, and competitive but, rather, self-dissolving, risk-buffering, and asocial.

Machine life

As a sense of social ties and self fall away, so too does a sense of money value and temporal duration. "In my life before gambling," Patsy tells me,

> money was almost like a God – I had to have it. But with the gambling, money had no value, no significance, it was just this thing – just get me in the zone, that's all. . . . You lose value, until there's no value at all. Except the zone – the zone is your God.

Like money, time in the zone becomes a kind of credit whose value shifts in line with the rhythms of machine play; gamblers speak of *spending* time, *salvaging* it, *squandering* it. Randall comments: "I go into a different time frame, like in slow motion . . . it's a whole other time zone." In the zone, he experiences time as event-driven rather than clock-driven, elastic rather than rigid. While they may remain for 17 hours or even whole weekends at machines, the "clock time" (as they call it) by which those long stretches are measured "stops mattering," "sits still," is "gone" or "lost."

"I was like the walking dead," Patsy remembers. "I went through all the motions, but I wasn't really living, because I was always channeled, super-tunnel vision, to get back to that machine." "Awake, my whole day was structured around getting out of the house to go gamble," echoes Sharon. "At night, I would dream about the machine – I'd see it, the cards flipping, the whole screen. I'd be playing, making decisions about which cards to keep and which to throw away." The game interface structures her waking life and dream life with its unending flow of minute "decisions."

As we have seen, a complicated relationship exists between the technologically mediated mini-decisions that compose machine gambling and the ever-proliferating choices, decisions, and risks that selves face in free-market society. The activity narrows the bandwidth of choice, shrinking it down to a limited universe of binary rules, a formula. Although choices are multiplied, they are digitally reformatted as a self-dissolving flow of repetitive action that unfolds in the absence of "choosing" as such. In this sense, it is not the case that gambling addicts are *beyond* choice but that choice itself, as formatted by machines, becomes the medium of their compulsion. Sharon told me:

> Most people define gambling as pure chance, where you don't know the outcome. But at the machines I do know: either I'm going to win, or I'm going to lose. . . . I don't care if it takes coins, or pays coins: the contract is that when I put a new coin in, get five new cards, and press those buttons, I am allowed to continue.

Counterintuitively, what gamblers seek through their engagements with gambling machines is a zone of reliability, safety, and affective calm that removes

them from the volatility they experience in their social, financial, and personal lives. "It's one of the few places I'm certain about anything. If you can't rely on the machine, you might as well be in the human world where you have no predictability either." Although the activity deals in chance, it holds worldly contingencies in a kind of abeyance by immediately resolving bets with the quick press of a button, admitting gamblers into an otherwise elusive zone of certainty.

Case 2: devices of self-cultivation

While people have long used simple, analog devices to record, reflect upon, and regulate their bodily processes, use of time, moods, and even moral states (here we can list mirrors, diaries, scales, wristwatches, thermometers, or the lowly "mood ring"), the past decade has seen a dramatic efflorescence in individuals' use of digital technology to gather information about themselves through mobile apps and networked devices, convert this information into electrical signals, and run it through algorithms programmed to reveal insights and, sometimes, inform interventions into their future behavior.

Figure 8.2 Robin Barooah on stage at QS 2013, explaining his data timeline

Source: Screenshot from video of presentation, publicly available at http://vimeo.com.66928697.

The Quantified Self collective has been a key ethnographic site for examining this "new intimacy of surveillance," as the anthropologist Berson (2015, p. 40) characterizes it. Since its 2008 founding by Gary Wolf and Kevin Kelly, both former editors of *Wired* magazine, the group has facilitated online forums and live meetups where members gather to reflect on what they might learn from data-gathering devices and analytical software about the mundane mysteries, dynamics, and challenges of their day-to-day lives – drug side effects, sleep disorders, and the association between diet and productivity (Barta & Neff, 2016; Dudhwala, 2018; Greenfield, 2016, Neff & Nafus, 2016; Sharon & Zandbergen, 2016). "QS is one of the few places where the question of why data matters is asked in ways that go beyond advertising or controlling the behaviors of others," write Nafus and Sherman (2014, p. 1788). In the two scenes I present below (drawn from research at an annual QS meeting), I emphasize the theme of self-fashioning.

Discussing the data

After the 400-odd conference attendees had settled in their seats in the airy main hall of an Amsterdam hotel for a weekend of presentations and discussions, Gary Wolf took the stage to open the proceedings with a question: What exactly is a quantified self? Clearly, "quantification" involved collecting and computing data about ourselves, but "self," he ventured, was a more ambiguous term. How to understand the self in quantified self? What happens to the self when we quantify it – when "computing comes all the way in"?

Later that day, a breakout session on the theme of data tracking and identity commenced with a related set of questions posed by its convener, Sara Watson, a self-tracker and tech writer who had recently completed a master's thesis (2013) on QS practices: *What does it mean to have data about myself – a digital, binary representation of myself? And what is my relationship to that representation – what does it mean to be a human interacting with it?* Whitney Boesel, who regularly contributed thought-provoking pieces to the blog Cyborgology, suggested that digital self-data served as material for self-narratives: "we make stories about ourselves from the data, to make sense of our lives." Some in the room pushed back, wanting to preserve the facticity of data as expressing an objective truth: data was not some "made up" story; if anything, QS *de*narrativized the self.

Joshua, a bearded venture capitalist in his early 30s from California, elaborated on this idea:

> The self can be overwhelming as an integrated, whole thing. By doing QS, you can disaggregate various aspects of self, work on just those, maybe let them go, put them back in . . . It takes an incredible burden off you when you can take these small slices out and say, all that other stuff is complicated, let's just look at this.

Robin, a British technology designer now working in Silicon Valley, interjected to reinforce this point:

> Tracking isn't additive – it's *subtractive*: you work on some question about yourself in relation to this machine-produced thing and you know that it will stop; afterward, you're left with a narrower range of attributions you can make about your behavior or your feelings; you have eliminated uncertainty and gained a kind of liberation – you can move on with your life, with a new perspective.

If this extractive, subtractive, bitifying process was a form of self-narration, Joshua proposed, then we should call it "quantitative autobiography."

Joerg, a German activist whose background in business and philosophy complemented his pursuit of a data-based ethics in the corporate world, further specified the term "narrative" as it pertained to self-quantification: "Numeric expressions of ourselves are inherently syntactic, not semantic." The power of self-data lay in the relational grammar that emerged across its data points – not in the authorial intentions of "transcendent phenomenal selves" storying themselves forth. While self-quantification departed from traditional humanist modes of narrative, that did not make it dehumanizing; rather, it was vital, enlivening.

An American anthropologist employed at a leading technology firm suggested that art, rather than narrative, might be a better metaphor to describe what selves do with their data. "Maybe tracking is like sketching yourself," mused another participant in the session. "You have to fill in the details, it's a kind of self-portrait, an art." Robin nodded in agreement. He remarked that he had once characterized his tracking as a kind of "digital mirror" but now felt the metaphor to be inaccurate, "because mirrors represent a whole, projected image – which is not what we get from our data bits." Returning to the earlier point he and Joshua had made, he suggested that the value of data points tracked in time is the narrowness of the representation they provide: "Data is really just numbers, symbols – it doesn't reflect back something that already exists in the world as a mirror does; instead it shows us a model of some limited, extracted aspect of ourselves." Robin had come to prefer the metaphor of self-portraiture: "What we're doing when we track and plot our data is focusing in on one part of our lives and slowly building up that portrait as we collect data on it."

Sara, the moderator, pressed the group to further specify the metaphor: If not photo-realistic, was the portrait expressionist? Impressionistic? Pixelated? "I think it would have to be an algorithmic mosaic, with shifting composition, color, and patterns, an ever-changing portrait," Robin suggested. "But in what way does it change?" asked a fellow tracker, voicing some ambivalence over his relationship to his data.

> I only look at bits and pieces of myself because it's all I can handle. If it's a portrait, then it's a portrait with really bad lighting . . . Isn't the point, ultimately, to shine a brighter light on ourselves? Does the portrait ever gain fuller resolution, become more solid, more like a true mirror?

Joerg posed the question as a tension between self-making and self-unmaking: "If you start breaking yourself down piece by piece, it could lead to *non-self*, disaggregation, seeing ourselves as a big stream of data . . . Or can it, somehow, make us feel more solid as selves in the world?" Robin ventured that there was no contradiction between self-making and unmaking: "I think they're consistent views really. If self-quantification, *breaking ourselves down into bits*, enables us to create new experiences of ourselves, then those experiences are gateways to new degrees of freedom in how to act." The kind of digital portraiture at stake in the Quantified Self, he suggested, "allows you to imagine new types of self and move in new directions; you are no longer trapped in a limited set of pathways."

Time-series selves

Eric Boyd, a mechanical engineer known in the QS community for designing pendants that flash in time with wearers' heartbeats and vocal cadence, delivered a show and tell on the second day of the conference, sharing insights into the "daily rhythms" gleaned from his (since-discontinued) Nike Fuelband, a rubber-ized accelerometer worn on the wrist. He admitted being drawn to the "geeky bling factor" of the consumer gadget and its colorful, sequentially blinking lights, but was otherwise unimpressed. "The graphs on the app are pretty but mostly use-less; you can't even tell what time of day things happened. It was super frustrating how non-visible my activity was." The analytic features provided for users obfus-cated their activity as so many inscrutable "fuel points" – a measure of activity proprietary to Nike.

Wanting to examine his daily patterns more closely, Eric interfaced with the Fuelband's object-oriented programming language to feed the raw values from the accelerometer into a spreadsheet, rendering one cell for every minute of the day and one column for every day of the month: "1440 rows by 30 columns – that's a lot of data showing what I was doing when." He was able to see when he woke up at night to visit the bathroom, and that his usual brisk pace became slower when walking with his girlfriend. Her walking speed was something of an issue in their relationship, he admitted, "and it helped to see that it was actually only 30 percent slower." "The reason you begin tracking your data is that you have some uncertainty about yourself that you believe the data can illuminate," Eric told me. "It's about introspection, reflection, seeing patterns, and arriving at realizations about who you are and how you might change." His "introspection" commences not with a turn inward but a turn outward to the streaming data of a device: an extraction of information, a quantification, a visualization.

"You may not gain any knowledge in a week or even a month," said Eric, "but over time you might see something significant about yourself; you need a view that's longer than whatever moment you're in." A few years ago, out of concern for climate change, he decided to track his driving habits. He knew how many miles he was putting on his vehicle but was not certain which of his routines – going to work, going on road trips, going out socializing – was most significant. "So I tracked every single car trip for around three months and then I put it all into

an Excel spreadsheet, with different destinations into categories to see what was driving my miles." He learned that his daily trips to work, only a few kilometers away, were the major contributor to his mileage.

> My work was only around 3.5 km, so I hadn't thought it would be significant – but it added up because I would do it around two times a day, and often I would have to circle around the block to find parking. So the accretion of those little trips added up to at least as much as the road trips and the socializing.

By engaging data and its technologies to assist in his self-inquiry, Eric does not lose agency so much as he finds a new kind of agency. "In our physical world," he explains,

> our powers only extend a few meters – but in the temporal dimension we're extremely effective, we're actually going to live a billion moments or some-thing like that. The trouble for us is that it's difficult for us to see the amount of power we have in time because our sense of time is so limited; we go through life one minute at a time.

Data tracking and time-series analysis "give a longer view of our power in time" by showing how our habits – "the things we're doing over and over" – add up to affect our lives in positive and negative ways. Through tracking, Eric has come to regard himself as a "time-series self," one whose truth and consequences are not fixed but made of small actions over which he has some measure of control; he finds this vantage liberating and empowering.

In archived sequences and sums of bitified life, quantified selfers seek to bring to awareness the lived syntax – the patterns and rhythms that define their existence and that might, without digital tools, remain uncertain forces below the threshold of perception. "You set up this kind of external person or version of yourself, an avatar or companion – or something," said a tracker during Watson's breakout session in Amsterdam, recalling Foucault's (1997, p. 211) characterization of self-care as "establishing a relationship of oneself with oneself." "I had arrived at a place where it was necessary to start relation to myself," a QS member told two anthropologists (Kristensen & Ruckenstein, 2018, p. 9).

Trackers are often dismissed in popular literature as life avoiding and roboti-cally inclined; as victims of data capitalism and its surveillance apparatus; or as symptomatic figures of neoliberal subjectivity and its self-mastering, entre-preneurial ethos. Certainly, this diagnosis applies to many who use self-tracking technology. Yet the QS participants examined here are better regarded as pio-neers in the art of living with and through data. Inviting digital tools and episte-mologies to partake in their self-transformational ethics, they gain new methods

for apprehending, knowing, and inhabiting their lives – and, potentially, for resisting the governing logics that would seek to drive their conduct down certain pathways.

Conclusion

Although the aforementioned cases are exceptional in the sense that one concerns extreme machine gamblers and the other extreme self-trackers, together they demonstrate how common it has become in late capitalist societies for selves to enlist digital devices and algorithms to manage or shift their intimate self-states and ways of being in the world. But the cases' commonality goes further than a shared investment in technological self-modulation. While it is true that their respective ethnographic particulars reveal radically different aims and ends – self-exit on the one hand, self-transformation on the other – it is also true that both cases can be understood as reactions to the same broader pressures on selves.

Scholars of neoliberal society locate the source of these pressures in the diminished governmental regulation and increased demand for self-regulation that have characterized neoliberal society since the 1970s. Responsible citizens of contemporary neoliberal society are expected to "capitalize on existence itself through calculated acts and investments" (Rose, 1999, p. 164), evaluating life choices through a financialized vocabulary of "incomes, allocations, costs, savings, even profits." Yet, more often than not, they proceed without the knowledge, foresight, or resources that would enable them to be the maximizing, vigilant, actuarial virtuosi of self-enterprise they are exhorted to be.

Despite the evident cross purposes of the protagonists in the two cases presented here, they are responding to the same double bind. It is not simply that slot machine gamblers seek self-exit while quantified selfers seek creative self-transformation, for both sets of actors, in the face of an impossible demand to continually manage themselves in a field of uncertainty, express a wish to *bypass the self* in some measure – whether by escaping it altogether in a digitally configured "machine zone" or by outsourcing aspects of self-making to digital devices and algorithms.

In machine gambling, aspects of life central to contemporary capitalism – competitive exchange between individuals, money as the chief symbol or form of this exchange, and the market-based temporal framework within which it is conducted and by which its value is measured – are suspended, along with the social expectation for self-maximizing, risk-managing behavior. The activity achieves this suspension not by transcending or canceling out these elements and expected modes of conduct but by digitally intensifying them to the point where they turn into something else. Although machine gambling would seem to multiply occasions for the kinds of risk taking and choice making demanded of subjects in contemporary capitalist societies, in fact it contracts the scope and stakes of risks and choices into a digitized, programmatic, more automated

form. Gambling has very real consequences in players' daily lives, yet within the moment-to-moment process of repeat play, *inconsequentiality* holds sway. In the smooth zone of machine play, risky choices become a means for tuning out the worldly decisions they would ordinarily concern; every choice becomes a choice to continue the zone.

The self-trackers in Case 2 have a different wish in relation to the mandate for self-management: theirs is not to escape but to fulfill the expectation of responsible self-management – and yet they, too, turn to machinic forms of sensing and intelligence in this quest. It would be inaccurate to describe their relationship to digital devices as toxic for, in binary code, they find a means for new autobiographical agency and the ability to abide worldly temporality and contingencies.

While the two cases could certainly be mobilized to serve opposing sides of the well-worn debate over the effects of digital technology on human life (supportive or undermining of self-expression and identity formation, strengthening or weakening or social ties, restrictive or enabling of agency), their juxtaposition reveals in each an immanent critique of the same impossible mandate for responsible selfhood.

Notes

1 For an exhaustive review of ethnographic literature on digital media published prior to 2010, see Coleman, 2010.
2 For a review of the anthropological literature around communication technology prior to 2012, see Broadbent, 2012.
3 For a review of the anthropological literature on mobile health technology and digital self-tracking, see Ruckenstein & Schüll, 2017.

References cited

Alinejad D. 2019. Careful co-presence: The transnational mediation of emotional intimacy. *Social Media + Society* 5(2).

Ansari A, Klinenberg E. 2015. *Modern Romance*. New York: Penguin Press.

Barta K, Neff G. 2016. Technologies for sharing: Lessons from quantified self about the political economy of platforms. *Information, Communication & Society* 19: 518–31.

Barassi V. 2020. Datafied times: Surveillance capitalism, data technologies and the social construction of time in family life. *New Media & Society* 22(9): 1545–60.

Baym NK. 2010. *Personal Connections in the Digital Age*. Cambridge, UK: Polity.

Berg M. 2017. Making sense of sensors: Self-tracking and the temporalities of wellbeing. *Digital Health* 3: 1–11

Berson J. 2015. *Computable Bodies: Instrumented Life and the Human Somatic Niche*. New York: Bloomsbury Academic.

Boellstorff T. 2008. *Coming of Age in Second-Life*. Princeton: Princeton University Press.

boyd d. 2014. *It's Complicated: The Social Lives of Networked Teens*. New Haven: Yale University Press.

Broadbent, S. 2012. Approaches to Personal Communication. In *Digital Anthropology*, eds. H. Horst and D. Miller, 127–45. London: Berg

Burrell J. 2012. *Invisible Users: Youth in the Internet Cafes of Urban Ghana*. Cambridge, MA: MIT Press.

Calleja G. 2007. Digital game involvement: A conceptual model. *Games and Culture* 2: 236–60.

Calvão F. 2019. Crypto-miners: Digital labor and the power of blockchain technology. *Economic Anthropology* 6: 123–34.

Chan AS. 2008. Slashdot.org. In *The Inner History of Devices*. Ed. Sherry Turkle. Cambridge, MA: MIT Press.

Chen JY, Sun P. 2020. Temporal arbitrage, fragmented rush, and opportunistic behaviors: The labor politics of time in the platform eEconomy. *New Media & Society* 22(9): 1561–79.

Coleman B. 2010. Ethnographic approaches to digital media. *Annual Review of Anthropology* 39: 1–19.

Costa E. 2018. Affordances-in-practice: An ethnographic critique of social media logic and context collapse. *New Media & Society* 20(10): 3641–56.

Depper A, Howe P. 2017. Are we fit yet? English adolescent girls' experiences of health and fitness apps. *Health Sociology Review* 26(1): 98–112.

Dibbell J. 2007. The life of the Chinese gold farmer. *New York Times Magazine*, June 17: 36–40.

———. 2008. The Chinese game room: Play, productivity, and computing at their limits. *Artifact* 2(3): 1–6.

Doron A. 2012. Mobile persons: Cell phones, gender and the self in north India. *The Asia Pacific Journal of Anthropology* 13(5): 414–33.

Dudhwala F. 2018. Redrawing boundaries around the self: The case of self-quantifying technologies. In *Quantified Lives and Vital Data: Exploring Health and Technology through Personal Medical Devices*. Eds. R Lynch, C Farrington. London: Palgrave Macmillan.

Dudhwala F, Larsen, LB. 2019. Recalibration in counting and accounting practices: Dealing with algorithmic output in public and private. *Big Data & Society* 6(2).

Duguay S. 2019. 'Running the numbers': Modes of microcelebrity labor in queer women's self-representation on Instagram and Vine. *Social Media + Society* 5(4).

Frampton JR, Fox J. 2018. Social media's role in romantic partners' retroactive jealousy: Social comparison, uncertainty, and information seeking. *Social Media + Society* 4(3).

Foucault M. 1997. Self writing. In *Ethics: Subjectivity and Truth*. Ed. P Rabinow. New York: The New Press.

Gershon I. 2010. *Breakup 2.0: Disconnecting Over New Media*. Ithaca: Cornell University Press.

———. 2018. Calling the irrational unmanageable neoliberal self. In *A Networked Self and Love*. Ed. Z. Papacharissi. 1st ed., 12–30. New York: Routledge.

Golub A, Lingley K. 2008. "Just like the Qing empire": Internet addiction, MMOGs, and moral crisis in contemporary China. *Games and Culture* 3(1): 59–75

Goodwin I, Griffin C, Lyons A, McCreanor T, Barnes, HM. 2016. Precarious popularity: Facebook drinking photos, the attention economy, and the regime of the branded self. *Social Media + Society* 2(1).

Greenfield L. 2016. Deep data: Notes on the n of 1. In *Quantified: Biosensing Technologies in Everyday Life*. Ed. D Nafus. Cambridge, MA: MIT Press.

Gregg M. 2011. *Work's Intimacy*. Cambridge, UK: Polity Press.

Harris A, Kelly SE, Wyatt S. 2014. Autobiologies on YouTube: Narratives of direct-to-consumer genetic testing. *New Genetics and Society* 33: 60–78

Hellman M, Karjalainen SM, Majamäki M. 2017. 'Present yet absent': Negotiating commitment and intimacy in life with an excessive online role gamer. *New Media & Society* 19(11): 1710–26.

Humphrey C. 2009. The mask and the face: Imagination and social life in Russian chat rooms and beyond. *Ethnos* 74(1): 31–50.

Ito M. 2009. *Engineering Play: A Cultural History of Children's Software*. Cambridge, MA: MIT Press.

Ito M, Okabe D, Matsuda M. 2005. *Personal, Portable, Pedestrian: Mobile Phones in Japanese Life. Personal, Portable, Pedestrian: Mobile Phones in Japanese Life*. Cambridge, MA: The MIT Press.

Jablonsky, R. 2020. Mindbending: An Ethnography of Meditation Apps in an Age of Digital Distraction. PhD diss., Rensselaer Polytechnic Institute.

Kenny E. 2016 'Phones mean lies': Secrets, Sexuality, and the subjectivity of mobile phones in Tanzania. *Economic Anthropology* 3(2): 254–65.

Kent R. 2020. Self-tracking health over time: From the use of Instagram to perform optimal health to the protective shield of the digital detox. *Social Media + Society* 6(3).

Knorr-Cetina K, Bruegger U. 2002. Traders' engagement with markets: A post social relationship. *Theory, Culture and Society* 19(5–6): 161–85.

Kristensen D, Ruckenstein M. 2018. Co-evolving with self-tracking technologies. *New Media & Society* 20(10): 3624–40.

Kuehn KM. 2016. Branding the self on yelp: Consumer reviewing as image entrepreneurship. *Social Media + Society* 2(4).

Lavrence C, Cambre C. 2020. 'Do I look like my selfie?': Filters and the digital-forensic gaze. *Social Media + Society* 6(4).

Lee SS-J. 2013. Race, risk, and recreation in personal genomics: The limits of play. *Medical Anthropology Quarterly* 27(4): 550–69.

Lomborg S, Thylstrup NB, Schwartz J. 2018. The temporal flows of self-tracking: Checking in, moving on, staying hooked. *New Media & Society* (20)12: 4590–607.

Madianou M, Miller D. 2011. *Migration and New Media: Transnational Families and Polymedia*. London: Routledge.

Majamäki M, Hellman M. 2016. When sense of time disappears—Or does it? Online video gamers' time management and time apprehension. *Time & Society* 25(2): 355–73.

Malaby T. 2009. *Making Virtual Worlds: Linden Lab and Second Life*. Ithaca, NY: Cornell University Press.

McVeigh-Schultz J, Baym NK. 2015. Thinking of you: Vernacular affordance in the context of the microsocial relationship app, Couple. *Social Media + Society* 1(2).

Mialet, H. 2019. Becoming the other. *The Routledge Handbook of Language and Science*. Ed. D.R. Gruber and L. C. Olman. Abingdon: Routledge.

Miller D, Slater D. 2000. *The Internet in Trinidad: An Ethnographic Approach*. Oxford: Berg.

Mol A, Law J. 2004. Embodied action, enacted bodies: the example of hypoglycaemia. *Body and Society* 10: 43–62.

Nafus D, Sherman J. 2014. This one does not go up to 11: The quantified self movement as an alternative big data practice. *International Journal of Communication* 8: 1784–94.

Nardi B. 2010. *My Life as a Night Elf Priest: An Anthropological Account of World of Warcraft*. Ann Arbor: University of Michigan Press.

Neff G, Nafus, D. 2016. *Self-Tracking*. Cambridge, MA: MIT Press.

Oudshoorn N. 2011. *Telecare Technologies and the Transformation of Healthcare*. Hound-mills, UK: Palgrave Macmillan.

Oxlund B. 2012. Living by numbers: The dynamic interplay of asymptotic conditions and low cost measurement technologies in the cases of two women in the Danish provinces. *Suomen Antropology* 37: 42–56.

Pearce C. 2009. *Communities of Play: Emergent Cultures in Multiplayer Games and Virtual Worlds*. Cambridge, MA: MIT Press.

Petre C. 2018. Engineering consent: How the Design and marketing of newsroom analytics tools rationalize journalists' labor. *Digital Journalism* 6(4): 509–27.

Pink S, Fors V. 2017. Being in a mediated world: Self-tracking and the mind-body-environment. *Cultural Geographies* 24(3): 375–88.

Pink S, Lanzeni D, Horst H. 2018. Data anxieties: Finding trust in everyday digital mess. *Big Data & Society* 5(1).

Raval N. 2020. Hisaab-Kitaab in Big Data: Finding relief from calculative logics. In *Lives of Data: Essays on Computational Cultures from India*. Ed. S. Mertia, 128–35. Amsterdam: Institute of Network Cultures.

Reed A. 2005. My blog is me: texts and persons in UK online journal culture (and anthropology). *Ethnos* 70(2): 220–24.

Rettberg JW. 2014. *Seeing Ourselves Through Technology: How We Use Selfies, Blogs and Wearable Devices to See and Shape Ourselves*. New York: Palgrave Macmillan.

Roberts ST. 2019. *Behind the Screen: Content Moderation in the Shadows of Social Media*. London: Yale University Press.

Rose N. 1999. *Powers of Freedom: Reframing Political Thought*. Cambridge: Cambridge University Press.

Ruckenstein M. 2014. Visualized and interacted life: Personal analytics and engagements with data doubles. *Societies* 4: 68–84.

Ruckenstein M, Schüll N. 2017. The datafication of health. *Annual Review of Anthropology* 46: 261–78.

Schüll ND. 2012. *Addiction by Design: Machine Gambling in Las Vegas*. Princeton: Princeton University Press.

———. 2016a. Data for life: Wearable technology and the design of self-care. *BioSocieties* 11(3): 317–33.

———. 2016b. Abiding chance: Online poker and the software of self-discipline. *Public Culture* 28(3): 563–92.

———. 2018. Digital containment and its discontents. *History of Anthropology* 29(1): 42–8.

———. 2019. The data-based self: Self-quantification & the data-driven (good) life. *Social Research International Quarterly* 86(4): 909–30.

Scolere L, Pruchniewska U, Duffy, BE. 2018. Constructing the platform-specific self-brand: The labor of social media promotion. *Social Media + Society* 4(3).

Senft T. 2008. *Camgirls: Celebrity and Community in the Age of Social Networks*. New York: Peter Lang.

Sharon T, Zandbergen D. 2016. From data fetishism to quantifying selves: self-tracking practices and the other values of data. *New Media & Society* 19(11): 1695–709.

Shaw A. 2014. *Gaming at the Edge Sexuality and Gender at the Margins of Gamer Culture*. Minneapolis, MN: University of Minnesota Press.

Sherman J. 2016. Data in the age of digital reproduction: Reading the quantified self through Walter Benjamin. In *Quantified: Biosensing Technologies in Everyday Life*. Ed. D. Nafus. Cambridge, MA: MIT Press.

Smith GJD, Vonthethoff, B. 2017. Health by numbers: Exploring the practice and experience of datafied health. *Health Sociology Review* 26: 6–21.

Sutton, Theodora. 2020. Digital harm and digital addiction: An anthropological view. *Anthropology Today* 36(1): 17–22.

Taylor TL. 2006. *Play Between Worlds: Exploring Online Game Culture*. Cambridge, MA: MIT Press.

———. 2018. *Watch Me Play: Twitch and the Rise of Game Live Streaming*. Princeton: Princeton University Press.

Tembeck T. 2016. Selfies of ill health: Online autopathographic photography and the dramaturgy of the everyday. *Social Media + Society* 2(1).

Turco CJ. 2016. *The Conversational Firm: Rethinking Bureaucracy in the Age of Social Media*. New York: Columbia University Press.

Turkle S. 1984. *The Second Self: Computers and the Human Spirit*. New York: Simon & Schuster.

———. 1995. *Life on the Screen: Identity in the Age of the Internet*. New York: Simon & Schuster.

———. 2011. *Alone Together: Why We Expect More from Technology and Less from Each Other*. New York: Basic Books.

———. 2015. *Reclaiming Conversation: The Power of Talk in a Digital Age*. New York: Penguin Press.

Twigt MA. 2018. The mediation of hope: Digital technologies and affective affordances within Iraqi refugee households in Jordan. *Social Media + Society* 4(1).

Udwan G, Leurs K, Alencar A. 2020. Digital resilience tactics of Syrian refugees in the Netherlands: Social media for social support, health, and identity. *Social Media + Society* 6(2).

van Dijck J. 2013. 'You have one identity': performing the self on Facebook and LinkedIn. *Media, Culture & Society* 35(2): 199–215.

Venkatraman S. 2017. *Social Media in South India*. London: UCL Press.

Viseu, A, Suchman, L. 2010. Wearable augmentations: Imaginaries of the informed body. In *Technologized Images, Technologized Bodies*. Eds. J Edwards, P Harvey, P Wade. New York: Berghahn Books.

Watkins SC, Cho A. 2018. *The Digital Edge: How Black and Latino Youth Navigate Digital Inequality*. New York: New York University Press.

Watson, S. 2013. Living with data: Personal data uses of the quantified self. MPhil, University of Oxford.

Weiner K, Will C, Henwood F, Williams R. 2020. Everyday curation? Attending to data, records and record keeping in the practices of self-monitoring. *Big Data & Society* 7(1).

Wesch M. 2009. YouTube and you: Experiences of self-awareness in the context collapse of the recording Webcam. *Explorations Media Ecology* 8(2): 19–34.

Whitson JR. 2013. Gaming the quantified self. *Surveillance Society* 11: 163–76.

Wilson J, Chivers-Yochim E. 2017. *Mothering Through Precarity: Women's Work and Digital Media*. Durham, NC: Duke University Press.

Zaloom C. 2006. *Out of the Pits: Traders and Technology from Chicago to London*. Chicago, IL: University of Chicago Press.

Zhongxuan L. 2018. Paradoxical empowerment and exploitation: Virtual ethnography on internet immaterial labour in Macao. *Journal of Creative Communications* 13(1): 1–16.

Zwick D. 2012. Online investing as digital virtual consumption: The production of the neoliberal subject. In *Digital Virtual Consumption*. Ed. M Molesworth, J Denegri-Knott. New York: Routledge.

Part III

Politicizing digital anthropology

9 Digital politics

John Postill

The growing use of digital media by political actors of all kinds – politicians, jour-nalists, activists, celebrities, religious leaders, etc. – has spawned a bourgeoning literature, albeit one that is highly diverse and split along disciplinary and topical lines. The term 'digital politics' only began to acquire academic currency in the early 2010s. This signalled a rapidly growing scholarly interest in both the digiti-sation of the political field and in the politicisation of the digital realm. A forerun-ner to this umbrella term was 'internet politics', with a number of textbooks under this rubric appearing in the mid-2000s (including Chadwick 2006; Chadwick and Howard 2008; Oates et al. 2006). A good example of the recent terminological shift is Coleman and Freelon's (2015) *Handbook of Digital Politics*, which fea-tures sections on digital politics theories, collective action and civic engagement, and government and policy, among others.

Chadwick's (2013, 2017) concept of 'the hybrid media system' has been par-ticularly influential. This is the simple but powerful idea that our current media environments are a combination of old and new media technologies, practices and actors interacting in complex, non-teleological ways. Chadwick argues that the political sphere is increasingly dominated by those individuals, groups, and organisations best able to 'strategically blend older and newer media logics' (2013: 204). The encounter between these contrasting media logics, he suggests, can sometimes cause confusion and disorder, yet it also creates 'new patterns of integration' (2013: 209). For instance, 'techno-political nerds' (my term, not Chadwick's, see later and Postill 2018) such as Assange and Snowden chose to partner with the *Guardian* and other established media in order to amplify their whistleblowing campaigns, thus producing a mutually beneficial outcome (Chad-wick and Collister 2014, see also Di Salvo 2017). In turn, such collaborations had a profound effect on the international media landscape (Karatzogianni 2015), with some scholars positing the emergence of a 'networked fourth estate' (e.g. Benkler 2011; Russell and Waisbord 2017).

Other communication scholars have also investigated, like Chadwick, the var-ious forms of expertise that go into the practical repertoires of digital politics agents. For instance, Kubitschko (2015) describes how Germany's Chaos Com-puter Club (CCC), a hacker organisation funded in 1981, proved that comput-erised voting was unsafe. In doing so, they not only politicised a technological

issue but also attained a 'concrete change in democratic procedure,' that is, the scrapping of e-voting. CCC activists used a rich media repertoire to engage with diverse publics through 'ongoing communicative action.' Over time, they developed a set of 'interlocking arrangements' with politicians, journalists, judges, and other digital stakeholders through 'multilayered media practices' resulting in a virtuous cycle of cooperation (2015: 399). For his part, Hussain (2014) analyses the role of policy entrepreneurs in the promotion of internet freedom. These 'political technologists' played key roles in the 2011 protest movements in the Arab world and elsewhere, creating 'new norms about digital infrastructures' (see also O'Maley 2015, 2016). Similarly, elsewhere I have written about the involvement of 'freedom technologists' – a term I later replaced with 'techno-political nerds', or 'techpol nerds' for short – in the new protest movements, with Iceland, Tunisia, and Spain as the case studies (Postill 2014). These are societal actors at the intersection of technology and politics who believe the fates of democracy and the internet are inextricably entwined (see later).

Adapting and updating an earlier scheme by Chadwick (2006), we can speak of four main subareas of study: digital government (executives and bureaucracies), digital democracy (community, deliberation, participation), digital campaigning (parties, candidates, elections), and digital mobilisation (interest groups and social movements). This chapter starts with four brief review sections under precisely these labels. The subsequent sections exemplify the application of an anthropological approach to the study of digital politics. Drawing from my own fieldwork in Malaysia, Spain, and Indonesia as well as on the secondary literature, I argue that anthropology brings to the nascent field of digital politics a rich lexicon, processual analyses, and the ability to conjure up political worlds.

Digital government (executives and bureaucracies)

One of the more influential early introductions to the study of digital government is Fountain's (2001) *Building the Virtual State*, which explores the relationship between new internet technologies and institutional change within government agencies in the United States. Fountain argues that the US bureaucracy must modernise and move towards a more decentralised system, yet one that can still guarantee citizens' right to privacy. The system's 'structural obsolescence' presents, however, a formidable obstacle. Researchers working in Europe and Asia have similarly reported a wide chasm between the visions and realities of digital government. Thus in the early 2000s Malaysia's e-government flagship sought to 'improve the convenience, accessibility and quality of interactions with citizens and businesses' (Yong 2003: 189). The vision was, and remains, 'for government, businesses and citizens to work together for the benefit of the country and all its citizens' (2003: 190). In practice, however, officials report poor digital practices and a resistance to ICT integration throughout the Malaysian public sector (Karim and Khalid 2003: 81–87) – a finding familiar to researchers studying e-government projects in Europe (see Kubicek et al. 2003).

More recently, Janowski (2015) has proposed a four-stage evolutionary model of digital government consisting of digitisation, transformation, engagement, and contextualisation. Other scholars place their hopes in the transition from e-government to m-government, based on mobile platforms, particularly in the global South where 'last mile connection' infrastructure is often lacking (Kuscu et al. 2008; Narayan 2007; Nica and Potcovaru 2015). They see m-government as a way of bridging the digital divide, especially in rural areas of Africa and South Asia, creating a world in which citizens will have 'anytime, anywhere access' to public services (Alrazooqi and De Silvia 2010; see also Isagah and Wimmer 2018).

Digital government scholarship is hampered by its commitment to what Green et al. (2005) have called 'the imperative to connect' – an urge that they encountered during anthropological research into publicly funded digital projects in Manchester, UK. The overriding ambition on the part of ICT managers and staff was to link European projects across divides of geography, language, culture, and organisation. The aim was not to create virtual spaces but rather 'new networks of located connection' (2005: 817), a vision animated by a 'fantasy of . . . "flattened" connection' (2005: 817) that overlooked the constraints, tangles, and disconnects that invariably accompany such endeavours (see Strathern 1996).

Digital democracy (community, deliberation, participation)

If the key digital government metaphor is connectivity, the field of digital democracy has at its core the concept of 'public sphere', associated with the social philosopher Jürgen Habermas. A public sphere is '[a]n arena, independent of government [and market] . . . which is dedicated to rational debate and which is both accessible to entry and open to inspection by the citizenry. It is here . . . that public opinion is formed' (Holub, quoted in Webster 1995: 101–102). Despite Habermas's insistence that his concept of public sphere referred to a particular phase in European history, for many authors the public sphere has become a normative ideal (Benson 2009; Chadwick 2006). Thus, Dahlberg (2001) has evaluated the citizen-led initiative Minnesota e-Democracy, built around an email list forum, against five predefined public sphere criteria: autonomy from state and market, reciprocal critique, reflexivity, sincerity, and discursive inclusion. Like the term community (see later) or indeed connectivity, public sphere is used both as a 'rhetorical token' (Benson 2009: 175) and as a normative notion that guides research away from what is, and towards what *ought to be*. Instead of this romantic ideal Chadwick (2008) argues for new approach to democracy where 'a plurality of different sociotechnical values and mechanisms' can find their place, taking advantage of the low entry threshold and ease of use of Web 2.0 tools.

For his part, Carty (2010) explores the potential of digital media in the development of new ways of mobilisation, participatory democracy, and civic engagement. This requires leaving behind earlier models of mobilisation based on face-to-face communication, taking the logic of digital technologies on its own terms. Roberts

Khiabany 2010) and NGO technological activism (McInerney 2009) – a list to which we could add ethnographies of internet-mediated war (Bräuchler 2005), mobile phones and village politics (Tenhunen 2008), and local e-governance (Hinkelbein 2008; Strauss 2007). More recently, Coleman and Kelty (2017) co-edited an issue of the journal *Limn* on the proliferation of 'hacks, leaks, and breaches' across the contemporary political landscape. They ask whether hackers and hacking 'have crossed a techno-political threshold' and to what extent, if at all, these practices and actions are 'transforming our world, creating new collectives, and changing our understanding of security and politics'. The rise of hacktivism exemplified by Anonymous, they contend, signals as much a cultural and political change as it does a technological one. At the same time, though, the 'complex tools, techniques and infrastructure[s]' of hackers have not fundamentally changed.

In the following sections I draw from my own digital politics work of the past sixteen years to exemplify three key anthropological strengths. First, anthropology brings to the table a rich political lexicon developed over decades of cross-cultural research and theorisation around the globe. Second, political anthropology has a long tradition of 'following the conflict' (Marcus 1995) that is still highly pertinent to today's digitally mediated struggles. Third, ethnographic research lends itself to the conjuring up of political worlds hitherto unknown or underexplored. I shall now consider each of these strengths in turn.

Case study 1: online activism

A rich political lexicon

Subang Jaya and its sister township, USJ, make up a largely middle-class, ethnic Chinese suburb of Kuala Lumpur, in Malaysia. The Subang Jaya municipal council (MPSJ) was established in 1997. Two years later, in 1999, the new council faced the first in a long series of challenges from residents' groups when it raised local taxes by 240 per cent. This episode gave rise to a type of 'banal activism' that has predominated in Subang Jaya ever since – an activism led by technology-savvy residents who use the rhetoric of 'community' to campaign on issues such as taxation, traffic congestion, waste disposal, school provision, and local crime. These issues would seem mundane to the urban intelligentsia in Kuala Lumpur or to the young anti-globalisation activists in Barcelona studied by Juris (2008), but they are crucial to suburban parents embarked on family-building projects.

From 2003 to 2004 I conducted fieldwork in Subang Jaya, followed by intermittent online research from Britain until 2009 and a brief visit in 2010. I found a plethora of digital projects during my stay, ranging from a multimedia library and a 'cybermosque' to several web forums and a township-wide 'smart community' initiative. On returning to the UK my initial attempt at placing these various initiatives along a community-network continuum (with community-like initiatives at one end and network-like initiatives at the other) soon foundered. Eventually I realised that I had fallen into the community/network trap that lies at the heart

of Internet Studies (Postill 2008, 2011). The trap consists of reducing the plurality and flux of social and political formations that one invariably finds in contemporary localities (e.g. peer groups, cohorts, associations, gangs, clans, sects, mosques, factions, families, action committees, mailing lists, Facebook groups, Twitter hashtags) to a crude community vs. network dichotomy. This originates in the misguided idea that our 'local communities' are being impacted upon by a global network society and by that 'network of networks' known as the internet.

In search of a way out of this impasse, I revisited the early work of Gluckman, Turner, Epstein, and other members of the Manchester School of Anthropology. I also found unexpected links between this ancestral literature and more recent anthropological explorations (e.g. Amit and Rapport 2002; Gledhill 2000) as well as signs of a renewed interest in their pioneering studies (Evens and Handelman 2006). The Manchester scholars conducted fieldwork in a very different part of the world (British Central Africa) and under radically different historical conditions: the end of empire. Yet the conceptual issues they confronted were strikingly similar to those I was struggling with after returning from post-colonial Malaysia. The problem boils down to how to study a locality under conditions of rapid social and political change when 'tribal', regional, linguistic, and other groupings appear to be in flux and new kinds of affiliations and social formations are being constantly made and remade. Faced with such fluid actualities on the ground, the Manchester scholars moved away from the then predominant structural-functionalist paradigm and towards historical-processual accounts informed by new concepts such as 'field', 'ego-centred network', 'social drama', and 'arena'.

In my book *Localizing the Internet* (Postill 2011) I synthesise this approach with the equally historical and processual field-theoretical model developed by Bourdieu, best demonstrated in his *Rules of Art* (1996). Rather than positing the existence of a 'local community' being impacted upon by global networks, I discuss how variously positioned field agents and agencies in Subang Jaya (residents, politicians, committees, councillors, journalists, and others) compete and cooperate over matters concerning the local residents, often via the internet. I call this dynamic set of projects, practices, technologies, and relations 'the field of residential affairs'. This can be described as a digital field in that the set of social relations and practices that sustain it are inextricably entangled with digital technologies such as email, mailing lists, web portals, online forums, blogs, and mobile phones.

Like Epstein (1958) in his late 1940s fieldwork in Northern Rhodesia's mining areas, I found that processes of change were unevenly spread across Subang Jaya's field of residential affairs, with some regions of the field changing more rapidly than others. For example, the fight against crime is an ecumenical issue that has brought together people and agencies from across the governmental divide in the township. Crime prevention initiatives led by residents have received governmental support and mass media coverage and undergone considerable technological development, including new mobile applications. By contrast, a nationwide campaign to reinstate local elections made no lasting impact.

Besides having two or more main sectors, typically a field of residential affairs will exhibit both 'stations' and 'arenas' (the latter are described later). Adapting

Giddens' (1984: 119) notion of 'stations', I will define 'field stations' as those 'stopping places' in which field agents interact with other agents, ideas, and technologies on a regular basis, an interaction that in turn (re)produces the station. Examples would include a leading resident's daily tweets on local issues, a politician's weekly surgery, or the regular public meetings of a parish council. For a local leader, a regular presence in such settings is an essential part of maintaining good working relations with allies and supporters. Similarly, a prolonged absence from such stations is likely to undermine a leader's position within the field of residential affairs, a domain suffused with metaphors of co-presence, collaboration, and rootedness.

So far the picture of the field I have painted is one of Giddensian routinisation – the predictable cycles of political agents as they go about coordinating their activities and (re)producing their practices in clock-and-calendar time (Postill 2002). But to complete the picture we must also consider those irregular, often unpredictable patterns of collective action that disrupt the regular schedules of a field of practice. In other words, we need to 'follow the conflict' (Marcus 1995).

Following the conflict

Today we associate field theory with Bourdieu, whose analytical preference is for the slow-moving, cumulative changes that take place within a field (Swartz 1997: 129; Couldry 2003), not for potentially volatile processes such as court trials or popular uprisings that often migrate *across* fields. The Parisian salons, brasseries, and courthouses of Bourdieu's *Rules of Art* provided him with a fixed spatial matrix of objective relations – the socio-physical backdrop to a slowly changing field of practice (Bourdieu 1996: 40–43).

Political processes were, in fact, central to the collaborative work of the Manchester School, whose field theories predate Bourdieu's by many years. By political process they meant that kind of social process that is 'involved in determining and implementing public goals [as well as] in the differential achievement and use of power by the members of the group concerned with those goals' (Swartz et al. 1966: 7). One key Manchester School concept is 'social drama'. Coined by Victor Turner, a social drama is a political process that originates within a social group but can spread across a wider inter-group field unless appropriate 'redressive action' is taken (Turner 1974: 128–132). Social dramas undergo four stages: (1) breach, (2) crisis, (3) redressive action, and (4) either reintegration or schism.

The Subang Jaya digital drama I wish to recount revolved around a seemingly banal issue: the building of a food court. As the theory predicts, the conflict was triggered by a perceived breach of the regular norms governing relations between two local parties, in this case the residents versus the municipal council.

Breach. The drama began when a local activist named Raymond Tan announced online that construction of a food court had begun on land earmarked for the building of a police station in the crime-ridden suburb. He urged local residents to cast their vote on an online poll created to solicit their reactions. The following

day another leading activist, Jeff Ooi, replied suggesting that there may be some-body in the council promoting food courts. The fact that the land was reserved for a police station made the issue 'even fishier'.

Crisis. Within a few days the discussion had spread to a number of local list-servs. Raymond encouraged residents to feed the politicians' responses to their texting campaign back to the mailing list, or alternatively to either of two local portals. The following day, Jeff Ooi sent subscribers of all five mailing lists a citizen journalism item he had recently posted on the portal's news section. The piece chided the members of parliament and assemblymen for their inaction. It then noted the absence of the mandatory project notice board at the building site. This remark resonates with reports of local activism from elsewhere. Faced with powerful interests, people around the world 'have quickly invented resourceful means of resistance' (Abram 1998: 13).

Later that day, Raymond used both the web forum and five mailing lists to announce the recent formation of an action committee. He listed the names and affiliations of the pro tem committee members, with himself at the helm and a close associate as his right hand. The other eleven members were recruited from across the field of residential affairs. As we can see, the campaign was spear-headed not by an imaginary 'community' but rather by a subset of Raymond's local contacts in the shape of a small action committee. This improvised com-mittee is best described as an 'action-set', that is, a set of individuals mobilised to attain a specified goal who will disperse when that goal is either reached or abandoned (Mayer 1966; Turner 1974).

Within twenty-four hours, Raymond's deputy informed forum subscribers that the campaign to lobby local politicians via SMS had 'resulted in jolting each and every one of them into action'. He appended a list of politicians and their reac-tions to the texted messages, which ranged from 'full support' to a promise to 'look into the matter'. Here we can see clearly Turner's (1974) notion of 'arena' at work through a new technological articulation, that between internet and mobile media. In an arena, nothing must be left unsaid; all actors drawn into the drama ('jolted into action') must state publicly where they stand on the dispute at hand.

Redressive action. The climax of the drama came when the deputy home min-ister paid a visit to Subang Jaya and promised to resolve the dispute. This redres-sive move by the authorities was promptly reciprocated by the local activists, who were only too eager, as one of them put it, to 'complete the cycle' of the campaign. To this end, the action committee deputy leader circulated a message asking resi-dents to show their elected representatives their gratitude via SMS.

Reintegration? Yet only two months after these auspicious events, fresh rumours began to circulate online that the operator was planning to resume con-struction of the food court. Soon thereafter the local council approved the pro-ject, and physical work resumed at the site. Raymond's reaction was unequivocal: 'Friends and neighbours, are we going to allow these clowns [to] push the FOOD court down our throats?' There is no space here to discuss the subsequent unfold-ing of events, which included a highly unusual offline arena, namely a public hearing. The police station was eventually completed after a five-year struggle.

This digital drama demonstrates the limitations of the community/network paradigm for the study of internet localisation (Postill 2008). By broadening out the analysis from the neighbourhood domain to the wider field of residential affairs, we gained an understanding of local leaders' individual and collective agency, relations with other local agents, and their multiple uses of digital media at a critical point in the suburb's history.

The crisis spread virally, spilling over into the powerful fields of federal government and the mass media through the deft use of a range of digital media by an unprecedented alliance of residents' groups. The ensuing drama reveals the field's dynamics of factionalism, alliance-building, and technological mediation, as well as its entanglements with powerful neighbouring fields at a given point in time.

Case study 2: nerd politics

Conjuring up political worlds

Another anthropological strength is our ability to conjure up for ourselves and our readers new social and political worlds out of a mass of chaotic 'field materials' and impressions. Unlike fellow world-makers like novelists, poets, or scriptwriters, though, after taking this imaginative leap we then have to empirically substantiate our claim that such a world is not merely a figment of our imagination, and that we have indeed 'been there'. Nowadays this often occurs through an alternation of on-the-ground and 'remote' ethnography, via telematic media such as Skype or live streaming (see Gray 2016; Postill 2017).

Thus, in my recent book *The Rise of Nerd Politics* (Postill 2018) I posit the existence of a global 'nerd politics world' that has been 'hiding in plain sight' for the past forty years. This claim was a long time in the making. It was the outcome of a long and messy hermeneutic process involving a vast set of disparate materials not only from my two main field sites – Barcelona and Jakarta – but also from the secondary literature on places as diverse as Rio de Janeiro, San Francisco, Reykjavik, Tunis, and Taipei.

By combining four key notions I was able to bring onto the page and explore in writing this dynamic political world, namely the[1] term 'nerd politics' (which I borrowed from the Canadian sci-fi author Cory Doctorow),[2] my own notion of 'techpol nerds',[3] the idea that these nerds operate in four main spaces, or 'subworlds', of political praxis and, finally,[4],[5] Strauss' (1978) classic notion of 'social world'. Let me briefly unpack these notions in turn.

In May 2012, Cory Doctorow wrote a piece in the *Guardian* titled 'The problem with nerd politics'.[6] This came in the wake of successful campaigns against intellectual property legislation that technology 'nerds' saw as curtailing digital freedoms,[7] as well as fresh electoral gains by the nerdy Pirate Party in Germany. Doctorow entreated his fellow nerds not to seek tech solutions to political problems, but rather to 'operate within the realm of traditional power and politics' and defend the rights of 'our technically unsophisticated friends and neighbours' (ibid.).

It is unclear what effect, if any, this call to arms had across the world of nerd politics. What we can say with certainty is that this social universe has continued to

expand in the intervening years since Doctorow's article. This expansion includes the space of formal politics, which the Pirate parties and other nerd formations have managed to penetrate in recent times. The rise of nerd politics has, in fact, been a global trend hiding in plain sight for many years now, a trend crying out for an explanation. Since the late 2000s, the international media have covered many instances of it, including Anonymous's war on Scientology, WikiLeaks' Cablegate leaks, the Arab Spring, Spain's *indignados*, the Occupy movement, Edward Snowden's revelations about the US National Security Agency (NSA), and Russian and British meddling with the 2016 Trump campaign.

But so far we have lacked a common narrative to bind together these seemingly disparate events. Uniting all of them, I suggest in the book, is the pivotal role played by a new class of political actors I call 'techno-political nerds' – or simply 'techpol nerds'. By this I refer to people who operate at the intersection of technology and politics and who care deeply about the fate of democracy in the digital age. Far from the Western stereotype of geeks and nerds as young, white, socially awkward males, these women and men come in many different shapes, sizes, and colours. While some are indeed computer experts – Julian Assange and Edward Snowden spring to mind – many wouldn't be able to write a line of code or hack a computer to save their lives. Their interest in technology is mediated by other forms of expertise, such as law, art, media, politics, and even anthropology. Thus, I found that not all forms of knowledge are born equal in the world of nerd politics. Five forms in particular (computing, law, art, media, and politics, or 'clamp' for short) are valued above all others. Activists launching, say, a digital rights campaign, a data activism initiative, or a nerdy political party require not only computing skills but also legal, artistic, media, and political skills. It follows that nerd politics is not so much 'hacker politics' (see Coleman and Kelty 2017) as *clamper* politics. These nerds are clamping up, so to speak, on corruption, corporate abuses, internet censorship, and other perceived political malaises of the digital age. In other words, they are applying a diverse range of interdisciplinary skills to tackle a range of political problems, both digital (e.g. campaigning against a draconian internet bill) and non-digital (e.g. co-launching a social uprising with other political actors).

In order to answer the question of who these nerds were, I first had to find out what they actually did. However, an early attempt at mapping their social practices, as is customary today in anthropology (Postill 2010), came to nought. There were simply too many practices to consider, and it was not clear which were the 'core' practices (Postill 2015). Another failed attempt was to compile an annotated bibliography under the rubric of 'freedom technologists' (my earlier term for techpol nerds) on my research blog.[8] This yielded over seventy pages of text but little in the way of enlightenment.

The breakthrough came when I retraced the steps of some of my research participants, the Barcelona-based activists Xnet. This group is unusual for its high degree of nerd politics nomadism, but it is precisely this characteristic that helped me map this dynamic world. When I first met the group, in the summer of 2010, they were but a few years old and had been active exclusively within the *digital rights space* – a space of political action in which nerds fight for digital freedoms

and abide by the maxim that 'digital rights are human rights'. In early 2011 Spain's major parties ignored the protestations of Xnet and other net freedom activists and signed an unpopular anti-online 'piracy' bill into law. Xnet responded to this perceived betrayal by migrating to the *social protest space*. They did this supporting and joining the fledgling protest platform Democracia Real Ya! (DRY, Real Democracy Now!) which called for mass marches on 15 May 2011 to demand 'real democracy'. This switch from digital politics to politics writ large amounted to a Turnerian 'schism' (Turner 1974) between Spain's nerds and its now discredited political class. The marches were well attended and led directly to the indignados, or 15M, movement.

Exactly a year later, in May 2012, in front of a large crowd gathered at Barcelona's Catalunya Square to mark the first anniversary of the 15M movement, the group announced a new crowdfunded campaign named 15MpaRato. Their five-year goal was to bring to justice Rodrigo Rato and other senior bankers responsible for the collapse of Bankia, one of Spain's leading financial institutions. Xnet urged prospective whistleblowers to leak data on Bankia to a secure website they had set up for this purpose. In other words, Xnet were now moving into the *data activism space*. The maxim animating this space is that ordinary people should empower themselves by using digital data to hold the powerful accountable for their actions. This is what Keane (2009) would call a 'monitory democracy' ideal. In early 2013, Xnet migrated once again to another corner of the nerd politics world. This time they relocated to the *formal politics space*, where they registered a new political party called Partido X to campaign in the European elections of 2014, inspired by hacker principles and practices. When the party failed to secure any seats in the European Parliament, the group went through a period of soul-searching that eventually led them back to the *data activism space* in 2016. There they wrote and directed the 'data theatre' play *Become a Banker*, based on their 15MpaRato leaks, which earned them critical and popular acclaim. In late 2017 Xnet re-entered the *social protest space* when they became involved in Catalonia's independence referendum. This entailed, among other things, taking to task a major unionist newspaper from Madrid, *El País*, for unfairly accusing the regional government of violating the data privacy of its own citizens.

Xnet holds a special place in my eight-year struggle to understand the rise of nerd politics, for it was precisely their unusually nomadic trajectory that revealed to me the invisible external and internal boundaries of the nerd politics world. These boundaries may be porous and imperceptible to the human eye, but they are as empirically real as a herd of elephants or a parliamentary building. Xnet provided me with a map of Spain's techno-political terrain that I then applied to case studies from Indonesia, Brazil, Iceland, Tunisia, Taiwan, and the United States – as well as globally. The map was a revelation: the same four-cornered, dynamic geometry found in Spain helped to explain the limits and possibilities of nerd politics elsewhere, including on a global scale.

As I was nearing completion of the book, I found by chance a classic text by the sociologist Anselm Strauss (1978) on the concept of 'social world' that captured

perfectly the political universe I had conjured up. This author quotes Shibutani (1955) to define social worlds as 'culture areas' bounded not by formal membership or territory but rather 'by the limits of effective communication'. The diversity and scale of 'discernible worlds' found around the planet, argues Strauss, is virtually limitless (Strauss 1978: 121). While some social worlds are international, others are local; some are large, others are small; some are well established, others emergent; some are hierarchical, others egalitarian. These social universes, he concludes, 'won't and can't stand still' (1978: 123).

A social world perspective, argues Strauss (1978: 120), can help us understand sociocultural change. He gives the example of the 'explosive social world' of tennis. In the 1970s, this sport was experiencing rapid worldwide growth, as suggested by several indicators, including the total number of amateur and professional practitioners, the size of its live and TV spectator crowds, and a much greater mainstream visibility, which entailed, among other things, the 'management of celebrity careers'. There are striking echoes here of the contemporary world of nerd politics explored throughout the book. Like tennis in the 1970s, or indeed European green politics in the 1980s (Burchell 2014), nerd politics is experiencing a boom in the 2010s, including a worldwide proliferation of crowd-powered teams and causes, a rapidly growing track record of successes and failures, and the emergence of nerd celebrities such as Assange and Snowden around high-profile media events.

Strauss (1978: 123) writes that social worlds are inherently hard to study because most 'seem to dissolve, when scrutinised, into congeries of subworlds'. This allowed me to understand the significance of the uneven timing of the nerd politics splintering into four subworlds: while data activism and digital rights are older subworlds (or spaces) that already started differentiating in the 1980s, the social protest and formal politics spaces are more recent outgrowths, taking their present shape as late as the 2010s. I also discovered that while all four subworlds are driven by participants' deep concern about the present and future of democracy in the digital age, each subworld pivots around a different democratic ideal. This was a surprising finding that emerged inductively, in classic anthropological fashion (see Postill 2012), towards the end of the book's writing process. Where the data activism space has monitory democracy as its core ideal, digital rights has liberal democracy, social protest has assemblary democracy, and formal politics has participatory democracy. There are significant differences, however, in the extent to which each ideal is embraced within a given space. Thus whereas monitory and participatory democracy are both ecumenical ideals that raise few hackles among nerds, both liberal democracy and assemblary democracy are always problematic, contested ideals.

Conclusion

To recapitulate, I have suggested that digital politics is an emerging interdisciplinary research area whose practitioners are as interested in the digitisation of politics as they are in the politicisation of the digital. Indeed, both processes

are often hard to tell apart in reality. Four overlapping subareas can be distinguished: digital government, digital democracy, digital campaigning, and digital mobilisation.

With their long-standing interest in power and politics (Gledhill 2000; Kurtz 2018) and more recent turn towards the study of the digital (see the Introduction to this volume), anthropologists have a great deal to contribute to the study of digital politics. In this chapter I have drawn from my own anthropological work over the past sixteen years to single out three significant contributions: an extensive political vocabulary drawn from political cultures around the globe, an ethnographic penchant for 'following the conflict', and a well-honed ability to imaginatively bring to life political worlds.

As the world becomes more unruly, polarised, and unpredictable, anthropologists and their research participants working on digital politics face greater legal and physical risks. One urgent task for anthropologists is to go beyond our 'liberal' comfort zones and help bridge the current ideological rift between pro-democracy progressives and conservatives so that, together, we can take on the extremists and autocrats.

Acknowledgments

The Malaysian research reported here was funded by the Volkswagen Foundation through Bremen University. The cross-cultural nerd politics research was financed by the Open University of Catalonia and RMIT University, Melbourne. I am very grateful to these organisations for their support. I also wish to thank the book editors for their helpful feedback on early drafts of this chapter. The Malaysian materials are adapted from my book *Localizing the Internet: An Anthropological Account* (Berghahn Books, 2011) and the nerd politics ones from *The Rise of Nerd Politics* (Pluto Press, 2018).

Notes

1 In this and subsequent subheadings I have retained Chadwick's helpful explanatory keywords in brackets, e.g. 'executives and bureaucracies'.
2 It is telling of the ethnographic method that the political anthropologist Alexander T. Smith (22 May 2006) and I independently coined the term 'banal activism' within a few months from each other, in Smith's case whilst conducting fieldwork among Conservative Party supporters in Scotland.
3 Bill Flanders and Anthony Briggs are also pseudonyms (see Arnold et al. 2008).
4 Not without privately registering the irony of using software developed by the Swedish Pirate Party in order to exclude their Catalan comrades from the directory.
5 On the diffusion of viral information through the political blogosphere, see Nahon et al. (2011).
6 See www.theguardian.com/technology/2012/may/14/problem-nerd-politics.
7 This legislation included the Stop Online Piracy Act (SOPA) in the United States, Anti-Counterfeiting Trade Agreement (ACTA) in Europe, and the Trans-Pacific Partnership across Asia-Pacific and the Americas.
8 https://johnpostill.com/2015/09/07/23-freedom-technologists-bibliography/.

References cited

Abram, S. 1998. 'Introduction', in S. Abram and J. Waldren (eds.), *Anthropological Perspectives on Local Development*, 1–17. London and New York: Routledge.

Alrazooqi, M. and R. de Silvia. 2010. 'Mobile and Wireless Services and Technologies for m-Government', *WSEAS Transactions on Information Science and Applications*. www.wseas.us/e-library/transactions/information/2010/88-120.pdf.

Amit, V. and N. Rapport. 2002. *The Trouble with Community*. London: Pluto.

Arnold, M., C. Shepherd and M. Gibbs. 2008. 'Trouble at Kookaburra Hollow: How Media Mediate', *The Journal of Community Informatics* 3(4). (Consulted June 2010). www.ci-journal.net/index.php/ciej/article/view/329/380.

Benkler, Y. 2011. 'A Free Irresponsible Press: WikiLeaks and the Battle over the Soul of the Networked Fourth Estate', *Harvard Civil Rights-Civil Liberties Law Review* 46, 311–397.

Benson, R. 2009. 'Shaping the Public Sphere: Habermas and Beyond', *The American Sociologist* 40(3), 175–197.

Bimber, B. and R. Davis. 2003. *Campaigning Online: The Internet in U.S. Elections*. Oxford: Oxford University Press.

Bourdieu, P. 1996. *The Rules of Art: Genesis and Structure of the Literary Field*. Cambridge: Polity Press.

Bräuchler, B. 2005. *Cyberidentities at War: Der Molukkenkonflikt im Internet*. Bielefeld: Transcript.

Burchell, J. 2014. *The Evolution of Green Politics: Development and Change within European Green Parties*. London: Routledge.

Carty, V. 2010. *Wired and Mobilizing: Social Movements, New Technology, and Electoral Politics*. London: Routledge.

Castells, M. 2001. *The Internet Galaxy*. Oxford: Oxford University Press.

———. 2009. *Communication Power*. Oxford: Oxford University Press.

Chadwick, A. 2006. *Internet Politics: States, Citizens and New Communications Technologies*. New York: Oxford University Press.

———. 2008. 'Web 2.0: New Challenges for the Study of E-Democracy in Era of Informational Exuberance', *I/S: A Journal of Law and Policy* 5, 9.

———. 2013. *The Hybrid Media System: Politics and Power*, 1st edition. Oxford: Oxford University Press.

———. 2017. *The Hybrid Media System: Politics and Power*, 2nd edition. Oxford: Oxford University Press.

Chadwick, A. and S. Collister. 2014. 'Boundary-drawing Power and the Renewal of Professional News Organizations', *International Journal of Communication* 8, 2420–2441.

Chadwick, A. and P.N. Howard. 2008. *Routledge Handbook of Internet Politics*. New York: Routledge.

Chadwick, A. and J. Stromer-Galley. 2016. 'Digital Media, Power, and Democracy in Parties and Election Campaigns: Party Decline or Party Renewal?', *The International Journal of Press/Politics* 21(3), 283–293.

Coleman, G. 2010. 'Ethnographic Approaches to Digital Media', *Annual Review of Anthropology* 39, 487–505.

Coleman, G. and C. Kelty. 2017. 'Preface: Hacks, Leaks, and Breaches', *Limn* 8, February. https://limn.it/preface-hacks-leaks-and-breaches/.

Coleman, S., and D. Freelon (eds.). 2015. *Handbook of Digital Politics*. Cheltenham: Edward Elgar Publishing.

Costanza-Chock, S. 2008. 'The Immigrant Rights Movement on the Net: Between "Web 2.0" and Comunicacion Popular', *American Quarterly* 60(3), 851–864.

Cornfield, M. 2005. *The Internet and Campaign 2004: A Look Back at the Campaigners.* Washington, DC: Pew Internet & American Life Project (Consulted 2 February 2021). www.pewinternet.org/pdfs/Cornfield_commentary.pdf.

Couldry, N. 2003. 'Media Meta-Capital: Extending the Range of Bourdieu's Field Theory', *Theory and Society* 32(5–6), 653–677.

Dahlberg, L. 2001. 'Extending the Public Sphere through Cyberspace: The Case of Minnesota E-Democracy', *First Monday* 6(3). (Consulted 2 February 2021). http://first monday.org/issues/issue6_3/dahlberg/

Di Salvo, P. 2017. 'Hacking/Journalism', *Limn* 8, February. https://limn.it/articles/hacking journalism/.

Doostdar, A. 2004. 'The Vulgar Spirit of Blogging: On Language, Culture, and Power in Persian Weblogestan', *American Anthropologist* 106(4), 651–662.

Epstein, A. L. 1958. *Politics in an Urban African Community.* Manchester: Manchester University Press.

Evens, T.M.S. and D. Handelman (eds.). 2006. *The Manchester School: Practice and Ethnographic Praxis in Anthropology.* Oxford: Berghahn Books.

Fountain, J.E. 2001. *Building the Virtual State: Information Technology and Institutional Change.* Washington, DC: Brookings Institution Press.

Gerbaudo, P. 2018. *The Digital Party: Political Organisation and Online Democracy.* London: Pluto Press.

Giddens, A. 1984. *The Constitution of Society.* Cambridge: Polity Press.

Gledhill, J. 2000. *Power and Its Disguises: Anthropological Perspectives on Politics.* London: Pluto Press.

Graham, T., D. Jackson and M. Broersma. 2016. 'New Platform, Old Habits? Candidates' Use of Twitter During the 2010 British and Dutch General Election Campaigns', *New Media & Society* 18(5), 765–783.

Gray, P.A. 2016. 'Memory, Body, and the Online Researcher: Following Russian Street Demonstrations via Social Media', *American Ethnologist* 43(3), 500–510.

Green, S., P. Harvey and H. Knox. 2005. 'Scales of Place and Networks: An Ethnography of the Imperative to Connect Through Information and Communications Technologies', *Current Anthropology* 46(5), 805–826.

Hands, J. 2010. *@ Is for Activism.* London: Palgrave Macmillan.

Hara, N. 2008. 'Internet Use for Political Mobilization: Voices of the Participants', *First Monday* 13(7), 7 July. www.uic.edu/htbin/cgiwrap/bin/ojs/index.php/fm/article/viewArticle/2123/1976.

Hindman, M. 2009. *The Myth of Digital Democracy.* Princeton, NJ and Oxford: Princeton University Press.

Hinkelbein, O. 2008. 'Strategien zur Digitalen Integration von Migranten: Ethnographische Fallstudien in Esslingen und Hannover', unpublished PhD thesis, University of Bremen, Bremen.

Howard, P.N. 2005. 'Deep Democracy, Thin Citizenship: The Impact of Digital Media in Political Campaign Strategy', *The Annals of the American Academy of Political and Social Science* 597(1), 153–170.

Hussain, M.M. 2014. 'Digital Infrastructure Politics and Internet Freedom Stakeholders After the Arab Spring', *Journal of International Affairs* 68(1), 37.

Isagah, T. and M.A. Wimmer. 2018. 'Framework for Designing m-Government Services in Developing Countries', in *Proceedings of the 19th Annual International Conference on Digital Government Research: Governance in the Data Age*, 44. London: ACM.

Janowski, T. 2015. 'Digital Government Evolution: From Transformation to Contextualization', *Government Information Quarterly* 32(3).

Juris, J.S. 2008. *Networking Futures: The Movements Against Corporate Globalization.* Durham, NC: Duke University Press.

Karatzogianni, A. 2015. *Firebrand Waves of Digital Activism 1994–2014.* London: Palgrave Macmillan.

Karim, M.R.A. and N.M. Khalid. 2003. *E-Government in Malaysia.* Subang Jaya: Pelanduk.

Keane, J. 2009. *The Life and Death of Democracy.* London: Simon & Schuster.

Kubicek, H., J. Millard and H. Westholm. 2003. 'The Long and Winding Road to One-stop Government', paper presented at an Oxford Internet Institute and Information, Communication, and Society Conference, Oxford, 18 September.

Kubitschko, S. 2015. 'Hackers' Media Practices: Demonstrating and Articulating Expertise as Interlocking Arrangements', *Convergence* 21(3), 388–402.

Kurtz, D.V. 2018. *Political Anthropology: Power and Paradigms.* London: Routledge.

Kuscu, M.H., I. Kushchu and B. Yu. 2008. 'Introducing Mobile Government', in *Electronic Government: Concepts, Methodologies, Tools, and Applications*, 227–235. Hershey: IGI Global.

Marcus, G. 1995. 'Ethnography in/of the World System: The Emergence of Multi-Sited Ethnography', *Annual Review of Anthropology* 24.

Mayer, A. 1966. 'The Significance of Quasi-Groups in the Study of Complex Societies', in Michael Banton (ed.), *The Social Anthropology of Complex Societies, ASA Monographs*, No. 4, 97–122. London: Tavistock.

McInerney, P.B. 2009. 'Technology Movements and the Politics of Free/Open Source Software', *Science, Technology, & Human Values* 34(2), 206–233.

Melucci, A. 1996. *Challenging Codes: Collective Action in the Information Age.* Cambridge: Cambridge University Press.

Morozov, E. 2011. *The Net Delusion: The Dark Side of Internet Freedom.* New York: Public Affairs.

Nahon, K., J. Hemsley, S. Walker and M. Hussain. 2011. 'Fifteen Minutes of Fame: The Power of Blogs in the Lifecycle of Viral Political Information', *Policy & Internet* 3(1), Article 2. www.psocommons.org/policyandinternet/vol3/iss1/art2.

Narayan, G. 2007. 'Addressing the Digital Divide: E-Governance and M-Governance in a Hub and Spoke Model', *The Electronic Journal on Information Systems in Developing Countries* 31(1), 1–14.

Nica, E. and A.M. Potcovaru. 2015. 'Effective M-Government Services and Increased Citizen Participation: Flexible and Personalized Ways of Interacting with Public Administrations', *Journal of Self-Governance and Management Economics* 3(2), 92–97.

Oates, S., D. Owen and R.K. Gibson (eds.). 2006. *The Internet and Politics: Citizens, Voters and Activists.* New York: Routledge.

O'Maley, D. 2015. 'Networking Democracy: Brazilian Internet Freedom Activism and the Influence of Participatory Democracy', PhD dissertation, Vanderbilt University, Nashville.

———. 2016. 'How Brazil Crowdsourced a Landmark Law', *Foreign Policy*, 19 January. http://foreignpolicy.com/2016/01/19/how-brazil-crowdsourced-a-landmark-law/.

Pew Research Center for the People and the Press. 2008. *Social Networking and Online Videos Take Off: Internet's Broader Role in Campaign 2008.* Washington, DC: Pew Research Center for the People and the Press (Consulted 30 November 2018). http://people-press.org/reports/display.php3?ReportID=384_.

Postill, J. 2002. 'Clock and Calendar Time: A Missing Anthropological Problem', *Time and Society* 251–270.

———. 2008. 'Localising the Internet Beyond Communities and Networks', *New Media and Society* 10(3), 413–431.

———. 2010. 'Introduction: Theorising Media and Practice', in B. Bräuchler and J. Postill (eds.), *Theorising Media and Practice*. Oxford and New York: Berghahn.

———. 2011. *Localizing the Internet: An Anthropological Account*. Oxford and New York: Berghahn.

———. 2012. 'Digital Politics and Political Engagement', in H. Horst and D. Miller (eds.), *Digital Anthropology*. Oxford: Berghahn.

———. 2014. 'Freedom Technologists and the New Protest Movements: A Theory of Protest Formulas', *Convergence* 20(4), 402–418.

———. 2015. 'Fields: Dynamic Configurations of Practices, Games, and Socialities', in V. Amit (ed.), *Thinking Through Sociality: An Anthropological Interrogation of Key Concepts*, 47–68. Oxford: Berghahn.

———. 2017. 'Remote Ethnography: Studying Culture from Afar', in *The Routledge Companion to Digital Ethnography*, 87–95. London: Routledge.

———. 2018. *The Rise of Nerd Politics*. London: Pluto Press.

Rafael, V. 2003. 'The Cell Phone and the Crowd: Messianic Politics in the Contemporary Philippines', *Public Culture* 15(3), 399–425.

Rheingold, H. 2002. *Smart Mobs: The Next Social Revolution*. Cambridge, MA: Perseus.

Roberts, B. 2009. 'Beyond the "Networked Public Sphere": Politics, Participation and Technics in Web 2.0', *Fibreculture Journal* 14. http://journal.fibreculture.org/issue14/issue14_abstracts.html.

Russell, A. and S. Waisbord. 2017. 'Digital Citizenship and Surveillance: The Snowden Revelations and the Networked Fourth Estate', *International Journal of Communication* 11, 21.

Schapals, A.K., A. Bruns and B. McNair (eds.). (2018). *Digitizing Democracy*. London: Routledge.

Shibutani, T. 1955. 'Reference Groups as Perspectives', *American Journal of Sociology* 60, 522–529.

Shirky, C. 2009. *Here Comes Everybody: The Power of Organizing Without Organizations*. New York: Penguin.

Smith, A. and L. Rainie. 2008. *The Internet and the 2008 Election*. Washington, DC: Pew Internet & American Life Project (Consulted 30 November 2018). www.pewinternet.org/pdfs/PIP_2008_election.pdf.

Sreberny, A. and G. Khiabany. 2010. *Blogistan: The Internet and Politics in Iran*. London: Tauris.

Strathern, M. 1996. 'Cutting the Network', *Journal of the Royal Anthropological Institute* 2, 517–535.

Strauss, A.L. 1978. 'A Social World Perspective', in N.K. Denzin (ed.), *Symbolic Interaction*, vol. 1, 119–128. Greenwich: JAI Press.

Strauss, P. 2007. 'Fibre Optics and Community in East London: Political Technologies on a "Wired-Up" Newham Housing Estate', unpublished PhD thesis, Manchester University, Manchester.

Swartz, D. 1997. *Culture & Power: The Sociology of Pierre Bourdieu*. Chicago: University of Chicago Press.

Swartz, D., V. Turner and A. Tuden (eds.). 1966. *Political Anthropology*. Chicago: Aldine Publishing Co.

Tenhunen, S. 2008. 'Mobile Technology in the Village: ICTs, Culture, and Social Logistics in India', *Journal of the Royal Anthropological Institute (N.S.)* 14, 515–534.

Turner, V.W. 1974. *Dramas, Fields and Metaphors: Symbolic Action in Human Society*. Ithaca, NY: Cornell University Press.

Venkatesh, M. 2003. 'The Community Network Lifecycle: A Framework for Research and Action', *The Information Society* 19, 339–347.

Webster, F. 1995. *Theories of the Information Society*. London: Routledge.

Yong, J.S.L. 2003. 'Malaysia: Advancing Public Administration into the Information Age', in J.S.L. Yong (ed.), *E-Government in Asia: Enabling Public Service Innovation in the 21st Century*. Singapore: Times.

10 Traversing the infrastructures of digital life

Hannah Knox

In this chapter I turn my attention to the infrastructural qualities inherent to the experience of living with contemporary digital technologies. Digital technologies, from smartphones to bitcoin, rely on infrastructural networks – from undersea cables to the hundreds of communications satellites that orbit the earth, radio communications masts, fibre-optic cables, local Wi-Fi transmitters and mobile data communications standards. Communications protocols and programming languages, also infra-structure technological devices, making the interoperability of particular platforms possible and creating the basis for contemporary ways of communicating and socialising. Moreover, not only do digital devices rely on communications infrastructures, but infrastructures of other kinds, from energy grids to global logistics, are also undergoing their own processes of digitisation. Digital infrastructure includes, therefore, not only the wires and cables that support mobile and computer communication but also the integration of sensors, databases of measurements, and real-time data analytics into buildings, motorways, ticketing services, fast food delivery, taxi services and more. Digital infrastructures in either or both of these senses are now an inherent part of contemporary life for most people in the world, and their effects on the reorganisation of social life have been profound. These digital infrastructures have provided the grounds for structural transformations in social relations, for what it is possible to know and for communication, mobility, kinship and access to resources.

Work to understand the far-reaching social dynamics of digital infrastructures has been very much an interdisciplinary undertaking, involving not only anthropologists but also scholars in media studies, art and design, science and technology studies, philosophy, geography, sociology and computer science. As we will see, one of the characteristics of studies of digital infrastructures is that understanding their political and cultural aspects often requires a blurring of disciplinary theories and methods: social scientists find themselves becoming proto-engineers; computer scientists become political theorists; and media studies scholars turn from the communicative qualities of texts to the chemicals, substances and flows that enable information to flow along fibre-optic cables or be housed in Arctic data centres. Owned and controlled by a heady mix of corporations, states, individuals and communities, digital infrastructures are often highly opaque and difficult to trace, demanding a variety of disciplinary approaches to uncover different aspects

of their reality. Indeed, understanding digital infrastructures is often said to pose such a challenge to disciplinary boundaries that in some cases it has even led to proposals to create new disciplinary formations more appropriate to the study of the human in the context of digital life.[1]

In order to traverse these interdisciplinary debates and discussions, this chapter begins with a brief overview of recent work on digital infrastructures that crosscuts these disciplinary boundaries. I group these discussions under four sub-headings: 'The network society', 'The logic and form of digital infrastructure', 'Rematerialising digital life' and 'Coding inequality'. Key texts and thinkers in each of these discussions are introduced and the social effects of digital infrastructures under each of these headings is explored. I then move on in the second half of the chapter to two case studies through which I consider, in more depth, what an anthropological approach to digital infrastructures might look like. The two cases I have chosen highlight the opacity of digital infrastructures and the challenges that this poses to studying them. The first case study looks at engagements with smart grids to show how the unboxing of digital infrastructure points to the ecological qualities of infrastructural relations. In the second case study I unpack this ecological relationality further by looking at the information infrastructures of climate science and tracing some of their effects. Here I explore how the globally distributed systems of data analysis that constitute climate science come to create a phenomenon that challenges a networked and information-communication based understanding of knowledge and its transmission, replacing it with a more modulated and emergent understanding of relations between people, data and things.

Part 1 – approaches to digital infrastructures

The network society

It is now a quarter of a century since Manuel Castells published his seminal volume *The Rise of the Network Society* (Castells 1996b). Here Castells outlined what he saw as the profound transformative effects of new networked information technologies on social, political and economic life. Following in the footsteps of earlier theorists, from Daniel Bell and his prescient 1970s description of the Information Age (Bell 1973) to Mark Poster's exploration of the 'mode' of information (1990), and Paul Virilio's *Speed and Politics* (Virilio 1986), Castells' volume gave empirical meat to the philosophical bones of media theory to argue that global networks of computation were heralding a new 'space of flows' whereby political and social inequality was being reorganised around the question of who could tap into and control those flows and who could not. Castells' work pushed back against more celebratory accounts of the benefits of the knowledge economy for post-industrial nations which had lauded the boundary-crossing communicative potential of digital technologies and their ability to create new forms of economic wealth by generating new service and creative sector jobs (Florida 2002; Negroponte 1995). In contrast, Castells highlighted the more deleterious effects

of a network society for women, the poor and non-industrial economies (Castells 1996a).

Since the publication of this volume, others have elaborated on Castells' central observation that life in the space of flows is shaped by new trajectories of power and inequality. Some have developed his work on the digital divide with further empirical detail of precisely how digital networks exclude some whilst including others (Everett 2009; Norris 2001). Others have turned to the dark side of the digital industries themselves to explore the everyday labour that sustains the new economy (English-Lueck 2002; Gershon 2017; Ross 2003). Luc Boltanski and Eve Chiapello's *New Spirit of Capitalism* (2005) is perhaps the most well-known exploration of the pernicious and exploitative effects of neoliberal principles of autonomy, freedom and creativity that have informed the organisation of digital workplaces that drive the network society, whilst Shoshana Zuboff's book, *The Age of Surveillance Capitalism* (Zuboff 2019), provides a damning diagnosis of the new lines of power established by platforms which deploy consumer analytics to describe and shape human beings in new and disturbing ways.

The logic and form of digital infrastructure

If digital technologies have been shown to have structuring effects, then this has also begged the question: why? Structural accounts describe such effects in political economic terms, focusing on access to resources, ability to generate income, levels of cultural participation and work/life balance. However, they are often silent on the more fine-grained detail of the role of cultural beliefs and social practices in shaping how and why these effects emerge and how they are sustained. If the digital economy enacts an infrastructural violence on large numbers on people (Rodgers and O'Neill 2012), then what drives the desire for more connectivity, more devices, more analytics? Dissatisfied with the idea that digital infrastructures are expressly designed to have nefarious effects or that they are the straightforward manifestation of a rapacious logic of neoliberalism, other scholars have turned their attention to unravelling the hidden logical assumptions built into digital infrastructures and the way in which these logics produce specific digital media forms and effects.

This work cuts across the tradition of science and technology studies, critical software studies and a post-structural anthropology of technology and knowledge. Adrian Mackenzie, for example, has written extensively on the relational ideas built into and extended through digital infrastructures, looking at digital infrastructures as diverse as Wi-Fi, GitHub, DNA sequencing and search engines in ways that highlight how they both enact and create particular relational assumptions about the world (Mackenzie 2006, 2011, 2017; Mackenzie et al. 2016). Mackenzie's work, which builds on a reading of pragmatist and post-structural philosophers like Gilles Deleuze and William James, surfaces the inbuilt assumptions of hardware and software engineering and brings them into conversation with the relational principles that sociologists deploy in the creation of sociological knowledge. Anthropologists have also been exploring the cultural bases

of computational processes such as the cultural ideas inscribed in robotics, automation, AI and algorithms (Castaneda and Suchman Lucy 2005; Lowrie 2018; Maurer this volume; Seaver 2015; Wilf 2013).

In a similar vein, Paul Kockelman's (2013) work on spam filters as sieves also addresses digital infrastructures from the perspective of their logical operation – in this case looking at sieving as an ontological figure that informs and shapes statistical techniques through which spam filters and search engines make their selections. Here we see a shift from a focus on the relational logics or presuppositions of digital infrastructures to a question about the ontological qualities of digital technologies. Considering digital ontologies, and indeed whether it even makes sense to suggest that digital infrastructures have 'ontological' qualities, has been explored in various recent books and journal special issues (Boellstorff and Maurer 2015; Knox and Nafus 2018; Lowrie 2018). A recent collection of *Cultural Anthropology*'s Theorising the Contemporary series, edited by myself and Antonia Walford (Knox and Walford 2016), brought together anthropologists who have been exploring questions of ontology within anthropological theory with those more influenced by media theorists, from Frederick Kittler to Lev Manovich and Jonathan Sterne, who each in their own ways have been interested in the way in which media carry in their design relational logics that both shape the future and carry with them the historical legacy of prior media forms (Kittler 1999; Manovich 2001; Sterne 2012). Attending to the specific relational qualities of media forms, these scholars work across these theoretical traditions to force analyses of the cultural dimensions of digital infrastructure towards a more hybrid analysis that brings the question of the co-constitutive role that form, matter and the imagination play in the making of digital architectures, infrastructures and software systems.

Rematerialising digital life

As the infrastructural effects of digital technologies have been shown to be not just the inevitable playing out of a logic of capital, neoliberalism or elite cultural ideas but a more hybrid kind of techno-cultural emergence, this has opened the way for much more explicit attention to be paid to the role that the materiality of digital infrastructures themselves has played in establishing the shape of the space of flows. This has moved analysis from the relational form of digital infrastructures towards questions about the politics of matter. Influenced particularly by discussions in new materialist philosophy[2] and actor-network theory[3], studies of material infrastructures of digital life have highlighted that digital infrastructures are not just mediators for the flow of information to the digitally connected but also enact social and political effects through the hidden materiality of their infrastructural form. Like the hybrid studies of digital infrastructure described in the last section, these studies find, in attention to materiality, a way of pushing back against the ephemerality conjured by the language still used to talk about digital infrastructure (the cloud, the virtual). Moreover, these studies on the materiality of digital infrastructures have begun to explore how digital life is sustained not

only by social imaginaries and cultural norms but also by the embedded histories of particular infrastructures.

In their recent edited volume *Signal Traffic*, media theorists Lisa Parks and Nicole Starosielski bring together a collection of chapters working in this vein that explore 'physical installations, objects, sites, and processes in detail, analysing industrial transitions, and probing the socio-historical conditions and power relations that give shape to particular infrastructural formations' (Parks and Starosielski 2015: 17). The volume demonstrates first how digital infrastructures are frequently historically associated with prior infrastructural forms. Starosielski's research on the undersea cables that enable the global information economy demonstrates how fibre-optic cables lie along the same trenches as telephone and electrical cables that were laid in the early 20th century and carry with them something of this geo-political history (Starosielski 2015). In other work roads are shown to be the precursors to electricity and then telephony and fibre optics (Harvey and Knox 2015; Larkin 2013), meanwhile in places that were never connected to electrical grids or paved highways, the infrastructure of digital technologies more often relies on satellite communications rather than terrestrial cables (Cross 2016). Tracing histories of digital infrastructure uncovers military-industrial relations demonstrating how 'access' to 'the internet' is not a uniform phenomenon but is rather the materialisation of specific histories of state-building, globalisation and military control that still inform the development of information infrastructures today.

Another aspect that a focus on the materiality of digital infrastructures highlights is the link between digital technologies and the environment. Vast data centres which store the information that constitutes the network society are both massive users of energy and generators of excess heat. To keep servers operating efficiently requires keeping them cool, thus data centres are frequently found in remote locations where high tech comes into direct contact with other forms of environmental existence (Holt and Vonderau 2015). In the Facebook data centre in Luleå in the north of Sweden, located both in a region of extreme cold and near a hydroelectric dam which provides a close and easy source of electricity, the security requirements of the data centre have led to new forms of environmental enclosure. Here national energy resources are fed into servicing the data needs of a global company, Facebook; meanwhile the local national park has been enclosed as part of an attempt to keep people away from the closed walls of the data centre (Vonderau 2017). In contrast, data centres in urban settings are now being identified as potential generators of useful heat, transforming the materiality of digital communication into new forms of urban power stations.

If 'the cloud' requires data centres in cold places to keep it aloft, so elsewhere in the digital supply chain environments of other kinds service the digital economy. Silicon-based processors, lithium batteries and plasma screens depend on minerals which are mined, sold and traded to create their digital effects (Parikka 2011). At the other end of the supply chain, electronic waste poses its own social and environmental problems, including the as-yet-unknown effects of environmental

contaminants most of which currently go to landfill, and the informal and undocumented e-waste industry where e-waste produced in Europe, North America and Australasia is transported to developing countries for reprocessing (Gabrys 2011).

From the mining of heavy metals to create digital devices, to the digging of deep sea trenches that make landfall in particular countries and not others, to the reliance of internet infrastructures on water, ice and oil, work on the materiality of the internet has shown that the implications of the digital age for political and economic life extends far beyond their informational qualities.

Coding inequality

If materiality has generally been taken to mean the hard matter of digital infrastructure – wires, pipes, chemicals, concrete – there is a final aspect of digital infrastructure studies that I want to address which concerns information itself as a kind of material dimension of digital data. Information and matter are often opposed to one another, but by recasting information as a form of materiality, what these studies point to is not the physical substance of digital infrastructure, but the very concrete and tangible effects that the ordering of information has on people's lives.

We have known for a long time that infrastructures have the capacity for shaping the social world – probably the most famous example being the Long Island bridges discussed by Langdon Winner, whose infrastructural effect was to exclude low-income populations from being able to use the Long Island beaches (Winner 1986). It is also now clear that digital systems of categorisation and classification are powerful world-making technologies in terms of their capacity to both organise (Bowker, Star and Press 1999) and spatialise (Kitchin and Dodge 2011) social life. Often building on Foucauldian insights into the conduct of conduct, the analysis of digital infrastructures as information infrastructures opens up an understanding of digital technologies as techniques of governmentality that not only order social relations but also constitute the very categories upon which social scientists rely to describe the social landscape. Virginia Eubanks' recent study of the use of algorithms in the American welfare system describes, for example, how the digitisation of systems which have been developed to assess the eligibility of welfare claimants has recast the question of deservedness for welfare into a calculative logic (Eubanks 2018). Those excluded from the system and cast out as not worthy of welfare payments have found themselves not only excluded but also ostracised as inappropriately non-participative members of society. Similarly Amade M'Charek's work on the technologies and practices of racial profiling has shown how attempts to informationally order racial differences has the capacity to produce and reinforce racial categories (M'Charek 2013), meanwhile Natasha Dow Schüll's work on gambling de-individualises the figure of the gambler, showing how the category of addiction is the outcome of particular kinds of designed interactions between information displays, architecture, economies and bodies (Schüll 2012).

James Bridle's recent description of the algorithms that are used to organise content on YouTube provides perhaps one of the most disturbing demonstrations of how the demands of algorithmic processing combined with revenue generation from clicks and views on online ads is constitutive of new, at times absurd, social forms (Bridle 2018). Bridle describes the creation of online content where it is becoming ever harder to easily attribute authorship of content to human beings. The deployment of informational infrastructures in the age of machine learning and artificial intelligence not only deconstructs the question of human agency but goes even further, posing profound questions about juridical concepts like responsibility (who can be held responsible for the auto-generation of dark-absurdist content clicked on by the aimless hand of a bored 2-year-old?), agency (when bots speak to bots) and literacy (what does it mean to 'know' how to proceed in the face of digital infrastructure when even the designers of systems no longer really know how recommendation systems, databases, algorithms and decision-making machines generate their interventions and exclusions?).

It is this issue of the complexity and inherent opacity of digital infrastructures that feed off ever greater repositories of data and ever more sophisticated methods of analysis of that data which makes this final area of discussion so important. As machine-learning algorithms produce results in ways that arguably no human understands; digital devices produce constant outputs of information too big for any expert or machine to analyse; and the interplay of different systems – some automated, some not – produce non-representational[4] forms that are neither truths nor untruths, we appear to be heading into what Bridle terms a 'new dark age' where the ability to be able to claim to know what we are dealing with when we interact with infrastructures, digital or otherwise, is challenged. At the same time as people are cut adrift from any possibility of really understanding the systems that organise us, they are also becoming ever more aware that these digital systems have profoundly divisive effects, and so the desire to know becomes stronger. Here we have gone far beyond the digital divide, a problem essentially of access, into a situation where poverty, racism, nationalism, violence, misogyny and gross levels of capital accumulation are sustained by and supported by opaque informational infrastructures with powerful real-world effects.

Rather than trying to resolve infrastructural opacity through either an inter-disciplinary attempt to add different kinds of knowledge together or an attempt to follow the networks of relations through which such infrastructure come into being, in the following two examples I make the case for an anthropological stance which tries to 'stay with the ambiguity'[5] of these infrastructural configurations: that is to allow the opacity of digital systems to become part of the focus of ethnographic work. The complexity of digital infrastructures is recast here not as a barrier to anthropological understanding but is instead treated as a crucial part of people's sense-making practices in the face of the relations made evident by digital infrastructures. Given that anthropology itself is also a practice of sense-making, the case studies also raise questions about the role that digital infrastructures and the data relations they sustain might play in new kinds of ethnographies of/with digital infrastructure. Ultimately I argue that the seeming ambiguity and

opacity of digital infrastructures is less an indication of our failure to trace them in their entirety and more a result of the ecological form of relationality that digital infrastructures institute as they put people, environments and things into relation in new ways. I explore this through two related examples of digital infrastructure from my own work – the emergence of digital electricity grids and the digital infrastructure of climate modelling.

Part 2: life in the digital grid

Although 'digital infrastructures' are often taken to mean the infrastructures of digital technologies, already existing infrastructural forms like roads, railways and energy systems are also undergoing processes of digitisation. Entangled with the notion of the 'internet of things', in which sensors and communications are placed in and on objects in order to make them part of an information infrastructure, material infrastructures are being informationalised and digitally augmented in ways that are producing precisely the kinds of opacities that I touched on earlier. One area where practices of infrastructural digitisation is proceeding apace is in the monitoring and management of electricity. My first case study, therefore, concerns an example of an attempt to bring digital capacities into electricity generation, distribution and supply in the UK and Europe.

For most of the 20th century, electricity in Europe and the UK has been predominantly generated by centralised power stations – powered by either coal, gas, hydroelectric dams or nuclear reactors. However, as renewable energy technologies such as photovoltaics, wind power, and air-source heat pumps have gradually become more viable, certain qualities of the power generated through these technologies has begun to pose challenges to grid infrastructure.

First, the inability to store the source upon which renewable electricity is generated poses a significant challenge to the management of the electrical grid. Coal, gas, water and even nuclear are substances than can be held in a repository, or 'standing reserve', to be burned, released or activated at will. For the grid to operate successfully, supply and demand have to be carefully balanced in real time. Whilst demand has been hard to manage, supply has remained in the control of the grid operators. In the UK's nationalised energy system that existed until the early 1990s, power generators would sell their electricity at a fixed price to the national grid, which would then provide this electricity to consumers with whom they had a contract. Failure to match up supply and demand could be catastrophic.

The possibility of being able to balance national supply and demand for electricity is central to the logical operation of a national energy grid and was a key impetus for the construction of a national grid in the first place. Having a centralised network to transport electricity from one end of the country to the other at the speed of light enabled differences in the need for electricity, geographies of production and the contingencies of unreliable equipment to be overcome. Prior to the building of the national grid in the 1920s, over 600 local power stations supplied electricity on local grids operating at different voltages to nearby businesses and homes. Power stations were located close to industrial and urban

centres where the users of electricity could be found. Electricity prices in urban areas, where industrial and domestic electricity use balanced each other out, were typically lower than for people living in rural or remote areas whose electricity suppliers did not always have a ready demand for power. With the building of the national grid, it became possible for a standardised electricity tariff to be set for all customers regardless of location. The national grid in the UK was crucial then for creating a national energy public. Wherever people lived in the country, they could expect electricity to be supplied reliably at the moment they needed it and to pay the same amount for it as people living elsewhere.

One of the major challenges posed by renewable energy sources like wind and solar is that they risk disrupting this system. It is impossible to control when the sun will shine or the wind will blow, so ensuring there is sufficient electricity on the system requires different kinds of technologies and relationships to those demanded by a national grid powered by a few large generators. Technical answers to this problem include batteries that can store electricity, smart appliances that can turn on and off in response to the needs of the grid and differential pricing to encourage individuals and businesses to use electricity at different times of day. Whilst these technical challenges and solutions are well known, the social implications of putting renewable energy sources into the grid are less well rehearsed.

I had the opportunity to observe some of the ramifications of smart grid proposals first hand when in 2016 the EU Horizon 2020 Scheme awarded a grant to a consortium of European partners to explore the technical and social feasibility of 'smart' grids under the project heading 'NobelGrid'. The project was concerned in particular with the way in which these changes might open up new opportunities for community-organised energy production, distribution and consumption. The NobelGrid project was an investigation into the technical and social feasibility of grid balancing at a regional or 'community' level. Partners included an energy cooperative in Flanders, a former holiday park in Greece, a district supply operator in Spain, a district supply operator in Italy and both hardware and software engineers. It also included a partner organisation in Manchester, called the Carbon Co-op, with whom I spent time doing research.

The Carbon Co-op was set up in 2011 to help reduce the carbon emissions of the city of Manchester. The main focus of their work has been on how to make major improvements to the insulation of people's houses to reduce people's fuel bills. Although this may sound unrelated to the changes in the grid described earlier, it is very much part of the same story. Most heating in the UK is currently supplied by fossil fuel based natural gas. If carbon reduction targets are to be met, people will have to burn less of this gas. One option is to move from gas heating to electric heating, but the demand that this would put on the electricity grid would cripple the grid as it stands. Conservation of energy is therefore an important part of the conversation about a changing electricity grid, and one way in which it is hoped that reductions in energy use will be achieved is by using smart metering technologies.

Carbon Co-op's involvement in the NobelGrid project was primarily as a test site for smart meters. The Carbon Co-op were working with their own members, with local housing co-operatives and with a social housing group in order to see

how smart grids could support community energy projects and ultimately help achieve reductions in energy use. Smart meters would, it was hoped, be a way for people to get a better grasp on their own energy use, to balance out energy across a community and potentially to be able to sell energy back to the grid on a supply/demand basis.

What emerged from Carbon Co-op's involvement in this project were various unanticipated issues that a digitised energy system was likely to play in refiguring the kinds of social collectives that the electricity system would serve. One of the hopes associated with renewable energy technologies is that local sources of electricity generation might be able to provide local communities with a way of gaining control over the creation and use of their own electrical power, an example perhaps of what Alberto Corsín Jiménez has elsewhere termed 'a right to infrastructure' (Jiménez 2014). Smart metering would potentially enable communities to visualise and manage their own power distribution and to sell the excess collective power back to the grid. Moreover, interfaces between micro renewables and technologies like electric vehicles, whose batteries might offer a storage solution for an unstable grid, opened up a further vision of self-sufficient communities using their own green electricity to power sustainable lifestyles. Smart grids seemed to hold the revolutionary potential to pull power back from multinational corporations who currently control electricity generation and supply, returning the control of electricity to 'the people'.

However, here engagement with digital infrastructure was less a process of learning from technical experts about the possibilities available to communities of well-known technological infrastructures and more a process of 'infrastructural inversion' (Bowker 1994), whereby the more that the complexities of the digital grid infrastructure began to unravel the more other anticipated questions reared their head. Engaging materially with digital infrastructures served less to reveal their prior invisibility and more to refigure them as technical systems that seemed at first to be about one kind of thing (electricity supply and demand) but rapidly shifted to be about something completely different (democracy, fairness, rights and responsibilities). Digital infrastructures in their very opacity had, it seemed, the capacity to open up new questions about appropriate sociality.

As people began to tease out elements of the digital electricity grid that might pertain to what they were interested in, their own ways of conceiving of themselves and what they were doing were being transformed. Whilst smart energy seemed initially to provide the promise of greater democratic control through tropes like transparency, openness and freedom, the details of how digitally enabled renewable energy was actually being set up to work to benefit closed communities of people in fact risked undoing principles of equity and fairness that were originally built into the design of the grid. If community energy groups were able to generate their own energy, this reintroduced a geographical inequality into the energy infrastructure. Proximity to energy sources, like rivers or roofs with the correct aspect, and access to capital once again risked becoming the determining features of who has access to cheap and reliable electricity.

Perhaps we should not be surprised that when the 'space of flows' becomes part of energy infrastructure, it reproduces the tendency Castells observed several

years ago, to create new contours of inequality. What does seem surprising in this case is that those groups who have perceived themselves as the most politically radical and driven by principles of ethical living find themselves confronted with a system that simultaneously seems to support ambitions for more collective approaches to energy provision whilst potentially undermining another collective – that of the national public.

The unfolding implications of the digital infrastructure of the smart grid, then, is provoking people to reconsider what forms of social collective might be desirable and even achievable. Changes in one part of the socio-technical-environmental grid inevitably produced unanticipated knock-on effects elsewhere. Here in the discursive interstices riven open by the development of digital infrastructures, the national public is confronted by a digital agora that blurs boundaries between customers served by markets, communities pursuing collective life, cities interested in digitally enabled forms of devolved government, states appealing to a weakening national public and a global humanity that is challenged by climate change.

It is this last issue – the challenge of global climate change – that I want to end this first example with. For whilst smart grids could be understood as an extension of the problem of the network society – a question of how to create more effective, open and transparent communications between parts of a distributed network – they are also a technological solution to a problem whose systemic quality exceeds the problem of the network and bleeds into considerations of ecological relations. This is in terms of both literal ecological relations – how to engage the power of wind, water, tides, sun, bacterial digestion, crops and algae into the provision of electrical power – and an ecological mode of understanding of social/technical relations that acknowledges the modulating, shifting, unfolding qualities of assemblages of people, numbers, practices, lifestyles, media images, conspiracy theories and energy sources. The ecological relationality of digital infrastructures is rarely dwelt upon, but this is an aspect of digital relations to which anthropology has much to offer and which digital anthropology would do well to pursue. Anthropologists have a long history of analysing and understanding the unfolding interrelations between people and environments – from Gregory Bateson's enigmatic *Steps to an Ecology of Mind* to Tim Ingold's programmatic agenda for an anthropology of process and flow. Not usually seen as key references for digital anthropologists, these ecological understandings of socio-material relations offer, I suggest, an important resource for understanding the kinds of relations that contemporary digital infrastructures are producing. To explore this further, my second example of digital infrastructure turns directly to a case in which digital technologies have made newly explicit entangled ecological relations that include people, substances and things: the role of digital infrastructure in constituting the science of climate change.

Living with climate models

In September 2017 a paper was published in the journal *Nature Geoscience* which made the argument that there seemed to be slightly more chance than previously

thought that the Paris Climate Agreement to limit global warming to between 1.5°C and 2°C was geophysically possible (Millar et al. 2017). A press release was circulated by *Nature* which was picked up and discussed in a news briefing organised by the Science Media Centre. The news briefing was attended both by two of the paper's authors and by journalists from ten news outlets. The article's findings were then reported by several news channels, including BBC News online, Buzzfeed and the Mail Online, and the *Daily Telegraph* and the *Sun* newspapers, some coming with misleading headlines and op-eds that reinterpreted the research paper as evidence as a claim not that 'according to our models if we do everything humanly possible to reduce greenhouse gas emissions the 1.5°C target is still theoretically possible' but that 'climate models are wrong' and climate change is 'not as bad as we thought'.

The publication of the academic paper and its subsequent reporting caused something of a furore among those concerned with how best to communicate climate science. Coming hot on the heels of a series of devastating hurricanes in the Caribbean and Florida, the paper seemed to add grist to the mill of climate deniers who were keen to discount the effects of climate change in these recent weather events. But, people asked, was this reason enough to suggest that the academic paper itself should not have been published? Did the misinterpretation of the paper's message lie with its authors, who should have been clearer about the overall message to be taken from the technical findings they outlined? Should university media communications departments have anticipated how the paper would have been seen and deployed some kind of 'damage limitation'? Should the journal have put out a different press release? Should the Science Media Centre have managed their briefing better? Or was the variety of interpretations put forward in the press actually a healthy sign of democratic debate? At least, some said, climate science was being talked about at all. Perhaps it didn't matter if a few extreme columnists jumped on the 'uncertainty' inherent to scientific modelling techniques to bring down the veracity of climate science as a whole.

A perennial challenge facing those aiming to communicate the science of climate change to a general public has been how to translate the 'vast machine' of multidisciplinary, data-driven, statistical analysis that is climate science into a form that can carry into people's lives in effective and meaningful ways. This is generally described as a problem of translation, of education or of struggling against political bias in the news media. However, communicating climate science is more than just a problem of translating unpalatable facts through the filter of a biased news media to a generally disinterested audience. It is also a problem of how to translate what is a sprawling, multidisciplinary and computer-mediated knowledge infrastructure spread across journals, digital models, labs and reports into a singular message that is meant to inform people's practices, their politics and their interpretation of the world they live in. The difficulty that bedevils the communication of climate science is not just one of communication but one of how to engage people in the ecological relationality made evident through the distributed digital infrastructure of knowledge production.

To understand the problem here we need to understand something of the digital infrastructural qualities of climate science itself. Paul Edwards' (2010) magisterial book *A Vast Machine* provides a fascinating window onto this world, unravelling the workings of the knowledge infrastructure of climate science, tracing both the history and sociology of climate modelling. Aware that demystifying the production of scientific knowledge on a topic like climate change runs the risk of its own misinterpretation, Edwards states from the outset that his analysis offers not a deconstruction of the truths of climate science but rather a description of the infrastructural conditions out of which climate science has been forged. In this, Edwards follows in the footsteps of Bruno Latour and others working in the tradition of science and technology studies who use the method of tracing networks of relations to unravel the 'black boxes' of science and technology. In Edwards' case, the story that emerges from this meticulous tracing is not one that deconstructs the evidence of climate change but rather one that celebrates the amazing achievement of climate science as an assemblage that holds together findings, theories, technical devices, data traces and analytical techniques from disciplines ranging from earth sciences, atmospheric chemistry, computer science, geology, oceanography and policy sciences to weave a picture of a changing climate whose causes can be traced back to the burning of fossil fuels for heating, industry and transportation and the practices of industrial agricultural production.

Whilst Paul Edwards' book helps us to understand the conditions out of which climate models have emerged and the nature of the knowledge that they produce, this stance does not however touch on the experience that non-experts have of engaging with these information infrastructures. The problem of how to communicate climate science is unfortunately not resolved alone by a sociological analysis of how climate models are produced. Indeed, as I heard one climate communicator point out in relation to the controversy over the aforementioned *Nature Geoscience* paper (Millar et al. 2017),

> all modelling is 'wrong' but this is a subtle point . . . The very fact climate science has to use modelling means it's always going to be under attack and called wrong each time you refine and revise it, for as long as there are editors who want to say it.
>
> (Personal Communication)

The question then is not only how does climate science create evidence, but also how is the evidence that is produced in the manner adequate to climate science, described and received in other arenas. How does one communicate as fact something that is emergent, contingent, multidisciplinary and in this climate scientist's own terms empirically 'wrong', without necessarily going into a 400-page analysis of climate science itself? This demand generates its own responses and challenges which we will see as we turn our attention now to a science communication project launched in Manchester's Arndale shopping centre in 2012 – the Manchester Carbon Literacy project.

Literacy and social learning

As part of the city of Manchester's attempts to tackle climate change, community activist Phil Korbel and former IT consultant Dave Coleman came up with the idea of the Manchester Carbon Literacy project. The project was to be a way of responding to the question of how to bring about the cultural change that would be necessary to do something in the city about climate change. The project involved putting together an accessible public engagement and education tool that would be offered to every worker and citizen in the city of Manchester so as to improve their understanding of the science of climate change and how it related to their lives. Supported by the city council and many organisations in the city, the carbon literacy project was launched in October 2012 by Richard Leese, head of Manchester City Council, at a city centre shopping centre to an audience of 150 or so representatives of schools, businesses, universities and charities who had pledged their support for the programme.

The carbon literacy project was an example of many such attempts to engage people in the ecological relations made evident by the digital knowledge infrastructure of climate science and to make it relevant to people's lives. The carbon literacy programme set out to improve people's understanding of their involvement in climate change by explaining to them (a) the science of climate projections, (b) the role that greenhouse gas emissions are playing in atmospheric change and (c) how people's everyday activities contribute to global climate change. Whilst the project was set up as a literacy programme, it was not simply didactic but aimed to generate a form of public participation in the problem of climate change.

One part of the public engagement was an online learning tool. This web-based platform was designed to provide people with some of the basic science of climate change. Here summaries of information about global temperature change and levels of global carbon emissions were displayed – with links to the Met Office and other sites where people could check information for themselves and question-and-answer sections where people could test their understanding. Moreover, the information provided on the site was repeatedly tied back to Manchester – as site of the industrial revolution, as a place where particular climatological effects were projected to happen and as a location which was contributing a specific amount to global climate change. But it was also very clear to those designing the carbon literacy programme that an online tool could never be enough.

To accompany the website a half-day face-to-face workshop was also designed that would be attended by people who were signed up to the carbon literacy programme.

In the face-to-face training session, the people attending were not instructed but were asked to think about their carbon footprint with the evidenced information that they had been provided with. The session I attended started with an 'icebreaker' exercise of 'green bingo'. The twelve council employees in the room were each given a 'bingo' card with a grid of boxes inside of which were listed a range of green behaviours – 'cycles to work', 'recycles', 'always turns off

computer screen', 'is vegetarian'. People then had to go around the room asking others if they did one of the behaviours until all the boxes were ticked off.

Participants were then introduced to different ways of representing their own involvement in climate change. First, two kinds of carbon footprinting were introduced. The first was a footprint that calculated an individual person's carbon footprint in terms of tonnes of CO_2 emitted from their everyday activities. The project used an online tool[6] (oneplanetliving.org) that asked people a series of questions about travel, food eaten and type of houses that people lived in. The output of this carbon footprint was an individual figure in tonnes of carbon dioxide equivalent (tCO_2e) that each person could calculate for themselves. However, problems with this form of measurement were discussed. The people running the workshop recognised that this calculation was itself not easy for people to grasp. Discussion ensued about how best to represent something like carbon dioxide and how to understand, for example, how much is a lot or a little carbon dioxide. One question was what does a tonne of CO_2 *look like*? In another climate change workshop that was run as part of a different carbon reduction accreditation scheme, one of the organisers had tried to tackle this problem by bringing along a photograph that depicted the volume of a tonne of CO_2. The organiser of that workshop also used the analogy of 'so many double decker buses' to describe a volume of tCO_2e. In another conversation with a climate scientist, he told me about an art/science project he had heard of where the artist had found a way of drawing people's attention to their carbon footprint at the airport, by telling people when they got off a flight how many bags on the carousel represented the volume of CO_2 they had emitted as a result of the flight they had just taken.

The other way of representing people's environmental impact was not through carbon footprinting measured in tCO_2e but through ecological footprinting measured in terms of the area of the planet that was needed to support each person's lifestyle. Scaled up to the global population, this allowed people to see 'how many planets we would need if everyone lived like you'. Most people in the room found that we were in need of two to three planets if everyone 'lived like them'.

All of these devices were ways of trying to make sense of the relationality of climate science revealed by digital infrastructures of measurement and modelling and to make it relevant for people.[7] From the outset of the project, the organisers had decided not to use the carbon literacy programme as simply a science communication tool but to see it as a way of engaging people in a more extended participation in the problem of climate change. They used terms like 'social learning' to explain the intention of the project to 'embed behavioural change' in people's lives. This involved the use of teaching methods that focused on making the material taught 'directly relevant to where the learner is and "modelled" for learners'. Another key principle was that the training would be delivered by peers as far as possible rather than outside experts. In this model people who had done the carbon literacy training themselves would then become potential future trainers under a 'train the trainer' logic which was meant to both personalise the abstract science of climate change and allow the training to reach a large audience in a

short amount of time.[8] Ecological relationality was not just the content of the lesson being taught, but it also bled into the form through which that lesson was itself structured and delivered.

Conclusion

How to deal with the impossibility of ultimately knowing the unfolding digital infrastructures of everyday life raises issues not just for those who are grappling with these systems in their everyday work, but also for social scientists and anthropologists. Given the complexity of these systems and the unknown quality of their implications, which form and change at the same time as we try to understand them, how should we proceed? One answer is to try to find ways of describing the infrastructures 'themselves'. This cannot be a matter of going to the experts to ask them how things work, for what we find with digital infrastructures is that our own questions about what infrastructures are and how they work are often shared with those with whom we are doing research. In the face of such infrastructures, it turns out we are all social researchers of sorts. At the same time, the way in which these infrastructural systems are pursued and sustained by fetishistic marketing that occludes the institutional and material structures that are actually being invoked does seem to demand a more critical attention that is able to trace their actual manifestations rather than just their dream-like promise. Describing the specificity of digital infrastructures as they are designed, tested and implemented offers a way of tracing the often unacknowledged social and political relations that become hidden by the vernacular dream-image of smart cities or blockchain-enabled transparency. At the same time, we need to recognise that endlessly tracing networks of relations is a Sisyphean task which will never provide an ultimate picture of how things are. If we start with a belief in digital infrastructures as a network that can ultimately *be* traced, we risk blinding ourselves to what we can learn from the inherent *untraceability* of the relations that constitute the world of digital infrastructures. In the examples I provided of two digital infrastructures, we discovered some creative responses to this opacity. *Infrastructural inversion* and *social learning* appeared as two kinds of sociality that emerged out of an attempt to consider what it means to live with and in relation to complex and distributed infrastructures. Similarly, for ethnographers of digital infrastructures, I suggest that allowing the conditions for opacity to be acknowledged rather than done away with must be key to how we approach them. In this chapter I have suggested that staying with the opacity and uncategorisable qualities of digital infrastructures and their relations can reveal to anthropology that digital infrastructures have not only informational and network characteristics but also ecological qualities. Rather than tracing networks, our job could instead be to attend to these ecologies – attending to how infrastructures become constituted relationally rather than becoming overly preoccupied with their ontological characteristics. With this perspective, digital anthropologists would no longer only be the observers of digital infrastructural systems but could

also become newly involved in shaping, critiquing and transforming them. For as Gregory Bateson reminds us:

> in fact the problem of how to transmit our ecological reasoning to those whom we wish to influence in what seems to us to be an ecologically 'good' direction is itself an ecological problem. We are not outside the ecology for which we plan – we are always and inevitably part of it.
>
> (Bateson 1972: 512)

Notes

1 For example, the emergence of disciplinary groupings concerned with social data science such as SODAS at the University of Copenhagen (wwwhttps://sodas.ku.dk/), or Genevieve Bell's current work to "a new applied science for understanding our future humanness" (www.afr.com/brand/boss/genevieve-bell-investigates-how-humanity-can-prosper-in-a-datadriven-world-20171011-gyzau3).
2 See for example Bennett (2010), Coole and Frost (2010) and Morton (2013).
3 Good overviews to this approach include Law and Hassard (1999) and Latour (2005).
4 (Thrift 2007).
5 Paraphrasing Haraway's *Staying with the Trouble* (Haraway 2016).
6 Available through the website oneplanetliving.org (last accessed 10th May 2018).
7 There have been critiques of these kinds of carbon literacy schemes which see them as an extension of practices of neoliberal governmentality, asking the individual to take responsibility through the management of their own conduct (Stripple). Whilst this is a reasonable critique, it is not my focus.
8 These quotes are taken from a draft of the Manchester Carbon Literacy Standard which was being developed at the time of my research.

References cited

Bateson, Gregory. 1972. *Steps to an ecology of mind: Collected essays in anthropology, psychiatry, evolution, and epistemology* (Chandler Pub. Co: San Francisco, CA).

Bell, Daniel. 1973. *The coming of post-industrial society: A venture in social forecasting* (Basic Books: New York).

Bennett, Jane. 2010. *Vibrant matter: A political ecology of things* (Duke University Press: Durham, NC).

Boellstorff, Tom, and Bill Maurer. 2015. *Data: Now bigger and better!* (Prickly Paradigm Press: Chicago).

Boltanski, Luc, and Eve Chiapello. 2005. *The new spirit of capitalism* (Verso: London; New York).

Bowker, Geoffrey C. 1994. *Science on the run: Information management and industrial geophysics at Schlumberger, 1920–1940* (MIT Press: Cambridge, MA; London).

Bowker, Geoffrey C., and Susan Leigh Star. 1999. *Sorting things out: Classification and its consequences* (MIT Press: Cambridge, MA).

Bridle, James. 2018. *New dark age: Technology and the end of the future* (Verso: London).

Castaneda, Claudia, and A. Suchman Lucy. 2005. "Robot visions." In *Creative evolution* (Goldsmiths College, University of London: London).

Castells, Manuel. 1996a. "The net and the self: Working notes for a critical theory of the informational society." *Critique of Anthropology*, 16 (1): 1–46.

———. 1996b. *The rise of the network society* (Blackwell: Malden, MA; Oxford).

Coole, Diana H., and Samantha Frost. 2010. *New materialisms: Ontology, agency, and politics* (Duke University Press: Durham, NC).

Cross, Jamie. 2016. "Off the grid." In *Infrastucture and energy beyond the mains* (Routledge: London).

Edwards, Paul N. 2010. *A vast machine: Computer models, climate data, and the politics of global warming* (MIT Press: Cambridge, MA).

English-Lueck, J. A. 2002. *Cultures@silicon valley* (Stanford University Press: Stanford, CA).

Eubanks, Virginia. 2018. *Automating inequality: How high-tech tools profile, police, and punish the poor* (St. Martin's Press: New York).

Everett, Anna. 2009. *Digital diaspora: A race for cyberspace* (SUNY Press: Albany).

Florida, Richard L. 2002. *The rise of the creative class: And how it's transforming work, leisure, community and everyday life* (Basic Books: New York).

Gabrys, Jennifer. 2011. *Digital rubbish: A natural history of electronics* (University of Michigan Press: Ann Arbor, MI).

Gershon, Ilana. 2017. *Down and out in the new economy: How people find (or don't find) work today* (The University of Chicago Press: Chicago; London).

Haraway, Donna Jeanne. 2016. *Staying with the trouble: Making kin in the chthulucene* (Duke University Press: Durham, NC).

Harvey, Penelope, and Hannah Knox. 2015. *Roads: An anthropology of infrastructure and expertise* (Cornell University Press: Ithaca, NY).

Holt, Jennifer, and Patrick Vonderau. 2015. "'Where the internet lives': Data centres as cloud infrastructure." In Lisa Parks and Nicole Starosielski (eds.), *Signal traffic: Critical studies of media infrastructures* (University of Illinois Press: Urbana).

Jiménez, Alberto Corsín. 2014. "The right to infrastructure: A prototype for open source urbanism." *Environment and Planning D: Society and Space*, 32 (2): 342–362.

Kitchin, Rob, and Martin Dodge. 2011. *Code/space: Software and everyday life* (MIT Press: Cambridge, MA).

Kittler, F. 1999. *Gramophone, film, typewriter* (Stanford University Press: Stanford, CA).

Knox, Hannah, and Dawn Nafus. 2018. *Ethnography for a data-saturated world* (Manchester University Press: Manchester).

Knox, Hannah, and Antonia Walford. 2016. "Is there an ontology to the digital." https://culanth.org/fieldsights/820-digital-ontology.

Kockelman, Paul. 2013. "The anthropology of an equation: Sieves, spam filters, agentive algorithms, and ontologies of transformation." *Hau: Journal of Ethnographic Theory*, 3 (3).

Larkin, B. 2013. "The politics and poetics of infrastructure." *Annual Review of Anthropology*, 42: 327.

Latour, Bruno. 2005. *Reassembling the social: An introduction to actor-network-theory* (Oxford University Press: Oxford).

Law, John, and John Hassard. 1999. *Actor network theory and after* (Blackwell: Oxford).

Lowrie, Ian. 2018. "Algorithms and automation: An introduction." *Cultural Anthropology*, 33 (3): 349–359.

Mackenzie, Adrian. 2006. *Cutting code: Software and sociality* (Peter Lang: New York).

———. 2011. *Wirelessness: Radical empiricism in network cultures* (MIT Press: Cambridge, MA; London).

———. 2017. *Machine learners: Archaeology of a data practice* (MIT Press: Cambridge, MA).

Mackenzie, Adrian, Ruth McNally, Richard Mills, and Stuart Sharples. 2016. "Post-archival genomics and the bulk logistics of DNA sequences." *BioSocieties*, 11 (1): 82–105.

Manovich, Lev. 2001. *The language of new media* (MIT: Cambridge, MA; London).

Maurer, B. This volume. "Blockchain." In *Digital anthropology* (second edition).

M'Charek, Amade. 2013. "Beyond fact or fiction: On the materiality of race in practice." *Cultural Anthropology*, 28 (3): 420–442.

Millar, R., Fuglestvedt, J., Friedlingstein, P. et al. 2017. "Emission budgets and pathways consistent with limiting warming to 1.5 °C." *Nature Geoscience*, 10: 741–747.

Morton, Timothy. 2013. *Hyperobjects: Philosophy and ecology after the end of the world* (University of Minnesota Press: Minneapolis, MN).

Negroponte, Nicholas. 1995. *Being digital* (Hodder & Stoughton: London).

Norris, Pippa. 2001. *Digital divide?: Civic engagement, information poverty, and the internet worldwide* (Cambridge University Press: Cambridge).

Parikka, Jussi. 2011. *Medianatures: The materiality of information technology and electronic waste* (Open Humanities Press: Ann Arbor, MI).

Parks, Lisa, and Nicole Starosielski. 2015. *Signal traffic: Critical studies of media infrastructures* (University of Illinois Press: Urbana).

Poster, Mark. 1990. *The mode of information: Poststructuralism and social context* (Polity Press in association with Basil Blackwell: Cambridge).

Rodgers, D., and B. O'Neill. 2012. "Infrastructural violence: Introduction to the special issue." *Ethnography*, 13 (4): 401–412.

Ross, Andrew. 2003. *No collar: The hidden cost of the humane workplace* (Basic Books: New York).

Schüll, Natasha Dow. 2012. *Addiction by design: Machine gambling in Las Vegas* (Princeton University Press: Princeton, NJ).

Seaver, Nick. 2015. "The nice thing about context is that everyone has it." *Media, Culture & Society*, 37 (7): 1101–1109.

Starosielski, Nicole. 2015. *The undersea network* (Duke University Press: Durham, NC).

Sterne, Jonathan. 2012. *Mp3: The meaning of a format* (Duke University Press: Durham, NC).

Thrift, N. J. 2007. *Non-representational theory: Space, politics, affect* (Routledge: London; New York).

Virilio, Paul. 1986. *Speed and politics: An essay on dromology* (Semiotext(e): New York).

Vonderau, Asta. 2017. "Technologies of imagination: Locating the cloud in Sweden's North." *Imaginations: Journal of Cross-cultural Image Studies*, 8 (2).

Wilf, Eitan. 2013. "Toward an anthropology of computer-mediated, algorithmic forms of sociality." *Current Anthropology*, 54 (6): 716–739.

Winner, Langdon. 1986. "Do artefacts have politics?." In *The whale and the reactor: A search for limits in an age of high technology* (University of Chicago Press: Chicago; London).

Zuboff, Shoshana. 2019. *The age of surveillance capitalism: The fight for the human future at the new frontier of power* (Profile Books: London).

11 Blockchain

Bill Maurer

// Nodes collect new transactions into a block, hash them into a hash tree,
// and scan through nonce values to make the block's hash satisfy proof-of-work
// requirements. When they solve the proof-of-work, they broadcast the block
// to everyone and the block is added to the block chain. The first transaction
// in the block is a special one that creates a new coin owned by the creator
// of the block.[1]

Archaeologists of the future trying to understand computer network technologies of the early 21st century may stumble upon something called blockchain. By that time, far from now, blockchain will have either revolutionized all computational systems and become the basis of digital identification for future persons, things, computational agents, and their various hybrids and mixtures; or it will have faded into utter obscurity, leaving barely a trace in the technoarchaeological record; or maybe it will have the status of the ARPANET today – we all sort of know it was something important that laid the foundations for the Internet, even if we don't know how, or why, or what the TCI/IP protocol is that packages, transmits, and receives electronic communications on the computer networks we use every day.

Digital media scholar Finn Brunton maps out a speculative methodology for future scholars encountering, as he did, the "digital middens" of the era of networked computing – the "accidental archives, collections of digital rubbish" (2017:139), "the accumulations of by-products and junk and trash and bits and pieces of the working life of computers and communities" (p. 141). Like the waste dumps that provide such rich material for fleshing out the contexts of life of ancient peoples, digital middens – the archival and material throwaways of networked computing – open into the hidden infrastructures and implicit value systems of those who left them behind.

For blockchain, that detritus would include textual material like the epigraph to this chapter, the notes in the source code for the original Bitcoin blockchain. It would also include the so-called cryptograffiti or messages attached by users of the system to Bitcoin transactions to memorialize an event, spread an ideology, capture an image, or simply have fun (Figures 11.1 and 11.2). There exist digital dumps, too, related to blockchain: copies of various versions of different protocols and copies of various blockchains themselves, in whole or in part, in servers,

laptops, mobile phones, and the desktop computer in one of my offices in Irvine, California. That particular computer has not been turned on since sometime in 2017, unupdated, unused, not even really strictly speaking "idle" because, as long as the machine stays off, the data constituting the blockchain on that desktop computer exists as weak electrical charges trapped in a silicon nitride film. The charges dissipate over time – so our future archaeologist would find shreds and patches, literally bits of bits, and unless equipped with some fancy future technology would likely have to hunt from among multiple desktops and servers containing the same blockchain to piece together whatever it was these humans of the past had created in those strange conductive silicon surfaces.

The materiality of computer memory raises another interesting question regarding this future archaeology of blockchain, and digital materials in general: how will our contemporary ideological separation of the digital from the material or the virtual from the physical be captured in the digital middens available to future scholars? As Paul Dourish argues, the separation of the digital from the material requires a lot of effort: digital and material are mutually embedded, and embedded in society and community (computational, human, and hybrid). "Virtual objects manifest themselves as signals, charges, and states that must be grappled with materially in digital systems and which come with their own constraints" (Dourish 2017:202), and material can afford all kinds of perceptual virtuality, presenting spectacles, dazzling the humans who mistake their physical qualities for virtues (Strathern 2013). For blockchain, the sheer magnitude of computational power it requires, and the vast server farms created to maintain it, have led to piles and piles of electronic waste, environmental hazards that at least one historian has likened to the destruction caused by colonial-era silver mining (Zimmer 2017). Adopting an anthropological stance, how will future archaeologists grasp others' ontologies of that which I gloss as digital and material because of the sociotechnical and capitalist world within which I write (see, e.g., Bell and Kuipers 2018 for recent studies of the ontologies and intimacies of another set of digital/material technologies)?

Ten years into the history of Bitcoin and blockchain databases that sustain it and other similar "cryptocurrency" projects, it's difficult to say how much record it will leave behind. The business and technology worlds in the US and Europe are rife with intellectual and financial speculation about blockchain, even if few understand what it is and how it works. Regulators around the globe are in the process of grappling with some of its implications. Some of the more active regulators are in places like Singapore, Estonia, Malta, and Vanuatu – an odd collection of microstates that has not a little overlap with the offshore financial services economy. As for Bitcoin, the "currency" that unleashed this interest, its value relative to the US dollar has swung wildly during the time of my writing, between December 2017 (where it stood at nearly US$20,000/Bitcoin) and January 2019 (where it stood at just over US$3,600). In late February, 2021, the price ran up all the way to $57,489.

This chapter provides a chronicle from the past for that future archaeologist, situates the state of blockchain databases for the anthropologists of today, and explains some of the peculiarities of this new network technology suite. Academic

Figure 11.1 Screenshot of "cryptograffiti": message encoded in the Bitcoin blockchain

Source: Collected by Maurer 14 January 2019.

Figure 11.2 Cryptograffiti of the author in the Bitcoin blockchain

Source: Created by Caitlin Lustig, captured by Maurer 28 August 2017.

research on blockchain is in its infancy, yet there is a handful of anthropologists beginning to devise projects on blockchain or stumbling upon it in their existing fieldsites. Most of the work on the phenomenon that is not computer science is coming from communications scholars. This chapter is not a literature review, however, but a primer on blockchain for digital anthropology with some sug-gestions for method. Blockchain and cryptocurrencies provide new material for economic anthropology's enduring questions about the relation between money, politics, and commodity fetishism. Anthropologists can also use blockchain to query globalization in its digital forms, the creation of new localisms through globally networked digital media, or the contests over digital commons and their enclosure. Taken as media, blockchain raises questions about reproducibility, mimesis, and how digital media write their own historiographies. Whatever its futures, blockchain is good to think with.

Ultimately, I view blockchain as an interesting note in the history of accounting, more so than in the history of money, though it signals the revivification of some very Austrian economic theories on the nature and authorization of money, as I discuss in what follows. As an accounting technology, blockchain is being inserted into conversations in the technology and the business world about automation and "disintermediation." The former is founded on the idea that blockchain can begin to automate various kinds of decision-making and action in the physical world and/or in the world of communication among connected computational devices – a future of work without human labor. Think of a digital system for tracking the provenance of goods in a supply chain, whether digital or physical goods. The latter, disintermediation, is a keyword in blockchain communities that indexes both an anti-state or outright anarchist orientation toward liberal political institutions, an anti-bank or anti-central-bank commitment to "direct" economic relationships among transacting parties, and/or a related desire for unmediated, "peer to peer" communications channels (including money as a communicative practice; see Swartz 2018). These are political positions, and they stake out territory on the libertarian right and, perhaps to a lesser extent, the cooperativist left.

Blockchain has opened up a public conversation over the politics of infrastructure. And at stake is the control over the infrastructures subtending economic-cum-communicative relations. Insofar as blockchain helps illuminate these political positions, it is a useful case study for the potential transformation of neoliberal economies and political institutions that has been going on since the global financial crisis of 2008.

Money in the age of digital reproduction

For our future technoarchaeologist, there will likely be archival traces of something called the Satoshi whitepaper, and this is as good a place as any to begin. "Bitcoin: A Peer-to-Peer Electronic Cash System" (Nakamoto 2008) was written under a pseudonym of a programmer or a group of programmers. The paper proposed a digital cash system that would solve some of the problems inherent to creating digital objects of value. It also inaugurated a genre: the cryptocurrency "whitepaper." Whitepapers accompany almost all blockchain projects. In keeping with the Bitcoin blockchain's open source ethos, they are generally publicly accessible and sometimes even contain source code for the projects they promote. Posting a whitepaper is akin to announcing one's existence and is almost a prerequisite for entering into the blockchain developer community. During the huge run-up in the prices of cryptocurrencies in 2017, whitepapers also came under regulatory scrutiny because they have the function of advertising a project in order to solicit investors. Depending on the kind of project and the kind of fundraising suggested in the whitepaper or by the proposed technology itself, a whitepaper can be taken as a solicitation for investment in an unregistered security.

Chief among the problems Nakamoto sought to solve was the "double-spend" problem. In a digital environment, duplication of any data is relatively easy

Given this system requirement for circulation without unauthorized reduplication, Nakamoto sought to develop a procedure that would prevent malicious users from taking one instance of digital value, duplicating it, and using it more than once, that is to prevent users from creating new digital value from a set pool of it. Given the commitment to eliminating third-party intermediaries, Nakamoto sought a networked solution to the reduplication problem. And given a commitment to anonymity in transactions mirroring cash – a commitment reflected in Nakamoto's own anonymity – Nakamoto sought a digital identity system. The solution therefore involved four main parts:

A peer-to-peer network, so as to avoid the need for a third-party validator or verifier of transactions
A method for timestamping transactions
A method for ensuring the ownership claims of transacting parties
A method for ensuring the digital identity of the transacting parties without revealing those identities

Nakamoto did not refer to a "blockchain" in the paper. But the notes to the original source code, reproduced in the epigraph to this chapter, explain that a "block" of transactions is added, after some additional computational work, to a "block chain." The whitepaper refers to an "ongoing chain" of transactions (p. 1) and once (p. 7) to a "chain of blocks." Within a year or two of Bitcoin's creation, the database underpinning the Bitcoin cryptocurrency came to be known as "the blockchain" or simply "blockchain."

Blockchain refers to a database with some distinctive features. First and foremost, multiple copies of it exist and are held by multiple parties in a network. Generally, people involved in cryptocurrency and blockchain-related businesses refer to this feature as being "distributed." A truly distributed database, however, would be disaggregated into constituent components, each component held by a node in a network, such that the whole could only be knowable through the participation or agreement of the entire network. The whole would consist of pieces distributed among multiple parties. Blockchain does not work this way. Instead, the entire database in multiple instances is held by the nodes in the network. Each node has a copy of the whole thing in order to ensure that changes to the database cannot take place without having gone through a specific verification procedure involving all the nodes. If one node makes an unauthorized change to prior entries in its copy of the database and then shares data with the network or just another node, the other nodes should be able to spot the change. The protocol involved refuses such transactions.

Second, blockchain databases are "append-only." This means that old entries are never revised. Any change to an old entry must be made by following a protocol that adds a new entry to the database. The database is continuously expanding as a result. Bitcoin's inventors, however, gave it a fixed limit of 21 million Bitcoins. They did this for monetarist ideological reasons deriving from Austrian school economics, holding that any intervention in market relationships would

interfere with the freedom of individuals to transact. Money should be a scarce commodity subject to the same laws of supply and demand as other commodities. Rather than a government increasing the money supply, however, and thus interfering with the value of money, F.A. Hayek (1976) went so far as to propose the denationalization of money altogether and the creation of a competitive market of multiple private currencies.

Bitcoin's inventors also limited the amount of Bitcoin to solve a technical problem: fixing the amount of Bitcoin ever to exist helped support the verification procedure the network undertakes. The blockchain is potentially infinite and ever expanding. Its append-only nature means it will get bigger and bigger and bigger, until the computational networks maintaining it can no longer sustain it. Placing a "hard cap" on the number of Bitcoin ever to be mined mitigates the problem of database expansion.

It also lends itself to another feature: every entry is time-stamped, and time progresses linearly in a blockchain. It is a serialized, ongoing record of transactions. And, again, old transactions cannot be modified; changes involving old transactions – which is what any transaction in the blockchain actually is – become new entries appended onto the database. That it unfolds in real time, constantly moving forward in time, makes it resemble a digital chronicle more than a digital history: there is no hierarchization, or the elevation of one entry or set of entries over the others (see Brunton 2017). It is one damn thing after another. Individual Bitcoin transactions can be speeded up, however, and made to settle faster than others, as the nodes that serve as transaction verifiers ("miners") can assess fees to facilitate transactions by in effect moving them up in the queue.

The Bitcoin blockchain is also public: even non-participants in the network can view the transactions in the blockchain, in real time. Depending on what application they use to view the transactions, what they will see is something like this:

2018-12-01 16:37:20
3QwcnREdSxefKhweCiRwzcwU7f9zSaDV4k

 1LA1f3X7rpEVkSLEezzq6Kbt13cdQF6zLQ 0.00936694 BTC
 3BcVWDcjwTjGgVNJsWowyaLDe7ANbTBmQC 0.01000005 BTC

2018-11-27 04:44:22
3QwcnREdSxefKhweCiRwzcwU7f9zSaDV4k

 1GWugYqDG5voThwG8YeRPvmbyZeghTCcq1 0.00768251 BTC
 31iUswoeqPTF4VAKJYvLkQ9MJVJ6it1nMh 0.0098855 BTC

You can see that the data is time-stamped. Each transaction is identified as a transfer of value from one digital address to another. In this case, the address 3QwcnREdSxefKhweCiRwzcwU7f9zSaDV4k has engaged in two sets of paired transactions. (The underlying code calls for this duality in transactions, for reasons having to do with preserving the singularity of transactional records, and the digital metallist ideology of its developers [Maurer, Nelms, and Swartz 2013],

that is, their resemblance to historical goldbugs not just because of their monetary theory but also because of something they baked into the code which requires this transactional duality, to be explained later).

The Bitcoin blockchain maintains pseudoanonymity by using a digital addressing system to identify transactional partners. This system is derived from public key cryptography, a technique that allows a public address to be generated by a random number (called a private key). The private key serves like a secret password to verify the identity of the transactor but cannot be back-calculated from the public key (see DuPont 2018:60; for a history, see Blanchette 2012). In the earlier example, the digital addresses are generated by the public key – the private key is held by the entity associated with the public address 3QwcnREdSxefKhweCiRwzcwU7f9zSaDV4k.

New entries to the database are validated by a process through which individual nodes compete to verify the integrity of the transaction – that there has been no double-spend anywhere throughout the chain of transactions leading to the current one. This is done through a computational puzzle that both provides the incentive to compete for a reward denominated in Bitcoin and creates a throttle on the creation of new Bitcoin. The difficulty of the puzzle is set by the protocol to increase over time. This has led to centralization in "mining," with conglomerates of "miners" (called "mining pools") engaged in a hardware arms race so that they can devote more and more computational power to solving those puzzles. In this respect, Bitcoin mining resembles historical examples of actual mining in which artisanal extraction and smelting gave way to more chemical- and capital-intensive processes (Zimmer 2017).

When a new transaction is accepted as valid, it is then posted to the entire network in order to update every copy of the database on every node. This takes place only after two conditions are met: an individual node has won the competition to validate a transaction, and the consensus of the nodes agrees that its solution to the competition is valid. This in turn entails validating the transaction: solving the puzzle set forward in the competition involves using the data from the transaction in question; if it is not valid, the solution to the puzzle will not be valid, either. This process obviates the need for a central server operating as an accounts keeper.

One challenge of describing blockchain and cryptocurrencies is that the metaphors are, as one proponent and explainer puts it, "broken":

> In Bitcoin, every single term and design metaphor is absolutely and 100 percent wrong and broken. . . . A wallet is something that stores money – not in bitcoin it isn't. The money isn't in the wallet. The money is on the network. The wallet contains keys. So, it's not a wallet, it's a keychain. . . . Bitcoin. Coin – what a terrible, terrible word. What a terrible brand. Coin – take the most abstract form of money we've ever created that is based on a completely decentralized network that has no coins and then name it Bitcoin. Just to confuse everyone.

> (Antonopolous, quoted in Torpey 2015)

Blockchain is thus a database with a complicated updating procedure, managed by a network of participating computers, each of which holds a copy of the database in toto. Because it gained prominence with an experiment in digital money, its discursive context is full of metaphors that befuddle it. As Antonopolous exasperatedly remarks, there are no "coins" or representations of digital objects of money in the system. Instead, there are messages indicating transactions in specific amounts of "Bitcoin," marked with digital signatures derived from the cryptographic transformation of a key/message pair. Each new transaction depends on a prior transaction, not the identity of a prior transacting party. In fact, unlike 3QwcnREdSxefKhweCiRwzcwU7f9zSaDV4k, I do not need to use the same public/private key combination each time I want to transact. The system does not require it. I can create a new key pair for each transaction (and, indeed, if I am really interested in maintaining anonymity, this is what I should do, otherwise a clever computational agent could deduce my identity based on the reused public key's prior transactions). But people tend to reuse the same key pair because they think of it as a username.

As a networked communicative infrastructure in which digital chains of custody are established among key/message units, themselves bundled together and encrypted as a unit that forms the basis of the next entry in the database, blockchain can be metaphorized as a distributed ledger – as I (Maurer 2017) and many in the blockchain community have done, particularly as the technology gained some legitimacy and investors shied away from words like "cryptocurrency" or even "blockchain" itself – but even this, as Antonopolous would say, is a broken metaphor. Again, as noted earlier, a distributed ledger would be a ledger that is divided up into pieces, the pieces distributed among a network of computers, with the whole knowable only through the participation of each node in the network sharing with the others its own, unique piece. In the case of the Bitcoin blockchain, however, every full node in the network has the complete ledger. It is more of a massively replicated ledger than a distributed one.

Market models in the code

The transaction verification system called "mining" provides a window into the politics of code. Most blockchain systems rely on what is called a proof-of-work system in order for miners to have the privilege to verify a transaction. To verify a transaction, a node takes the proposed transaction (actually a hash or digital fingerprint of the proposed transaction) and is provided an output of a complex computational operation. The node has to "guess" the inputs to this operation that will generate that output. One of the inputs is the hash of the transaction itself. The other is referred to as a "nonce" from a term for anything that has only one purpose. (Think Chaucer: "A cook they hadde with hem for the nones/To boille the chiknes with the marybones" [A cook they had with them for the sole purpose of boiling the chickens with the marrow bones]). Miners go through a process of guessing the nonce to generate the predetermined, correct output. They could

verify the transaction without this step. Proof-of-work makes the process more difficult and raises the stakes in incentivizing transaction verification: the faster I can run through potential solutions to the nonce, using more and more computational power, the greater my chances of finding it. Miners who find the nonce – and post the hashed transaction to the blockchain, where it is then verified by all the other miners (who can just take the correct nonce and plug it in to see that indeed it generates the correct output) – are rewarded in new Bitcoin. The system was set up to increase in difficulty as the maximum 21 million Bitcoin limit is reached.

The process consumes great quantities of computational cycles and electricity. By 2017 it had become common in blockchain circles to worry about all that electricity, and in that year it was reported (Digiconomist 2017) that the Bitcoin blockchain ranked between Denmark and Ireland in terms of total energy consumption. But why go to all the trouble? The answer lies more in ideological commitments than technology.

In 1993, Cynthia Dwork and Moni Naor proposed a proof-of-work system to solve a problem besetting early electronic mail. Email was "free" of cost to the sender – there was no monetary price attached to sending an individual email, even if Internet service providers charged for access to the network. In the early days of email, advertisers and other bulk users of email could exploit its lack of a monetary price and send thousands or even millions of messages. Spam was born. Dwork and Naor proposed an ingenious solution to the spam problem: attach a price to every email and require receiving servers to verify that that price had been paid. The price was not monetary, but computational. They devised a system that demanded a tiny bit of extra computational work to be conducted in order to send each email. For the individual user sending messages on the order of scores or hundreds, this extra computational effort would go unnoticed – in terms of computational speed or central processing unit cycles devoted to the task or in terms of electricity consumption (or its byproduct, heat generation). To a spammer, however, proof-of-work would impose a real cost in computational time, electricity, and heat, rendering it less profitable.

Dwork and Naor treated email like a commons pool resource, and wrote in code a strategy for dealing with it in much the same way that economist Garrett Hardin (1968) proposed a solution to the so-called tragedy of the commons. Arguing that free access to commons pool resources will inevitably lead to their degradation and depletion since each self-interested economically rational agent will try to take for itself as much as it can get, Hardin proposed putting a price on and creating markets in common goods. Left unexamined was the possibility of public, cooperative, or collective ownership or management of such resources, arrangements anthropologists have documented (see Agarwal 2003 for a review).

Other market models inform blockchain systems. The consensus model is essentially a derivative of earlier explicitly market-based systems for allocating computational resources. Mark Miller and Eric Drexler, two computer scientists who cite the impact of Austrian school economics on their thinking, devised what they called "agoric systems" for computational resource management, a

market-derived allocation or bidding system (Miller and Drexler 1988). Vitalik Buterin, founder of Ethereum, and others in the blockchain community adopted the language of agoric systems for their own projects, especially voting or blockchain-based governance-without-government projects.

That libertarian market models inform blockchain systems should not be that much of a surprise, given their origins in communities of coders whom Swartz loosely groups under the term crypto-anarchy. Most blockchain systems have relied on achieving consensus on transactional validity through monetarily incentivized competition. Or, "monetarily," since the "money" here is not state-issued currency but chains of custody in digital message/signature combinations that are imagined as monetary tokens.

But there's more. Because of the way blockchain solves the double-spend problem, every transaction has to be treated as unique and singular (see Dallyn 2017, following Karpik 2010 on economic singularities). And now we come to how Bitcoin's digital metallism, its adherence to a theory of money aligned with the gold standard, is in the details of the code itself. As we saw previously with our friend 3QwcnREdSxefKhweCiRwzcwU7f9zSaDV4k, most Bitcoin transactions are dual. What is happening is that the algorithm searches for an unused message/signature of a certain denomination or value in Bitcoin (and unspent transaction output, or UTXO – the output from a prior unique transaction that has not yet been attached to a new message indicating a new transaction). It then initiates two transactions: one in the amount of the intended transfer, and the other in the amount of the "change" from this transaction, which is then "paid back" to the address initiating the transaction. This operation sutures the metaphorical relationship between Bitcoin or any cryptocurrency modeled on it to a physical world commodity. It makes it make sense to say that every "piece" of Bitcoin is itself unique. It is as if one party has a digital rock that has to be broken into two pieces in order for the one piece of the intended value to be transferred to another party. The other piece, the remainder, is transferred back to the first party. So even if a user goes beyond the metaphors Antonopolous decried and digs into the code itself, one finds operations that lend themselves to the identification of messages/signatures with a physical hunk of gold.

It is also ironic that such messages/signatures can be thought of in money terms probably only because of the existence of exchanges – the new intermediaries of the blockchain world. These exchanges allow users to purchase rights to those chains of messages/signatures, using state-issued money. Participants envision such transactions as taking a token "out" of the blockchain system – when what has really been taken out, or taken anywhere, is state-issued money from one user's bank account to another.

Other models than proof-of-work operate in blockchain systems, some to mitigate the energy problem, others to recentralize blockchains among a narrower set of "peers." So-called permissioned systems are often closed to outside parties and work according to a buy-in or "proof-of-stake" model. But lest the economic singularity of a Bitcoin transaction be seen as far outside the mainstream, contemporary EMV (Eurostar/Mastercard/Visa) transactions – using a chip embedded in a

plastic card to authorize credit and debit card transactions – also generate a unique identifier for each and every transaction (see Maurer, 2020). Digital records of such transactions will likely also puzzle our future archaeologist.

Anarchists and mutualists

Nakamoto's solution to the double-spend problem was thick with a specific ideology of money and of governance. That Nakamoto wanted to obviate the need for a third-party intermediary and instead establish a peer-to-peer system speaks to longstanding and specifically American criticism of banking institutions and central banks in particular. Much has been made of the link between Bitcoin and right-wing libertarian political thinking (Golumbia 2016; Brunton 2019), as well as the message hidden in the so-called genesis block – the first block of Bitcoin transactions – which has been interpreted as a criticism of banking institutions in light of their role in the 2008 global financial crisis (GFC): "The Times 03/Jan/2009 Chancellor on brink of second bailout for banks," referencing the headline of the Financial Times for 3 January 2009. For Nakamoto's part, the original whitepaper discusses money in relation to a "mint" (Nakamoto 2008:2), that is, a government entity which produces the money, not a bank which serves as an intermediary among transactors. Golumbia traces Bitcoin's right-wing ideology to anti–Federal Reserve conspiracy theories from the 1950s (Golumbia 2016:19), but ever since its founding in 1913 the United States' central bank has been seen as an example of federal overreach if not downright tyranny (Medley 2014:54–56). Tyranny and liberty are twinned in the lexicon of right-wing extremism in the United States (Golumbia 2016:11). Nakamoto's early readers embedded a conversation over "liberty" into a plan for a new money.

There are least two overlapping social sources for this concern with money and liberty. As Lana Swartz (2018) explains, one is the community of "cypherpunks" advocating privacy in digital networks. Realizing the potential for digital communications networks to create a new panopticon for corporations and governments to peer into anyone's digital identity, contacts, movements, and activities, cypherpunks sought to give humans the ability to control access to their digital data trails. Their focus was on building "shared communication systems that would form the basis of a new society predicated on privacy" (Swartz 2018:626).

The other is the community of "crypto-anarchists" advocating freedom from state constraints in all affairs. Technologically inspired libertarians saw in noncentralized digital networks like the Internet the possibility of freedom from any state control over anything, from communication to individual decision-making to economic exchange. In order to hold onto this dream, of course, they had to deny the role of the state in helping create and maintain infrastructures, to say nothing of the electricity grid and other systems necessary to facilitate digital networks.

Swartz further identifies two approaches to cryptocurrencies and blockchains emanating from these two overlapping social groups. The first emphasizes the work of building privacy-focused (digital) institutions and infrastructures and the collaborative, collective maintenance of such institutions and infrastructures.

The second emphasizes an imagination of money as existing outside and beyond the state and its infrastructures, given by the nature of the cryptographic protocols involved in systems like Bitcoin and subject to "natural" constraints explicitly modeled on gold. The former she terms infrastructural mutualism. The latter, as I've been using it in this chapter, is digital metallism (see also Maurer, Nelms, and Swartz 2013).

Swartz's analysis is instructive for illuminating the loosely organized social movements behind blockchain, given that there remain few social scientific studies of its actual user base (but, for an early attempt, see Lustig and Nardi 2015). It also helps separate out how blockchain has unfolded between 2008 and 2018, as the tendencies toward emphasizing the collaborative coordination and upkeep of digital distributed databases on the one hand and the making of digital cash on the other have vied for prominence. In 2014, Swartz, Nelms, and I were pretty confident that the former would win out. The networks of people involved in cryptocurrencies and blockchain work seemed to be professionalizing; new companies were forming and existing companies including the major investment banks (Maurer 2016) and payment providers (like Visa and MasterCard, among others) had begun looking at blockchain to trim financial clearance and settlement times, solve complex coordination and collateralization problems in securities trading, or speed crossborder money transfers. While not necessarily "mutualist," these were surely infrastructure builders, thinking about blockchain as the next wave of digital infrastructure for record-keeping and facilitating transactions of all kinds. Ethereum, a blockchain system released in 2015 and focused on these sorts of infrastructure and coordination problems, seemed to represent a step in the same direction.

Yet Ethereum, like most blockchain systems up to 2018, relied on a similar incentive structure for participating nodes in the network to validate transactions. And that incentive – in the case of Ethereum and most other blockchain systems – was metaphorically represented as a valuable token or currency-like unit. This sets up the system as more money-like than mutualist. That different blockchains' tokens are convertible into one another and into state-issued currencies only made the association between them and "money" even tighter. Announcements of major investments by established and recognizable global companies like IBM, Intel, JP Morgan, and Walmart lent legitimacy to the endeavor; more people – now "investors" – literally bought in, not by participating in the work of maintaining the database by becoming a node but simply by buying the digital units associated with a blockchain on an exchange.

In 2017, the prices of all extant cryptocurrencies skyrocketed. Startups got into the act, and many people with a programming background, in the payments industry, and in banking and financial services and other sectors realized they had better chances of raising funds for a new venture by floating a blockchain project than seeking venture capital from traditional Silicon Valley or Wall Street firms. They solicited investors who would purchase (sometimes pre-purchase) the digital tokens that form the basis for reward in their blockchain's proof-of-work system. This was the birth of the International Coin Offering (ICO) phenomenon,

modeled on startups' initial public offerings – and soon the target of regulators concerned that ICOs resembled nothing so much as unregistered sales of unauthorized securities. Regardless, an ICO bubble ensued with projects ranging from the plausible – systems using blockchain to track the provenance of baby food to ensure it is not counterfeit – to ridiculous – "DentaCoin," for people to win a cryptocurrency for posting reviews of dentists, or celebrity-branded "coins" with no discernable purpose like CentraCoin, backed by music personality DJ Khaled and the boxer Floyd Mayweather Jr. and which ran afoul of securities regulators.

The bubble began to burst in late 2018. Journalists began to sound the death knell. Yet this had happened before, when the first Bitcoin bubble saw the currency trading at US$1,000 in November 2013, before falling again to around $200 throughout the next 18 months. It seems premature to write off the phenomenon just yet. And indeed, in early 2021, in the midst of the coronavirus pandemic, its price skyrocketed.

Swartz argues that Bitcoin will remain interesting for social science and critical inquiry because it crystallized early 21st-century technoeconomic imaginaries. It is also a convening technology, bringing together diverse constituencies that otherwise might never have met, such as experimental artists, money utopians, and investment bankers – literally in the same physical space (Baym, Swartz, and Alarcon 2019). The post-2008 financial crisis world opened up established verities for political contestation. From banks to governments to the tenets of liberalism and the global capitalist economic order themselves, institutions that had been relatively secure in their position and authority since the end of World War II have been questioned by increasingly vocal and powerful populist and anti-state movements and agents. Again, digital networks seem to lend themselves to unleashing reformation or outright dismantling of these institutions, and many diverse constituencies want to get in on the act, not least because the stock market went "sideways," as an informant put it to me, after the financial crisis. Renewed skepticism of banks and regulatory agencies alike put wind in the sails of libertarians. Digital networks seemingly allow direct, unmediated communication, "peer" connection without the intercession of gatekeepers, filters, or agents to authorize this or that perspective or organization. In reality, of course, digital networks themselves are newly empowered intermediaries whose power derives precisely because it is masked by the ideology of pure "peer" connection, or of being exactly and without remainder or externality "the social network" entire.

Blockchain is interesting in this context because even though it may have inspired a frenzy of intellectual and financial speculation, and even though it is tethered to these ideologies of disintermediation and populism, it is not a free-for-all. Quite the contrary. Blockchain purports to provide a means for a distributed, decentralized network of computational agents to create and maintain a "permanent, verifiable, unalterable version of truth." I put these words in quotation marks because they are so frequently intoned but – appropriately, perhaps – I do not believe there is one authoritative source to which it could be attributed. The phrase is so commonplace as to serve as a creed or incantation, calling forth, abracadabra, the truth it names.

Blockchain anthropology

I have tried to hint at why this should be interesting for anthropology along the way. Blockchain tugs at several longstanding concerns of the field, from the nature and politics of money, to the creation and negotiation of the commons, to the culture of the copy and the problem of authenticity.

Digging into the blockchain helps illuminate how people think about the digital and money together and the shifting cultural politics of the institutions and infrastructures of money. My colleagues and I have argued that things like blockchain and associated payments industry attempts to disintermediate established payment providers and the banks are opening up for discussion both the nature of money and the nature of the social. After all, what is a society of "peers," or of "just us" (Future of Money Research Collaborative 2018)? Current challenges to liberal world orders seem to bear out the contemporary viability of anarcho-nihilist political positions and the idea of a future non-society of atomistic individuals whose associations are purely transactional.

Anthropologists have also started happening upon people around the world actually using blockchain and cryptocurrencies, sometimes with surprising reversals of the ideological positions on which they are founded. Most of this work is not yet published. For example, late in 2017, Peter Graif reports, the Nepali authorities arrested several Bitcoin miners and the owners of BitSewa, the country's most prominent cryptocurrency exchange. People in general held negative views of miners since they were seen as enriching themselves using publicly subsidized electricity. But unlike the US, where cryptocurrencies are not really used to buy things, in Nepal people purchased digital goods online from the US, Singapore, and Europe with them. Cryptocurrency enthusiasts had formed small, rather intimate social groups, meeting at coffee shops in order to get around the country's foreign exchange controls. A system designed to be purely digital and anonymous instead fostered a new kind of in-person community. In this context, however, exchangers like BitSewa faced another criticism than just their use of electricity: as they sought out new exchange partners outside those social circles, they were seen as breaking the trust of these nascent communities. Graif reports that one of his interlocutors said, horrified, "They were selling bitcoin to people they don't even know." In Nepal, he writes, Bitcoin forms new social ties while permitting "access to anonymous markets outside Nepal" (Graif, personal communication, December 2018).

Taylor Nelms (2015), working in Ecuador, writes of the "monetary mixup" that took place when the Ecuadorean and global press mistook an Ecuadorean state mobile money project for both a blockchain-based project and a state ban on Bitcoin. It was neither. Nelms shows, however, how the debate tapped into long-simmering questions about the endurance of value after Ecuador's dollarization. Gretchen Bakke found that small-scale energy producers imagine blockchain-based systems for "transactive energy" to facilitate a new, distributed, and decentralized grid (personal communication, November 2018). Elizabeth Ferry,

working on gold, asks how gold's capacity to be a sign is based on its claim not to be a sign at all (2016:77) and that claims about Bitcoin as existing only in the code or being governed in a non-governing, trustless system, replicate that claim.

In allied fields adjacent to anthropology, scholars are considering utopian blockchain dreams in cooperative movements – and what happens in practice (Feria 2019), as well as blockchain's potential for fostering a kind of economic plurality. Plurality, however, might also encompass forms like slavery – and in my own research I have repeatedly come upon explicit and implicit invocations of a future world of enslaved computational agents managed by distributed ledger systems.

These examples show that although blockchain has primarily been located not so much in globally distributed computer networks as in the contemporary metropolitan centers of computational power – the US, Europe, and increasingly China – it has been taken up for various projects around the world. Its meanings and practices are reconfigured in the process, and some of its precepts, like anonymity, are reset, much as anthropologists have found for other money and accounting technologies.

This brings me back to my initial claim about blockchain as an accounting technology and toward a query for my imagined future archaeologist. Renaissance double-entry bookkeeping provided a vision of truth. It derived from a specific moral order (the subject as orator of his moral progress, as discussed by Aho 2006), instituted a new way of understanding "facts" (as discussed by Poovey 1998), and centrally animated the economic relations of capitalism. These relations found their fullest form – relying crucially on double entry – in the transatlantic slave trade (see Baucom 2005).

Blockchain also provides a vision of truth and derives from a specific moral order, arising in technolibertarian or anarcho-libertarian philosophies and deriving from very specific notions of the economy as agoric (which is, after all, an evocation of ancient Greek systems of political domination and enslavement, see Maurer 2020). They create a new regime of facticity, allowing for the imagination of everything as a singular, discrete unit of information that can be permanently, unalterably recorded on a distributed ledger that everyone can see and that can exist on every computational device of sufficient power.

This is not the panopticon, however. Rather than one central seeing point or place of perspective, the evidence of the fact can be "everywhere," available to all, and eternal, in a massively replicated database held by potentially "everyone" – or at least every computer with enough storage to hold it. But it is not radically democratic. The political morality is complicated. It obviates the relations of control that older systems instituted. What does it institute in their place? In supply chains or electricity management, for example, blockchain can permit multiple, radically different systems to exist on the "input" side without the need for standardization. So long as relevant data can be entered into a distributed ledger, existence can be recorded and thereafter forever tracked as verified and true. How something came to be is immaterial, if the mere fact of being is what is at stake. Blockchain can thus provide a platform for plural and alternative economies to interoperate. This

means, in theory, we can have both communal, regenerative agriculture and plantation slavery, each creating organic food (for example) easily accommodated in the same universe. We can get our agricultural produce, our manufactured goods, our oil, knowing what it is, where it came from, that it is "true" and has remained true, without having to police its production. Rather than a center that has to "see" everything, blockchain institutes a world where the fringes of the network – the moment when what we imagine to be material is recorded with its digital double – are the crucial places in it.

Second, blockchain allows other sorts of computational agents to start doing various kinds of work. One area of development is in so-called smart contracts. A smart contract is a distributed application, executable code in a blockchain. When certain changes in state in the physical or digital world meet certain predetermined requirements, the code runs. For example, when sensors confirm that the temperature in a shipping container has been maintained at a predetermined constant without interruption from Time A to Time B, and the shipping container has arrived in port, and a commodity price reaches a certain level, and a corporate account has the required reserve, a smart contract can issue a payment or transfer title without the intervention of any human or institutional intermediary.

Heralding automaticity does not of course mean the liberation of human labor. It raises twinned questions tied to the history of accounting: what happens to the abjected human whose physical labor is obviated by technologies of automaticity or to global, racial, and gendered hierarchies of human labor when some machines run smarter than others? And what happens to the new computational agents, presumably getting "smarter" themselves as they learn from their data-rich environments, and operating as legal actors? Listening to some of its most starry-eyed proponents, I often wonder whether blockchain might institute both human and computational slavery as part of the distributed universe of economic plurality. For me, blockchain occasions speculative fantasies about future heterogeneous human/computational economies.

Just science fiction, I know. But then: how, future archaeologist, are you conducting your work, through what human-computer agencies, and with what attendant or squashed liberties?

Acknowledgments

Research was supported by grants from the US National Science Foundation, Law and Social Sciences program (SES 1455859 and SES 0960423). Any opinions, findings, and conclusions or recommendations expressed in this material are those of the author(s) and do not necessarily reflect the views of the National Science Foundation. I would like to thank the editors for the invitation to contribute this chapter as well as for comments on earlier drafts. I would also like to thank my colleagues who are also working on blockchain and allied systems, particularly Quinn DuPont, Lana Swartz, Taylor Nelms, Elizabeth Ferry, Peter Graif, and Gretchen Bakke. Special thanks to Jenny Fan, Farah Qureshi, Melissa Wrapp, Nathan Dobson, and Nima Yolmo for research assistance along the way.

Note

1 Satoshi Nakamoto. 2009. Original code for Bitcoin. The code is at present maintained on GitHub, a web-based hosting site for code developers to share and maintain version control over computer code, by Leo Trottier, whose "original-bitcoin" repository is "a historical repository of Satoshi Nakamoto's original bitcoin sourcecode." Available at https://github.com/trottier/original-bitcoin, last accessed 8 October 2018.

References cited

Agarwal, Arun. 2003. Sustainable Governance of Common Pool Resources: Contexts, Methods, and Politics. *Annual Review of Anthropology* 32: 243–262.

Aho, James. 2006. *Confession and Bookkeeping: The Religious, Moral, and Rhetorical Roots of Modern Accounting.* Albany, NY: SUNY Press.

Baucom, Ian. 2005. *Specters of the Atlantic: Finance Capital, Slavery, and the Philosophy of History.* Durham, NC: Duke University Press.

Baym, Nancy, Lana Swartz, and Andrea Alarcon. 2019. Convening Technologies: Blockchain and the Music Industry. *International Journal of Communication* 13: 402–421.

Bell, Joshua A., and Joel C. Kuipers, eds. 2018. *Linguistic and Material Intimacies of Cell Phones.* New York: Routledge.

Benjamin, Walter. 1936 [2008]. *The Work of Art in the Age of Mechanical Reproduction.* New York: Penguin.

Blanchette, Jean-Francois. 2012. *Burdens of Proof: Cryptographic Culture and Evidence Law in the Age of Electronic Documents.* Cambridge, MA: MIT Press.

Brunton, Finn. 2017. Notes from /Dev/Null. *Internet Histories* 1(1–2): 138–145.

———. 2019. *Digital Cash: The Unknown History of the Anarchists, Utopians, and Technologists Who Created Cryptocurrency.* Princeton, NJ: Princeton University Press.

Dallyn, S. 2017. Cryptocurrencies as Market Singularities: The Strange Case of Bitcoin. *Journal of Cultural Economy* 10(5): 462–473.

Digiconomist. 2017. Bitcoin's Energy Consumption Surpasses Ireland. *Digiconomist*, 14 November. Available at: https://digiconomist.net/bitcoin-energy-consumption-surpasses-ireland, last accessed 26 January 2019.

Dourish, Paul. 2017. *The Stuff of Bits: An Essay on the Materialities of Information.* Cambridge, MA: MIT Press.

DuPont, Quinn. 2018. *Cryptocurrencies and Blockchains.* London: Polity.

Dwork, Cynthia, and Moni Naor. 1993. Pricing via Processing or Combatting Junk Mail. In: E.F. Brickell (ed.), *Advances in Cryptology – CRYPTO'92.* Lecture Notes in Computer Science, vol. 740. Berlin, Heidelberg: Springer, 139–147.

Errington, Shelly. 1998. *The Death of Authentic Primitive Art and Other Tales of Progress.* Berkeley: University of California Press.

Feria, Inês. 2019. Trust, Reputation and Ambiguous Freedoms: Financial Institutions and Subversive Libertarians Navigating Blockchain, Markets, and Regulation. *Journal of Cultural Economy* 12.

Ferry, Elizabeth. 2016. On not Being a Sign: Gold's Semiotic Claims. *Signs and Society* 4(1): 57–79.

Foster, Robert. 1999. In God We Trust? The Legitimacy of Melanesian Currencies. In: David Akins and Joel Robbins (eds.), *Money and Modernity: State and Local Currencies in Melanesia.* Pittsburgh, PA: University of Pittsburgh Press, 214–231.

Future of Money Research Collaborative. 2018. Social Payments: Innovation, Trust, Bitcoin, and the Sharing Economy. *Theory, Culture and Society* 35(3): 13–33.

Geismar, Haidy. 2013. *Treasured Possessions: Indigenous Interventions into Cultural and Intellectual Property*. Durham, NC: Duke University Press.

Golumbia, David. 2016. *The Politics of Bitcoin: Software as Right-Wing Extremism*. Minneapolis, MN: University of Minnesota Press.

Gregory, C.A. 1996. Cowries and Conquest: Towards a Subalternate Quality Theory of Money. *Comparative Studies in Society and History* 38(2): 195–217.

Hardin, Garrett. 1968. The Tragedy of the Commons. *Science, New Series* 162(3859): 1243–1248, 13 December.

Hayek, F.A. 1976. *The Denationalization of Money*. London: Institute of Economic Affairs.

Karpik, Lucien. 2010. *Valuing the Unique: The Economics of Singularities*. Princeton, NJ: Princeton University Press.

Lustig, Caitie, and Bonnie Nardi. 2015. *Algorithmic Authority: The Case of Bitcoin*. IEEE Computer Society, presented at the 48th Hawaii International Conference on System Sciences, Kauai. doi:10.1109/HICSS.2015.95.

Maurer, Bill. 2016. Re-Risking in Real Time: On Possible Futures for Finance After the Blockchain. *Behemoth* 9(2). doi:10.6094/behemoth.2016.9.2.917.

———. 2017. Money as Token and Money as Record in Distributed Accounts. In: N.J. Enfield and Paul Kockelman (eds.), *Distributed Agency*. Oxford: Oxford University Press.

———. 2018. Primitive and Nonmetallic Money. In: S. Battilossi, Y. Cassis, and K. Yago (eds.), *Handbook of the History of Money and Currency*. Singapore: Springer. doi:10.1007/978-981-10-0622-7_2-1.

———. 2020. The Politics of Token Economics, Then and Now. In: A. Crisà A., M. Gkikaki, and C. Rowan (eds.), *Tokens: Culture, Connections, Communities*. London: Royal Numismatic Society, 215–229.

Maurer, Bill, Taylor Nelms, and Lana Swartz. 2013. 'When Perhaps the Real Problem Is Money Itself!' The Practical Materiality of Bitcoin. *Social Semiotics* 23(2): 261–277.

Medley, Bill. 2014. *Highways of Commerce: Central Banking and the US Payments System*. Kansas City: Federal Reserve Bank of Kansas City.

Myers, Fred. 2002. *Painting Culture: The Making of an Aboriginal High Art*. Durham, NC: Duke University Press.

Miller, Mark S., and K. Eric Drexler. 1988. Incentive Engineering: For Computational Resource Management. In: Bernardo Huberman (ed.), *The Ecology of Computation*. North-Holland: Elsevier Science Publishers.

Nakamoto, S. 2008. *Bitcoin: A Peer-to-Peer Electronic Cash System*. Available at: https://bitcoin.org/bitcoin.pdf, last accessed 26 January 2019.

Nelms, Taylor. 2015. 'Ecuador Bans Bitcoin!' A Monetary Mixup. *The King's Review*, 20 October. Available at http://kingsreview.co.uk/articles/ecuador-bans-bitcoin-a-monetary-mix-up/, last accessed 26 January 2019.

Poovey, Mary. 1998. *A History of the Modern Fact*. Chicago: University of Chicago Press.

Price, Sally. 2002. *Primitive Art in Civilized Places*. Chicago: University of Chicago Press.

Shell, Marc. 1978 [1993]. *The Economy of Literature*. Baltimore, MD: Johns Hopkins University Press.

Strathern, Marilyn. 1975. *No Money on Our Skins*. Canberra: New Guinea Research Unit, Australian National University.

———. 2013. *Learning to See in Melanesia*. Chicago: HAU Books.

Swartz, Lana. 2018. What Was Bitcoin, What Will It Be? The Technoeconomic Imaginaries of a New Money Technology. *Cultural Studies* 32(4): 623–650.

Torpey, Kyle. 2015. Andreas Antonopoulos: Bitcoin Terminology Is Completely Broken. *Inside Bitcoins*, 2 September. Available at https://insidebitcoins.com/news/andreas-antonopoulos-bitcoin-terminology-is-completely-broken/34641, last accessed 1 December 2018.

Zimmer, Zac. 2017. Bitcoin and Potosí Silver: Historical Perspectives on Cryptocurrency. *Technology and Culture* 58(2): 307–334.

12 Digital economy and labor

Iris Bull and Ilana Gershon

When people consider how digital workers live, they often imagine workers who rarely, if ever, have to go to an office. In this imaginary, the Internet enables people to set their own on-the-clock hours, even parenting while working from home. By leaving an Initech-like corporate environment, workers are believed to have greater freedom in their professional and personal lives.[1] Sometimes people assume that special pleasures and privileges come from running a business online, streaming gameplay to Twitch.tv, or working for a firm like Google. It is easy to overlook how the obligations that come with working digitally make it difficult for people to separate work and home life, start a family, or take medical leave.

For several decades, scholars across disciplines have critiqued these assumptions about computer-mediated life. Occasionally, scholarly work influenced popular discourses about moderating conduct online or cultivating emerging high-tech businesses to seed urban development. In this chapter we review some of that literature, which for many scholars has tended to come from and be about regions in North America and Europe. We will focus on popular beliefs that shape industry and academic perspectives of digital work, and we will review three types of field sites that often guide critical inquiry into modern practices of working with and through digital technologies: corporate culture in Silicon Valley, online work distribution platforms, and virtual games. In each case, scholars have challenged popular ideas about digital work in their disciplines, exploring how computers shape contemporary working relationships between people and technologies across the world.

Popular imaginaries from Silicon Valley about digital work

Many popular ideas about digital work tend to come from a persistent focus on 'creatives' – a specific subgroup of people involved in developing and promoting computing technologies. These are the people who do things with information communication technologies (ICTs) at a technical and 'creative' level – they might design computer software, manage online communities, or tell multimedia stories. Some view working as a creative as the ideal, which shapes all their educational choices. For others, it is an alternative escape-hatch career choice that anyone can adopt to escape unemployment or manual service work. News headlines such as

"Florida man says he went from homeless to millionaire by investing in Bitcoin," or "Second Life realtor makes $1 million" create the impression that working in the digital information economy can be lucrative, even for the unskilled (WFTX Webstaff 2018; Boyes 2006). In almost every case, these kinds of jobs seem like reasonable alternatives to manual labor and service work in cities that were once built around factories.

These narratives about creatives have been especially appealing to the people in charge of growing local economies for the better part of the past 30 years, but commitment to these popular myths reached a kind of fever pitch in the early 2000s. Scholars, Silicon Valley capitalists, and others responded to decades of major corporations outsourcing and relocating factories overseas and across national borders, by finding ideas like the 'knowledge economy' and 'information economy' especially compelling as a way to frame post-factory-era work in places like the United States. Generally speaking, many Americans, Australians, and Europeans have come to believe that creative jobs could be a replacement for factory work of a bygone era. Whatever creatives may actually do in practice, the stories about them tend to involve a progressive Silicon Valley culture that enables anyone to make money from the merit of their good ideas.

Richard Florida may be the most influential thinker among a bevy of public intellectuals who cultivate a reputation for envisioning a utopic future of work on the World Wide Web. In the early 2000s, Florida was an urban studies scholar with a simple and inflammatory thesis: "regional economic growth is driven by the location choices of creative people – the holders of creative capital – who prefer places that are diverse, tolerant and open to new ideas" (2002: 223). From Florida's perspective, modern companies were beholden to the desires of creatives whose capacity for creativity "cannot be bought and sold, or turned on and off at will" (2002: 5). Although widely critiqued, his ideas about the 'creative class' validated some progressive stereotypes about young people, while offering relatively simple policy recommendations for urban developers in the US and across Europe (Sternberg 2013; Long 2009: 210). Florida argued that city planners should develop social and material infrastructures that would appeal to creatives and thus attract modern companies.

Florida uncritically simplified why tech companies like Apple thought it would be profitable to exploit white-collar, creative labor of people concentrated in "hippy havens" – places where businessmen were willing to appropriate the ideals and practices of "eccentric technology types from Berkeley and Stanford" (2002: 204–205). In these havens, Florida argued, high-tech firms and industries fuse Bohemian values and Protestant work ethics – "the creative ethos" – into a motivating force that could then be reproduced in most work environments appealing to consumer culture lifestyles (2002: 207). Urban developers even implemented several of his recommendations, but what he predicted in his earlier volume did not in fact happen, as many scholars have since observed (Sternberg 2013: 308; Krätke 2010: 2; Peck 2005: 759). Under closer scrutiny, Florida's argument was flawed because he appropriated superficial aspects of mid-century software and computing cultural history and naturalized the success stories of Silicon Valley

elites in a misguided effort to advocate for the contemporary adoption of progressive spatial and microeconomic development policies.

Florida's positive outlook on the role of creatives is just one canonical example of widespread sociotechnical imaginaries about digital technologies and the people who use them. According to Jasanoff and Kim, sociotechnical imaginaries are "collectively imagined forms of social life and social order reflected in the design and fulfillment of nation-specific scientific and/or technological projects" (2009: 120). These imaginaries underpin normative arguments about personal agency and technological power, and they reflect commonly expressed ideologies about the future of digital technologies and the people who wield them. Two of these imaginaries are techno-utopianism and techno-libertarianism. Techno-utopianism is also known sometimes as technological determinism; it is a belief that technologies can solve problems that people perceive in society. Techno-libertarianism is an economic and political philosophy that combines libertarian ideals and free-market political principles, especially in the context of e-commerce, a term first coined by Paulina Borsook (Borsook 2000: 2; Steinmetz and Gerber 2015: 32). Early scholarship tended to conflate techno-utopianism and techno-libertarianism under the moniker "the Californian Ideology" referring to the "free-wheeling spirit of the hippies and the entrepreneurial zeal of the yuppies" whose beliefs seemed to shape how high-tech industries connected to Silicon Valley developed between 1960 and 1996 (Barbrook and Cameron 1996). In tandem, techno-utopianism and techno-libertarianism encourage scientists and business professionals to solve social problems by investing, developing, and distributing technologies because all these technologies will presumably eliminate barriers to social progress and ease social conflict. These scientists and business people believe that once the technology has been invented, the only dilemma is ensuring that people will access it. Once people have access, either they will solve the problem themselves or the technology will solve the problem for them. Historians of technology would be quick to point out that techno-utopianism and techno-literarianism are much older than the digital revolution – no one in Silicon Valley invented them; however, these ideas' popularity helps to explain changes in people's attitudes towards digital work and computing technologies over the course of the 20th century (English-Lueck 2017; Toyama 2015; Ensmenger 2010; Turner 2010).

Historically, ethnographic and historical studies of digital work have tended to study personal computing and digital work in Western nations, and thus also engaging with Western presuppositions about the nature of work and freedom. While today it may be rather commonplace for some people to think of personal computers as symbols of personal freedom, scholars such as Paul Edwards and Fred Turner remind us that this was not always so. During the Cold War, computers were typically portrayed as symbols of militarized command and control in the United States. Public anxieties about these technologies often appeared in popular films such as *2001: A Space Odyssey* (1968), *Star Wars* (1977), and *The Terminator* (1984) – stories about people fighting against a dominating system guarded and empowered by technology (Edwards 1997: 311). During and immediately following the Cold War, this rhetoric slowly shifted from a closed-world discourse

to a techno-utopian vision that held that the ever-proliferating computers heralded the arrival of a "decentralized, egalitarian, harmonious, and free" society (Turner 2010: 1, 16; Edwards 1997: xiii). How does one explain this transformation? For Turner, nothing about this ideological shift was natural, and he writes, "there is nothing about a computer or a computer network that *necessarily* requires that it level organizational structures, render the individual more psychologically whole, or drive the establishment of intimate, though geographically distributed, communities" (2010: 3, emphasis in original). People's media ideologies of computers were not determined by properties inherent in the devices or people's rational preferences for the best technologies available at the time.

People do not suddenly decide to think differently about computer-mediated forms of communication; someone or some group need to help create widespread shared beliefs and practices through collective action. This collective effort requires more than just the virality of a good idea; the idea has to be supported by complementary infrastructure so that these ideas can be realized in a material form. The popular social media platform Twitter, for example, could ask that all users limit how much they share with a single tweet. They could ask very nicely. But, most people won't do so or won't know to limit the number of words or characters in a tweet without a hard limit on what is allowed. Engineers at Twitter can make it easier for users to evaluate their tweets before sharing by providing them with a graphical representation of how many characters have been used in a drafted tweet. In this case, engineers are trying to ensure that adopters' ideological beliefs and expectations about Twitter complement how they designed the infrastructure for the communication medium. This too is a form of digital labor that has to accompany recently introduced technologies so that more people will be willing to adopt these media.

Contemporary Silicon Valley culture is now widespread in part because a select group of very influential entrepreneurs and journalists amplified Silicon Valley's philosophies and social practices by publishing two important periodicals: the *Whole Earth Catalog* (which becomes a seed and model for the first and most influential virtual communities to date and is the brainchild of Stewart Brand) and *Wired* magazine (Turner 2010: 141, 207). The people behind the *Whole Earth Catalog* helped establish widely shared agreements about what work should look like. During initial runs of the publication in 1968–1972, virtually everyone producing the catalog was white, young, financially well-off, and formally educated (Turner 2010: 100). They used the catalog to share information about science, technology, Eastern religions, 'acid mysticism,' and communal social theory; readers also contributed writings that "celebrated entrepreneurial work and heterarchical forms of social organization, promoted disembodied community as an achievable ideal, and suggested that techno-social systems could serve as sites of ecstatic communion" (Turner 2010: 73). The *Whole Earth Catalog* promoted the idea that computers and computer networks could serve as tools for liberation in building society (2010: 72). At the time, liberation was a compelling political project for two reasons. First, many feared living in a society where a person's value correlated with their willingness and capacity to perform standardized, routine

tasks. Second, some believed that many social institutions had become too large and powerful for individuals to self-determine their lives and shape their environments (Turner 2010: 82). Ultimately, the *Whole Earth Catalog* and its online forum, The WELL, modeled 'rhetorical and social infrastructures' – literally, new information systems (magazines, meetings, and online gatherings) that helped legitimate and popularize flat organizational structures, short-term employment contracts, project-based contracting, and neoliberal social networking (Turner 2010: 239).

For digital labor studies scholars, the industry histories of Silicon Valley computer companies and counterculture movements illustrate where popular myths and beliefs about creative work come from, but they also tend to normalize who counts as a digital worker and what counts as digital work. For most historians, the definition of a creative or a digital worker will be shaped by the stories that industry leaders tell themselves because historians rely in part on archive materials for their analysis. As a result, historiographies can sometimes amplify the partial truths inherent in their archival materials. In particular, industry histories tend to selectively attribute credit to people producing a commodity, and they often privilege narratives explaining the success of corporate enterprise through the decisions and experiences of specific people and companies. For example, Silicon Valley origin stories tend to overdetermine the role of 'good ideas' and to ignore the interdependent relationship between computer-dependent workers and other service and manufacturing industries (Ekbia and Nardi 2017: 23; Matthews 2003: 229; Pellow and Park 2002: 3).

Classifying people as digital workers

Why bother with distinguishing workers from digital workers? This analytical quirk has a great deal to do with scholarly approaches to studying work. Many anthropologists studying digital work engage with analytical tools developed by Karl Marx because his framework offers a critical analysis of the logistical operations of businesses. When scholars adopt a Marxian lens, they start to wonder who owns and controls the means of production and how those who own the means of production make use of the labor they purchase from other people, since these kinds of questions reveal power relationships at work. However, Marx's framework is predicated on the operation of farms and factories. For scholars wanting to explain how corporations monetize the Internet, Marx's model requires some adaptation.

In translating Marxist concepts, scholars tend to employ different classification schemes to qualify who they study when they observe digital labor in the field. These different schemes reflect competing interpretations of Marxist thought. Earlier Marxist analyses of creative labor focused on "those forms of labor with an especially strong element of aesthetic, expressive, and informational symbol making" in an effort to maintain Marx's division between artisans and factory workers (Hesmondhalgh and Baker 2011: 382). Following a similarly narrower rubric, digital workers were once thought of as "AOL community leaders, the

open source programmers, the amateur Web designers, mailing list editors, and the NetSlaves willing to 'work for cappuccinos' just for the excitement and the dubious promises of digital work" (Terranova 2000: 51). This scheme largely persists for scholars who follow the Italian autonomist Marxist tradition. Popularized by Hardt and Negri in their well-known volume *Empire*, this school of thought maintains continuity between analyses of factory labor and creative labor (the likes of which are conducted in factories without walls) by analyzing whether value was produced from immaterial labor – activities which produce surplus value, from producing and managing communication, and symbols (Dyer-Witheford and De Peuter 2009; Gill and Pratt 2008, Hardt and Negri 2001). The word 'immaterial' specifically describes activities you wouldn't necessarily see in a factory or on a farm but that are readily observable in an office space or art studio. Factory work might be vulnerable to automation, but immaterial work is not totally resistant to it. Depending on the application, a computer program may allow someone to 'automagically' render unique art, translate between languages, or moderate offensive content. In each cases, the value of work depends upon how well workers make judgements about what is good and bad, right and wrong to ensure that systems function as intended. Studies of immaterial labor offer scholars one way of delineating between types of work using qualities assumed to be inherent to each task, using the idea of individual creativity as an innovative aspect of certain forms of computer-mediated labor (Barada and Primorac 2018: 130). However, critics of this scheme contend that janitors, machine workers, and farmers think creatively when working, even if they aren't compensated for those thoughts directly (Zlolniski 2006: 75). Some scholars argue that valuing work on the basis of whether people think something is creative may lead people to erroneously attribute the success of high-technology or knowledge economy corporations to a few people working at the top of an organization (Nakamura 2014: 936; King 2010: 293).

For those critical of Silicon Valley narratives around labor and success, the definition of digital worker has become more inclusive over time to include working-class people propping up, cleaning up, and otherwise caring for high-tech industry celebrities (Dyer-Witheford 2015: 128). These scholars have studied the global supply chains that support places like Silicon Valley for decades, consistently correlating corporate success in the marketplace with human rights abuses, systemic workplace racism and sexism, chronic fatigue and burnout, favorable intellectual property law domains, and environmental pollution. As Lisa Nakamura has demonstrated, such industry strategies are evident in the archives of Fairchild Semiconductor, a pioneering electronics company whose factories initially produced integrated circuits in North America (2014: 921). Fairchild operated a semiconductor assembly plant in Shiprock, New Mexico, from 1965 to 1975 because management believed that they could exploit "the inherent flexibility and dexterity of the Indians" – whose weaving and silversmithing experience suggested a capacity for producing integrated circuit designs, and who were not protected by United States minimum wage laws (Nakamura 2014: 926).

If, Nakamura argues, we accept Nick Montfort and Ian Bogost's definition of a platform as "whatever the programmer takes for granted when developing, and whatever, from another side, the user is required to have working in order to use particular software," then categorically including Navajo women factory workers in the definition of digital worker honestly accounts for the material conditions required for digital media device creation: the existence of cheap, female labor (2014: 936).

As an analytical strategy for counting the digital worker, studying global supply chains allows scholars to focus on a wide variety of industries and technical jobs. Fuchs and Sandoval acknowledge how broad this analytic can be when they compare the occupations of different people that they included in their study:

> The working lives of Muhanga, Lu, Bopha, Mohan, Bob, and Ann seem completely different. Muhanga extracts minerals from nature. Lu and Bopha are industrial workers. Mohan, Bob, and Ann are information workers creating either software or designs. They work under different conditions, such as slavery, wage labor, or freelancing. *Yet they have in common that their labour is in different ways related to the production and use of digital technologies[2] and that ICT companies profit from it.*
>
> (2014: 487, emphasis added)

For Fuchs and Sandoval and others invested in a broadly defined digital worker, scholars should include people whose labor may sometimes be invalidated as more functional than creative (2014: 488). An inclusive definition classifies workers based on how work products satisfy needs (use-values) related to digital media technologies. Studying workers based on their status as creatives tends to overemphasize the role that individual talents and people play in the profit-seeking schemes of international corporate enterprise. Using more inclusive terminology, scholars are better positioned to compare the experiences of people whose work constitutes some kind of computational service – from professional e-sports video game players and streamers to Amazon Mechanical Turkers, hackers to software entrepreneurs, and semiconductor manufacturers to gig-economy service workers (Greene and Joseph 2015: 240; Irani 2015: 226).

Of course, one of the inherent challenges to a broad definition is knowing how and where to draw the line between what constitutes work for a profit-seeking enterprise. This challenge has been most visible for scholars who study media production in an online context, where the distinction between worker and fan can blur significantly. Sometimes, the things that fans do for each other produce value for corporate enterprises. Some fans create additional art assets for a game or manage an online cultural forum around a specific franchise or media commodity, and they do so without any prompting or compensation from an owning media company. In effect, people who are typically considered mere consumers are participating in marketing and producing novel and new assets for a commodity with an established fan or user base.[3]

business in creative cultural industries (2010: 279). Scholars might forget to question why it feels necessary to compensate people with money in the first place.

The concept of playbour has become important in video game production studies and central to the study of gamification as a generalized theoretical approach. Researchers studying playbour or gamification often rely on ethnography to examine the function of fun in doing work. When an ethnographer sets out to study the production process of a video game, they typically engage in multisited fieldwork. They go behind the scenes and talk to software developers making and maintaining the virtual environment, but they also rely on firsthand experience inhabiting an in-game avatar, participating in online forums, consuming fan-made multimedia projects, and studying web-based resources about that virtual world (Boellstorff 2015; N. Taylor et al. 2015; T. L. Taylor 2009). Scholars focus on distinguishing and understanding how social and technical processes govern social life and inform expressions of creativity (Shaw 2015; Stabile 2014; Bull 2014; Chee 2006). Industry studies of virtual worlds and video game production companies tend to describe the working conditions of professional game developers and global supply chains that support the video game industry (Banks and Cunningham 2016; O'Donnell 2014). These systems are often supported by manufactured reward systems and artificially maintained markets for goods and services exchanged in cyberspace (Malaby 2009).

Video game production sometimes seems like a particularly exciting industrial domain because game developers are typified as a passionate, self-sacrificing breed, and the products they make are often readily exploitable with microtransactions and cosmetic items of a player's avatar. But as Thomas Malaby has observed in an ethnography of virtual commodities in Linden Lab's *Second Life*, this perspective positions players as temporary users and virtual goods as possessions no more purchasable than the putters you rent at a miniature golf course (2009: 18). The situation on the ground is often a little more complicated, as players frequently find value in services (regardless of who is offering them) that help socially differentiate them from other players (Malaby 2009: 20). And, while the affordances of virtual worlds have cheapened and eased the transactional costs that would be a burden with exchanging material goods, virtual commodities often emerge from social situations requiring a human touch. By and large, virtual worlds have not inspired people to invent new goods and services; they have changed how relationships between humans and nonhumans, codes and laws are made while managing risk and reward (Malaby 2009). These relationships are not only shaped by the digital affordances but also by regional laws and customs around professional workplace behavior and media production. Video game production scholars tend to study how local histories and material environments can typify work cultures differently on each Internet-connected continent. T. L. Taylor studied professionalized and competitive computer gaming, for example, and has demonstrated how players, gaming cultures, and entertainment professionals are influenced by region-specific structuring mechanisms (such as teams, leagues, broadcasters) and pre-existing infrastructures (such as network connections, gaming rules, tournament venues) (2012).

Other scholars have developed practical theories about how play and work relate to technological use when studying the complex relationships between players, game developers, and digital technologies. Some researchers see digital technologies as ushering in both a new era of commodity production and a new regime of scientific management principles through gamification, and in doing so, they are following an alternative intellectual trajectory from analyses of playbour and play as work. Gamification describes both a process of applying game design principles in the execution of not-game tasks and a pseudo-legitimate business strategy for developing new revenue streams. Most people, when they hear about gamification for the first time, receive an abbreviated, CliffNotes version of the belief that fun can be architected into any task, and that any fun task can increase someone's engagement and enjoyment. More nuanced explanations of gamification tend to elaborate on the specific use of particular game design principles in redesigning information management and task organization strategies. There are assumptions made about how game design concepts relate to universal experiences of fun or play. Indeed, which game design principles actually matter is usually up for debate. Few scholars have gained as much notoriety in translating such concepts as has Jane McGonigal, a self-namedfuture forecaster, game designer, and performance studies scholar, whose work exemplifies how these debates typically function. She has explicitly derided gamification as a misguided application of points, levels, leaderboards, and achievement badges. At the same time, McGonigal instead argues for her own brand of "gameful design" principles such as "positive emotion, relationships, meaning, [and] accomplishment" (2011). While for McGonigal there are meaningful distinctions between adopting extrinsic and intrinsic reward systems, this nuanced distinction is often lost on other researchers who identify gamification more broadly as a set of mechanisms intended to exploit consumers (Bogost 2014; M. Fuchs et al. 2014: 10). Gamification techniques are often legitimated by people who argue the developers were making good-faith efforts to accomplish good or inoffensive tasks.

Online work distribution platforms

Contemporary work distribution platforms illustrate a different set of issues around how technologies reconfigure the social organization of particular forms of labor. For digital labor studies scholars, online work distribution platforms change the hierarchical structure of labor allocation tasks and require ethnographic study to understand how people design technologies and implement particular social norms to turn digital workers' efforts into profit. Many are familiar with some of these platforms, such as Uber, Amazon MTurk, TaskRabbit, and Upwork, which all fit this broader rubric of work-distribution platforms because they allow work requesters and work seekers to opt in. Work requesters choose whether to solicit work on these platforms and work seekers select the tasks that they want to do. This contrasts with most jobs, where the employer typically chooses the employee and assigns tasks to the employee. On these work-distribution platforms, work requesters ask whether anyone is interested in doing a certain task, often for a

previously established price or by asking for a bid, and workers choose the tasks they are willing to do. For example, on TaskRabbit (recently acquired by IKEA), you can request that someone come to your house and assemble a recently bought bookshelf or wait in line for tickets to a concert. These tasks are arranged online but not necessarily performed online. And not all the tasks are performed by a single individual. In some cases, a crowd is assembled to perform the work, using the technology to coordinate individual tasks. On other platforms, while the possibility of completing a task for pay is opened up to a crowd, the actual task will be done by a single individual who, depending on the platform, may or may not have been explicitly selected by the work requester upfront.

These platforms make visible some of the social labor that goes into jobs, social labor that tends to be unrecognized. To illustrate this, we draw upon an article by Ilana Gershon and Melissa Cefkin discussing research that Cefkin and her team conducted at IBM on how people integrate work distribution platforms into the daily rhythms of how companies allocate labor (see also Cefkin, Anya, and Moore 2014). Cefkin and her team wanted to study people who were used to job roles determining which tasks they should be tackling, and see what would happen when asked to engage with a system that let them make choices about the tasks they wanted to complete independent of a specialized role. This research revealed that when people request work, they have to consider how tasks are made into distinct units. They also have to figure out how to segment work, anticipating how the resulting products will travel and be recombined. As one work requester succinctly explained, "To a retained team member I can simply say, 'scramble an egg,' whereas to a [crowd work system] player, I have to say, 'open the refrigerator,' 'remove the egg carton,' 'open the egg carton,' 'remove one egg,' etc." In short, the platforms are giving rise to new ways of designing work, either by breaking work into bits and parts or, alternatively, leaving tasks more holistically assembled as unified wholes, shifting the labor of figuring out how to accomplish it so that another can perform the task.

Done badly, and the work requested can be unusable. For example, Melissa Cefkin interviewed one work requester who used one of these platforms to find someone to do the seemingly straightforward task of extracting addresses from a set of data to integrate into a mass email. However, she had not specified its purpose or preferred form of delivery in the work specs, so the results she got back were not properly formatted for her email system. Members of her local team would have already known why she wanted this information and anticipated the best way of providing results had they, rather than crowd-sourced labor, performed the task. A common lesson learned by new users, this example illustrates, nonetheless, that scrambled eggs are never just scrambled eggs. Scrambled eggs could be for breakfast or for mixing into an emulsifier. They can be prepared hard or soft, plain or salted. Jobs, in short, provide a social context through which people become aware of how to organize tasks in implicit ways that are not easily or quickly explained outside of the context.

From the perspective of those disseminating the work, work-intermediation platforms promise that people can have work performed that they themselves

would not be able to do. This leads to more kinds of work being performed by strangers – work performed for us but by people with whom we have little or no knowledge or contact. At some level, this is nothing new – few of us will know who drove the trucks that delivered food we buy at a grocery store. But these mechanisms radically decrease the distance between someone and that stranger. Anyone can commission a complete stranger through a crowd-work system to build a website or arrange a travel itinerary. They may be known only by an online alias, if specified at all. This too can rearrange how people are used to managing knowledge flow in workplaces. Cefkin observed a particularly interesting discussion among work requesters in the technical crowd-work platform for software development she studied. Workers in the system use account names rather than real names.[4] The project managers who used the platform for sourcing labor for some of their technical development met weekly to share tips and status. In the discussion one week, a manager raised an issue: the results she received from a crowd-worker were incomplete. Based on prior experience with this worker (known by his screen name) she felt certain that this was a simple error, the worker had uploaded the wrong document. And when she shared his account name, others agreed based on their own prior positive interactions with this worker. Their discussion turned to concern as she indicated that repeated messages to him through the system were going unanswered. Might something have happened to him? Might he (they assumed it was a 'he') be sick? "How would we know if he has fallen off the face of the earth?" they pondered. Might he have meanwhile gotten a full-time job and left the platform? Was there anyone who could find out who he (really) was and where he lived and check on him? In this instance, platform users quickly began to imagine a wider set of obligations because someone had begun to act in ways perceived as uncharacteristic to their previous platform-mediated interactions. They were quickly stymied in their efforts to act on these obligations by realizing how much contact only through the platform limited off-platforms interactions.

Online work distribution platforms put into sharp relief questions of qualification and the adequacy of training. Can you trust your Uber driver? To deal with this uncertainty, platforms often provide reputation systems in which people choose workers that have been previously rated by other work requesters. But this means that it is hard to be a newcomer to this system, and it is, as Mary Gray has pointed out, much harder to switch from one platform to another, since you can't bring your reputational rating with you in the same way that you can bring a resume (2015).

In the United States, these systems have appealed to workers, in part, because they hold out the promise of a meritocracy. Work requesters often have no way of ascertaining someone's ethnicity, age, or gender when accepting the offer to work. As a result, organizations like Samasource have championed these platforms, claiming that platforms offer much-needed opportunities for low-income workers who face regular discrimination when being hired in person. Reputation systems, however, can still allow people to practice discrimination. One African American woman Gershon interviewed in the Bay Area preferred platforms in which

all work remained online to those that coordinated offline work. She explained that if work requesters saw her in person, her chances of getting a good rating in the reputation system would plummet because the work requestors did not want to risk having her return. They were not able to turn away black workers at the outset, but they used the reputation system of the online platforms to discourage black workers from being chosen in the future.

These systems also hold appeal because of the promise of autonomy, an autonomy that is largely absent from the ways that jobs organize tasks. Put simply, these systems allow people to imagine working without a boss, often on tasks that traditionally involve a boss. Instead of a boss, they now simply have clients. That workers are continuously choosing the work they do, and may even in turn outsource tasks to others, is seen as evidence that they are working as equals among individuals who also can select tasks and structure their time on their own terms. This is a general perception, but anthropologists of work know to be a bit skeptical of this claim. Just because a person is continuously consenting to do work for others does not necessarily mean that the person has more autonomy or has more equitable work relationships than a person occupying a more traditional job. Neither the temporary contract (however short) nor the technological infrastructure supporting open calls, in and of themselves, are harbingers of autonomy or equity. Anthropologists know all too well that freedom or equity only arises from the social organization shaping the use of technologies and the decisions and actions of participants over time as they put contracts into practice.

In maintaining a foothold within these systems, individual crowdworkers often collaborate closely within a social network of other crowdworkers to navigate and manage the challenges associated with their work (Gray et al. 2016: 134). Specifically, crowdworkers often assume hidden responsibilities and risks born from working in a competitive environment where lucrative tasks are in short supply and disreputable employers are difficult to identify on your own. Many crowdworkers often earn less than minimum wage, and they are often responsible for maintaining the infrastructure that puts them in touch with work platform opportunities, such as vehicles, computers, healthcare, and insurance (Ekbia and Nardi 2017: 60; Horton and Chilton 2010). They must not only demonstrate some proficiency with the task asked of a crowdworker; they must also demonstrate a technical competency with the technologies and systems that connect them with task contractors. Building community with other crowdworkers can thus serve as a mechanism for learning about strategies and techniques for optimizing and enabling their role on any given work platform. These strategies may change over time, however, as designers often inflect their own beliefs about how individuals should realize themselves as dutiful, reliable, and proper servers on crowdwork platforms. Amazon Mechanical Turk and Uber crowdworkers, for example, are generally expected to adopt particular beliefs about economic efficiency, individual autonomy, and contractual consent in their use of each platform's technical affordances and limitations (Cefkin and Gershon 2018). When these beliefs about work are shared among different parties in the digital labor supply chain, work distribution platforms practically transform digital workers into a computational

service that helps grease the proverbial wheels of many modern day feats of putative automation (Irani 2015).

Crowdworkers often assume the duties and responsibilities of work that others wish computers could do automatically and without fault, and some may believe that crowdwork tasks simply represent the kinds of work that software algorithms will eventually perform on command. Thinking of crowdwork and work distribution platforms in this way, though, assumes that crowdwork is a temporary phenomenon that will inevitably go away as computing hardware and software become increasingly 'intelligent.' This is not likely to happen for two reasons. First, historians of technology have long observed that efforts to automate labor have always fallen short of their promises to reduce the amount of work required for a task's completion; what more often happens is that the people once tasked with a job are replaced, in part, with a machine that does some of the work required. Another person or many more people are then needed to maintain and control the quality of the work a machine does. This means that automation does not automatically make cheaper and more efficient systems, although that is often its promise. Automation always pushes work down the line as the responsibilities of particular tasks are fragmented and divided among the delicate fingers of many hands. As manual tasks become increasingly micromanaged and standardized this way, supply chains elongate. Longer supply chains are not necessarily bad, but they present different challenges to profit-seeking corporations. Ekbia and Nardi observe, for example, that Blizzard Entertainment generates billions of dollars annually while making video games with an employee count of fewer than 5,000 people; however, the company's accomplishment principally relies on the outsourcing of hardware and software manufacturing required to make and maintain personal computers and game consoles that run Blizzard-made software executables (2017: 62). The company also relies on existing networking infrastructure to support massively multiplayer online virtual environments – material distribution systems that maintain fiber optic cable connections between geographical regions and transcontinental communities. Increasingly smart technologies do not eliminate the need for human workers; rather, they create different material conditions for the way work is done, and they require different and novel forms of intervention to maintain the integrity of automated tasks.

Mediating work through digital technologies and computer networks does not change a corporation's need for the kinds of social work people regularly do at home and in the office; rather, digital technologies afford corporations with newfound techniques to surveil and codify the value of particular social tasks. Thinking of crowdwork as a temporary phenomenon ignores how corporations and organizations rely on work distribution platforms to help them make money in a globalized economy. Specifically, Ekbia and Nardi argue that digital technologies uniquely enable people and corporations to profit from the kinds of labor that usually go unrecognized in business: communicative labor, cognitive labor, creative labor, emotional labor, and organizing labor (2017: 89). For them, crowdwork and online work distribution platforms exemplify how inclusionary logic, active engagement, and invisible control function in how human labor is managed

(Ekbia and Nardi 2017: 39). These represent attributes of digital work online that help to define a new approach to extracting economic value from low-cost or free labor: heteromation. Online work distribution platforms standardize how people orchestrate tasks on a global scale for companies and organizations that rely on heteromated labor. They equip companies and organizations to accomplish incredible feats of human processing and computation, while also characterizing a new domain of worker exploitation.

As we conclude this overview on topics relevant to the study of digital work, it is again helpful to return to popular imaginations of future work environments. Dystopian visions of computationally advanced societies tend to emphasize the ways in which people use digital technologies to subjugate and exploit the vulnerabilities and inequities of individuals or automate human labor out of existence. Utopian visions, by contrast, often represent digital technologies as tools for personal and community liberation. However, anthropologists are also duty bound to investigate what popular stories often miss about work mediated by computers. What makes digital work possible? Who benefits from such work conditions, and how do they benefit? Who is harmed by the material conditions of digital work, and how so? And finally, who is burdened when these technological systems break down or fail to work as intended?

Notes

1 Initech is a fictional software company imagined in Mike Judge's 1999 cult classic, *Office Space*, starring Ron Livingston, Jennifer Aniston, Gary Cole, and Ajay Naidu (among others). The corporate environment in the film is a parody of software companies circa 1997. At Initech, employees are chronically unmotivated and frustrated; managers are exploitative and self-serving. Workplace efficiency experts are brought in to help the organization downsize.
2 As Fuchs notes, the 'products of digital work' depend on type of work done, and these can include "minerals, components, digital media tools or digitally mediated symbolic representations, social relations, artefacts, social systems and communities" (2014: 352).
3 See Ritzer and Jurgenson 2010 for a more detailed analysis of the concept 'prosumer capitalism.'
4 A number of work intermediation platforms use the approach of screen names. One reason is an attempt to avoid identifiers that could lead to bias. Another is to ensure that all activity has to happen through the system itself. Interactions brokered by the system but which move outside the system can no longer be monitored for their acquiescence to the terms of engagement.

References cited

Banks, John A., and Stuart D. Cunningham. 2016. "Games Production in Australia: Adapting to Precariousness." In *Precarious Creativity Precarious Creativity: Global Media, Local Labor*, 186–199. Los Angeles, CA: University of California Press.

Barada, Valerija, and Jake Primorac. 2018. "In the Golden Cage of Creative Industries: Public-Private Valuing of Female Creative Labour." In *Technologies of Labour and the Politics of Contradiction*, edited by Paško Bilić, Jake Primorac, and Bjarki Valtýsson, 121–139. Dynamics of Virtual Works. London: Palgrave Macmillan.

Barbrook, Richard, and Andy Cameron. 1996. "The Californian Ideology." *Science as Culture* 6 (1): 44–72.

Boellstorff, Tom. 2015. *Coming of Age in Second Life: An Anthropologist Explores the Virtually Human*. Princeton, NJ: Princeton University Press.

Bogost, Ian. 2014. "Why Gamification Is Bullshit." In *The Gameful World: Approaches, Issues, Applications*, edited by Steffan P. Walz and Sebastian Deterding, 65–79. Cambridge, MA: MIT Press.

Borsook, Paulina. 2000. "Cyberselfish: Ravers, Guilders, Cyberpunks, and Other Silicon Valley Life-Forms." *Yale Journal of Law & Technology* 3: 1–10.

Boyes, Emma. 2006. "Second Life Realtor Makes $1 Million." *Gamespot*, November 27. www.gamespot.com/articles/second-life-realtor-makes-1-million/1100-6162315/.

Bull, Iris. 2014. "Just Steve: Conventions of Gender on the Virtual Frontier." In *Understanding Minecraft: Essays on Play, Community and Possibilities*, edited by Nate Garrelts, 88–105. Jefferson, NC: McFarland.

Cefkin, Melissa, Obinna Anya, and Robert Moore. 2014. "A Perfect Storm? Reimagining Work in the Era of the End of the Job." In *Ethnographic Praxis in Industry Conference Proceedings*, 3–19. New York: Wiley.

Cefkin, Melissa, and Ilana Gershon. 2018. "Click for Work: Rethinking Work, Rethinking Labor Through Online Work Distribution Platforms." Manuscript in preparation.

Chee, Florence. 2006. "The Games We Play Online and Offline: Making Wang-Tta in Korea." *Popular Communication* 4 (3): 225–239.

Dyer-Witheford, Nick. 2015. *Cyber-Proletariat: Global Labour in the Digital Vortex*. Toronto: Between the Lines.

Dyer-Witheford, Nick, and Greig De Peuter. 2009. *Games of Empire: Global Capitalism and Video Games*. Vol. 29. Minneapolis: University of Minnesota Press.

Edwards, Paul N. 1997. *The Closed World: Computers and the Politics of Discourse in Cold War America*. Cambridge, MA: MIT Press.

Ekbia, Hamid, and Bonnie A. Nardi. 2014. "Heteromation and Its (Dis) Contents: The Invisible Division of Labor Between Humans and Machines." *First Monday* 19 (6). https://firstmonday.org/article/view/5331/4090.

———. 2017. *Heteromation, and Other Stories of Computing and Capitalism*. Cambridge, MA: MIT Press.

English-Lueck, June Anne. 2017. *Cultures@ Siliconvalley*. Stanford: Stanford University Press.

Ensmenger, Nathan. 2010. *The Computer Boys Take Over*. Cambridge, MA: MIT Press.

Florida, Richard. 2002. *The Rise of the Creative Class, and How It Is Transforming Work, Leisure, Community and Everyday Life*. New York: Basic Books.

Fuchs, Christian. 2014. *Digital Labour and Karl Marx*. London: Routledge.

Fuchs, Christian, and Marisol Sandoval. 2014. "Digital Workers of the World Unite! A Framework for Critically Theorising and Analysing Digital Labour." *TripleC: Open Access Journal for a Global Sustainable Information Society* 12 (2): 486–563.

Fuchs, Mathias, Sonia Fizek, Paolo Ruffino, and Niklas Schrape. 2014. "Introduction." In *Rethinking Gamification*, 7–17. Luneberg: Meson Press.

Gill, Rosalind, and Andy Pratt. 2008. "In the Social Factory? Immaterial Labour, Precariousness and Cultural Work." *Theory, Culture & Society* 25 (7–8): 1–30.

Gillespie, Tarleton. 2018. *Custodians of the Internet: Platforms, Content Moderation, and the Hidden Decisions That Shape Social Media*. New Haven: Yale University Press.

Gray, Mary L. 2015. "The Future of Work: Caring for the Crowdworker Going It Alone." *Journalism: Pacific Standard*. August 21. https://psmag.com/economics/the-future-of-work-caring-for-the-crowdworker-going-it-alone.

Gray, Mary L., Siddharth Suri, Syed Shoaib Ali, and Deepti Kulkarni. 2016. "The Crowd Is a Collaborative Network." In *Proceedings of the 19th ACM Conference on Computer-Supported Cooperative Work & Social Computing*, 134–147. San Francisco, CA: ACM.

Greene, Daniel Marcus, and Daniel Joseph. 2015. "The Digital Spatial Fix." *TripleC: Communication, Capitalism & Critique: Open Access Journal for a Global Sustainable Information Society* 13 (2): 223–247.

Hardt, Michael, and Antonio Negri. 2001. *Empire*. Cambridge, MA: Harvard University Press.

Hesmondhalgh, David. 2010. "User-Generated Content, Free Labour and the Cultural Industries." *Ephemera* 10 (3–4): 267–284. www.ephemerajournal.org/sites/default/files/10-3hesmondhalgh.pdf.

Hesmondhalgh, David, and Sarah Baker. 2011. "Toward a Political Economy of Labor in the Media Industries." In *The Handbook of Political Economy of Communications*, 381–400. Chichester: Wiley-Blackwell. doi:10.1002/9781444395402.ch17.

Horton, John Joseph, and Lydia B Chilton. 2010. "The Labor Economics of Paid Crowd-sourcing." In *Proceedings of the 11th ACM Conference on Electronic Commerce*, 209–218. San Francisco, CA: ACM.

Irani, Lilly. 2015. "Difference and Dependence Among Digital Workers: The Case of Amazon Mechanical Turk." *South Atlantic Quarterly* 114 (1): 225–234.

Jasanoff, Sheila, and Sang-Hyun Kim. 2009. "Containing the Atom: Sociotechnical Imaginaries and Nuclear Power in the United States and South Korea." *Minerva* 47 (2): 119.

King, Barry. 2010. "On the New Dignity of Labour." *Ephemera* 10 (3–4): 285–302. www.researchgate.net/profile/Barry_King/publication/228753053_On_the_new_dignity_of_labour/links/00b7d526afdfb96283000000/On-the-new-dignity-of-labour.pdf.

Krätke, Stefan. 2010. "'Creative Cities' and the Rise of the Dealer Class: A Critique of Richard Florida's Approach to Urban Theory." *International Journal of Urban and Regional Research* 34 (4): 835–853.

Kücklich, Julian. 2005. "Precarious Playbour: Modders and the Digital Games Industry." *Fibreculture* 5 (1). http://journal.fibreculture.org/issue5/kucklich_print.html.

Long, Joshua. 2009. "Sustaining Creativity in the Creative Archetype: The Case of Austin, Texas." *Cities* 26 (4): 210–219.

Malaby, Thomas M. 2009. *Making Virtual Worlds: Linden Lab and Second Life*. Ithaca: Cornell University Press.

Matthews, Glenna. 2003. *Silicon Valley, Women, and the California Dream: Gender, Class, and Opportunity in the Twentieth Century*. Stanford: Stanford University Press.

McGonigal, Jane. 2011. "We Don't Need No Stinkin' Badges: How to Re-Invent Reality without Gamification." Presented at the Game Developers Conference 2011, San Francisco, CA, February 27. www.slideshare.net/avantgame/we-dont-need-no-stinkin-badges-how-to-reinvent-reality-without-gamification.

Nakamura, Lisa. 2014. "Indigenous Circuits: Navajo Women and the Racialization of Early Electronic Manufacture." *American Quarterly* 66 (4): 919–941.

O'Donnell, Casey. 2014. *Developer's Dilemma: The Secret World of Videogame Creators*. Cambridge, MA: MIT Press.

Peck, Jamie. 2005. "Struggling with the Creative Class." *International Journal of Urban and Regional Research* 29 (4): 740–770.

Pellow, David N., and Lisa Sun-Hee Park. 2002. *The Silicon Valley of Dreams: Environmental Injustice, Immigrant Workers, and the High-Tech Global Economy*. New York: New York University Press.

Postigo, Hector. 2007. "Of Mods and Modders: Chasing Down the Value of Fan-Based Digital Game Modifications." *Games and Culture* 2 (4): 300–313.

Ritzer, George, and Nathan Jurgenson. 2010. "Production, Consumption, Prosumption: The Nature of Capitalism in the Age of the Digital 'Prosumer'." *Journal of Consumer Culture* 10 (1): 13–36.

Ross, Andrew. 2013. "In Search of the Lost Paycheck." In *Digital Labor: The Internet as Playground and Factory*, edited by Trebor Scholz, 20–45. London: Routledge.

Shaw, Adrienne. 2015. *Gaming at the Edge: Sexuality and Gender at the Margins of Gamer Culture*. Minneapolis: University of Minnesota Press.

Stabile, Carol. 2014. "'I Will Own You' Accountability in Massively Multiplayer Online Games." *Television & New Media* 15 (1): 43–57.

Steinmetz, Kevin, and Jurg Gerber. 2015. "'It Doesn't Have to Be This Way': Hacker Perspectives on Privacy." *Social Justice* 41 (3 (137)): 29–51.

Sternberg, Rolf. 2013. "Learning from the Past? Why 'Creative Industries' Can Hardly Be Created by Local/Regional Government Policies." *DIE ERDE – Journal of the Geographical Society of Berlin* 143 (4): 293–315.

Taylor, Nicholas, Kelly Bergstrom, Jennifer Jenson, and Suzanne de Castell. 2015. "Alienated Playbour: Relations of Production in EVE Online." *Games and Culture* 10 (4): 365–388.

Taylor, Tina L. 2009. *Play Between Worlds: Exploring Online Game Culture*. Cambridge, MA: MIT Press.

———. 2012. *Raising the Stakes: E-Sports and the Professionalization of Computer Gaming*. Cambridge, MA: MIT Press.

Terranova, Tiziana. 2000. "Free Labor: Producing Culture for the Digital Economy." *Social Text* 18 (2): 33–58.

Toyama, Kentaro. 2015. *Geek Heresy: Rescuing Social Change from the Cult of Technology*. New York: PublicAffairs.

Turner, F. 2010. *From Counterculture to Cyberculture: Stewart Brand, the Whole Earth Network, and the Rise of Digital Utopianism*. Chicago: University of Chicago Press.

WFTX Webstaff. 2018. "Florida Man Says He Went from Homeless to Millionaire by Investing in Bitcoin." *RTV6*, January 22. www.theindychannel.com/news/national/florida-man-goes-from-homeless-to-millionaire-by-investing-in-bitcoin.

Zlolniski, Christian. 2006. *Janitors, Street Vendors, and Activists: The Lives of Mexican Immigrants in Silicon Valley*. Los Angeles, CA: University of California Press.

Part IV

Designing digital anthropology

13 Design for and against digital anthropology

Adam Drazin

In this chapter I explore the historical entanglements between the development of digital technologies and the interdisciplinary field of design anthropology (Drazin 2011). Design anthropologists have played an important but often overlooked role in the design of digital artefacts like email and smartphones, which digital anthropologists frequently take as the focus of their research. Design anthropologists have participated in the process of designing these technologies, as well as being active in the reconceptualisation of design itself as a more collaborative, participatory and reflexive way of knowing. This in turn has influenced both the development and democratisation of digital technologies as design tools and the use of design methods and approaches in anthropological research.

Through design, society rethinks its products, services, styles and aesthetics, and in doing so rethinks itself. The practice of design involves *reflexivity*, bringing together different skills, communities and ideas to address significant social issues. The resultant experience of design therefore involves a material world of goods and services which appears pre-thought and conceptualised. Because a designed world appears as both made and thought, it manifests a very particular kind of social connection based on mutual consideration, a relatedness based on sharing concepts of one another (Drazin 2013). 'Somebody has thought of someone like me' is the social message of a designed thing. Social reflexivity happens in design in at least two ways. It can be understood as "reflexive praxis" (Schön 1983), where cultural knowledge is made or created, confronted and re-created. Alternatively, it can be understood as collaborative and necessarily embedded in social relationships. By presenting and representing cultural information, one throws up a mirror for professional design to examine and evaluate itself, while thinking about communities. Suchman (2011) calls this "knowledge relocation".

Traditionally, the parallel coexistence of these two forms of reflexivity has been central to how the design professions have negotiated their politics. Most design has a political tension at its heart, the progressive aspiration to shape better lives, which can imply privilege and inequality, alongside the aspiration for accessibility and equality. Reflexive praxis offers anyone the possibility of working with design approaches, although of course some people may be more skilled than others. Collaborative reflexivity works across boundaries, between different contexts and social groups, so that one can maintain a sense of difference between

vernacular and professional design, while also asserting their interconnection. When design anthropology first emerged in 2002, the anthropologists concerned chose to associate themselves with 'design' (rather than 'digital' or a similar term). Even though they largely worked in Silicon Valley firms, their work was firstly about a socially well-conceptualised world and not defined by the particular technologies they worked with. One aspiration was to use digital tools to produce more reflexive, embedded anthropological research knowledges (Hegel et al. 2019; Salazar et al. 2017). Digital interfaces seemed to combine shape-ability with communication, integrating reflexive praxis with knowledge relocation.

I argue that in recent years, this aspiration for an integrated digital-design anthropology, which was always historically particular, has not been successfully realised. In digital culture, ubiquity of design knowledges suggests anybody can become a reflexive practitioner, above being a reflexive collaborator. Unexpectedly, some recent design approaches, such as design thinking and design futuring, have less need of social research or ethnography. This means studio-based projects can lose the very sense of social "situatedness" (Haraway 1991) and the idea of being contingent on certain social circumstances, which design anthropology has aspired to build. Digital cultures therefore foster forms of DIY design, where people and institutions try to design 'for themselves', but without ethnography and designing for 'other people' these approaches lack perspective. In designing for self, they are in effect less able to perceive whom it is they are designing for. Herein lies the emergent tension which characterises a growing gap between design anthropology and the study of the digital.

To develop this basic argument through this chapter, I present a brief history of anthropological work in computing design, with a particular focus on how people have been represented and conceptualised in collaborations with computing designers. This narrative is my own, an attempt to synthesise some of the many good accounts of what design anthropology comprises and what its roots are (Gunn et al. 2013; Clarke 2018) and of computing research paradigms (Bannon 2010, 2011; Dourish 2001b; Harrison et al. 2007; Grudin 2007, 2005; Pew 2003). At the core of this history is anthropologists' relentless focus on people.[1] In design disciplines (which are many and varied), ideas of people and their lives are an important and valuable currency. Design users and communities are what motivate design work and lend it validity, and acts of intellectual conjuring of people, places, and activities are crucial. These knowledge artefacts are both representations and reflections, they become reflexive knowledges of the world. With each shift in research approaches, purposes and technologies, anthropological researchers have naturally worked to shift attention back to real people and their lives, giving rise to new terminologies and representations. By seeing how the 'significant other' of computing design has changed over the decades, we can see how ideas of what makes us human have changed.

My history is divided into four periods of transformation. I characterise the first three as 'from bodies to organisations', 'from individuals to infinity' and the 'emergence of design anthropology'. This is followed by two short examples of design anthropology work which used digital artefacts to manifest design

concepts and reflect on a cultural situation. I then examine more recent transformations and the divergence of digital and design anthropology. At the conclusion of the chapter, I set out what we can learn from this narrative. By examining the history of changing genres and research traditions, the chapter is effectively asking, in computing research, what has happened to 'people'?

From bodies to organisations

'Human-computer interaction' (HCI) is generally speaking the broadest term for the research field which led, over some decades, to a self-aware 'design anthropology'. As the name suggests, HCI does not define itself by a specific disciplinary approach, but by its subject – *computing* – as activity, as human work and as material culture. HCI therefore implies a putatively universal human moment as the lens through which to understand how all sorts of actual people ('humans') engage with all sorts of hi-tech machines ('computers') in all sorts of ways ('interactions').

In the early days of computing, interaction meant physical engineering. To reprogram the early computers, going back to the 1960s and before, you did not necessarily have a keyboard, or screen, or software. Reprogramming a computer could mean rewiring and resoldering the physical parts by hand (see Dourish 2001b). This meant that the understanding of the person who 'used' a computer was highly physical. There was an interest in posture, in how an arm or hand for example might interact with the machine, more than how a brain might. Over time, keyboards and screens were introduced and then (in the 1960s) the mouse. Early models of computer processing considered just the machine as a self-contained informational system, not the people, and while people's intentions were considered, they were not seen as a serious topic of research but as given constants.

The HCI field grew with the realisation that there was a need to include humans in the understanding of informational systems, a research interest initially called "human factors". HCI turned to psychology (Card et al. 1983) to find answers to its new questions about the human. Multidisciplinary teams resulted, which could also incorporate anthropologists and sociologists. It has been suggested that a "second paradigm" of HCI originated at this time, "organised around a central metaphor of mind and computer as symmetric, coupled information processors" (Harrison et al. 2007: 5). However, the initial deployment of psychology from the 1950s through to the 1970s still tended to be very one-sided, as if people are one-dimensionally striving to make rational decisions. The notion that people aspire to optimal behaviour, efficiency and social achievement was a tremendously optimistic and inspiring idea and drove forwards the agenda of developing computing in the service of humanity. But because of the influence of thinkers such as Simon (1969), representations of humanity in HCI at this time emphasised collective rationalities and workflows as the connecting structures of human life, more than thinking individuals and their own experience. Many studies observed individual moments of human life and practice (decisions, choices, events) and how they fit into systems, groups, companies, workflows and offices. This work therefore

combined sociological and psychological approaches and had a strong engineering element. The 'design' which featured was of a kind heavily inspired by engineering design, often more pragmatic and problem-oriented, and celebrating the aesthetics of function and of technology for its own sake, more than beauty or fashion.

At a global level, two very important design traditions emerged in the 1970s which proved very influential in the later emergence of design anthropology, the Silicon Valley and participatory design traditions. They had utterly different roots, but both proved capable of computing systems innovation. At Xerox PARC in Silicon Valley, the Work Practice and Technology group had a major impact, definitively convincing many HCI researchers that researching computing involved researching entire social ecosystems. This work was explicitly culturally informed. Ethnographers, psychologists and engineers together asked questions such as "how were computers embedded within the complex social framework of daily activity, and how did they interplay with the rest of our densely woven environment (also known as 'the real world')?" (Weiser et al. 1999: 693). Xerox PARC has been credited as "the birthplace of many radical ideas that affected the world of technology, including the laser printer, the desktop graphical user interface, and the Ethernet, the technology that connected it all" (Sellen and Harper 2002: 2–3). But importantly, the anthropologists involved did not invent technologies based on their ethnography, rather they critiqued, questioned and recontextualised them (Suchman 2007, 2011). Anthropology challenged what could be done, by studying what was done.

While some histories of design anthropology focus almost wholly on Silicon Valley, in fact it was one design tradition among many. In Scandinavia, the development of the participatory design movement also emphasised the social and collective aspects of human life in its analyses (Schuler and Namioka 1993; Robertson and Simonsen 2012). But its motivations were more political than commercial, seeking to mitigate potential damage from unconsidered technical innovation. Social democratic governments in Sweden and Denmark, in dialogue with workers' unions, introduced legislation which required "consultation with workers" (Crabtree 2003: 132) over any new workplace technologies to avoid de-skilling. In the 1970s–80s, projects which engaged with workers proved you could devise new systems this way, or "design by doing" (Bødker 1987; Bjerknes et al. 1987). Participatory design showed how attention to the rights and wellbeing of people, independent of the profit motive, could help build better computing systems.

Hence by the mid-1980s "social computing" (Dourish 2001b: 55) was important: the term implied new research foci "from product to process" (Grønbæk et al. 1993), more social science, and a more socially aware design politics. The academic legacies of this period are still very much alive and have continued to develop and grow, as in the CSCW (computer-supported cooperative work) tradition (Hakken 2000; Luff et al. 2000; Blomberg et al. 1997; Greif 1988). Among other things, CSCW asks key questions about how people know the significance of what they do and so has advanced cultural critiques of both work and

of technological objects. In CSCW, it is inadequate to evaluate the 'needs' of users in a design project unless one considers what people value, and what they regard as achievements, in their own workflow and work relationships. If you research the work of reading, as an example, you don't just consider words per minute, you ask what makes a 'good book'.

By the 1970s–80s therefore a vision of the computer user was established as a person who was a worker but also a social being often motivated by the networks of relationships and hierarchies of which they were a part. They were seen as strongly driven by the achievement of certain tasks, according to their own and others' rationalities. Computing at this time was well established in work environments, but the beginnings of domestic computing and gaming also began to introduce ideas that computer users could also be playful and motivated by leisure.

From individuals to infinity

The period from 1984 into the 1990s witnessed a much more developed deployment of psychological understandings in HCI, which manifested in a shift "from factors to actors" (Bannon 1991). People really began to feature in research as thinking individuals, imagined as coherent and bounded. Their capacity to engage with computing was appreciated as involving intentionality, motivation and evaluation, not just knowledge processing. Whereas projects and work teams had been the focus, with individuals as elements within them, increasingly persons were placed centre stage, and this change of emphasis changed the framework. People move, they inhabit many contexts, they undertake many parallel projects with different rationalities, thoughts, actions and experiences, and their lives came to be understood as cross-cutting and binding together all these different phenomena.

It also became evident during the 1980s that design skills could be more important than engineering in computing. Desktop computers introduced a new computing reality. Rather than groups sharing processing power, it was packaged into individual entities on a par with individual people, which then might network. In 1984, Apple introduced the Macintosh computer, which integrated many already-existing technical features into a single accessible unit. Designs such as the Macintosh revolutionised the conception, experience and material culture of computing. Computing was now relatively available to all, at work and home, as a branded resource, in the form of takeaway objects.

The intellectual work which underlay these shifts was both psychological and anthropological. After Don Norman's (1986) *The Design of Everyday Things*, designers and many computing engineers felt that a large part of their work comprised understanding how people think and act. Lucy Suchman's (1987) *Plans and Situated Actions* argued that a human perspective is crucial in systems design of any kind. It was Norman's work which established the notion of user-centred design (UCD), design methodologies which start with potential users or communities of users (Norman and Draper 1986). Many UCD practitioners developed much greater skills in social reconceptualisation than in individual domains of design. A project originating as a response to working with users and contexts

various aims and ways of working. These communities included at least seven kinds of practitioners. At the core were US computing and branding researchers. Anthropologists in the European participatory design tradition also identified as design anthropologists. There were general business anthropologists who might not previously have worked more with marketing, but who now began to recognise their work was becoming more about design. A fourth, very different group was comprised of academics who were exploring ways to rehabilitate anthropology as a discipline through non-textual methodologies, such as sketching, making, crafting and other forms of studio work (Rabinow and Marcus 2008). Very importantly, design anthropology included designers who were beginning to see their work as an exploration of the human condition, of culture and society. This was anthropology in the small case, but undoubtedly a form of anthropology. These people included critical designers (Dunne and Raby 2013; Dunne 2006) producing artistic social commentaries and contextual designers (Holtzblatt et al. 2005, Holtzblatt 2003). Sixth, various forms of social innovation within policy circles were also important (Murray et al. 2010), running collaborative research events where communities explore their own values and possibilities. Lastly, but perhaps most important of all, international design and craft traditions engaged with design anthropology, celebrating the diversity of design practices, cultures of creativity, and ways to culturally improve human lives. For example, Japanese design has always engaged with local craft communities in the Mingei tradition (see Kikuchi 2004; Moeran 1997), while in India designers have deployed ethnographic work with various skilled communities to build cottage industry focused on craft (see Balaram 2011).

Hence the concept of design anthropology did not emerge as an approach (like UCD), an agenda (participatory design and Ubicom), or a specific research focus (CSCW), but more as a coalescence of approaches, many of which had roots in those other movements. The various currents tended to share an orientation towards businesses and organisations, to social commentary as an end in itself, to collaborative working, and to ever greater social engagement. Design anthropology then comprises a group of anthropologists who do anthropological work, producing critical cultural commentaries, alongside design and in ways that aspire to be constructive for design.

The years of the early 2000s were the key growth years for design anthropology, and its rise meshed with new ways of representing and conceptualising people in computing research. Important concepts included culture, experience and the self. Many anthropologists in universities may believe that humans are self-evidently cultural, but as we have seen, this association of people with culture is contingent, a question of when, where and who is doing the associating, and for what purpose. HCI at this time experienced a marked research shift towards a "phenomenological" paradigm (Harrison et al. 2007: 7–9). More attention was paid to meanings, identities, relationships, feelings and affect. For example, exploring 'practice' grew into 'experience' (practices plus meanings and affect). A question such as 'how fast should a mobile phone interface be?' might be reframed as 'what does a mobile phone interface speed mean?' These shifts of emphasis worked well with

developments in design and technology, with exciting innovations within product design practices leading to the growth of service design (Stickdorm and Schneider 2012; Sangiorgi and Prendiville 2017, see also Shostack 1982) and interaction design (IxD; see Moggridge 2006). In the new technological environment, designers began to reframe products as 'interfaces' and concern themselves with the wider structure of a series of what were called 'interactions'.

The reconceptualisation of design users as 'cultural' went along with an emphasis on 'experience' both as a focus of research and as a defining factor of what makes us human. Companies understood their role increasingly as providing 'experiences' (Pine and Gilmore 1998), and the trope of user-experience design (UxD; Picard 1997; Heath et al. 2002) often surpassed user-centred design (UCD). Different pragmatic considerations of experience are often pulled between the idea of meanings, which can be expressed and named, and the idea of a degree of emotional and affectual engagement (Norman 2005; Hutchins 1995; Caspi and Gorsky 2006).

Rather than talking about individuals, identities, agents, persons or humans, in a world where people are characterised by their experience the 'self' emerges as more relevant. Selfhood as a construct favours a temporal and biographical constitution of what makes a person, instead of rationalities, work, relationships, social belonging or their biological body. Selves are formed and reformed in an ongoing temporal flow of events, happenings, memories and future plans. Selves are affective and potentially emotional, remembering, recording, reacting and engaging.

Hence as design anthropology grew in influence, it foregrounded persons and humans within design research (Wakeford 2004), but in doing so it also tended to emphasise certain characteristics and elements as more important qualities than others. Human characteristics included diversity, contextuality, locality and being the locus of experience. In a situation where commercial value also resided in experience, these kinds of persons often became an end of design research, not only a means. For example, in many studies of workflows, meaningfulness is often considered as reflecting how people evaluate their work, to judge the outputs, successes, failures and effects of work practices. In experience design, by contrast, the significant output is rather the experience which shapes and constructs the person themselves. People who were previously merely 'users' of a design created by others became taken much more seriously as designers of their own realities in their own right. The notion of 'user-as-designer' (Gunn and Donovan 2012), in which professional design often becomes a meta-activity to support people's own design practices, is one example. Co-design, in which design happens within the sites where people work and live, rather than being abstracted away to studio environments, is another.

By 2010, anthropologists working in computing research had been involved in conceptualising people in many ways: as workers, bodies, information processors, planners, pragmatists, collaborators, communicators; as agents, users, humans, communities, groups or organisations; as rational, desirous, experiencing, emotional, and creative. No matter your question, there is a suitable image of

remembering works differently with music or with a photo, for example. A Christmas photo can evoke a particular Christmas moment, while a piece of Christmas music more often brings habitual memories of 'Christmases when I was young'. We noticed how specific ways of framing images, and there were several specific ways, indicated people's intentions to remember somebody in future: for example long-lasting framed portraits for family members or loose scrappy snapshots on the fridge for college friends (Drazin and Frohlich 2007). Material framings enabled working with subtle and diverse social timeframes. The material treatment of an image, in short, was an incredibly subtle and expressive means to negotiate a particular future intention to remember a certain person in a certain way, and there was a strong moral obligation to be 'good' by remembering appropriately.

Following stage one of the research, making the audiophotos became a cultural exploration and a process, not an informational exercise. It revealed something of the emotional burdens and responsibilities of memory artefacts. Immense nostalgia surrounded events, absent friends and departed children, and attaching music and soundscapes needed judgement as well as preference. People do not necessarily consciously know 'how' to remember appropriately, rather they are faced with potentially difficult choices. Memory involves socialised skill and instinct, mobilised through a palpable sense of obligation surrounding images and music to treat them right (see Favero 2018). To receive, or even see, an image or audiophoto implies moral responsibilities for the future around that image. Perhaps our most important observation was that a lot of remembering is actually more about the future than the past. This means acts of remembering around artefacts (holding, viewing, narrating, framing, storing) are integrated as one compounded unending

Figure 13.1 Many ways of remembering with photographs and media. On the left, a mother used an image from Disneyland to 'narrate a story' of the trip. On the right, her daughter produces sequences of framed images to produce her own stories for the family

Source: Images by author.

moral activity, simultaneously remembering and remembering ahead (see Gomez Cruz and Lehmuskallio 2016).

This project illustrates something about digital artefacts in design anthropology work. In a lot of anthropological work, you would avoid the second and third stages (making audiophotos) altogether, because it has an imaginary element. Audiophotographs, now commonplace, did not exist in these people's homes, and might never exist. And yet the framework of remembering did, and we tried to fit into this framework 'from inside', so to speak. Making audiophotographs was a creative act in which a new artefact, a plausible artefact, was made which might fit that relationship. So we did not see this only as 'creating digital memory artefacts', it was rather an act of re-creating a realistic social context. The artefact would attempt to demonstrate an imagination of what sort of relationship that was, without the fixity of words. Strangely, this suggests that anthropological work which draws on digital design methods to pay explicit attention to material forms can be very good at abstract imagination of sociality. Conversely, anthropological work which pays less attention to material forms, unquestioning of them, may remain bound by current and past material conditions.

The work also produced a reflexivity within the organisation. We learned more about an 'engineering culture of remembering', which equated better memory with technical excellence (higher resolution, better sound). This threw a lot of the low-tech domestic remembering into sharp relief and actively helped us perceive what was important about domestic practices. Hence the newly created digital audiophotos proved reflexive in three ways: they provoked dialogues into people's existing social context, stimulated reflections on aspiration and changes for the future, and were the focus of reflection within the company.

Irish rural transport research at Intel Digital Health Group

A second example shows how a project without a very specific technological remit can deploy digital prototypes to initiate user-centred design processes by exploring spaces of possibility. The rural transport research was conducted in 2007–8 by Intel Digital Health Group in Ireland, whose brief was to understand and design for global ageing. The gatekeeper for the ethnography was the Rural Transport Network, a range of slightly different organisations across the counties of Ireland. Most of the organisations run weekly minibuses which go door-to-door across the countryside, bringing elderly passengers to a local town or a community centre. They may collect pensions, shop, attend a community group or fulfil health appointments. Three anthropologists (myself, Simon Roberts and Tina Basi) spent at least a week on one or two projects. We spent a lot of time on the buses and also met and interviewed a range of community and project stakeholders (passengers, drivers, district nurses, office organisers, post office staff, priests, etc.). We worked alone but with various technology to 'capture' as much as possible: camcorders, voice recorders and GPS locators tracking our routes by satellite. We worked to try to learn as much as possible, to gather as much data as possible, and to maximise its value from many contrasting viewpoints and situations within

Figure 13.2 Passengers on Irish Rural Transport buses feel a sense of ownership and com-
munity on 'their' routes and 'their' buses

Source: images by author (right) and by Tina Basi (left).

the rural transport. It was a project about understanding the 'experience' of the
transport.

Many of our informants were very suspicious, certainly at first, and clearly
many suspected that we were there to audit their buses, perhaps to cut or with-
draw them. In the past, anthropology has had a mixed record in rural Ireland
(see Peace 1989; Wilson and Donnan 2006). To sympathetically portray some-
one living alone, with severe mobility difficulties, in a house distant from any
other, and yet who is at home, is problematic (see Drazin 2018). What was very
clear however was that in our work, isolation was evident in its negation by the
buses. The rural transport transforms lives. It improves social contact, shopping,
diet and exercise. It intensifies the grapevine of local news. Spirits rise. The rural
transport is not a utopia, because it often happens against a background of grow-
ing inequality, poverty, changing gender and generational relationships, and rural
economic decline. Yet a single, short minibus ride each week makes a difference,
and the tangible experience is important in this. The buses can be full of banter,
jokes, gossip and laughter, to the extent of being intimidating to join. Transport is
sometimes seen as functional, an asocial moment between two social ones (home
and community), but people often travel on these buses even without anything to
do at the other end. The bus is another social event in the rhythms of rural life,
alongside the church, the pub, the Gaelic sports match and the livestock market.
In our first phase of fieldwork, our informants' accounts of local community life
were overwhelmingly positive, as if nothing bad ever happens.

After fieldwork, we then spent some months developing concepts, in short
bursts of brainstorming, and narrowing them down to a few which might be
workable. A designer imagined these conceptual services as on-screen interactive
simulations. In the main, the concepts adapted and redeployed elements of the

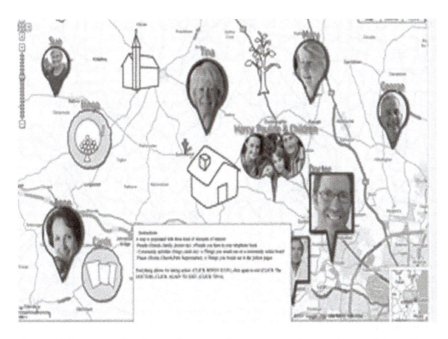

Figure 13.3 A screenshot from a 'provotype' transport service, used as a talking point to explore the kind of transport service passengers might use

ethnographic research, using images and instances from the fieldwork which had been digitally recorded.

These digital demos (provotypes) were brought 'back' to the rural transport projects, not to test but to try to advance them constructively, in a participatory way. So we tended to not ask 'would you use this or not?' but to rather envisage specific elements about them. Where might an interface be located? Who uses them? Who has responsibility for personal information? Specific suggestions were also invited about the concepts, how the screen looks, touch-screens, split-screens, different kinds of devices and so on.

The moment we presented these concepts to people, to try to engage them in the design process, marked a shift in the relationship. The previous suspicion of 'being tested' fell away, so conversations about local communities became less optimistic and more balanced, and these shy and respectful people were not afraid to criticise either our demos or rural life.

"Our village is dead" (Nan & Ettie, rural transport passengers in Sligo, reacting to product concepts)
"Not one person in our club would use that" (Kate, Westmeath)
"I'm happy enough with a 'phone call'" (Anthea, Sligo)

The presentation of digital demos was no longer primarily an interpretive act, but a demonstrative one. This was the moment people realised we were serious about engaging, and the digital artefacts were the calling card of our intentions. They facilitated the imagination of benefits (or detriments) in actual, immanent social terms.

"You wouldn't feel under a compliment" (Dorothea, Sligo – poetically expressing the burdens of community life and responsibility)

"It should have a 'funeral' button, to automatically invite people to a funeral" (Julia, Sligo – funerals are key social events in the West of Ireland)

So the digitalised concepts began to illuminate problems and tensions and unpack the appearance of unity and uniformity in the rural transport. Such tensions were important for us to think about what isolation and mobility mean and how they articulated. What they also helped us negotiate in this work was the balance between an exercise in learning and in being taught. A simple idea of the research might have been that it was to understand social problems, which anthropology interprets and models to inform a design response. However, the fact is that a response to a complex set of problems of ageing and rural life is already there: the rural transport minibuses work, and require support. So the work asked, what sorts of digital artefacts adequately manifest and support these existing values and practices?

Digital for and against design anthropology

As both examples show, the inception of design anthropology ushered in a period during which design and digital seemed to be mutually inseparable, a digital-design culture (see Pink et al. 2016) celebrating creativity and innovation. In computing research circles, the aspiration of the later 2000s was that digital artefacts used in co-design work would facilitate on the one hand a manifest conceptuality, things which are concepts (see Henare et al. 2006), and on the other a design conversation between design professionals and design users, while maintaining a sense of difference between professional and vernacular design practices. My examples make clear how digital artefacts have been understood as 'things to think with', ways of reflecting on a social situation as individuals and in communications between field site and a design studio or lab. In that sense, using digital technologies, one is arguably better equipped to instantiate the critical 'situated knowledges' which many design anthropologists aspire to (Haraway 1991; Suchman 2011). Hence there are many reasons for suggesting that design anthropology and digital anthropology are mutually supportive, mutually conceived and naturally compounded projects.

However, design is not necessarily the same as digital anthropology. While a new technology can exist without thinking much about people, a new design must think about people and requires ways of 'drawing them in'. The study 'of' digital phenomena may mean one informs their design, but that is about what one does

with the information, not the research work in itself. Since 2010, in several ways there has been a divergence of design and digital fields of practice, within which we can posit a potentially much more contested relationship, and design is having to work harder to re-establish its authority. We can illustrate the divergence by looking at how two recent design approaches (design thinking and design futuring) engage with the phenomenon of digital ubiquity.

Since the 1980s, designers have argued that their approaches comprise an alternative way of thinking (Cross 1982; Schön 1983). To research, develop and propose products and services is intellectual work. From the 1990s, IDEO and Stanford d.school promoted design thinking as a distinctive set of intellectual approaches with its own toolkit of methods, including forms of ethnography, for problem-solving in business (Brown 2009). Design thinking does not depend on digital technologies but usually emphasises non-digital media such as paper, whiteboards and modelling. Its tenets and ways of working have been promoted in themselves, not as contingent upon certain infrastructures, technologies or material resources. At the time of writing, design thinking and brainstorming in groups is something which is no longer seen as an activity which you necessarily need a professional to do, rather it happens in any company or work environment, in schools and colleges.

Design futuring comprises the work of conceptualising, critiquing and exploring 'futures' in various ways (Dunne and Raby 2013; Yelavich and Adams 2014; Smith et al. 2016; Salazar et al. 2017). Far from being a limited studio practice, futuring occurs across business, government policy and financial sectors and concerns dealing with certainty in a more uncertain world (Gregory 2013). One can think of the example of Singapore's design policy aimed at a future "loveable Singapore" (DesignSingapore 2016), or the "Future Trends" and predictions which companies and think tanks produce annually. In design, a lot of futuring evokes a "what if" scenario, in which a future is presented as a social commentary, perhaps a happier utopia, or perhaps an unsustainable dystopia. Often, futuring uses studio-based artistic methods more than it uses ethnography and active social research, although it does combine methodologies. Consequently, futuring can potentially displace design work which is oriented towards people, communities and lifestyles existing in the present. Combined with the offer of DIY design methodologies, futuring results in effect in design work whose significant object is a future self, not somebody else living in the present. The sense of alterity and the capacity for critical cultural distance is drastically reduced in a great deal of futures work (see Drazin et al. 2016; Drazin forthcoming).

At the same time as design approaches have become more conceptual, at some undefined moment, ubiquitous computing happened as a reality (Bell and Dourish 2011). At this point, design anthropologists also became less concerned with designing computing or mobile IT and more concerned with what digital technologies might mean in different areas of human life and activity. With ubiquity, design work also became understood as popularly available and something open to the general public to engage in. On the surface of it, one is able to rethink all sorts of material dimensions of everyday life using predesigned elements and

Bødker, S. (1987). *A Utopian Experience: On the Design of Powerful Computer-Based Tools for Skilled Graphical Workers. Computers and Democracy: A Scandinavian Challenge*. G. Bjerknes, P. Ehn, and M. Kyng (eds.). Aldershot: Avebury: 251–278.

Brown, T. (2009). *Change by Design: How Design Thinking Transforms Organisations and Inspires Innovation*. New York: Harper Business.

Card, S., T. Moran, and A. Newell. (1983). *The Psychology of Human-Computer Interaction*. Hillsdale: Lawrence Erlbaum Associates.

Caspi, A., and P. Gorsky. (2006). "Online Deception: Prevalence, Motivation and Emotion." *Cyberpsychology and Behaviour* 9(1): 54–59.

Clarke, A. (2018). *Design Anthropology: Object Cultures in Transition*. London, Bloomsbury.

Crabtree, A. (2003). *Designing Collaborative Systems: A Practical Guide to Ethnography*. New York; London: Springer.

Cross, N. (1982). "Designerly Ways of Knowing." *Design Studies* 3(4): 221–227.

DesignSingapore. (2016). *Design2015: Singapore by Design*. Singapore: National Design Centre.

Dilley, R. (1999). *The Problem of Context*. Oxford: Berghahn Books.

Dourish, P. (2001a). "Seeking a Foundation for Context-Aware Computing." *Human-Computer Interaction* 16(2–4): 229–241.

———. (2001b). *Where the Action Is: The Foundations of Embodied Interaction*. Cambridge, MA: MIT Press.

———. (2004). "What We Talk About When We Talk About Context." *Personal and Ubiquitous Computing* 8(1): 19–30.

Drazin, A. (2011). "Digital Anthropology in Design Anthropology." *Digital Anthropology*. D. Miller and H. Horst (eds.). London: Berg.

———. (2013). "The Social Life of Design Concepts." *Design Anthropology: Theory and Practice*. W. Gunn, T. Otto, and R. C. Smith (eds.). London: Bloomsbury.

———. (2018). "The Fitness of Persons in the Landscape: Isolation, Belonging and Emergent Subjects in Rural Ireland." *Social Anthropology* 26(4): 535–549.

———. (Forthcoming). *Design and Anthropology*. London: Routledge.

Drazin, A., and D. Frohlich (2007). "Good Intentions: Remembering Through Framing Photographs in English Homes." *Ethnos* 72(1): 51–76.

Drazin, A., R. Knowles, I. Bredenbröker, and A. Bloch. (2016). "Collaboratively Cleaning, Archiving and Curating the Heritage of the Bauhaus." *Design Anthropological Futures*. R.C. Smith, K. Tang Vangkilde, M. Kjaersgaard, T. Otto, J. Halse, and T. Binder (eds.). London: Bloomsbury.

Dunne, A. (2006). *Hertzian Tales*. Cambridge, MA: MIT Press.

Dunne, A., and F. Raby. (2013). *Speculative Everything*. Cambridge, MA: MIT Press.

Favero, P. (2018). *The Present Image: Visible Stories in a Digital Habitat*. London: Palgrave Macmillan.

Forsythe, D. (2001). *Studying Those Who Study Us: An Anthropologist in the World of Artificial Intelligence*. Stanford: Stanford University Press.

Foster, R. (2007). "The Work of the New Economy: Consumers, Brands and Value Creation." *Cultural Anthropology* 22(4): 707–731.

Friedman, K., and E. Stolterman. (2011). "Series Foreword." *Design Things*. T. Binder, G. De Michelis, P. Ehn, G. Jacucci, P. Linde, and I. Wagner (eds.). Cambridge, MA: MIT Press: vii–xi.

Frohlich, D. M. (2004). *Audiophotography: Bringing Photos to Life with Sounds*. London: Kluwer Academic.

Gomez Cruz, E., and A. Lehmuskallio. (2016). *Digital Photography and Everyday Life: Empirical Studies of Material-Visual Practices*. London: Routledge.

Gregory, C. (2014). "On Religiosity and Commercial Life: Toward a Critique of Cultural Economy and Posthumanist Value Theory." *Hau* 4(3): 45–68.

Greif, I. (ed.). (1988). *Computer-Supported Cooperative Work: A Book of Readings*. San Mateo, CA: Morgan Kaufman Publishers.

Grønbæk, K., J. Grudin, S. Bødker, and L. Bannon. (1993). *Achieving Cooperative Systems Design: Shifting from a Product to a Process Focus. Participatory Design: Perspectives on Systems Design*. D. S. A. Namioka (ed.). Hillsdale, NJ: Lawrence Erlbaum Associates: 79–97.

Grudin, J. (2005). "Three Faces of Human-Computer Interaction." *IEEE Annals of the History of Computing* 27(4): 46–62.

Grudin, J. (2007). *A Moving Target: The Evolution of HCI. The Human-Computer Interaction Handbook* (2nd ed.). A. S. J. Jacko (ed.). Abingdon: CRC Press.

Gunn, W., and J. Donovan. (2012). *Design and Anthropology*. Abingdon: Ashgate.

Gunn, W., T. Otto, and R. C. Smith (2013). *Design Anthropology: Theory and Practice*. London: Bloomsbury.

Hakken, D. (2000). "Resocialing Work? Anticipatory Anthropology of the Labor Process." *Futures* 32(8): 767–775.

Haraway, D. J. (1991). *Simians, Cyborgs and Women: The Reinvention of Nature*. London: Free Association.

Harrison, S., D. Tatar, and P. Sengers. (2007). *The Three Paradigms of HCI. CHI 07*. London: ACM Press.

Harvey, P., and C. Krohn-Hansen (eds.). (2018). *Dislocating Labour: Anthropological Reconfigurations*. Oxford: Wiley-Blackwell.

Heath, C., P. Luff, D. vom Lehm, J. Hindmarsh, and J. Cleverly. (2002). "Crafting Participation: Designing Ecologies, Configuring Experience." *Visual Communication* 1(1): 9–33.

Hegel, C., L. Cantarella, and G. Marcus. (2019). *Ethnography by Design*. London: Bloomsbury.

Henare, A., M. Holbraad, and S. Wastell. (2006). *Thinking Through Things*. London: Routledge.

Holtzblatt, K. (2003). "Contextual Design." *The Human-Computer Interaction Handbook*. J. A. S. Jacko (ed.). London: Lawrence Erlbaum Associates.

Holtzblatt, K., J. Burns Wendell, and S. Wood. (2005). *Rapid Contextual Design: A How-to Guide to Key Techniques for User-Centred Design*. London: Morgan Kaufman, Elsevier.

Hutchins, E. (1995). *Cognition in the Wild*. Cambridge, MA: MIT Press.

Kikuchi, Y. (2004). *Japanese Modernisation and Mingei Theory*. London: Routledge.

Kilbourn, K. (2011). "The Patient as Skilled Practitioner." *Design and Anthropology*. W. Gunn and J. Donovan (eds.). Abingdon: Ashgate: 35–45.

Luff, P., J. Hindmarsh et al. (2000). *Workplace Studies: Recovering Work Practice and Informing System Design*. Cambridge: Cambridge University Press.

Moeran, B. (1997). *Folk Art Potters of Japan*. London: Routledge.

Moggridge, B. (2006). *Designing Interactions*. Cambridge, MA: MIT Press.

Murray, R., J. Caulier-Grice, and G. Mulgan. (2010). *The Open Book of Social Innovation*. London: The Young Foundation.

Norman, D. A. (1986). *The Design of Everyday Things*. New York: Basic Books.

Norman, D. A. (2005). *Emotional Design: Why We Love (or hate) Everyday Things*. New York: BasicBooks; Oxford: Oxford Publicity Partnership [distributor].

Norman, D. A., and S. Draper. (1986). *User-Centred System Design*. Hillsdale, NJ: Lawrence Erlbaum Associates.

Peace, A. (1989). "From Arcadia to Anomie: Critical Notes on the Constitution of Irish Society as an Anthropological Object." *Critique of Anthropology* 9(1): 89–111.

Pew. (2003). *Evolution of Human-Computer Interaction: From Memex to Bluetooth and Beyond. The Human-Computer Interaction Handbook* (1st ed.). S. S. A. J. Jacko (ed.). Hillsdale, NJ: Lawrence Erlbaum Associates: 1–15.

Picard, R. (1997). *Affective Computing*. Cambridge, MA: MIT Press.

Pine, J., and J. Gilmore. (1998). "Welcome to the Experience Economy." *Harvard Business Review* July–August.

Pink, S., E. Ardevol, and D. Lanzeni. (2016). *Digital Materialities*. London: Bloomsbury.

Rabinow, P., and G. Marcus. (2008). *Designs for an Anthropology of the Contemporary*. Durham, NC: Duke University Press.

Robertson, T., and J. Simonsen (eds.). (2012). *Routledge International Handbook of Participatory Design*. London: Routledge.

Robinson, R., and J. Hackett. (1997). "Creating the Conditions of Creativity." *Design Management Journal* 8(4): 9–16.

Rodden, T., A. Crabtree, T. Hemmings, B. Koleva, J. Humble, K.-P. Akesson, and P. Hansson (2004). *Between the Dazzle of a New Building and Its Eventual Corpse: Assembling the Ubiquitous Home*. ACM Conference on Designing Interactive Systems, ACM, San Francisco.

Salazar, J., S. Pink, A. Irving, and J. Sjoberg. (2017). *Anthropologies and Futures: Researching Emerging and Uncertain Worlds*. London: Bloomsbury.

Sangiorgi, D., and A. Prendiville. (2017). *Designing for Service: Key Issues and New Directions*. London: Bloomsbury.

Schatzberg, E. (2019). *Technology: Critical History of a Concept*. Chicago: University of Chicago Press.

Schön, D. (1983). *The Reflexive Practitioner*. New York: Basic Books.

Schuler, D. E., and A. E. Namioka. (1993). *Participatory Design: Principles and Practices: 1st Participatory Design Conference: Papers*. Hillsdale, NJ: Lawrence Erlbaum Associates.

Sellen, A. J., and R. Harper. (2001). *The Myth of the Paperless Office*. Cambridge, MA; London: MIT Press.

Shostack, G. (1982). "How to Design a Service." *European Journal of Marketing* 16(1): 49–63.

Simon, H. (1969). *The Sciences of the Artificial*. Cambridge, MA: MIT Press.

Smith, R.C., K. Tang Vangkilde, M. Kjaersgaard, T. Otto, J. Halse, and T. Binder (eds.). (2016). *Design Anthropological Futures*. London: Bloomsbury.

Squires, S., and B. Byrne. (2002). *Creating Breakthrough Ideas: The Collaboration of Anthropologists and Designers in the Product Development Industry*. Westport, CT: Bergin & Garvey.

Stickdorm, M., and J. Schneider. (2012). *This Is Service Design Thinking*. New York: Wiley.

Strathern, M. (1987). "Out of Context: The Persuasive Fictions of Anthropology." *Current Anthropology* 28(3): 251–281.

Streitz, N., A. Kameas, and I. Mavrommati (eds.). (2007). *The Disappearing Computer: Interaction Design, System Infrastructures and Applications for Smart Environments*. Berlin: Springer-Verlag.

Suchman, L. (1987). *Plans and Situated Actions*. Cambridge: Cambridge University Press.

————. (2007). *Anthropology as 'Brand': Reflections on Corporate Anthropology. Colloquium on Interdisciplinarity and Society.* Oxford, Occasional Papers. Oxford: Oxford University Press, Centre for Science Studies, Lancaster University, 24 February.

————. (2011). "Anthropological Relocations and the Limits of Design." *Annual Review of Anthropology* 40: 1–18.

Tolmie, P., J. Pycock, T. Diggins, A. MacLean, and A. Karsenty (2001). *Unremarkable Computing. CHI'01.* San Francisco: ACM.

Tunstall, D. (2013). "Decolonizing Design Innovation: Design Anthropology, Critical Anthropology and Indigenous Knowledge." *Design Anthropology.* W. Gunn, R. Smith and T. Otto (eds.). London: Bloomsbury: 232–250.

Wakeford, N. (2004). *Innovation Through People-Centred Design: Lessons from the USA.* London: DTI (Department of Trade and Industry).

Weiser, M. (1991). "The Computer for the Twenty-First Century." *Scientific American* 94–104, September.

Weiser, M., R. Gold, and J. Brown. (1999). "Origins of Ubiquitous Computing Research at PARC in the Late 1980s." *IBM Systems Journal* 38(4): 693–696.

Wilson, T., and H. Donnan. (2006). *The Anthropology of Ireland.* London: Berg.

Yelavich, S., and B. Adams. (2014). *Design as Future-Making.* London: Bloomsbury.

14 Museum + digital = ?

Haidy Geismar

Updated introduction

In the first edition of this chapter, I drew on several examples to unpack the ways in which digital technologies are expanding our understandings of museum practices and our experience in museums. I argued that very particular definitions of accessibility, democratization and the social have been imported into museums inside of digital media and that the task of the digital anthropologist is to try to place these values and expectations about how digital media can work in museums in cultural and local context. I initially drew on Horst and Miller's definition of the digital from the original introduction to this volume as an ongoing process of translation and standardization, coded and underpinned by binary register and machine languages. Since then, I have become increasingly uncomfortable with fixing any one definition of the digital as a catchall term to unite the different projects that use digital media and technologies in museums. Indeed, in a recent book exploring the digital/analogue interface in relation to a number of different collections, I polemically suggested,

> there is no essential quality of the digital that links all of these projects. Rather, by observing the digital as another kind of thing in the world, we may begin to understand how the digital encompasses a plethora of different representational forms, techniques and technologies.
>
> (Geismar 2018: 112)

In this updated chapter, I have revisited my discussion and updated my references and examples. I have also extended my focus on digital mediation in museums to include a discussion of digital materiality, an area that has generated significant attention since 2012 and been a productive place to think about the nature of the digital within digital anthropology.

Introduction

As is common within many discussions of digital technologies, the term 'digital' is used as a catchall term, uniting many different forms and practices. This is

particularly the case in museums, where digital technologies are increasingly integrated into diverse practices of collection and collections management, information management, curating, exhibiting and educating. Miller and Horst's assertion is that the digital is fundamentally defined by the technical process of translation into binary register (and back again) and by the standardization, transformation and mediated experience this technological shift effects. This is perhaps the most invisible aspect of museum digital projects, which are more generally characterized by their entanglement within broader museum technologies of performance, spectacle and didactic narrative and by making visible epistemologies of museum classification in both exhibitions and archives.

As representational forms, analysts have long drawn analogies between the drawing together of objects for collection and exhibition and the constitution of society *through* the representation of these objects within the museum (see Bennett 1995). How do digital technologies participate in the representational and creative habitus of the museum? How does binary code and the performances and spectacle it facilitates fit into a continuum of knowledge management and presentation? How does the digital enhance the sensory power and affectivity of exhibitions and extend conversations about the circulation and ownership, indeed the sovereignty, of collections? In the case studies that follow, I re-evaluate the broad claim, common across digital studies, that the digital is a completely new domain of form and practice that creates social and material encounters that are radically different from its antecedents. The emergence of digital technologies in museums is in fact part of a long-standing trajectory of networking, classifying and forging representations of relationships between people and things.[1]

An overview of the anthropology of digital technologies in museums

Accounts of the digital as a 'new' genre of museum practice are largely celebratory, applauding the democratic expansion of a commons of cultural information and objects to greater numbers of people. The discursive tropes of access and accountability are also hallmarks of a continually emergent 'new museology' that has documented a shift of interest in museums away from objects and toward people, society and experience (see Hein 2000; Hooper Greenhill 2000; Vergo 1989).

Broadly speaking, accounts of digital practices in museums recognize the digitization of museums in the catalogue, the website, online exhibitions, social media and the technological interfaces that act as communicative and structuring mechanisms that simultaneously interpret and provide greater access to museum work (collecting, exhibiting, educating, socializing and researching). Many analysts focus on the ways in which these digital museum practices challenge conventional understandings of museum collections and perceptions of authenticity, replication and the visitor experience (see Bayne, Ross and Williamson 2009; Conn 2010; Isaac 2008; Henning 2007, 2015).

Much of the literature has focused on the ways in which museums use digital technologies to generate new social relations and to create new epistemologies

collections but the social relations that collections and knowledge systems are active participants within. This is why digital museum tools are often described in terms of their social effects – access, accessibility, availability, democratization, community, constituency – and their alter egos: secrecy, restriction, protocols and hierarchy.

Chris Kelty (2008) has described the ways in which the digital and social may be seen to produce one another in reference to the ways in which free and open-source software constitutes a "recursive public sphere" (2008). Sociality in this context is modelled in terms of networks, access and openness, and many discourses from the open source and creative commons movements have entered into museums, which as institutions also curate and constitute ideas about the public. What, however, is achieved through access to this kind of social encounter? How do these codes transform social relations, if at all? What do they really describe? The emergence of social tagging, and the representational theory of folksonomy (collaborative forms of classification), in relation to museum information management systems is a good place to think these questions through. In 2005 the *Steve.museum* project was founded in the United States to address concerns by art museums regarding the expansion of access through digitization and placing their collections online. One of many similar museum projects at this time interested in harnessing the power of Web 2.0 in the museum, Steve attempted to create and investigate the potential for tagging, or user-generated taxonomies, in describing collections. As its website describes, the Steve project "formed a collaboration, open to anyone interested in thinking about social tagging and its value to museums, and began to develop a set of open source tools for collecting, managing, and analysing user-contributed descriptions".[6]

The notion of open-access via digitization of collections and their accessibility on the Internet and the kinds of participation that this both presumes and promotes has been a central theme to many museum engagements with the digital. Tagging, objectwikis, folksonomies and crowd curation have all become frames for articulating and promoting the democratization of the museum, often described in glowingly utopic terms.[7] For example, Cameron and Mengler, framing the work of the Powerhouse Museum in Sydney's investigations of a more open classificatory system, comment:

> Google-mediated searches are enabling the 'networked object' to play a role in political interventions in public culture . . . This highlights the fluidity, complexity, contested and political nature of cultural interactions and exchanges around what an object might mean. It also demonstrates how the divide between so-called high culture and popular culture, museum culture and public culture can spontaneously dissolve, and how easily people can combine museum collections with other cultural forms.
>
> (Cameron and Mengler 2009: 192)

Srinivasan et al. (2009a, 2009b) challenge such celebratory discussions of tagging and folksonomy. They are sceptical of the kinds of expert knowledge that are required to make sense not only of collections but of the digital interface,

and they question the assumption that tagging and other online additions to cata-
logue information permit a deeper, more sustained engagement with collections.
A certain kind of curatorial process is needed for projects that potentially engage
masses of people, which in some ways replicates the same structures of authority
that the utopian visions of open access and folksonomy are trying to leave behind.
In a February 2011 search on the Steve website intended to locate examples of
interesting tags, most of the links to participating museums were broken, and of
the images of artworks linked in the section 'Steve in Action', almost all of them
remained untagged (and the entire site is now inaccessible). There was recogni-
tion by museum professionals, and by the project, that in order to be useful, tag-
ging needs to be moderated and standardized, with constituencies organized into
communities of 'trust'.[8] Access to the democratic republic of tagging works best
with smaller communities of like-minded people who share knowledge bases,
interests and skill sets.[9]

Tagging and folksonomies are perhaps better understood as representations of
users as well as collections, reflecting the intent of the museum to represent itself
as open and non-hierarchical on the one hand and reflecting the opinions and
knowledge of the public on the other. They are recursive in that they create a form
of openness (and a perception of the public) that in turn alters the public's percep-
tion of the museum as an open space. Many projects are successful in these terms
and genuinely inflect a sense of participation even if the actual form of participa-
tion in formalizing knowledge around collections remains limited.

In the successfully crowd-curated exhibition *Click!* held at the Brooklyn
Museum in 2008, anyone with Internet access was invited to participate in the
selection of images online. An open call to artists invited electronic submissions
on the theme 'The Changing Face of Brooklyn'. Visitors to the website were then
invited to go through the image bank and anonymously jury the exhibition. The
final selection included images 'democratically' preferred by the majority of visi-
tors. The supplementary information on the website broke down jurists by loca-
tion, allowed access to comment and discussion around the images and collected
other facts and figures about the exhibition. However, one of the invited commen-
tators (Kevin Stayton, curator at the Brooklyn Museum of Art) noted, highlighting
the recursivity or 'meta' quality of these digital initiatives,

> So if the crowd juried the images, how was it curated? And what was the idea
> curated? The theme of the photographs submitted was 'The Changing Faces
> of Brooklyn,' but that is not the theme of the installation that is presented in
> our galleries. Although the changing faces of Brooklyn is an idea that under-
> lies each of the works of art in the exhibition, the exhibition itself is about the
> notion of selection, and, specifically, selection by the crowd.[10]

Case two: radical archives and the limits of openness

My first example focused on the ways in which digital technologies have been
used to open up the process of knowledge production, interpretation and cura-
tion to different, non-traditional constituents and highlighted briefly how digital

museum practices encode social theories and work to produce an image of a public and, by extension, generate self-consciousness for the museum-visiting public itself. These 'new' museum subjects inevitably add a layer of (self)representational effect to digital collections. In a second case study, I move behind the scenes to look at the ways digital archives constitute an alternative imaginary of access and public access that critiques the representational authority of the museum and archive. Unlike the crowd curation and tagging projects, which open up collections promiscuously, these 'radical' archives resist and subvert the model of open access. They critique the authority of museum collecting practices – speaking back to histories of privileged access and exclusion. For many Indigenous peoples, especially those in settler colonies with vibrant national museum cultures (e.g. Australia, Canada and New Zealand), this is a question of sovereignty as much as protocol. Access to archives becomes a political act where control over the visibility of information is hoped to facilitate the devolution of other kinds of power and authority.

The potential for openness evoked by digital technologies makes them fertile grounds for expressing this critique. Helen Verran has called this "postcolonial databasing" (Verran 2014). The project *Digital Futures* by anthropologist Elizabeth Povinelli, who has worked for many years in Aboriginal Australia, interrogates the resonance of archiving practices for Aboriginal people and "asks what a postcolonial digital archive becomes if, instead of information, circulation, and access, we interrogate it from the perspective of socialities of obligation, responsibility and attachment". Upon entering the project and clicking on a map location, text on screen informs us that:

> You are about to participate in a form of circulation, the circulation of information, persons and socialities. This form of circulation has a metaform, a sociality, a way of anticipating, addressing, and incorporating the things that move through it, including you. The government wishes to help.[11]

The site then presents a series of filmed narratives, mediated by a digital cartography, that fundamentally destabilizes the viewer. The narratives are elliptical, like the footage, and off subject, challenging our expectation of the kinds of information that should be archived or the ways in which cultural knowledge might be visually and discursively embodied. As digital catalogues move outside of the space of the museum or archive (via web technologies), the context in which these relationships are viewed becomes infinite, as the terminals on which the catalogues are viewed will vary as well as the physical environments in which they are located, challenging the boundaries of how the museum itself frames this material and holds authority over it. Povinelli's archive was designed to be accessed via handheld units (like smartphones), in which geographic information system technologies could link stories, photos, videos and other data in ways that can only be accessed when people are in specific places. Another text that scrolls over the screen as you navigate the prototype site states, "Even as I address you as *you* this is an impersonal you, a third person

form of the second person. We have programmed *you* into this site without knowing who you are".

Many discussions of the process of digitizing in museums take for granted, particularly in the context of museums and archives, that collections are supposed to be seen (see Brown 1998). This is part of our own, often unexamined, cultural perspective that insists on visibility as one of the prime modes of acquiring knowledge (seeing is believing). There are powerful cultural assumptions that digitization equals access and broad circulation, even as governments and corporations are desperately encoding restrictions in law.[12] The open circulation of images and objects and information may, in fact, work against local understandings of the appropriate use of museum collections. For some Aboriginal Australians, for instance, only initiated cultural insiders are traditionally supposed to fully apprehend the true meaning and stories contained within locally produced images, even as they circulate in wider and wider contexts (see Myers 2002, 2004). Indigenous protocols that hinge around the idea of invisibility (or holding back) are carried through into other contexts, for example in some parts of Australia, when someone died, all mention of the person would cease and his or her belongings would be destroyed. The person was no longer referred to, represented or seen – provoking an anxiety regarding the unauthorized presence of photographs in print, on display or in archives.

These traditional protocols are now being institutionalized in new ways, despite an on-the-ground fluidity in the ways in which Aboriginal Australians themselves use photographs and other media images (see Deger 2006; Morphy 2014). In Australia, it is a well-established institutionalized custom to preface publications, exhibitions, websites and films with a warning to Aboriginal people that they may see images of people now deceased in order to limit the cultural harm that this visibility may render. However, the proliferation of technology works in communities in different ways, and opening images up to different forms of mobility (particularly through smartphones) has altered Aboriginal engagements with the materiality and visibility of digital images (see Christen 2005; Deger 2013, 2016).

Digital technologies thus facilitate a sustained and developing engagement with the power relations that surround the museum and archive. In Australia, this takes form in part within a growing digital movement that rethinks the openness and accountability of digital archives. The Ara Iritija project is a database and archive housed in mobile units that service thirty-one Aboriginal communities in central Australia (see Christen 2006; Thorner 2010; www.irititja.com/). The mobile platform is an archive organized with community engagement and protocols in mind that is networked on a localized intranet. Thorner describes this process of "indigenizing the internet" but comments,

> the potential of the new Ara Iritija (both the software package and its dynamic approach to archiving) is embedded in its optimized flexibility, and yet, there are limits to the ways in which digital technologies can be mobilized in the interests of Anangu cultural production.
>
> (Thorner 2010: 138; see also Christie 2005)

Another example of how these protocols can be expressed (and effected) digitally can be found in the Mukurtu Wumpurrarni-kari Archive, a browser-based digital archive created initially for the Warumungu community in Tennant Creek, Northern Territory, Australia, in collaboration with Kim Christen, Chris Cooney and other researchers from the United States and Australia. Mukurtu has now been launched globally as open-source software aimed specifically to provide archiving solutions for Indigenous peoples and other communities with nonhegemonic archival needs and desires. In this way, the specificity of Aboriginal Australian negotiations with their own traditions of image management and the settler-colonial culture of museum collection has been extended to other cultural and colonial contexts, competing with other generic collections management system that do not conventionally interrogate their own categories. An offshoot of the project, *Local Contexts*, is developing Traditional Knowledge Licenses and Labels to complement the initial intervention that Creative Commons Licenses have made into the landscape of intellectual property, and to rezone the cultural commons with greater attention paid to alternative protocols surrounding access to knowledge and cultural information (see Anderson and Christen 2013; Christen and Anderson 2019).[13]

A demonstration of the Mukurtu archive (also as a contribution to the journal *Vectors*, entitled 'Digital Dynamics Across Cultures'[14]) illustrates a number of ways to deal with the combination of Aboriginal protocols and the reproduction of images in the archive: photographs are obscured by pieces of tape or made

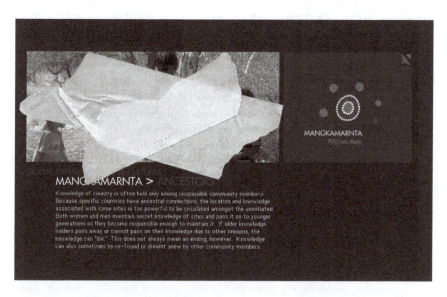

Figure 14.1 Screenshot from the digital dynamics across cultures Project by Kimberly Christen and Chris Cooney

Source: http://vectors.usc.edu/projects/index.php?project=67

entirely unavailable; videos cut out or fade halfway through and warnings are given about the gendered nature of knowledge. In addition, each of these protocols is explained carefully on the site to give the non-Indigenous viewer a chance to rethink the viewing restrictions that are embedded within Aboriginal engagements with images in the archive. The commons – a public-domain resource open to all to appropriate both visually and in other operational ways – has been indigenized, re-presented within a frame of very different values around access, visibility and entitlement (Christen 2012).

It is becoming clear that in some places the upshot of community collaboration and consultation around collections may in fact be the end of public access to certain collections and the emergence of what I have termed an 'Indigenous commons' – archives regulated in relation to very different kinds of protocols to those that have developed within the colonial or modern museum (Geismar 2013: chap. 5; c.f. Brown 2003). Rather than being tools of enlightenment, in which the world is neatly packaged and displayed for a general public, democratically defined (see Bennett 1995), the sensibility of 'radical archives' suggests an understanding of knowledge as constructed through power-inflected and specific relations between object, institution and visitor, and in which visibility is not the only way in which this relationship may be configured.

The questions raised by many of these projects are, like the Steve.museum, fundamentally about the politics of representation, and they are technically embedded and enacted. The visibility of these archives draw attention to the basic assumptions of access and availability and the presence of other epistemological and ordering protocols. A debate has arisen between commentators such as Michael Brown (1998, 2003), who think it inappropriate and impractical to translate the diversity of Indigenous values and entitlement into generic or national cultural/ museum policy, and those, often scholars representing Indigenous or minority constituencies such as Audra Simpson, who think that this view perpetuates the very hierarchies and elitisms that recoding and resignifying projects aim to address (e.g. Simpson 2007). I argue that such digital projects need to be understood not simply as representational projects but also as crucibles within which the grounds of representation are established and as real-world sites of engagement and experience.

Case three: new database, new epistemology? the digital practices of the Vanuatu Cultural Centre

In my final example, I turn to the digitizing practices of the Vanuatu Cultural Centre and National Museum (VCC), which have aimed to constitute a synthetic archive that unites many different kinds of collections: audio, photographic, video, objects, archaeological site research and languages. In this example (published in longer form in Geismar and Mohns 2011) I argue that we need to understand the emergence of digital practices in cultural context and with historical specificity. Two key tropes within contemporary accounts of the digital are rupture and novelty: the digital is presumed to herald unprecedented radical structural and social

power to remove the record entirely from visibility. An entry archived in relation to these restrictions will not be made available in a search until a user with the appropriate rights of access logs in.

Developed using open-source software, the database protocols have been structured by committee (a team comprising technical staff and cultural experts). This committee extends the remit of the VCC to bring local knowledge into the museum, to respect grassroots and newly national hierarchies of entitlement and authority and to engage with this through museum practices from collecting to exhibiting and programming. This coding practice unites very local concerns for knowledge management with more global templates.

The template for the database's model of secrecy is not only the affordances of new digital technologies but a number of geophysical locations: the sacred men's houses within local *nasara* (dancing grounds) *and* a room within the inner sanctum of the VCC archive known as the *Tabu Room* (where the secret sacred material is quietly filed away). This room, with locked door, was constructed to reassure those permitting sensitive or restricted material to be recorded and collected that the material would not be freely available for viewing by those who were not entitled, and as a safe house to protect such material from the potential threat of hurricanes, tropical rain and erosion. Since its inception, villagers have been encouraged to use the room as a bank for *kastom*, to protect valued artefacts and documentation and to preserve them for future generations, safe in the knowledge that the archives can be restricted along *kastom* guidelines defined mainly by connections of persons to places and to families and by traditional status (see Geismar 2009a). The collections in the Tabu Room thus constitute a pre-digital archive drawn out of traditional practice by the idiosyncratic appropriation of international museum technologies and principles by the VCC: audiovisual recording, archiving and conservation (see Geismar and Tilley 2003; Sam 1996).

Such newly made museum objects include documentations of personal testimonies, stories, myths, music, ceremonies, national political and cultural events, ritual paraphernalia and artefacts recorded in a variety of media: written texts, audio tapes, film, slides and photographs. As the Tabu Room is in the process of being incorporated, and indeed transformed, into the database, all material, including digital material, is subject to the same restrictions as any other artefact, and a copy of every recording is left with the people with whom it was made, both assuaging people's concerns about the removal of local *kastom* from the islands and creating further anxiety about the possibility of endless circulation or mishandling.

At the time of updating this chapter in 2019, the VCC database has been de-aggregated back to separate catalogues, and its local intranet is not functioning due to lack of sustained funding. The collections databases are accessed only by the curatorial team in the VCC and are used by members of individual sections to upload and organize data, to perform searches for internal use and on behalf of the general public and visiting researchers. The most synthetic use of the catalogue is in the National Library and Archive, which opened in a new building in 2013. Visited every day by local ni-Vanuatu and schoolchildren, the librarians use the catalogue to do thematic searches for any visitor, and the list of associated music,

Figure 14.2 Screenshot of the photography catalogue in the Vanuatu National Museum database showing the different levels of access that can be set for any image

sound, films, documents and books are printed out and given to visitors to assist them with their research. What is really impairing the usability of the database is a lack of networked hardware and the limitations of the built-in obsolescence to both hardware and software that the small funds of the institution cannot keep pace with. There are no networked computers available for public access currently in the VCC and limited resources for the maintenance and upgrade of network infrastructure to facilitate both internal and public access.

Despite these limitations, the database remains a remarkably robust template for restructuring the ways VCC staff and other users interact with the collection and archives, with a longevity far beyond many of the other projects referenced here, most of which have become defunct since the first edition of this book was published in 2012. Staff still control the level of accessibility of information stored in the archives, but once the appropriate staff member assigns a level of accessibility, then anyone who is granted that level of access can potentially access that information without the knowledge or assistance of that staff member. In short, while VCC staff control the parameters for access to individual objects, some of the role of keeper and gatekeeper of knowledge is transferred from the staff member to the database system as the user, rather than the staff of VCC, interacts with the system to retrieve cultural information.

Through discussing how to deal with the issue of place in cataloguing these images in the database, it was clear that for the database committee the form of the database was mapped directly onto the handling of the material in question. There was no distinction made between the virtual information within the database and any other object: masks, cassettes, photographs, videos and other documents and documentation. This conflation is supported by the pragmatic decision of the VCC to use the hard drive, or very substance of the database, as its fundamental unit of storage. Increasingly, these gigabytes of storage are the very form of the collection, particularly as the VCC focuses its work on audiovisual documentation.[15] Therefore, when browsing the image or music files of the newly digitized collection of oral traditions or of photographs, one is able to connect directly with the source of the reference – to download the museum-quality image or to listen to the recording itself. The difference between an idea of the original object and any other copies is therefore not really an issue in this digital space, and this pragmatic view maps onto an ontological view of authenticity that has been described by many anthropologists as very Melanesian (see Leach 2003). This is in keeping with local understandings of objects, in which it is the reference point or knowledge behind the form that is the essential object rather than the momentary form in which it might be manifested.[16]

Unlike most databases, which are perceived to be almost shadows or partial representations of the collection (itself housed elsewhere), the VCC database configures the digital collection *as* the work of the VCC. Object collection has always been a subsidiary occupation of the VCC, with photography, sound and video being perhaps the archetypal materials collected. The principles of audio-visual media, with their basis in evidential and objective recording and the potential for multiple reproduction and circulation, is much more suited to the main interests

of the VCC in cultural regeneration and activation than the more traditional and museological object-led model of salvaging material which is supposed to stand in for disappearing or diminished cultural practice. Instead, museum objects (photographs, video, film and audio recordings) are very much viewed as momentary manifestations of cultural practices, the recording of which, as a process, contributes to the perpetuation of practice, both within and without the museum walls (see Geismar 2006; Geismar and Herle 2010). Focusing on the ways in which the database participates in creating networks focused on place, secrecy and restriction, and language demonstrates how digital spaces do not simply represent other spaces but are part of the processes by which these spaces, and relationships, are forged. We see how the importing of certain technologies (and the attendant importing of flexibility and cultural sensitivity they permit) engenders a dialogue that is made visible via the aesthetic of the database itself. Its users are not abstract citizens, or the public, but people with specific investments in the networks of connection that lie within.

Conclusion: towards a nuanced understanding of digital materiality

In the case studies presented in this chapter, I have emphasized the ways in which digital technologies encode different forms of sociality in very different places around the world. It might seem that I am promoting a reification of cultural difference along borders very familiar to anthropologists, in which Melanesians, or Aboriginal Australians, are somehow radically different to people living in Brooklyn, New York. In fact, I am highlighting the ways in which digital technologies are bound up within the same epistemologies of cultural representation as other kinds of museum artefact and practice and should be scrutinized with the same level of comparative attention and cultural sensitivity. However, it is also true that digital technologies have provided an important forum for Indigenous people to raise a series of critiques of mainstream museum practices and issues regarding access, accessibility and the public – to levy a critique of cultural relativism itself. I am suggesting here that digital technologies do *not*, contra many accounts, merely engender new forms of sociality, at least not in the way that they are usually described. Rather, digital technologies facilitate the emergence and development of existing social concerns through the one quality that they have that differs to other formal mechanisms for engendering social connectivity or managing access and accountability. That quality is that of recursivity, or reflexivity. It is a quality in which sociality is reflected through the forms that both produce and represent it. This recursive effect creates a compressed zone in which technology and sociality seem to, in fact, be the same thing. The recursive effect of the digital in museum is to foreground and make visible a kind of sociality that was historically obscured by museums in the ways in which collections were made, organized and displayed. Now, Aboriginal Australians and ni-Vanuatu are also making their own cultural protocols visible (and, indeed, deciding what to render invisible). These are true challenges to the authority of the museum, but they are made using tools

provided and structured by that very institution. In turn, and somewhat paradoxically, digital encodings of collections can also challenge this very visibility, and they have the potential to restructure display and access.

Discussions of digital materiality move us beyond attempts to define and describe digital objects. It is useful to anchor this discussion in the ways in which it has emerged in relation to museums and collections, since they tend to make explicit the epistemologies and infrastructures that define our material world in discrete terms. The conversations that have taken place in museums around what collections are, and how digital objects may be collected (e.g. Altshuler 2013; Rubio 2014; Boyle and Hagmann 2017; Were 2014), demonstrate the ways in which museums contribute to very particular philosophies and theories of the object world. Rubio (2016) describes how museum practices of curation and conservation produce objects out of things by stabilizing the material world into very specific institutional assemblages. His example is the *Mona Lisa*, and he exposes the regimes of care that are required to stabilize it as an art work, including management of the environment and air quality, the light surrounding it and the pigments on canvas (2016). In many ways digital media works against these efforts to stabilize the material world since its hallmark seems to be material instability, uncertainty and obsolescence. Indeed, as should have become clear if you look at the footnotes to this chapter, none of the projects I referred to in the 2012 version of this paper are either currently active or visible, and few are even available to look at online. Part of my edits have been to change my discussion to talk about these projects in the past tense: the Steve tagging project and the Click! exhibition have vanished from both museums and the web apart from their presence on web archiving platforms such as the Internet Archive's Wayback Machine.[17] Indeed, museums, along with the rest of us, are having to let go of what Lorraine Daston has described as "common-sense thing ontology . . . chunky and discrete" (2007: 16). We must, however, take care not to substitute a naive discourse of immateriality in its place.[18] For instance, the obsolescence that partially underpins the digital's seeming ephemerality is constructed by the infrastructures and political economies that underpin the design and development of digital technologies (Tischleder and Wasserman 2015). It is increasingly obvious that our ability to recognize, create and circulate digital objects depends on the production of global standards, the creation of global communities of care and preservation in the information architectures that underpin them, and the production of global values about what should be preserved and how (and that this is ushering in new hegemonies and normativities). It is also the case that digital materiality is constituted from a complex and performative mimesis in which digital media is used to create indexical reality effects: presenting us with images in two or three dimensions that simulate other kinds of objects. This is especially the case in the creation of 3D images of museum collections in which incredibly complex craft and labour of skilled programmers generates the impression of mechanical and absolute reproduction (see Geismar 2015, 2018). It is not, however, the case that these digital objects are treated as collections in London as they are in Port Vila, Vanuatu: in

most European and American museums, digital objects circulate, are replicated and are reauthored, in ways that other collections are simply not allowed to do.

Accounts of digital practice and form in museums that can be called truly anthropological are still rare. Studies of digital technology in museums tend to be overdetermined by the form of the digital and less descriptive of the intricate ways in which the digital can be embedded in pre-existing frames of being: of classification, epistemology and sociality (but see Isaac 2011). However, many of these accounts draw out the ways in which these digital projects are themselves inherently anthropological: in that, they are de facto representations of emergent theories of sociality, and which in fact function *through* these representations of social interconnection. The forms of sociality that are presumed by the relational database and the way in which it may be extended into a hypersociality of the World Wide Web or made to conform to more exclusive sets of Indigenous protocols suggest that the work of digital anthropology is itself encoded in the digital platform. This is not to suggest that the task of the analyst is merely to expose an endless recursivity between objects, data, cultural systems and digital systems but rather to highlight the ways in which all of these digital projects continue the foundational work of museums more generally – to create a sense of public, to draw in community and engage community with broader educative, expressive and experiential ideas about knowing things through things. The digital is yet another object through which these knowledge practices are channelled within museums.

As museums, galleries and cultural centres both utilize and are integrated into digital environments more and more; as we increasingly experience objects first and foremost in digital form; and as the strategy of the hyperlink both defines and expands the ways in which different forms of knowledge can be connected to collections, it is important that we have accounts of digital practice that are ethnographic, that focus on the decisions, structures, assumptions and imaginaries that themselves encode code.

Notes

1 This is the argument that I develop in more depth in *Museum Object Lessons for the Digital Age* (Geismar 2018). In this volume I focus on four objects, two from the classic ethnographic collection (an effigy and a cloak) and two that belong more to the technologies of the museum (a pen and a box) and explore the ways in which longstanding histories of collections and theories of materiality are imported into the digital domain.

2 The conference proceedings are published and archived each year: www. archimuse. com/conferences/mw.html

3 See, for instance, the digital re-creation of Barnum's museum, which was destroyed by fire in 1865 in the Lost Museum project (http://lostmuseum.cuny.edu/), or the interventions of Art Mob – creating unofficial podcasts for New York's Museum of Modern Art (http://mod.blogs.com/art_mobs/).

4 Digital repatriation may refer to projects that share digital resources or return historic collections in digital form. More critical discussion is required with reference to the complex evaluation and politics of repatriation and its diverse cultures in different

places. For a more nuanced discussion, see Bell (2003) on the implications and effects of the circulation of historic photographic collections and see Geismar (2005, 2009b, 2009c, 2010) and Geismar and Herle (2010). The edited collection, *After the Return* (Bell, Christen, and Turin 2013), utilizes the term return, in recognition of the political problems embedded within the practices of digital repatriation. Indeed, Boast and Enote argue trenchantly against the return of digital material being a form of repatriation, claiming that "it is neither virtual nor repatriation" (2013).

5 The Pitt Rivers Museum's project, Rethinking Pitt Rivers, analyzes the collector as a centralizing force within complex networks that drew together objects, information and the nascent discipline of anthropology (http://web.prm.ox.ac.uk/rpr/).

6 The Steve Project website is now defunct but has been partially archived by the Internet Archive: https://web.archive.org/web/20150408001309/http://steve.museum/

7 It is noteworthy that all the links from the original version of this chapter are now defunct or broken, although some have been archived via the Internet Archive see, for example, https://web.archive.org/web/20150404213627/http://tagger.steve.museum/, and https://web.archive.org/web/20080705012539/http://objectwiki.sciencemuseum. org.uk/ for two such projects.

8 The Steve team, a collaboration with the University of Maryland and the Indianapolis Museum of Art, went on to develop a second project called T3 (text terms trust). The project combined "text mining, social tagging and trust inferencing techniques to enrich the metadata and personalize retrieval" (Klavans et al. 2009)

9 Another project that rethinks and indigenizes the commons can be found in the Reciprocal Research Network (www.rrncommunity.org), an international network that aims to unite communities from the north-west coast of Canada to museums and other repositories all around the world. Managed out of the University of British Columbia's Museum of Anthropology, the network has developed a digital platform that links catalogue information and collections databases from all of the partner institutions to communities via research hubs, to which access must be gained by collaboration and partnership. The network allows for discussion, comment, critique and information sharing in a safe and sensitive way, utilizing the digital to create a different kind of openness – not a public but a more restricted community that would not normally be able to access the collections in situ (see Phillips 2011, Turner 2016a for a longer discussion on the critical history of museum catalogues).

10 In the exhibition, 389 photographs were submitted, and 344 evaluators cast 410,089 evaluations. On average, each evaluator looked at 135 works. The top 20 per cent of ranked images were displayed in the final exhibition (www.brooklynmuseum.org/exhibitions/click/). The quoted comment was taken from the broader blog post by Kevin Stayton, archived at https://web.archive.org/web/20110310023543/http://www.brooklynmuseum.org/community/blogosphere/2008/07/23/crowd-curated-or-crowd-juried/.

11 See Elizabeth Povinelli, *Digital Futures* (2011), http://vectors.usc.edu/projects/index. php?project=90

12 See the highly contentious Digital Economy Act of 2010, which aims to crack down on peer-to-peer file sharing and which advocates the ability for Internet access to be denied to file-sharing perpetrators. See also the conflict, Joywar, between artist Joy Garnett and Magnum photojournalist Susan Meiselas over Garnett's appropriation, from the Internet, of Meiselas's photo of a Sandinista, the subsequent legal battle (which Garnett lost) and continued reproduction by artist activists of the image. The entire debate is archived at https://web.archive.org/web/20120205013815/http://www. firstpulseprojects.com/joywar.html.

13 www.mukurtuarchive.org/, www.localcontexts.org

14 http://vectors.usc.edu/projects/index.php?project=67

15 Backups are stored in Noumea, New Caledonia, and in Australia with support of Paradisec, a digital archive supporting endangered archives across the Pacific region (www. paradisec.org.au).

16 This is a common philosophy behind many different objects in the Pacific, notably Malanggan; see Küchler (1988) Geismar (2009b) and Bell and Geismar (2009).
17 http://web.archive.org. I have tried to archive all the links referred to here to hopefully increase their longevity.
18 For instance, take John Perry Barlow's assertion in his Declaration of the Independence of Cyberspace: "Your legal concepts of property, expression, identity, movement, and context do not apply to us. They are all based on matter, and there is no matter here" (Barlow 2016 [1996]). See Buchli (2016); Blanchette 2011, 2012) for more considered explorations of our definitions of immateriality.

References cited

Altshuler, Bruce, ed. 2013. *Collecting the New: Museums and Contemporary Art*. Princeton: Princeton University Press.

Anderson, Jane, and Kimberly Christen. 2013. ' "Chuck a Copyright on It": Dilemmas of Digital Return and the Possibilities for Traditional Knowledge Licenses and Labels'. *Museum Anthropology Review* 7 (1–2): 105–26.

Barlow, John Perry. 2016 (1996). 'A Declaration of the Independence of Cyberspace'. *Electronic Frontier Foundation*, 20 January. www.eff.org/cyberspace-independence. Archived at https://web.archive.org/web/20210125095512/https://www.eff.org/cyberspace-independence

Bayne, S., J. Ross, and Z. Williamson. 2009. 'Objects, Subjects, Bits and Bytes: Learning from the Digital Collections of the National Museums'. *Museum and Society* 7 (2): 110–24.

Bell, J. A. 2003. 'Looking to See: Reflections on Visual Repatriation in the Purari Delta, Gulf Province, Papua New Guinea'. In *Museums and Source Communities: A Routledge Reader*, eds. L. Peers and A. K. Brown, 111–22. London: Routledge.

Bell, J. A., and H. Geismar. 2009. 'Materialising Oceania: New Ethnographies of Things in Melanesia and Polynesia'. *Australian Journal of Anthropology* 20: 3–27.

Bell, J. A., Kimberly A. Christen and Mark Turin. 2013. 'Introduction: After the Return'. *Museum Anthropology Review* 7 (1–2): 1–21.

Bennett, T. 1995. *The Birth of the Museum: History, Theory, Politics*. London: Routledge.

Blanchette, Jean-François. 2011. 'A Material History of Bits'. *Journal of the American Society for Information Science and Technology* 62 (6): 1042–57. https://doi.org/10.1002/asi.21542.

Blanchette, Jean-François. 2012. *Burdens of Proof: Cryptographic Culture and Evidence Law in the Age of Electronic Documents*. Cambridge, MA: MIT Press.

Boast, Robin, and Jim Enote. 2013. 'Virtual Repatriation: It Is Neither Virtual nor Repatriation'. In *Heritage in the Context of Globalization: Europe and the Americas*, eds. Peter F. Biehl and Christopher Prescott, 103–13. New York: Springer. http://dx.doi.org/10.1007/978-1-4614-6077-0_13.

Bouquet, M. 1996. 'Family Trees and Their Affinities: The Visual Imperative of the Genealogical Diagram'. *Journal of the Royal Anthropological Institute* 2: 43–66.

Bowker, Geoffrey C., and Susan Leigh Star. 2000. *Sorting Things Out: Classification and Its Consequences*. Cambridge, MA: MIT Press.

Boyle, Alison, Johannes-Geert Hagmann, and Smithsonian Institution Scholarly Press, eds. 2017. *Challenging Collections: Approaches to the Heritage of Recent Science and Technology*. Artefacts: Studies in the History of Science and Technology, volume 11. Washington, DC: Smithsonian Institution Scholarly Press.

Brown, D. 2007. 'Te Ahu Hiko: Digital Cultural Heritage and Indigenous Objects, People and Environments'. In *Theorizing Digital Cultural Heritage: A Critical Dis-course*, eds. F. Cameron and S. Kenderdine, 77–93. Cambridge, MA: MIT Press.

Brown, D. 2008. 'Ko to ringa ki nga rakau a te Pakeha'. *Virtual taonga Māori and Museums. Visual Resources* 24 (1): 59–75.

Brown, M. 1998. 'Can Culture Be Copyrighted?' *Current Anthropology* 39 (2): 193–222.

Brown, M. 2003. *Who Owns Native Culture.* Cambridge, MA: Harvard University Press.

Buchli, Victor. 2016. *An Archaeology of the Immaterial.* London ; New York: Routledge, Taylor & Francis Group.

Cameron, F., and S. Kenderdine. 2007. *Theorizing Digital Cultural Heritage: A Critical Discourse.* Cambridge, MA: MIT Press.

Cameron, F., and S. Mengler. 2009. 'Complexity, Transdisciplinarity and Museum Collections Documentation: Emergent Metaphors for a Complex World.' *Journal of Material Culture* 14: 189–218.

Christen, K. 2005. 'Gone Digital: Aboriginal Remix and the Cultural Commons.' *International Journal of Cultural Property* 12: 315.

Christen, K. 2006. 'Ara Iritija: Protecting the Past, Accessing the Future – Indigenous Memories in a Digital Age.' *Museum Anthropology* 29: 59–60.

Christen, K. 2011. 'Opening Archives: Respectful Repatriation'. *American Archivist* 74: 185–210.

Christen, K. 2012. 'Does Information Really Want to Be Free? Indigenous Knowledge Systems and the Question of Openness'. *International Journal of Communication* 6: 24.

Christen, K., and Jane Anderson. 2019. 'Toward Slow Archives'. *Archival Science* 19 (2): 87–116. https://doi.org/10.1007/s10502-019-09307-x.

Christie, M. 2005. 'Words, Ontologies and Aboriginal Databases'. *Media International Australia: Digital Anthropology* 116: 52–63.

Conn, S. 2010. *Do Museums Still Need Objects?* Philadelphia: University of Pennsylvania Press.

Daston, Lorraine. 2007. 'Speechless'. In *Things That Talk: Object Lessons from Art and Science*, ed. Lorraine Daston, 9–24. New York: Zone Books.

Deger, Jennifer. 2006. *Shimmering Screens: Making Media in an Aboriginal Community.* Minneapolis: University of Minnesota Press.

Deger, Jennifer. 2013. 'The Jolt of the New: Making Video Art in Arnhem Land'. *Culture, Theory and Critique* 54 (3): 355–71. https://doi.org/10.1080/14735784.2013.818277.

Deger, Jennifer. 2016. 'Thick Photography'. *Journal of Material Culture* 21 (1): 111–32. https://doi.org/10.1177/1359183515623312.

Frey, B. S., and B. Kirschenblatt-Gimblett. 2002. 'The Current Debate: The Dematerialization of Culture and the De-accessioning of Museum Collections.' *Museum International* 54 (4): 58–63.

Geismar, Haidy. 2005. 'Footsteps on Malakula: A Report on a Photographic Research Project'. *Journal of Museum Ethnography* 17: 191–207.

Geismar, Haidy. 2006. 'Malakula: A Photographic Collection'. *Comparative Studies in Society and History* 48: 520–63.

Geismar, Haidy.2008. 'Cultural Property, Museums, and the Pacific: Reframing the Debates'. *International Journal of Cultural Property* 15: 109.

Geismar, Haidy. 2009a. 'Contemporary Traditions: Museum Collecting and Creativity in Vanuatu'. In *Creative Arts in the Pacific*. Bathurst: Crawford House Publishing.

Geismar, Haidy. 2009b. 'The Photograph and the Malanggan: Rethinking Images on Malakula, Vanuatu'. *Australian Journal of Anthropology* 20: 48–73.

Geismar, Haidy. 2009c. 'Stone Men of Malekula on Malakula: An Ethnography of an Ethnography'. *Ethnos: Journal of Anthropology* 74: 199.

Geismar, Haidy. 2010. Review of *Do Museums Still Need Objects?* by S. Conn. 4 March. www.materialworldblog.com. Archived at https://web.archive.org/web/20210125095703/https://materialworldblog.com/2010/03/do-museums-still-need-objects/

Geismar, Haidy. 2013. *Treasured Possessions: Indigenous Interventions into Cultural and Intellectual Property*. Durham, NC: Duke University Press.

Geismar, Haidy. 2015. 'Post-Photographic Presences, or How to Wear a Digital Cloak'. *Photographies* 8 (3): 305–21. https://doi.org/10.1080/17540763.2015.1102760.

Geismar, Haidy. 2018. *Museum Object Lessons for the Digital Age*. London: UCL Press.

Geismar, Haidy, and A. Herle. 2010. *Moving Images: John Layard, Photography and Fieldwork on Malakula since 1914*. Honolulu: University of Hawaii Press.

Geismar, Haidy, and W. Mohns. 2011. 'Database Relations: Rethinking the Database in the Vanuatu Cultural Centre and National Museum'. *Journal of the Royal Anthropological Institute* 17(s1): S126–48.

Geismar, Haidy, and C. Tilley. 2003. 'Negotiating Materiality: International and Local Museum Practices at the Vanuatu Cultural Centre and National Museum'. *Oceania* 73 (3): 170–88.

Glass, Aaron. 2015. 'Indigenous Ontologies, Digital Futures: Plural Provenances and the Kwakwaka'wakw Collection in Berlin and Beyond'. In *Museum as Process: Translating Local and Global Knowledges*, ed. Raymond Silverman, 19–44. Oxford and New York: Routledge.

Glass, Aaron, and K. Keramidas. 2011. 'On the Relational Exhibition in Analog and Digital Media'. In *Objects of Exchange: Social and Material Transformation on the Late Nineteenth-Century Northwest Coast*, ed. A. Glass, 217–27. New York: BCG Focus Gallery/Yale University Press.

Hein, H. S. 2000. *The Museum in Transition: A Philosophical Perspective*. Washington, DC: Smithsonian Institution Press.

Hennessy, K. 2009. 'Virtual Repatriation and Digital Cultural Heritage: The Ethics of Managing Online Collections'. *Anthropology News* (April): 5–6.

Henning, M. 2007. 'Legibility and Affect: Museums as New Media'. In *Exhibition Experiments*, eds. P. Basu and S. Macdonald, 25–47. Oxford: Blackwell.

Henning, M. 2015. 'Museum Media: An Introduction'. In *The International Handbooks of Museum Studies*, eds. Sharon Macdonald and Helen Rees Leahy, xxxv–lx. Oxford: John Wiley & Sons, Ltd. https://doi.org/10.1002/9781118829059.wbihms300.

Hooper-Greenhill, Eilean. 2000. *Museums and the Interpretation of Visual Culture*. London; New York: Routledge.

Isaac, G. 2008. 'Technology Becomes the Object: The Use of Electronic Media at the National Museum of the American Indian'. *Journal of Material Culture* 13: 287–310.

Isaac, G. 2011. 'Whose Idea Was This?' *Current Anthropology* 52 (2): 211–33.

Isaac, G. 2015. 'Perclusive Alliances'. *Current Anthropology* 56 (S12): S286–96. https://doi.org/10.1086/683296.

Kelty, C. M. 2008. *Two Bits: The Cultural Significance of Free Software*. Durham, NC: Duke University Press.

Kirschenblatt-Gimblett, B. 2009. *Materiality and Digitization in the Museum of the History of Polish Jews*. 25 July. www.materialworldblog.com. Archived at https://

web.archive.org/web/20151003090014/http://www.materialworldblog.com/2009/07/materiality-and-digitization-in-the-museum-of-the-history-of-polish-jews/.

Klavans, Judith L., Susan Chun, Jennifer Golbeck, Dagobert Soergel, Robert Stein, Ed Bachta, Rebecca Laplante, Carolyn Sheffield, Kate Mayo, and John Kleint. 2009. 'Language and Image: T 3 = Text, Tags, and Trust'. In *Digital Humanites 2009 Conference*. College Park, Maryland, USA. Unpublished. https://doi.org/10.13140/RG.2.2.18247.70566.

Kramer, J. 2004. 'Figurative Repatriation'. *Journal of Material Culture* 9: 161–82.

Küchler, Susanne. 1988. 'Malangan: Objects, Sacrifice and the Production of Memory'. *American Ethnologist* 15 (4): 625–37. https://doi.org/10.1525/ae.1988.15.4.02a00020.

Leach, J. 2003. 'Owning Creativity: Cultural Property and the Efficacy of Custom'. *Journal of Material Culture* 8 (2): 123–43.

Malraux, A. 1967. *Museum without Walls*. London: Secker & Warburg.

Manovich, L. 2002. *The Language of New Media*. Cambridge, MA: MIT Press.

Manovich, L. [1999] 2010. 'Database as Symbolic Form'. In *Museums in a Digital Age*, ed. R. Parry, 64–71. New York: Routledge.

Miller, D. 1987. *Material Culture and Mass Consumption*. Oxford: Blackwell.

Morphy, Howard. 2014. 'Open Access Versus the Culture of Protocols'. In *Museum as Process: Translating Local and Global Knowledges*, ed. Raymond Silverman, 90–104. Routledge.

Myers, F. R. 2002. *Painting Culture: The Making of an Aboriginal High Art*. Durham, NC: Duke University Press.

Myers, F. R. 2004. 'Ontologies of the Image and Economies of Exchange'. *American Ethnologist* 31: 5–21.

Parry, R., ed. 2010. *Museums in a Digital Age*. New York: Routledge.

Phillips, R. 2011. 'The Digital (R)Evolution of Museum-Based Research'. In *Museum Pieces: Toward the Indigenization of Canadian Museums*. Montreal, Canada: McGill University Press.

Povinelli, Elizabeth A. 2011. 'The Woman on the Other Side of the Wall: Archiving the Otherwise in Postcolonial Digital Archives'. *Differences* 22 (1): 146–71. https://doi.org/10.1215/10407391-1218274.

Rubio, Fernando Domínguez. 2014. 'Preserving the Unpreservable: Docile and Unruly Objects at MoMA'. *Theory and Society* 43 (6): 617–45. https://doi.org/10.1007/s11186-014-9233-4.

Rubio, Fernando Domínguez. 2016. 'On the Discrepancy between Objects and Things: An Ecological Approach'. *Journal of Material Culture* 21 (1): 59–86. https://doi.org/10.1177/1359183515624128.

Sam, J. K. 1996. 'Audiovisual Documentation of Living Cultures as a Major Task for the Vanuatu Cultural Centre'. In *Arts of Vanuatu*, eds. J. Bonnemaison, K. Huffman, C. Kaufmann, and D. Tryon, 288–90. Bathurst, Australia: Crawford House Publishing.

Simpson, A. 2007. 'On the Logic of Discernment'. *American Quarterly* 60: 251–7.

Srinivasan, R., R. Boast, K. Becvar, and J. Furner. 2009a. 'Blobgects: Digital Museum Catalogues and Diverse User Communities'. *Journal of the American Society for Information Science and Technology* 60 (3): 1–13.

Srinivasan, R. S., R. Boast, J. Furner, and K. M. Becvar. 2009b. 'Digital Museums and Diverse Cultural Knowledges: Moving Past the Traditional Catalog'. *The Information Society* 25 (4): 265–78.

Srinivasan, R. S., and J. Huang. 2005. 'Fluid Ontologies for Digital Museums'. *International Journal of Digital Libraries* 5: 193–204.

Taylor, B. L. 2010. 'Reconsidering Digital Surrogates: Towards a Viewer-Orientated Model of the Gallery Experience'. In *Museum Materialities: Objects, Engagements, Interpretations*, ed. S. Dudley. London: Routledge.

Thorner, S. 2010. 'Imagining an Indigital Interface: Ara Iritija Indigenizes the Technologies of Knowledge Management'. *Collections: A Journal for Museums and Archives Professionals* 6: 125–47.

Tischleder, Babette B., and Sarah Wasserman, eds. 2015. *Cultures of Obsolescence: History, Materiality, and the Digital Age*. 2015 edition. Houndmills, Basingstoke, England; New York: AIAA.

Turner, Hannah. 2016a. 'Critical Histories of Museum Catalogues'. *Museum Anthropology* 39 (2): 102–10. https://doi.org/10.1111/muan.12118.

Turner, Hannah. 2016b. 'The Computerization of Material Culture Catalogues: Objects and Infrastructure in the Smithsonian Institution's Department of Anthropology'. *Museum Anthropology* 39 (2): 163–77. https://doi.org/10.1111/muan.12122.

Vergo, P. 1989. *The New Museology*. London: Reaktion Books.

Verran, Helen, and Michael Christie. 2014. 'Postcolonial Databasing? Subverting Old Appropriations, Developing New Associations'. In *Subversion, Conversion, Development: Cross-Cultural Knowledge Encounter and the Politics of Design*, 57–78. Cambridge, MA: MIT Press.

Were, Graeme. 2014. 'Digital Heritage, Knowledge Networks, and Source Communities: Understanding Digital Objects in a Melanesian Society'. *Museum Anthropology* 37 (2): 133–43. https://doi.org/10.1111/muan.12058.

Zeitlyn, D., F. Larson, and A. Petch. 2007. 'Social Networks in the Relational Museum: The Case of the Pitt Rivers Museum'. *Journal of Material Culture* 12 (3): 211–39.

15 The role of the digital anthropologist in citizen science and public participation mapping projects

A case study or two

David Jeevendrampillai with Gillian Conquest

In dialogue with the work of Gillian Conquest[1]

Introduction

Citizen science is a broad term that relates to scientific research that is in some way inclusive of amateur or non-professional scientists. It is sometimes referred to as participatory action research, public participation science research or any of a wide range of associated terms. This is not a review of the different types of citizen science, as these have been comprehensively reviewed by others (see Hecker et al. 2018; Strasser & Haklay 2018; Follett & Strezov 2015; Leach & Fairhead 2002; Leach & Scoones 2005; Leach et al. 2005). This chapter looks specifically at how a digital anthropologist can approach citizen science projects. We focus on the role of the authors as anthropologists in two different projects which involved participatory mapping, using digital mapping platforms in particular.

Citizen science projects have expanded dramatically since the 1990s with a proliferation of new information communication technologies (ICTs) and the internet. As Lane DeNicola (2012) points out, the rise of the internet has fuelled participation in geomedia. Following Horst and Miller's (this volume) assertion that the study of the digital within anthropology is but a continuation of the study of how people meditate relations, what we offer here is a focus on the material and social processes behind such mapping projects. We assert that attentiveness to the ways in which maps come about and are engaged with or not, as the case may be, facilitate an understanding of the forms of relations being enacted in the ideals and practicalities of such projects as they are lived.

The chapter briefly introduces the idea of citizen science with a focus on public participation mapping. We work through two case studies of public participation mapping projects in which the authors were embedded as anthropologists. Through these case studies of mapping (or not mapping) the uses of suburban high streets and forests in the Congo Basin, respectively, we examine the ways in which an anthropological analysis can provide both a critical and a constructive

engagement with such projects. Further, we look at how the anthropologist may be in a unique position to ethnographically examine the use of ideas, ideals and terms such as participation, democracy and knowledge, and we consider the way in which they are understood by different actors involved in such projects. After we have outlined the case studies we conclude the chapter with a consideration of the issues a digital anthropologist faces in such cases and what sort of contribution such an analysis can make, not only to anthropology but also to the development of such projects themselves.

Citizen science

The term 'citizen science' has multiple origins and refers to a range of differing concepts. As noted earlier, the general consistency is to be found in the involvement of non-professional scientists. The term gained an increased poignancy in the second half of the twentieth century as the sciences became increasingly the preserve of specialist and elite scientists and organisations and doing science became radically transformed through the processes of professionalisation and the 'laboratory revolution' (Strasser & Haklay 2018: 40). Until this time, it was relatively common for amateurs to conduct innovative science, but gradually the 'citizen', or amateur scientist, was distanced from scientific practice. Concurrent with this division between the professional and the amateur, the notion of expert grew distinct from the public. The professional world of science drew its epistemic power from the very exclusion of the public. This exclusion often came hand in hand with a sense of distrust of science and expertise (Boyer 2005, 2008). As Strasser and Haklay (2018) note, following the use of atomic weapons in the Second World War there was an increasing critique of scientists who uncritically developed weapons or products that seemed to serve corporations or the military-industrial complex rather than the needs of the people. This scepticism grew in the 1960s through critique of agricultural chemicals such as DDT, pharmacological drugs, genetic engineering technologies and such like. Through the 1970s scientists in the USA called for greater independence and control over their research whilst in Europe there were calls for a greater level of involvement from the public in the ethical debates around such research. Citizen science could contribute to making science more 'democratic' by including participants that are (more) representative of the general population than the scientific community (see Moore 2008). There were increasing efforts to involve people in the production of scientific knowledge, address the concerns of the public and focus on issues groups commonly marginalised from research.

By the 1980s the importance of the experience of lay people became understood as vital to tackling public health issues such as AIDS. Public policy shifted as controversies around genetically modified organisms, contaminated food, nuclear power and emergent genetic experiments were symbolic of a crisis of trust between the public and elite science. There was now a real urge to include the public in discussions, and citizen forums and 'science shops' were established (Jasanoff 2003; Strasser & Haklay 2018). However, there was still a concern that

such forums prefigured the frame of the discussion and that inclusion was still tokenistic or marginal. By the 1990s advancements in ICTs, in particular the internet, provided more opportunity for new forms of inclusion; however, it was the prevailing social approaches to science that fuelled this move, as Strasser and Haklay point out:

> the rise (or the rediscovery) of citizen science reflects deep transformations in Western societies, such as the democratization of education, the strengthening of direct democracy, and the growing modernist reflexivity.
>
> (2018: 45)

Strasser and Haklay state that citizen science can be characterised by four key concepts. Firstly it is practiced by amateurs. Secondly it is about non-professionals *producing* knowledge which is further to deliberating over the direction and use of research. Thirdly it is about producing *scientific* knowledge, that is, that which can be recognised by the professional community. Finally it seeks to "make the world a better place", which is taken from Alan Irwin's original idea of democratising science in order that it "serve the people" (see Irwin 1995). Strasser and Haklay also state that the diverse uses of the term can be seen in four typologies of citizen science: (1) contractual projects, where amateurs have asked professionals to help; (2) contributory projects where amateurs contribute data; (3) collaborative projects whereby the public contribute to the design of the research question and to data collection; and (4) co-created projects where all aspects of the project are done in collaboration with amateurs from initial hypothesis through to design, data collection and interpretation. Haklay and colleagues have developed the Extreme Citizen Science group (ExCiteS) whereby citizens and grassroots organisations initiate the research projects before engaging in, or not, collaboration with scientists. It is this explicitly bottom-up approach that we are interested in here. Both authors were involved in mapping projects emanating from the UCL-based ExCiteS team. In Jeevendrampillai's case, the team that developed the community-mapping platform he studied stated, "The concept behind community mapping is to move away from 'top-down' mapping that so often fails to reflect the needs of people".[2] A similar ethic could be found in Conquest's field site working in with forest-dwelling hunter-gatherers in Congo. Both projects took 'the needs of the people' as an ethnographic entry point through which to consider the issues of representation within the practice of mapping and map making.

The ideals of democracy, inclusion and participation are at the heart of citizen science. The democratisation of science is seen to be aided by citizen science in two ways. Firstly, it aims to include people, and secondly, it aims to better serve the public interest. In this chapter, we are focused on the inclusionary and participatory aspects of such projects, in particular the role of Geomedia, that is, participatory mapping projects, which have proliferated with the developments in information technologies. We will approach an analysis of participatory mapping projects through the case studies which we will first contextualise within the wider field of participatory mapping.

Mapping and public participation geographic information systems (PPGIS)

Public participation geographic information systems are intended to bring the practice of GIS mapping to the local level to promote inclusive knowledge practices. There are two distinct approaches, top down and bottom up. The former serves the public but is less by the public whilst the latter is much more by the public whereby groups learn, develop and advance mapping technologies.

PPGIS has been widely discussed and adopted in development and planning discourses, mainly though their promise to facilitate a wider participatory framework. A focus on participation grew in the 1980s as the failures of development initiatives designed by outsiders became increasingly apparent. With an emphasis on "putting the last first", Robert Chambers' (1992, 1997) hugely successful development of participatory rural appraisal methods transformed expectations for the contributions that indigenous knowledge should make to development planning and interventions on their lands (Agrawal & Gibson 1999; Brosius et al. 1998). Conquest (2013) notes that as this thinking became dominant, new technologies also began emerging that offered new opportunities for involving people in natural resource management, and reorientating policy processes from top down to bottom up.

Although participation was the "new orthodoxy" (Henkel & Stirrat 2001: 168) of the 1990s, by the late 2000s a more critical review of ICTs was emerging with Parfitt (2004) claiming that the idea of participation had become a dogma without meaning, a means to an end – to continue imposing outsider-conceived objectives on local people. Critical attention focused on the ways in which participatory techniques are themselves products of, and permeated by, power relations. Critical attention was being brought to the framing of data such as the use of the idea of territory to what counts as the most important aspect of place to map (see Kapoor 2002). Cooke and Kothari (2001) argue that previous approaches to participation had misunderstood power, obscured its dynamics and in many cases actively depoliticised the development process. Cooke and Kothari refer to this as the "tyranny" of participation, arguing that such approaches operate as a means to deliver the same top-down, donor-led, outsider-driven initiatives as before, but in a manner designed to reduce local opposition and create an appearance of greater democracy (see also Hildyard et al. 2001). At the same time, participatory projects may serve to reinforce the interests of the already powerful by bringing marginalised populations into the reach of centralised state control and the market. As Williams (2004) elegantly summarises, "If development is an 'anti-politics machine' (Ferguson 1994), participation is an efficient way of greasing its wheels" (ibid.: 557).

In the context of map making, the issue of representation can be considered through problems of design. A traditional map is a rather static representation designed from a particular perspective for a particular purpose. More optimistic scholars have suggested that appropriately designed digital mapping technologies can present a "third space" (Turnbull & Chambers 2014: 167) or a "third

translating domain" (Verran & Christie 2014: 66) where disparate knowledges can come together to be "worked together", on even terms, without being subjugated to a single, technologically mediated, Western tradition. At its heart, what this claim attempts to deal with is the politics inherent in the translation and communication of knowledge across cultures (Leach & Wilson 2014).

Such arguments foreground the importance of employing relational perspectives in order to take seriously questions of alterity and difference. The argument goes that to do so would ensure the "ontological self-determination of the world's peoples" (Viveiros de Castro 2003: 18, 2009) to the point that it may be necessary, in order to avoid obliterating this difference, to do away with "representationist" accounts altogether (Holbraad 2012). However, others have expressed concerns that what has come to be called the "ontological turn" serves to fetishise and reify alterity, diverting attention away from the "actually existing politics of nature and culture" by replacing "an ethnography of the actual with a sociology of the possible through the composition, imposition, and disavowal of ideal typologies" (Bessire & Bond 2014: 449). Our question here is how do such mapping projects work in the 'actual' and how are the ideals of the possible to be understood as informing social relations in such projects.

GIS has been at the foreground of attempts to map and represent alternative knowledges of natural resources such as forests (see Conquest 2013) or urban environments (see Jeevendrampillai 2017) in order to include more stakeholders in the management of the resource. For anthropologists, promising areas for enquiry in participatory mapping practices must not only focus on the intention or the unconscious bias of the designers but also pay attention to the agency of maps themselves in terms of the representation and the forms of knowledge they allow (or do not allow). A map, through the visual image, aligns particular aspects of the material world to the social value of that world according to its designers to "perform territory" (see Perkins 2004; Dodge et al. 2009). It has an "ontological authority" but further a potency of "ontological genesis" (Roberts 2012: 14); that is, they make worlds more than represent them. Maps make visible and invisible different social and material relations and in so doing can work to advance and simultaneously delimit the various possibilities of social life or "arguments about existence" (Wood 2010: 34).

Turnbull (2007) describes maps as the dominant trope for the management and assemblage of knowledge in the Cartesian tradition, with mapping according to location and coordination in a standardised, metricised space taken as the "essential prerequisite for understanding the world" (ibid.: 146). The problem of incommensurability, he argues, lies at the heart of the relationship between mapping and indigenous knowledge. If maps are essentially a technology to represent environmental knowledge, how can they incorporate knowledge informed by, for example, relational cosmologies that perceive continuity between humans and animals and their environments? Such indigenous cosmologies include "Amerindian perspectivism" argued to be an organising trope among indigenous Amazonian groups (Viveiros de Castro 1998) or the "cosmic economy of sharing"

Bird-David used to describe Indian hunter-gatherers' environmental relations (1992 *passsim*), which has also been used to describe BaYaka Pygmies in the Congo Basin (Köhler 2005: 413; Lewis & Köhler 2002: 298; quoting Bird-David 1992). Maps find the display of such relationships or the 'fuzzy' social nature of nested rights challenging (Campbell 2002; McCall 2006).

Whilst new technologies offer new possibilities for engaging with alternative forms of knowledge production, in such contexts anthropological attention can be focused not just on participation in mapping, but also on the design processes of making such technologies (see Leach & Wilson 2014) and implementing them on the ground, and the forms of exclusions that these afford. The question of *who* participates in mapping projects has been extended to *how* and *why* people participate in such projects. PPGIS technologies are increasingly being tailored to the specifics of the people and projects they engage with, and participation now encompasses the design of the mapping tools and analysing the data. The next section describes two different PPGIS projects, to which the authors contributed as anthropologists. The projects have very different contexts yet in both cases the notions and terms of participation, inclusion and representation were vital points of analysis.

Mapping suburban London

In 2011 I (Jeevendrampillai) joined the UCL Adaptable Suburbs project (ASP) as a doctoral anthropology student. The ASP's aims were to study how small-scale centres of social and economic activity, primarily suburban high streets, changed over time. The project was based in UCL's Bartlett School of Architecture and built on a previous project[3] where data on the changing nature of the physical infrastructure – the streets, transport and buildings – was gathered. My role as an anthropologist was to study how people felt about their local community high street, the changes it had been through and how it might be used in the future, in essence to add a 'social layer' to the existing data.

Due to the ASP's need to build on previous data, I needed to conduct my study in locations partly determined by the project. The locations were South Norwood in South East London and Surbiton in South West London, both well-established suburban areas. In both locations I searched for community groups who were actively taking a role in the shape and health of the high street. I worked with local history groups and local business forums, but in both locations the most active, visible and loud groups were the South Norwood Tourist Board and the Seething Villagers respectively. Both groups use fun, jokes, serialism and what they describe as 'being stupid' as a way through which they can develop community cohesion and raise the profile of their local area.

Whilst there is not space to outline the details of such activities here (see instead Jeevendrampillai 2017), some brief examples will make our point. In South Norwood the self-declared Tourist Board declare on their website that they are "celebrating what others fail to see". They use social media to gather large

crowds of 50–100+ people on a semi-regular basis to celebrate the mundanity of their suburb. They sang happy birthday to the world's first concreate re-enforced tunnel (which serves as a small pedestrian walkway under the local train station) and renamed the local park's local lake Conan Doyle Lake after the author of the Sherlock Holmes stories, Arthur Conan Doyle, who lived in the area. All is done with good humour, irony and an element of surrealism. They indulge in a sense of local pride against the predominant popular cultural imaginary of the suburbs as dull middle England. Surbiton is perhaps the epitome of such an imaginary. The ordinariness of Surbiton stands as a synecdoche for 'suburbs'. It has been harnessed as an image of middle England in comedy shows (see *The Good Life* [Esmonde & Larbey 1975] and *Monty Python* [Chapman et al. 1972]) and political campaigns (see Wickstead 2013). In 1999, *The Big Issue* magazine ran an editorial feature, "I Want the Good Life", with the subtitle "Bland. Boring. Banal. Everything You Think You Know about Suburbia Is Wrong; says Jim McClellan and to prove it, he's moving to Surbiton" (McClellan 1999). In 1995, Liverpool City Council "seriously considered adopting 'Liverpool – it's not Surbiton' as a marketing slogan" (Statham 1996: xiii; Wickstead 2013).

The ordinariness of the suburb is used ironically by the Seething Villagers, who use the very idea that they live in a place of little importance, history or culture to play with the public image of Surbiton and suburban community. The Villagers have invented a whole series of myths, legends and stories about an ancient village called Seething (this name refers to an old place name in the area that is little used in that context today). This village is an ideal place to live; it has a strong community and a strong sense of inclusion. The legends of Seething are celebrated in annual festivals and are memorialised in children's books (see Hutchinson 2010a, 2010b, 2011, 2012). These stories are read at local schools, sold for charity and re-enacted at the community festivals. The main legend of Seething revolves around the ancient story of Lefi the goat boy. Lefi, being half boy, half goat, was exiled from the village of Seething for being different. Lefi went to live in a cave in the base of the Mountain of Seething on top of which lived a giant. Lefi survived on the food that the children of Seething took to him, as they were still good at heart. The giant, called Thamas Deeton, would come down from the mountain once a year to terrorise the villagers. One year Lefi made a bet with the giant that he could live only on the food passed through a small ring for a month. He passed milk through the ring, made cheese and survived. As such the giant was ordered to leave. As he did he smashed the mountain, but as he stomped away a falling rock hit him on the head and he fell in the River Thames. Afterwards the villagers celebrated but Lefi was nowhere to be seen. All that was left was a small gold ring were Lefi's cave once was. The villagers felt bad for judging him and vowed never to judge again. Once a year the modern Seething Villagers remember this tale by parading a giant down the local high street. They note that the local place names, such as Thames Ditton Island, are clues to the truth of the story. They hold the parade in February, the month that was so named as the cheese 'fed you and me'.

Figure 15.1 The Lefi parade of Seething

When such elaborations on the legends are made newcomers are faced with a choice, to say "this did not happen" or to play along. The ambiguous and silly nature of the story means that one does not have to be a local history expert, have lived in the area for long or even be from the area. The choice to play is the choice to commit to the ideals of this community. This style of community building, my interlocutors assert, is a mechanism through which a claim to expertise, in the form of local knowledge, length of time lived in an area, and political, economic or academic standing, cannot be held as a form authority to claim, belong to, or manage place more than another. The Seethinger's aim is to make Surbiton a fun, inclusive, community-focused place to live; the very antipathy of its popular media image.

These mechanisms are vitally important to suburban life in Surbiton. This was in evidence when I approached the community and requested to be able to conduct fieldwork with them. This involved a deep ethnographic emersion of over 18 months, which started with my giving a lecture, alongside others, in a local pub under the name the University of Seething. At this event I introduced the 'community map' that was developed by the ASP under the rubric of citizen science. This map, accessible via the ASP, was a basic Google application program interface (API) with a specifically designed 'wrap', a specially tailored interface specific to each suburb, onto which the user could place symbols that tell the reader what sort of information is being shared. These symbols would relate to a list of 'categories'

which would align to the interests that a community might hold. To share information a user would register, log in, upload text, photo or video and locate the information on a point on the map, listed under a particular category. Initially the categories of information such as 'historical fact', 'cycling', 'transport', 'green space' and so on were designed by the ASP but were intended to be open to change over a period of consultation via fieldwork with the communities that use the maps so that they could define their own needs. In the words of the ASP, the aims of the map were to supplement structural architectural understandings of settlements with a "need to understand the built landscape as a social place", to reveal "meaning, values, symbols". This platform, it was hoped, would be rolled out to numerous communities in order to form a participatory mechanism for data gathering and eventually aiding communities in managing, deliberating and representing places of interest so that local councils and policy makers can work towards a more democratic, bottom-up form of urban planning.

Initially Seethingers were enthusiastic about adding data to the map, all of which was moderated by the UCL-based team. However, some weeks after adding a point of information Seething regular Steve informed me that his story had not appeared on the live site. He had added data about the location of the now destroyed Mount Seething where Lefi and the giant once lived. The data indicated the absence of a mountain at what is now the back of a local pub (co-incidentally?) and suggested that this absence was in fact proof that it was destroyed by Thamas. On following up the lack of addition with the ASP map moderators, I was told that the data submitted was not 'historical fact' and as such could confuse persons

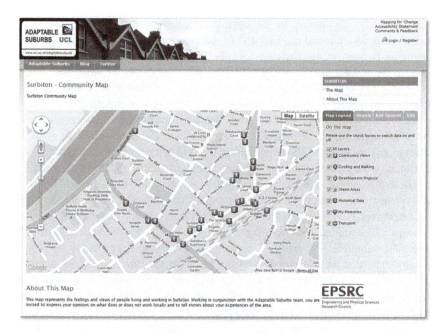

Figure 15.2 The Adaptable Suburbs community map interface

using the map who may not be familiar with the local 'myths'. The Seethingers refused to label the stories anything other than 'fact' and rejected the terms 'stories', 'myths' and 'legends'; they wanted this to be recorded as historical 'fact' in order to maintain the mechanics of inclusion through "being stupid".

At the end of the project the map remained sparsely used with very little data uploaded. However a lot had been learnt through the use of the map, its failure and its emptiness. Through a sustained ethnographic emersion with the community, I was able to understand the social mechanisms behind the Seethinger's stories. The social productivity of being stupid via myths, legends and activities of the community groups I was working with became evident. I was able to contrast this with the ASP project itself to see how ideas of data, equality, democracy and participation are understood. It was clear that the ASP and the Seethingers were working toward the same aim, an improvement in the ways in which people use and relate to their built environment and increased public participation in urban planning to this regard. Yet both groups were engaged in different social projects. The ASP whilst building tools of participation had, to a degree, prefigured the frame of the map. The ASP could not compromise the labelling on the map due to the dedication the project had for the data to be understood across communities of differing scales. The Seethingers could not compromise on their framing of the data on the map due to the ways in which such data works at the local scale. The reader of the data is supposed to doubt its legitimacy and is forced therefore to either play along or resist. Such a decision places the reader either as an equal – part of the Seethinger's project – or as an outsider.

For the ASP the failure of the map was understood as a technical failure. Conversations around its non-use revolved around the fact that 'in the future' such idiosyncratic local information would be able to be worked into more complex and developed platforms. As such, the ideal of bottom-up democracy that guided the ASP was seen as being in the future tense, that is, always about to arrive (see Derrida 1993). For the Seethingers the rejection of being able to define 'fact' was also a rejection of the authority of experts. The mechanisms of being 'stupid' enabled a form of egalitarian idealism to be realised now, in the present. That is, if local history is made up then nobody can be an expert and all people find their legitimacy based on participating in the ideals of community – inclusion, fun, togetherness and so on.

The point we wish to make here is less an analysis of this specific project and more that the success or failure of a map cannot be judged through the ideals and desires of one project alone. A map, for an anthropologist, is an ethnographic object that circulates and has social effect. The ASP's silent map is still incredibly productive in terms of developing an understanding of the social mechanisms at play in this situation. The role of the anthropologist on this project was to get behind the seemingly failed map to see what forms of relations it engendered and reflected and, further, to explain its non-use through a consideration of the social milieu in which it is embedded. The silence of the map therefore can be understood as a productive symbol of tension between two groups of people, or social projects, both trying to affect the built environment of place but in different ways.

Mapping in the Republic of Congo

In this section we take a case study from the UCL-based ExCiteS research, with a specific focus on Conquest's work in the Republic of Congo. Conquest was part of an Engineering and Physical Sciences Research Council–funded ExCiteS project which ran from 2011 to 2016. The project worked in the UK, the Brazilian Amazon and Namibia but started with the case of supporting Pygmy hunter-gatherers, local NGOs and other local indigenous partners tackling illegal logging in the Congo. The primary focus on Conquest's work was an ethnographic exploration of the process of developing the digital mapping platform and the supporting open source software, named Sapelli. She conducted ethnography with both the Mbendjele hunter-gatherers in the Congo and the London-based ExCiteS team. The software, named after an important resource-rich tree species for the Mbendjele, aims to facilitate data collection across language and literary barriers through configurable icon-driven interfaces, that is, picture-based icons.

Taking from Dourish and Bell's work on the concepts of 'myth' and 'mess' (2011), Conquest paid attention to the 'guiding ideals' (myths) of the ExCiteS project and to those aspects of design decisions that are behind the map (mess). That is, Conquest was interested in the foundational assumptions of the various parties involved: on motivations, ideas and beliefs, such as democracy, fairness and inclusion. At the same time the focus on mess grounds the larger guiding ideals in the contingent and contextual everydayness of the project's workings. A focus on why software and hardware decisions were made, for example, brings attention to the material politics of the everyday and demonstrates how things about the wider material network of relations can affect how one designs such projects. As an anthropologist Conquest both contributed to the working of the project in the field and, through the methodological freedom to scale her analysis out to wider contexts, usefully reflected on the social ideals and the material networks that informed the design.

Myth

As Escobar (2018) notes, all aspects of design practice are based on prefiguring an ideal. This ideal is tensed, always placed as a future state to be achieved. What we advocate here is an attentiveness to the myths – the underlying and grounding ideals that motivate such projects and how these foundational ideals and categories intersect with the other participants in such projects.

In meeting the BaYaka during the ExCiteS project, Conquest was inspired by the ritual practices that she witnessed in the forest. Lewis's analysis of BaYaka music and dance (2013) emphasises how such practices establish a "special world of time" (Blacking & Nettl 1995: 34). In these musically organised moments key relationships, ideal types and mediating relations are magnified and made easier to read. This led Conquest to pay attention to the founding 'myths' that animated the work of producing democratic participatory technologies. Trying to assess the impact of these foundational myths or principles guiding the ExCiteS team proved

to be especially revealing. She considered the ExCiteS project performatively, that is, in a similar way to how BaYaka rituals conjure new temporal arrangements. Conquest analysed ExCiteS's work as a form of conjuring a future to come, where indigenous knowledge interacts with commercial concerns, scientific descriptions and policy decision-making on equal terms. The ideal of democracy was always on the horizon. This is not to say that such projects do not work in the present; indeed, they often have dramatic effect, but they are always in the process of being realised, capable of being better, tweaked and adapted towards a future-orientated ideal. The analysis helped the team to understand why certain aims and ambitions are greeted differently by different users and work through, or at least better understand, any tensions that may arise in the process.

Conquest turned her analysis towards the ExCiteS team's self-stated aims of trying to "expand the reach" of traditional citizen science practices by developing "methodologies and tools to enable wider participation by lay people – especially those with low literacy levels and limited technical abilities, living in extreme environments" (Stevens et al. 2014: 20). This aim specifically relates to the global challenges of long-term, sustainable management of key global environments, and particularly those of "marginalised populations, such as indigenous peoples" (ibid.: 20). The ExCiteS group developed methodological approaches and supporting technologies, in line with these ideals, to facilitate local populations to participate in the co-production of environmental knowledge as equals alongside other experts (Haklay 2013). The methodology is based on a community engagement protocol, designed around a free, prior and informed consent (FPIC) process and participatory co-design of the data sets to be collected. The Sapelli software was released as on an Android app (www.sapelli.org and on Google Play) designed to be equally accessible to non-literate and literate users and able to transmit data in extreme environments and technologically limited situations (Stevens et al. 2014: 20).

This approach has its origins in, and expands on, earlier work by social anthropologist Jerome Lewis, who began developing digital mapping tools collaboratively with hunter-gatherer populations in the Congo Basin in the early 2000s (Lewis 2012). At this time the Mbendjele hunter-gatherers, with whom he has conducted research since 1994, were struggling to cope with the livelihood implications of the expansion of the logging industry into the forest where they lived.

A particular point of conflict was the sapelli trees, the most valuable commercial tree species logged but also an important source of highly valued caterpillars for Mbendjele groups at a time when other sources of protein are scarce. At the time, Congolese forest law provided few rights for forest-dwelling populations; however, one of the logging companies operating in the area, Congolaise Industrielle des Bois (CIB), was seeking Forestry Stewardship Council (FSC) certification which includes a requirement to respect the rights and resources of local people. Lewis worked with the logging company, a software company called Helveta and local people to develop software for handheld GPS units that could be used by the mostly non-literate Mbendjele to map the resources they wished to protect so that they could be easily uploaded into the logging company's GIS system. By

developing a simple, pictorial user-interface (UI) tailored to local needs, Lewis writes that it was possible for people who were non-literate, non-numerate and had never used a digital device before to learn how to accurately record positional data on a handheld GPS with just half an hour of training (Lewis 2014).

Following this early work, Lewis went on to develop a methodology of iterative, participatory co-design for the pictorial UI in projects in Cameroon (Lewis & Nkuintchua 2012; Lewis 2007). Meanwhile, the success of the original project led the Mbendjele to request new software for the handheld GPS devices that would enable them to record and communicate evidence of illegal poaching activity (Lewis 2012). While earlier versions of the mapping software were proprietary, difficult to modify and built to run on one specific device, ExCiteS's Sapelli software was designed to run on smartphones and tablets running Google's Android operating system (OS). It could be easily adapted to the requirements of any project using the process of participatory co-design with local people and was to be released free-of-charge under an open source licence.

Information recorded to the device, such as a photo or a recording of a GPS point and relating that to a resource, can be transmitted automatically via SMS to any other smartphone equipped with the same application. Data can be exported in formats readable by most common spreadsheet applications and geographic information systems. The group needed to take such information and develop a visualisation application (Sapelli Maps) that can similarly be used by non-literate and non-numerate users to view, edit and analyse geo-located data.

The two pillars (the technological tools adapted through the methodology of participatory design) had been developed in relation to the specific 'use-cases' of monitoring illegal poaching and logging activities in the Congo Basin (see Stevens et al. 2014; Vitos et al. 2013). The intention was that the ExCiteS approach could be applicable anywhere in the world, with any user group, for any project that involves geo-located data collection and analysis. However, despite the emphasis on universality, the majority of current and planned projects relate to forest conservation and management because of the salience of participatory mapping and monitoring activities in global policy and funding contexts related to tropical forests. In the Congo Basin, the introduction of new forest law enforcement, governance and trade (FLEGT) laws, the revision of the Forest Code to promote expanded rights for indigenous peoples and criticism faced by the conservation industry concerning ecoguard behaviour have all lead to increasing support for such activities.

Collaborating with the international NGO Forests Monitor and local civil society organisation Cercle d'Appui à la Gestion Durable des Forêts (CAGDF) to pilot a project for community monitoring of illegal logging activity in 2013, the ExCiteS team were challenged by local requests made during participatory workshops for features to be added to the adaptable Sapelli decision tree that were not within the remit of the project itself.

One community of Bantu farmers asked whether it would be possible to map valuable cultural artefacts, such as a bracelet, using the software. Cases like these present an interesting dilemma for Extreme Citizen Science, which is predicated on a participatory methodology that seeks to involve Sapelli's end users – the

'citizen scientists' – as collaborators in the development of project agendas and the tools that will be used to meet them. The mapping of moveable cultural arte-facts falls outside what project funders considered relevant to monitoring illegal logging, even though this was important to some community members. Extreme Citizen Science is not a neutral process, and like any other participatory exercise lays itself open to negotiation and manipulation by differently positioned political actors – in this case, the knowledge space offered by Sapelli was controlled by ExCiteS's NGO partners, limiting the design freedom of those who were expected to develop it.

The ideal of universal applicability is constantly coming up against the practi-cal realities of differing priorities, scales of relations, funding, resource and time limits. Tracing how the ideals of a project meet the daily practice of implementing such a project brings us the idea of 'mess'.

Mess

Dourish and Bell (2011) use "mess" to describe the technological realities contin-gent on a material infrastructure and contested by multiple actors within complex networks. As they state:

> the practice of any technology in the world is never quite as simple, straight-forward, or idealized as it is imagined to be. For any of the infrastructures of daily life – the electricity system, the water system, telephony, digital networking, or the rest – the mess is never far away. Lift the cover, peer behind the panels, or look underneath the floor, and you will find a maze of cables, connectors, and infrastructural components, clips, clamps, and duct tape. Push further, and you will also encounter the regulatory authorities who authorize interventions and certify qualified individuals, committees that resolve conflicting demands in the process of setting standards, governments that set policy, bureaucrats who implement it, marketers who shape our views of the role of the infrastructure in our lives, and more. Mess is always nearby.
> (2011: 4)

Thinking about the Sapelli software as a globally distributed assemblage of parts that included hardware, software, users, markets and more enabled Conquest to also focus on how the project itself was shaped and influenced by 'mess'. Such technologies, inevitably connected to global supply chains and market agendas, implicitly connect users to such processes and, further, to assumptions about what type of users they are. ExCiteS and other projects are both limited and enabled in different ways by this prefiguration. From this point of view, a focus on messiness can be ethnographically productive. For example, after being dis-appointed with the results of usability tests of Sapelli, the ExCiteS development team began experimenting with a novel user interface called Tap and Map that embedded RFID tags in large cards showing the icons normally stored in a decision tree that would record the icon and a geo-location when tapped against the phone. This innovation of a new mapping platform was briefly prototyped

and tested in the field. Results suggested that users were more accurate using Tap and Map than the decision tree format. Yet, since this project was ending, it was unlikely that there would be time to develop it to the point where it could support the context for which it was invented. Questions remained around who would program this functionality and how. How would this new idea of interacting with the mapping interface work with the backend software? Was it worth developing a new system for mapping with the BaYaka when such a format was unlikely to resemble the functioning of any technology that they may encounter in future? Thus substantial design limitations where inherent to the wider socio-economic forces in which the project was embedded. Attention to what is not made, not designed or not brought into being offers the anthropologist illuminating insight into the implicit constraints affecting creativity, design and the solutions that are eventually produced.

Conclusions

By collaborating with anthropologists who are well versed in issues surrounding participatory development, local knowledge and citizen science, and by implicating them directly in the design of the approach, the projects outlined earlier engage in a process of iterative critique. This guides and develops their methods and tools through conceiving of them as contingently and contextually embedded. The critical perspective brought by the group's anthropologists forced the projects to confront their claims to be a technological solution to issues of democracy, participation and the ideal process of the co-production of environmental or (sub) urban knowledge by differently positioned actors on equal terms. An anthropological analysis can scale out its analysis to challenge citizen science projects to live up to their own propositions and to get at the social ideals at work. It enables such projects to move beyond the idea that a map does not work, fails or is empty or that a particular group of people do not engage correctly. Through a detailed focus on the social processes at play and the material politics of how such maps come about, an anthropological analysis can return to the aims of such collaborations to think through and attended to 'the needs of the people'.

Similarly, by being embedded in such projects the practice of the anthropologist is also challenged. Is reflexive critique a sufficient response to situations where forests are being damaged and ways of living are being destroyed, situations where life itself is at stake? In both case studies, the authors have discussed with each other, over a number of years, the tensions we both felt to both be part of the projects whilst trying to find the space for reflexive critique. We both noted that through moving away from the project, thinking creatively about the myths and the mess of the project itself and its application, we were able to scale back in to make a valuable contribution to the projects' own objectives.

This chapter has shown how digital anthropologists can attend to the claims and ideals behind emergent digital technologies as they are positioned as solutions to advance particular social ideals. Attending to the myths and the mess, through being able to scale out and move across different communities of actors, the digital

anthropologist is well placed to make valuable contributions to discussions about participation, representation and digital technologies not only in anthropology but in other disciplines and applied projects such as those outlined earlier.

Notes

1 Gill Conquest very sadly passed away from cancer on May 5, 2017, aged 32. This chapter was written by David Jeevendrampillai, with some input from her PhD supervisor Jerome Lewis, and is intended to reflect the promise and aspirations of the work of Conquest in dialogue with Jeevendrampillai's project and the broader thematic issues raised by PPGIS. Gill was a larger than life personality, an unbelievably great colleague and an even better friend. Gill was a tour de force. This chapter is an attempt to write through some of the issues she was thinking about based on her written work, conference papers and masters and PhD upgrade documents. Gill was an exciting and promising anthropologist, tackling issues of representation, technology and democracy. She was keen on experimenting with writing and always sought new angles through which to see the world. Gill endeavoured with her work all through her illness with an admirable passion. She wanted it to be read, not because she thought she was right, but because she genuinely loved thinking through and discussing different ways of seeing and representing the world and doing so with a smile on her face, no matter what.
2 www.mappingforchange.org.uk/services/community-maps/ accessed 3/7/13.
3 Towards Successful Suburban Town Centres: EPSRC ref EP/D06595X/1 www.sstc.ucl. ac.uk/sstc_index.html accessed 01/12/2018.

References cited

Agrawal, A., & Gibson, C. C. (1999). Enchantment and disenchantment: The role of community in natural resource conservation. *World Development, 27*(4), 629–649.

Bessire, L., & Bond, D. (2014). Ontological anthropology and the deferral of critique. *American Ethnologist, 41*(3), 440–456.

Bird-David, N. (1992). Beyond "the original affluent society": A culturalist reformulation *Current Anthropology, 33*(1), 25–47.

Blacking, J., & Nettl, B. (1995). *Music, Culture, and Experience: Selected Papers of John Blacking*. Chicago: University of Chicago Press.

Boyer, D. (2005). The corporeality of expertise. *Ethnos, 70*(2), 243–266.

Boyer, D. (2008). Thinking through the anthropology of experts. *Anthropology in Action, 15*(2), 38–46.

Brosius, J. P., Tsing, A. L., & Zerner, C. (1998). Representing communities: Histories and politics of community-based natural resource management. *Society & Natural Resources, 11*, 157–168.

Campbell, J. (2002). Interdisciplinary research and GIS: Why local and indigenous knowledge are discounted. In P. Sillitoe, A. Bicker, & J. Pottier (Eds.), *Participating in Development: Approaches to indigenous knowledge* (pp. 189–205). London: Routledge.

Chambers, R. (1992). *Rural Appraisal: Rapid, Relaxed and Participatory*. Brighton: Institute of Development Studies, University of Sussex.

Chambers, R. (1997). *Whose Reality Counts? Putting the First Last*. London: Intermediate Technology Publications.

Chapman, G., Cleese, J., Idle, E., Jones, T., Palin, M., & Gilliam, T. (1972). *Monty Python's Flying Circus*, Series 3, episode 28. Mr and Mrs Brian Norris Ford Popular. BBC British Broadcasting Corperation, London, UK.

Conquest, G. (2013). *Dodging Silver Bullets: Opportunities and Challenges for an "Extreme Citizen Science" Approach to Forest Management in the Republic of the Congo* (Unpublished MA dissertation), University College London, London.

Cooke, B., & Kothari, U. (2001). The case for participation as tyranny. In B. Cooke & U. Kothari (Eds.), *Participation the New Tyranny* (pp. 1–15). London: Zed Books.

DeNicola, L. (2012/2013). Geomedia: The reassertion of space within digital culture. In H. A. Horst & D. Miller (Eds.), *Digital Anthropology* (pp. 80–98). London: A&C Black.

Derrida, J. (1993). *Specters of Marx, tr. Peggy Kamuf.* London and New York: Routledge.

Dodge, M., Kitchin, R., & Perkins, C. (Eds.). (2009). *Rethinking Maps: New Frontiers in Cartographic Theory.* London: Routledge.

Dourish, P., & Bell, G. (2011). *Divining a Digital Future: Mess and Mythology in Ubiquitous Computing.* London: MIT Press.

Escobar, A. (2018). *Designs for the Pluriverse: Radical Interdependence, Autonomy, and the Making of Worlds.* Durham, NC: Duke University Press.

Esmonde, J., & Larbey, B. (1975). *The Good Life.* BBC. 4 April 1975–10 June 1978.

Ferguson, J. (1994) *The Anti-politics Machine: 'Development,' Depoliticization, and Bureaucratic Power in Lesotho.* London: University of Minnesota Press.

Follett, R., & Strezov, V. (2015). An analysis of citizen science based research: Usage and publication patterns. *PloS One, 10*(11), e0143687.

Haklay, M. E. (2013). Citizen science and volunteered geographic information – Overview and typology of participation. In D. Sui, S. Elwood, & M. Goodchild (Eds.), *Crowdsourcing Geographic Knowledge: Volunteered Geographic Information (VGI) in Theory and Practice* (pp. 105–122). Berlin: Springer.

Hecker, S., Haklay, M., Bowser, A., Makuch, Z., & Vogel, J. (Eds.). (2018). *Citizen Science: Innovation in Open Science, Society and Policy.* London: UCL Press.

Henkel, H., & Stirrat, R. (2001). Participation as spiritual duty; Empowerment as secular subjection. *Participation: The New Tyranny*, 168–184.

Hildyard, N. et al. (2001). Pluralism, participation and power: Joint forest management in India. In B. Cooke & U. Kothari (Eds.), *Participation the New Tyranny* (pp. 55–71). London: Zed Books.

Holbraad, M. (2012). *Truth in Motion: The Recursive Anthropology of Cuban Divination.* Chicago: University of Chicago Press.

Hutchinson, R. (2010a). *The Legend of Lefi Ganderson.* Seething: Homage Publishing.

Hutchinson, R. (2010b). *The King's Soup.* Seething: Homage Publishing.

Hutchinson, R. (2011). *Jack and the Golden Egg, or, How the Seething Community Sports Day Started.* Seething: Homage Publishing.

Hutchinson, R. (2012). *The Last Sardines.* Seething: Homage Publishing.

Irwin, A. (1995). *Citizen Science: A Study of People, Expertise, and Sustainable Development. Environment and Society.* London: Routledge.

Jasanoff, S. (2003). Technologies of Humility: Citizen Participation in Governing Science. *Minerva, 41*(3), 223–244.

Jeevendrampillai, D. (2017). Failure as constructive participation? Being stupid in the suburbs. In T. Carroll, A. Parkhurst, D. Jeevendrampillai, & J. Shaklesford (Eds.), *The Material Culture of Failure: When Things Do Wrong* (pp. 113–131). London: Bloomsbury Press.

Kapoor, I. (2002). The devil's in the theory: A critical assessment of Robert Chambers' work on participatory development. *Third World Quarterly, 23*(1), 101–117.

Köhler, A. (2005). Of apes and men: Baka and Bantu attitudes to wildlife and the making of eco-goodies and baddies. *Conservation and Society, 3*(2), 407–435.

Leach, J., & Davis, R. (2012, November). Recognising and translating knowledge: navigating the political, epistemological, legal and ontological. *Anthropological Forum*, *22*(3), 209–223. Routledge.

Leach, J., & Wilson, L. (2014). Anthropology, Cross-Cultural Encounter, and the Politics of Design. In J. Leach & L. Wilson (Eds.), *Subversion, Conversion, Development: Cross-Cultural Knowledge Exchange and the Politics of Design* (pp. 1–19). Cambridge, MA: MIT Press.

Leach, M., & Fairhead, J. (2002). Manners of contestation: "citizen science" and "indigenous knowledge" in West Africa and the Caribbean. *International Social Science Journal*, *54*(173), 299–311.

Leach, M., & Scoones, I. (2005). Science and citizenship in a global context. In *Science and Citizens: Globalization and the Challenge of Engagement*. London: Zed Books.

Leach, M., Scoones, I., & Wynne, B. (2005). Introduction: Science, citizenship and globalization. In M. Leach, I. Scoones, & B. Wynne (Eds.), *Science and Citizens* (pp. 3–14). London: Zed Books.

Lewis, J. (2007). Enabling forest people to map their resources & monitor illegal logging in Cameroon. Before Farming: The Archaeology and Anthropology of Hunter-Gatherers, 1–7.

Lewis, J. (2012). Technological leap-frogging in the Congo Basin, pygmies and global positioning systems in central Africa: What has happened and where is it going? *African Study Monographs*, (Suppl. 43), March, 15–44.

Lewis, J. (2013). *A Cross-cultural Perspective on the Significance of Music and Dance to Culture and Society Insight from BaYaka Pygmies*. Cambridge: MIT Press.

Lewis, J. (2014). 7 Making the invisible visible: Designing technology for nonliterate hunter-gatherers. In J. Leach & L. Wilson (Eds.), *Subversion, Conversion, Development: Cross-Cultural Knowledge Exchange and the Politics of Design* (pp. 127–152). Cambridge, MA: MIT Press Infrastructures Series.

Lewis, J., & Köhler, A. (2002). Putting hunter-gatherer and farmer relations in perspective. A commentary from central Africa. In S. Kent (Ed.), *Ethnicity, Hunter-Gatherers, and the "Other": Association or Assimilation in Southern Africa?* (pp. 276–306). Washington: Smithsonian Institute.

Lewis, J., & Nkuintchua, T. (2012). Accessible technologies and FPIC: Independent monitoring with forest communities in Cameroon. *Participatory Learning and Action*, *65*, 151–165.

McCall, M. (2006). Precision for whom? Mapping ambiguity and certainty in (Participatory) GIS. *Participatory Learning and Action, 54*.

McClellan, J. (1999). Everything you think you know about suburbia is wrong *The Big Issue*, 4 November.

Moore, Kelly. (2008). *Disrupting Science: Social Movements, American Scientists, and the Politics of the Military, 1945–1975*. Princeton: Princeton University Press.

Parfitt, T. (2004). The ambiguity of participation: A qualified defence of participatory development. *Third World Quarterly*, *25*(3), 537–555.

Perkins, C. (2004). Cartography-cultures of mapping: Power in practice. *Progress in Human Geography*, *28*(3), 381–391.

Roberts, L. (2012). Mapping cultures: A spatial anthropology. In L. Roberts (Ed.), *Mapping Cultures* (pp. 1–28). Basingstoke: Palgrave Macmillan.

Statham, R. (1996). *Surbiton Past*. Guildford, Surrey: Phillimore.

Stevens, M., Vitos, M., Altenbuchner, J., Conquest, G., Lewis, J., & Haklay, M. (2014). Taking participatory citizen science to extremes. *IEEE Pervasive Computing*, *13*(2), 20–29.

Strasser, B., & Haklay, M. E. (2018). *Citizen Science: Expertise, Democracy, and Public Participation*, SSC Policy Analysis (pp. 1–92). Bern, Switzerland: Swiss Science Council.

Turnbull, D. (2007). Maps narratives and trails: performativity, hodology and distributed knowledges in complex adaptive systems ? An approach to emergent mapping. *Geographical Research, 45*(2), 140–149.

Turnbull, D., & Chambers, W. (2014). Assembling diverse knowledges: Trails and storied spaces in time. In J. Leach & L. Wilson (Eds.), *Subversion, Conversion, Development: Cross-Cultural Knowledge Exchange and the Politics of Design* (pp. 153–182). Cambridge, MA: MIT Press.

Verran, H., & Christie, M. (2014). Postcolonial databasing? Subverting old appropriations, developing new associations. *Subversion, Conversion, Development: Cross-Cultural Knowledge Exchange and the Politics of Design, 57*.

Vitos, M., Lewis, J., Stevens, M., & Haklay, M. (2013). Making local knowledge matter: Supporting non-literate people to monitor poaching in Congo. In *Proceedings of the 3rd ACM Symposium on Computing for Development* (p. 1). Bangalore, India: ACM.

Viveiros de Castro, E. (1998). Cosmological deixis and Amerindian perspectivism. *Journal of the Royal Anthropological Institute, 4*(3), 469–488.

Viveiros de Castro, E. (2003). "AND": After-dinner speech given at anthropology and science, the 5th decennial conference of the association of social anthropologists of the UK and commonwealth, 2003. *Manchester Papers in Social Anthropology, 7*.

Viveiros de Castro, E. (2009). *Métaphysiques cannibales*. Paris: Presses Universitaires de France.

Wickstead, H. (2013). The goat boy of mount Seething: Heritage and the English suburbs. In M. Dines & T. Vermeulen (Eds.), *New Suburban Stories* (pp. 199–213). London and New York: Continuum and London: Bloomsbury Press.

Williams, G. (2004). Evaluating participatory development: Tyranny, power and (re)politicisation. *Third World Quarterly, 25*(3), 557–578.

Wood, D. (2010). *Rethinking the Power of Maps*. London: Guilford Press.

16 Digital futures anthropology

Sarah Pink

Introduction

New digital, automated and intelligent technologies and services – including self-driving cars, drones, smart home technologies, digital health applications and more – are becoming increasingly possible, available and integrated into everyday circumstances and imagined near and far futures. Academics, government, policy makers, activists and industry organizations – all stakeholders in our digital futures – have realized that it is essential that we contemplate and confront the challenges and opportunities presented by these developments. The context raises a series of questions concerning the design, ethics, governance, use and societal impact of such technologies, which have become represented through multiple, sometimes conflicting and often utopian or dystopian narratives or future visions.

Digital anthropology as a field of scholarship and research has played an important role in bringing our attention to how the digital, material and social are increasingly and inextricably entangled in the ways that our lives have been lived in the very recent past. In this chapter I extend this field of study beyond the focus on the ethnographic past of conventional anthropological research to instead confront those moments where we step over into our as yet unknown futures, and where we imagine and sense what those futures might feel like in both their near and their far iterations. This extended version of digital anthropology might be thought of as digital futures anthropology. It is an anticipatory anthropology which attends to questions regarding the experiential, social, economic and narrative aspects of digital futures both as they unfold between our contemporary present and the immediate future and as they are imagined in near and far futures.

There are many signs that anthropology itself needs to be rethought beyond its conventional concerns and boundaries. My hope is that anthropology will become known as a discipline that is known for critically but constructively and collaboratively engaging across disciplines and outside academia with the technological and temporal issues that are part of our contemporary worlds and imagined futures. Therefore, this chapter responds to two current facets of anthropological work. First it engages with existing fields of theory and practice, in the conventional sense of wishing to advance these by building on but exceeding three recent moves to take anthropology forward: digital anthropology (Miller and Horst 2012,

this volume), digital ethnography (Pink et al. 2016) and futures anthropology (Pink and Salazar 2017). Second it responds to recent calls to rethink the elitist (see Stoller 2018) and self-referential core of much (although not all) anthropological theory and practice through an outward-facing anthropology. This anthropology advances its theory not simply through internal debate within the discipline but by engaging with other disciplines and practices. It works ethnographically by seeking new ways to apply ethnographic principles and anthropological ethics to research questions, topics and circumstances that have not conventionally been the subject matter of anthropological enquiry. Digital futures anthropology follows the spirit of the future anthropologies agenda that I set out with Juan F. Salazar (Pink and Salazar 2017) in arguing for refiguring anthropology 'beyond its reliance on documenting and analysing the past; its dependence on long-term fieldwork; and its tendency to close itself off in critical isolation' (Pink and Salazar 2017: 3) and seeking to 'derail mainstream social and cultural anthropology from an insular and inward looking single-discipline route that threatens to exacerbate its isolation and incapacity to participate and intervene in the major worldmaking activities of our times' (Pink and Salazar 2017: 3). Of course these critiques of anthropology are not applicable to all anthropologists, and I acknowledge those who believe that their work also contests such approaches. The strength of opening digital futures anthropology to collaboration and debate with other disciplines and fields of practice is that it provides ways in which anthropological practice can be endorsed through its engagement with multiple academic disciplines and through its effectiveness in rendering anthropological ideas relevant in the world beyond academia. This is not a 'watering down' of either theory or ethnography but a reorientation that seeks to engage anthropology, and the ethnographic theoretical dialogue that is at its core, in interdisciplinary and interventional practice.

Digital futures anthropology, therefore, on the one hand would offer new modes of understanding what might be about to happen next. Here, like other recent initiatives that focus on anticipatory modes, such as uncertainty (e.g. Samimian-Darash and Rabinow 2015; Akama et al. 2018), it has an interest in how people cope with not knowing what will happen next, and the implications this has for contemporary societies. However unlike such projects, at the core of the agenda of the approach I advocate is an impulse to not simply critically view and comment on the lamentable state of society as it proceeds but to seek ways to intervene to ensure that our digital futures are enacted and directed in ways that are ethical and responsible. This means engaging and partnering as anthropologists across the government, policy, activist and industry contexts where various stakeholders and actors in our digital futures are also intervening. Such a practice exceeds the work of an applied anthropology that serves the needs of stakeholders in these futures and goes beyond the critical stance of public anthropologists (although of course both these roles are still needed). Instead I am concerned with an active and interventional anthropology that is built on a theory of digital futures, which will enable anthropologists to partner with other stakeholders in our digital futures, to influence how they are imagined, narrated and enacted. A theory of digital futures is also needed in order that the concepts that are used to guide its work are

viable, supported and where relevant also generalizable. To develop this I draw on concepts developed in earlier work: digital materiality (Pink et al. (2016); the idea of future as contingent, open and indeterminate (see Pink and Salazar 2017); a critical account of the notion of the socio-technical (Pink and Fors 2017) and its use in relation to futures (see Bechtold et al. 2017); and a call for an ethics for a future-focused anthropological practice (Pink 2017).

Investigating digital futures moreover demands research methods that surpass the conventional anthropological tendency to take refuge in the epistemological and ethical past. I examine how future-focused ethnographic methods of investigation and representation offer opportunities to undertake collaborative and speculative futures research that is non-predictive and evades the problem of objectification and the dependency on the long-term fieldwork tradition (Akama et al. 2018).

A theory of digital futures

The term digital futures has the obvious connotation of being concerned with the roles played by technologies in a time that has not yet happened and is used across many contemporary contexts. However both concepts – of the digital and futures – have been deeply interrogated by academics and require further explanation, in relation to both what they stand for now and how they might be best articulated as we move to an increasingly digitally connected and automated world.

In the social sciences and humanities in general as well as in anthropology in particular, studies of the 'digital' have focused on a range of non-analogue technologies, devices, media (content, information), forms of communication and their users. This existing body of work highlights the need to account not only for the social uses of digital technologies, but also for their materiality and presence (Pink and Leder Mackley 2013). Much of the work in that field is evidence in this edited volume for readers to gain a strong sense of the current directions in the field. It is nevertheless significant to note that the relationship between the digital and material has been at the centre of the material culture studies inflected approach to digital anthropology developed by Miller and Horst (2012: 4) in their emphasis on 'the materiality of digital worlds, which are neither more nor less material than the worlds that preceded them'. Here, acknowledgment of the materiality of the digital responds to earlier tendencies to focus on the digital as ephemeral and unsituated in the actuality of everyday worlds and involves three elements: 'First, there is the materiality of digital infrastructure and technology. Second, there is the materiality of digital content, and, third, there is the materiality of digital context' (2012: 25). More recently Lanzeni and Pink (2021) have discussed how while this understanding of the digital and material has worked well for 'understanding how people consume technologies' to understand how digital materiality is implicated in the ongoing processes through which futures emerge, we need to expand our understanding 'to account for changing configurations of things and processes and the imagined futures that people attach to them'. The concept of digital materiality rejects 'an a priori definition about what

is digital and what is material' (Pink et al. 2016: 10–11) and enables this through three principles. First it maintains that the digital and material elements of any 'thing' emerge as inextricable from each other rather than being previously separate components that are somehow put together or combined. Second it sees digital materiality as a process, rather than a quality of a finished or complete object, emphasizing that 'digital materiality is itself processual'; while it can be witnessed in a snapshot of a moment, it is in fact ongoingly being formed. Third, the digital materiality of something is not meaningful alone, rather it becomes meaningful with and within other things and processes (Lanzeni and Pink 2021).

This processual account of digital materiality understands digital technologies as always unfinished and open to and porous with other things or processes, in that 'things are alive because they leak' (Ingold 2008: 10). When translated into the context of technology product design and development, this means that rather than being finished and complete when they are ready for markets, digital technologies might be theorized as being always incomplete things. The advantage of this in relation to understanding digital futures is that it opens us up to understanding digital technologies as unfinished and ongoingly remade and becoming part of the social, digital and material world in ways that are not predetermined. This applies as much to the way we see technologies in the past and present to how we might imagine them changing as they move into as yet unknown futures. This is not only a theoretical mode of understanding technology, but it can also be applied in a more practical sense as an interventional extension of digital anthropology which seeks to examine not only the ways that people consume digital technologies and media in the present but that might inform how future technologies (or the future participation of technologies) might be thought of. Reconceptualizing technologies as open, as able to flow into each other or at least being realized relationally to each other provides a useful way to understand technology use in the present. For example Pink, Fors et al. (2018) have discussed how the car and the smartphone can sometimes be seen as a hybrid technology whereby they are used in ways that makes them inseparable. However it also opens up ways of considering how we might influence the design of the qualities and affordances of the particular types of new digital technology that will become part of everyday life in the near and far future. Such technologies can be seen as more obviously unfinished or incomplete and with the capacity to be involved in ongoing processes of change through their involvement with humans and with other technologies. Examples include how forms of machine learning will ensure that future technologies evolve with us and with our everyday activities. That is, technologies could be seen as being open to changing *with* us. Already existing examples of technologies that are open in some ways include the smartphone in that it is open to updates that might change aspects of its functionality. Similarly new automotive innovations such as the Tesla car, which rather than being a complete finished product when purchased is subject to a changing functionality when new software updates are made available (Lindgren et al. 2018).

This understanding of digital materiality already begins to indicate the idea of technologies as things that are continually moving on into as yet unknown future

circumstances, where they will configure in ways that cannot be wholly predictable. To study digital futures involves considering how to render such possible configurations meaningful in academic terms, as well as considering how the insights they imply might enable us to intervene towards securing 'better' digital futures. With regard to this, the concept of futures anthropology (Pink and Salazar 2017) is intended to inform a new approach to anthropology that engages with futures in ways that go beyond earlier anthropologies of the future, as well as other disciplinary approaches to futures, and seeks to make multiple futures 'ethnographically thinkable' (Pink and Salazar 2017: 5). The approach is concerned with creating an anthropology that takes an ethical responsibility for as yet unknown futures and acknowledges that there is 'a moral obligation for us to implicate ourselves in futures' (Pink and Salazar 2017: 15) which is embedded in an interventional and interdisciplinary approach – as outlined in the Future Anthropology Network's collectively developed ten-point manifesto (reproduced in Salazar et al. 2017: 1–2). This movement towards a 'futures anthropology' reworks what future can mean from an anthropological perspective. This approach emphasizes (like human geography and areas of design research) the contingency (Bessire and Bond 2014; Irving 2017) and uncertainty (Akama et al. 2018) of as yet unknown futures, as elucidated through ethnography and design ethnographic experimentation. Design anthropology brings to this an equally theoretical strand, through a focus on emergence combined with a practical and interventional stance (Smith and Otto 2016; Pink et al. 2016) that examines how we might encounter the 'possible' (Halse 2013) ethnographically.

The approach to future that is advanced at this intersection is necessarily critical of determinist approaches and in this sense coincides with mainstream anthropologists (and other social scientists) who have consistently shown that any form of determinism – technological or otherwise – is problematic when we consider how things and processes are embedded in processual everyday worlds, be this through theories of appropriation (Miller 1988), of use (Arendt 1958) or of exaptation (how things are refined in use) (Ingold 1997). The understandings of these different scholars represent general anthropological theories – particularly where they make reference to materiality – that are not be completely coherent with each other, yet they all entail modes of acknowledging what Sneath et al. call 'the *generative capacity* of the technological implements in relation to the social projects in which they are embedded' (2009: 18) and in this sense enable us to consider the malleability of things (material and not material) and the ongoingness of the processes in which they participate and to account for emergent configurations and circumstances. It is highly relevant that such approaches equip anthropologists to contest forms of determinism when they are encountered in our interdisciplinary critiques or collaborations. Yet, these are limited in three ways. First, they are contained within the conventional mode of anthropological study, which focuses on existing phenomena. Second, they retain the scholarly distance of the critical but not interventional anthropologist. Third, such approaches have most often been used to support arguments that propose that what people do with technologies is usually subversive, or goes 'against the grain' (Moore 1994) of dominant

narratives in some way, most likely because they have been used in the context of studying relations of power or inequality between the designers of things and their users. Ingold's work is perhaps the exception in that he draws on examples of how people make things in small-scale societies, thus focusing on the maker-user (Ingold 2013). This focus, which takes us beyond the idea of the maker and user existing only in opposition to each other, is useful for understanding the indeterminacy of technology design and development as it moves into imagined futures. This is because it enables us to think beyond the idea of use as subverting or contesting the intentions of the designer and towards the idea of use and design happening in the same process.

Disrupting the distinction between designer and user in this way emphasizes that possible worlds are not as yet unrealized futures, but instead only ever possibilities. Such an approach contests not only the societal assumptions that frame the structures of predictive risk mitigation and prevention that are part of contemporary modes of governance, insurance and the like, but also challenges the ways in which these structures underpin the governance of research practice through university ethical approval committees. The ethics of a futures anthropology approach to the digital are particularly important, since not only do they underpin the ways in which we engage with research participants in anthropological fieldwork but they also call for us to engage with questions of uncertainty and intervention anew (Pink 2017) and in doing so connect with a design anthropological futures agenda (Smith and Otto 2016). Significantly, a futures anthropology follows a non-predictive stance; it is informed by the processual theory of emergence and incompleteness that drives the theory of digital materiality outlined earlier and that underpins design anthropology. In doing so it directly challenges conventional research practice in anthropology (which is risk averse in its taking of ethical refuge in the past) and institutional research governance (which is risk averse because it seeks to predict ethical and research safety problems and mitigate these before they can happen), and it reveals the ironies of similar societal structures. It additionally offers us an alternative vision of futures to those proposed by the narratives of innovation that dominate the fields of technology design (Pink, Fors et al. 2018).

Together these two approaches that focus on the processuality of digital materiality and on the uncertain and contingent nature of futures offer a vision of a continually changing world where digital technologies form part of ongoingly emergent configurations of things and processes. This has implications for how we think about the processes through which digital technologies emerge through both design and use towards being part of everyday worlds. Thus my focus is on emerging technologies in two senses of the term. First, I am interested in how emerging technologies are constituted as a category of thing in influential public, policy and industry narratives and news media and in the need for anthropologists to create critical responses to this. For instance, the concept of emerging technologies is commonly used, in technology and business (as well as less frequently mainstream) news and websites, within a narrative of technological innovation and tends to refer to technologies such as autonomous vehicles, quantum

computing, face detecting payment systems and forms of machine learning. For example in 2017, *Scientific American* announced '10 Emerging Technologies to Watch: Innovations That Are on the Verge of Making a Difference to Society'. Likewise, the *MIT Technology Review* documented '10 Breakthrough Technologies 2017'. The claim associated with these was,

> These technologies all have staying power. They will affect the economy and our politics, improve medicine, or influence our culture. Some are unfolding now; others will take a decade or more to develop. But you should know about all of them right now.

Second, I am concerned with understanding such technologies which are emerging, theoretically and empirically, through the ongoing processes of design and use through which they are activated and become able to participate in our worlds. That is, in the anthropology of the design and use of emerging technologies.

Researching digital futures and emerging technologies ethnographically is a step away from mainstream anthropological ethnographies undertaken in a present moment that is always acknowledged as immediately slipping into the past. The idea of undertaking ethnographies of or relating to futures that have not played and might not ever play out requires us to think differently about research and to consider what practical and analytical entry points we might take into fields of the future. Existing discussions of future-focused research practice have harnessed existing ethnographic techniques to understand how people imagine future possibilities, developed hybrid methods in conjunction with documentary and design techniques to create speculative fictions, developed design ethnographic futures workshop methods, and collaborated in other design research modes (see Salazar et al. 2017; Smith et al. 2016; Akama et al. 2018). A particularly pertinent example of this design anthropological collaboration which specifically focused on technology futures is the 'Myths of the Near Future' workshop where Sarah Pink and Yoko Akama collaborated with the designer Katherine Moline in a workshop that developed and documented activity that pushed participants beyond their usual comfort zones with everyday technologies (Akama et al. 2017, 2018). The workshop activities both disrupted the ways that people experienced their smartphone technologies in the present and engaged them in exacting imagined and im/possible future technological scenarios. Workshop methods have also been used by Sarah Pink and Debora Lanzeni to explore data futures (Pink, Lanzeni et al. 2018). Other examples of hybrid methods include the ethnographic Wizard of Oz research discussed later. However, ethnographic futures research also involves adaptations of more typical anthropological ethnography, with a more interventional stance towards collaborating with participants in research, such as Debora Lanzeni and Sarah Pink's research in technology maker spaces and in futures workshops with technology designers (Pink et al. 2018; Lanzeni and Pink 2021) and Pink's use of conversational interviewing, also discussed later.

In the following section I demonstrate the theoretical and empirical insights that we can draw from the study of emerging technologies as a route through

which to consider what our digital futures might entail. In line with my argument that long-term anthropological fieldwork is not always necessary or even possible and is definitely not the defining feature of good anthropology, these examples are not each based on a single ethnographic study. Rather I focus on bringing together common insights from three different projects in order to demonstrate a set of principles regarding how digital futures are constituted and how we might both research and account for these as anthropologists of emerging technologies.

Designing digital futures – emerging technologies in the making

There is an increasing number of anthropological, interdisciplinary and other disciplinary studies of futures in technology design. This includes Dourish and Bell's work which brings together anthropology and computer science. Through a focus on ubiquitous computing, Dourish and Bell examine how the 'mythology of ubicomp' and the visions that accompanied it actually played out in the actually messy present (2011: 4), reminding us that visions for technologically driven change always need to be moderated by the question of what people actually do with technology. The point that people use or appropriate technologies in ways not intended by designers or others has consistently been made in anthropology, and not least in material culture studies. However, it is now increasingly relevant to connect this anthropological approach to analysis and contestation of the future visions that are embedded in political, economic, technological and societal narratives of innovation. This agenda is not limited to anthropology and bears resonance with anticipatory geographies. For instance, the human geographer Kinsley's (2012) ethnographic research has also revealed the anticipatory modes of technology design in ubiquitous computing through an examination of how future visions are constituted in this field. Kinsley outlines how 'From the outset, the details of ubicomp have been positioned in the future' (Kinsley 2012: 1555–1556) and stresses the importance of understanding such visions and how they are constructed (2012: 1565). As this and other related works have shown, a number of ways of knowing and envisioning futures are implicated in technology design. In anthropology, Debora Lanzeni's ethnographic research with Internet of Things technology developers reminds us to consider how this digital materiality might be understood in relation to futures. Lanzeni distinguishes between imaginaries which refer to the idea of wider global smart futures and the visions of the future constituted through the designers' own local and everyday experience, to argue that the former have less significance in the technology design process than do the latter (2016: 46). The designers whom Lanzeni worked with brought 'into existence possible technologies that they imagined, based on their experiential knowledge from other projects' (2016: 60). Drawing on these works, I next reflect on how digital futures are manifested and imagined as changing realities across three examples of technology design in different contexts: the automotive industry, a maker space and a university. While inflected by similar discourses of innovation, each of these contexts is

differently funded, and the design process itself bears different relationships to markets.

Technology design involves a series of stages, which might include research, ideation and cycles of prototyping, testing and modification. Even after these have been undertaken a product might not yet be ready for market if regulatory requirements, infrastructures or even technological components are not yet in place. In this sense in each of the examples discussed later, we can regard technology design as a process of creating possible technologies as much as a mode of creating complete and finished technologies. The implication of this regarding how we might think about digital futures is likewise, and following the future anthropologies theory outlined previously, as contingent futures in which the technological possibilities we are presented within the present are likely to participate, but in which the ways they are experienced and used will also be shaped through the ways they are configured with other technologies, persons, things and processes. To explore this I examine how technology research, design and development processes play out in the experience of those involved in them, with a focus on the contingent circumstances through which new technologies emerge from research and design, and become part of future visions, predictions or aspirations.

Autonomous driving cars: interrogating digital futures (1)

Autonomous driving (AD) cars (sometimes called self-driving cars) are a pertinent example of a technology in development. In the narratives of technological innovation which propose that technologically driven change will impact society, AD cars were the most hyped emerging technology in 2015 and are still reported on daily in the technology and business media. In these narratives, AD is envisioned as part of our automated and connected digital future, usually through either utopian or dystopian narratives. The former tend to emphasize the safety, personal time and environmental benefits that are associated with AD; the latter raise ethical and logistical issues related to algorithmic decision-making, power relations and urban planning (see Pink, Lanzeni et al. 2018). In these digital futures AD cars share a context with other increasingly automated technologies and a predicted growing digital service economy as part of an Internet of Things.

Yet while this future is often presented and is imaginable, it is not certain. AD cars are already technologically possible, and there are media reports of them having been tested on the road in certain circumstances, along with an increasing number of governments giving approval for AD testing. At the time of writing, some AD features are now available in cars that are already on the market, such as auto-brake, pilot-assisted cruise control and automated parking. However, the fully AD cars, which would need no or little driver intervention and which are at the centre of the popular imaginary of how AD would be part of our digital futures, are not yet available to the public. This is due mainly to questions relating to safety, regulatory frameworks needing to be in place and infrastructural requirements. Indeed, predictions relating to when fully AD cars will be on the roads have been changing over the last years, towards increasingly conservative

predictions. The current consensus tends to vary between 2020 and 2030, and during this period there will be other technological, infrastructural, social and climatic changes in our environments. In this context, the idea of the AD car as a possible, rather than predictable, future technology offers an interesting perspective on digital futures in that it suggests a site in which we might investigate possible futures. Projects in which I have collaborated have involved examining AD futures ethnographically in a series of different everyday life commuting and car testing situations. Here I reflect specifically on work undertaken with Vaike Fors and Katalin Osz regarding ethnographic research in testing scenarios.

In recent publications (Pink et al. 2021; Osz et al. 2018) we have reflected on what we might learn from anthropological collaborations with experimental testing in the automotive industry. Our research was undertaken as part of a larger project focusing on human experiences and expectations of autonomous driving undertaken in 2016–18. Our work presented a methodological challenge since we were researching human experience of a technology, which as outlined earlier was technologically possible but not yet available to the public. Earlier publications outline how we used participants' experiences of existing automated and connected technologies as ways to understand future possibilities (Pink, Lanzeni et al. 2018). The part of the project discussed here focused on how 'drivers' experienced testing Wizard of Oz (WOz) cars, which are designed to simulate the experience of self-driving cars. These offered us a rare opportunity to research people's experiences of a possible future technology, which does not yet exist. This corresponded with a version of what in design anthropology has been called ethnography of the possible, whereby possible futures scenarios are created so that people can experience them, and their experiences can be researched ethnographically (Halse 2013). WOz cars are presented to test participants as self-driving cars, but are in fact operated by a safety driver, often sitting in the back seat of the car (the ethics of this is discussed in Pink et al. 2021). Usually this is revealed to the test participants once the test is completed. Our research involved studying the tests, the participants' experiences through interviews with them before and after the tests and discussions with the test leaders.

This research exercise enabled us to illuminate a set of insights and issues through a dialogue between anthropological theory and ethnographic research. Theoretically it inspired us to continue to work on the question of how an anthropological theory of trust (also developed in Pink et al. 2018) could be engaged to revise interactional and transactional theories of trust that tend to inform human-computer-interaction (HCI) research approaches that dominate in automotive testing research. In doing so, it engages the theory of digital materiality and of technology as unfinished outlined earlier. Using these theoretical perspectives rooted in anthropology was significant, since our intention was to use these in dialogue with our ethnographic findings in order to provide alternative understandings of human-machine relationships to those offered in technological research disciplines. Ethnographically the research enabled us to elucidate the sensory and affective elements of the experience of WOz self-driving cars, to understand how people imagined elements of their future relationships with self-driving cars, and

the significance of this in relation to if and how people trust. As an intervention towards shaping our digital futures, this work seeks to develop new interdisciplinary methodologies (Osz et al. 2018), elucidate the relationships between humans and automated and intelligent technologies, and propose ways in which the relationship between processes of design and use might be reconfigured through the idea of unfinished technology (Pink et al. 2017; Pink, Fors et al. 2018).

AD futures research therefore enabled our team to better understand – theoretically and ethnographically – how people imagined and experienced possible digital futures scenarios and how and why they began to feel confident and comfortable in these situations and when they did not. It additionally demonstrated the need to engage a revised theory of trust and to attend to the sensoriality of human experience in near and far future iterations of AD. This offers us one mode of seeking, through anthropological theory and ethnography, to participate in a technology design process with a view to bringing the human experience of digital futures as understood anthropologically more directly into the centre of concerns in this field.

Simultaneously the example contributes to a wider project in theory building in relation to emerging technologies. As introduced previously, the theories of trust, futures and digital materialities all point to an understanding of technologies as incomplete and unfinished and are co-implicated in two interdependent processes: in the structures and narratives of an innovation paradigm that funds and fuels both the work that goes into making them and the future imaginaries that our work seeks to contest; and in the ongoing processes of everyday improvisation and use that humans are continuously engaged in. As we see later, these narratives similarly shape how digital futures are imagined and made comprehensible in other technology design contexts.

Making drones: interrogating digital futures (2)

As an emerging technology, drones offer an ambiguous example. While there are many existing and sometimes high-profile examples of drones already being part of the consumer market and used in often controversial if not military applications (see Gusterson 2016) as well as for commercial uses such as Amazon deliveries and the like, drones still remain in development for some applications. This was the case in the context of ethnographic research undertaken with Debora Lanzeni in a Melbourne maker space – Make Create (discussed in more depth in Pink et al. 2018; Lanzeni and Pink 2021).

Whereas our AD futures research discussed in the previous section involved researchers participating in simulated scenarios, our research into drone development took the form of more conventional ethnographic hanging around, combined with documentary video (in collaboration with the filmmaker Citt Williams), photography and video recorded interviews in a Melbourne maker space, and has continued for approximately two years to date. Within this research we have followed a business development project, which involves the making and ultimately using

Figure 16.1 Looking at drone design in the maker space
Source: copyright Sarah Pink.

of drones for agricultural applications, such as tracking crops. While media and academic reports on existing uses of drones in military contexts, for photography or for deliveries tend to give the impression that drones are already active technologies in society, there still remain both regulatory and technological limitations to their roll out, particularly in relation to the complexities of flying them in urban contexts. The drones being developed in this project were a possible technology since due to a series of enduring technological constraints they were not yet ready to be used. When we visited the maker space in 2018, one of the leaders of the drone project updated me on their progress. I learned that a key issue the developers confronted was the problem of battery weight, size and endurance. The developers were working on reducing the battery power needed by the drone, while simultaneously waiting for new advances in battery design, which would reduce the size and weight of batteries. While they were 'waiting', however, the drones had generated various side projects, including consultancy and supplying drone parts. Through this research Debora Lanzeni and I were able to trace how the drones were not only a linear product that would be completed and marketed. Instead, on the one hand, during the course its development the drone project had opened up new business activities and consultancies. On the other, the digital future that it was imagined the drones would participate in was itself contingent

on the ways that different technological advances configured; that is, the drones were an incomplete technology which was accompanied by a future vision but that remained uncertain, since without advances in battery research and design their hoped-for agricultural applications would not come about (Lanzeni and Pink 2021). In this example, therefore, we can witness the development of a future technology that remains positioned for an imagined market that is contingent on a series of other elements of a digital future co-configuring.

In this case the technology development process was dependent on future visions in the sense that these visions offer a specific framework, ambition and future focus. However, the future visions with which they work are themselves inherently unstable and uncertain, specifically because they depend on particular configurations to make them possible. This does not necessarily mean that such projects are high risk, since as other elements of our digital futures unfold, so will these designs in progress. That is, that the present is populated with emerging technologies, which are not exactly 'waiting' but are ready to configure with other technologies, and also opportunities about which we cannot yet be completely aware.

As for the example of AD cars, studying digital technologies in the making invites us to understand these technologies as incomplete. The drones were very obviously incomplete in a practical sense, since the developers wished to modify them towards a more efficient version. However, we can conceptualize their incompleteness further in the sense that because emerging technologies will always be subject to the development of other related technologies, services and markets, they can never be finished in an absolute way but rather will need to leak in and out of those other things that configure with them in the processes of which they will become part.

Gas-sensing capsules: interrogating digital futures (3)

Digital health is a major theme in contemporary considerations of our digital futures, and technological innovation in this field can bring new modes of preventative and diagnostic health applications and monitoring the success of interventions. In this section I reflect on the processes through which possible digital futures come about in this field through the example of a technology that was in preparation for commercialization. This offers us a further perspective on the contingencies of technology development and how possible digital futures are imagined during technology design and testing. When he spoke about his work with me in 2018, the engineer Kourosh Kalantar-Zadeh, with his research team, had spent eight years developing a new medical technology: a ingestible gas-sensing capsule which uses sensors to identify and measure gases in the gut and creates digital data which has a number of possible applications, including being used for detecting and potentially preventing medical conditions and for monitoring the success of interventions afterwards. The work has won numerous international awards and is acknowledged as a major advance in interdisciplinary medical and engineering research. Our discussion of the technology and the events that led to it was retrospective, although it included reflection on what might happen next. It took the form of a conversational audio-recorded interview, which followed a

Figure 16.2 Photograph of the open capsule, showing the electronic circuit, sensors, pack-
aged batteries and coil antennae (left) and the packaged capsule (right)

Source: Photograph supplied by Kourosh Kalantar-Zadeh.

number of previous discussions around the topic, and existed in relation to already
extensive media coverage of the capsule.

Kourosh described how, when he embarked on this project initially, 'I didn't
know that it could be that important. At the beginning it was just finding a solution
for a simple problem'. He explained that as a result of having a conversation with
a gastroenterologist, he realized that there was a gap that technology might be able
to fill and began to seek a more direct and accurate way to measure gases in the
gut than is possible with conventional breath-testing methods. At this early stage,
his vision of what might be possible was quite localized in that he was seeking to
identify a solution to a specific problem. Moreover, what was possible was also
limited, as our conversation about batteries demonstrates.

Kourosh: At the time actually eight years ago we didn't have the right batteries.
 We were very very lucky that they came during the process. So the
 first capsules we made were 4 centimetres.
Sarah: But did you know that that would be possible later?
Kourosh: It was a very simple guess at the time, that batteries were becoming
 better and smaller and it happened, by two years after when we started
 and by the middle of animal trials, we suddenly had new batteries on
 the market that allowed us to make it small enough, so that it could be
 swallowed by humans.

By the time of our interview eight years later, Kourosh and his team had
undertaken the human trials and subsequently reported on the findings that 'Our
gas capsule offers an accurate and safe tool for monitoring the effects of diet

of individuals, and has the potential to be used as a diagnostic tool for the gut' (Kalantar-Zadeh et al. 2018). He said it had been predicted that the capsule had a market of $20b for diagnostic uses, without counting the market for prevention and monitoring, which would involve using the capsule as a less invasive procedure than an endoscopy. However, he also believed that there could be much greater future markets including for personal health tracking and understanding the effects of diet on the body. These possible commercial uses were also coupled with the potential of the capsule and the data to produce across such wide population samples that they could be used for research purposes.

As this story unfolds, we can see how future visions for the capsule, a commercial, research and life-saving technology, were not directly derived from an initial concept and plan for its implementation, but rather they emerged incrementally from the contingencies and circumstances of its development. As Kourosh expressed, 'It's a gradual process, it's never a Eureka moment'. The mundane process of the development of a new technology can involve a long series of lab-based experiments and simulations and holds no absolute certainties concerning what might be possible. As he described, the processes through which he and his colleagues had brought about groundbreaking research findings (in this and other projects) were riddled with long and mundane processes: 'No one had done this before. And seeing something, every time you see something, you never understand it at the beginning, you go back to the lab and you do simulations for months and months'.

Therefore, if we ask ourselves where digital futures lie in the process of health technology research of this kind, it becomes clear that future visions do not necessarily directly shape the everyday and mundane work that researchers undertake in labs. Rather, the work in the lab is part of an everyday process of research that underpins the making of the possibilities upon which more spectacular future visions of societal impact are imagined. In the case of the capsule, the possible societal digital futures that Kourosh described to Sarah when talking about its market predictions and possibilities were emergent from the process of development and had not been part of the localized vision of problem solving which originally inspired the project.

The examples of AD futures and drone development offered two different ways of looking at emerging technologies as incomplete and digital futures as contingent and non-determinate. The story of the gas-sensing capsules concerns a technology that could have a remarkable impact on the future of personal and collective health. It opens up a technological possibility that, as shown previously, could potentially be activated in a number of ways when configured with other interests, stakeholders and users to produce data, diagnosis and prevention. The example suggests a further moment where the possibilities of digital futures are constituted and planned for, when the technology is at the cusp of encountering its markets.

Conclusion

Technology design and engineering are supported by global imaginaries and by local or personal visions of futures. These hope for or predict the impact that particular new technologies will have on business, society and individuals. Yet the

processes of technology design are themselves not precise or certain; they have loose ends as developers wait for batteries to get smaller or as applications emerge that had not previously been anticipated. They are contingent on relationships, on funding, on moments of realization and ideas, as well as on long and mundane processes of research and testing, as well as on institutional power relations. Such processes are ongoing and open, waiting to be inflected in new directions; they create technological possibilities, which themselves are not closed. As these examples imply, future visions, predictions and aspirations ongoingly emerge in relation to technology design processes in ways that are not linear but that are always contingent on the circumstances that come about as technology design happens.

The examples discussed earlier also show how the starting point for a technology might be to work with what can be and is already known and to imagine how it will be part of a digital future. Yet it is within the process of research and design that new imaginaries and applications begin to emerge. The making of these imaginaries into realities can involve both a long and an often mundane process of research, development and waiting.

A digital futures anthropology is poised to play a significant role in the ways our futures become entangled with emerging technologies. By bringing together the ethnographic sensibility of anthropology with design research techniques and an anticipatory model of researching, thinking and creating interventions, a revised anthropology could make a difference. The ethnographic-theoretical dialogue of anthropology has the benefit of being able to account for the sites at which our digital futures are made, located, experienced and narrated. By treating these localities as our research sites, we will not access futures that have not yet happened, but rather we will gain new ways of understanding the anticipatory ways in which materialities, actions, ideas and discourses are mobilized in ways that seek to envision, influence and constitute futures. By applying anthropological understandings, we are able to comprehend the relationship between the specificity and diversity of the everyday sites where futures are imagined and where the present slips over into the near future. However, we can also understand how theoretically these futures are interwoven and are constituted through similar principles, even when differently and locally configured. It is based on this that we can seek to shift and shape these narrations and the actions and futures that might go with them, towards ethical and responsible human futures.

Acknowledgements

The argument developed in this chapter is my own. However, I shared the development of the ideas and ethnographic research discussed here in the examples of drones and AD cars with Debora Lanzeni and with Vaike Fors and Katalin Osz respectively. Where I have discussed this work, I have referred to the published articles and book chapters in which it is developed in more detail and recommend the readers to refer to these where relevant. I would like to thank these colleagues for the important ways in which they have supported the development of the ideas I have

discussed here. I also thank all the research participants who have participated in our projects for their time and enthusiasm, particularly Kourosh Kalantar-Zadeh for talking with me about his work. The AD car and WOz research was undertaken as part of an academic-industry collaboration between Halmstad University and Volvo Cars, funded by Vinnova, in Sweden. Part of our research with drone developers was funded through a partnership with an unidentified industry partner.

References cited

Akama, Y., K. Moline and S. Pink (2017) 'Design+ethnography+futures: knowing through uncertainty', in L. Hjorth, H. Horst, A. Galloway and G. Bell (eds.) *The Routledge Companion to Digital Ethnography*. Oxford: Routledge.

Akama, Y., S. Pink and S. Sumartojo (2018) *Uncertainty and Possibility*. London: Bloomsbury.

Arendt, H. (1958) *The Human Condition*. Chicago: University of Chicago Press.

Bechtold, U., D. Fuchs and N. Gudowsky (2017) 'Imagining socio-technical futures – challenges and opportunities for technology assessment', *Journal of Responsible Innovation* 4(2): 85–99. DOI: 10.1080/23299460.2017.1364617.

Bessire, L. and D. Bond (2014) 'Ontological anthropology and the deferral of critique', *American Ethnologist* 41(3): 440–456.

Dourish, P. and G. Bell (2011) *Divining a Digital Future: Mess and Mythology in Ubiquitous Computing*. Boston: MIT Press.

Gusterson. H. (2016) *Drone: Remote Control Warfare*. Cambridge, MA: MIT Press.

Halse, J. (2013) 'Ethnographies of the possible', in W. Gunn, T. Otto and R. Smith (eds.) *Design Anthropology: Theory and Practice*. London: Bloomsbury, 180–196.

Ingold, T. (1997) 'Eight themes in the anthropology of technology', *Social Analysis* 41(1): 106–138.

Ingold, T. (2008) 'Bringing things to life: Creative entanglements in a world of materials', ESRC National Centre for Research Methods, NCRM Working Paper Series, 1–15.

Ingold, T. (2013) *Making*. Oxford: Routledge.

Irving, A. (2017) 'The art of turning left and right', in J. F. Salazar, S. Pink, A. Irving and J. Sjoberg (eds.) *Anthropologies and Futures*. London: Bloomsbury.

Kalantar-Zadeh, K., K. J. Berean, N. Ha, A. F. Chrimes, K. Xu, D, Grando, J. Zehn Ou, N. Pillai, J. L. Campbell, R. Brkljača, K. M. Taylor, C.K. Yao, S. A. Ward, C. S. McSweeney, J. G. Muir and P. R. Gibson (2018) 'A human pilot trial of ingestible electronic capsules capable of sensing different gases in the gut', *Nature Electronics* 1: 79–87.

Kinsley, S. (2012) 'Futures in the making: practices to anticipate ubiquitous computing', *Environment and Planning A* 44: 1554–1569.

Lanzeni, D. (2016) 'Smart global futures: Designing affordable materialities for a better life', in S. Pink, E. Ardevol and D. Lanzeni (eds.) *Digital Materialities: Anthropology and Design*. Oxford: Bloomsbury.

Lanzeni, D. and S. Pink (2021) 'Digital material value: making data matter in emerging technologies', *New Media and Society*.

Lindgren, T., M. Bergquist, S. Pink, V. Fors and M. Berg (2018) 'Experiencing expectations: extending the concept of UX anticipation', 9th Scandinavian Conference on Information Systems (SCIS9), August 5-8, 2018, Aarhus University, Denmark.

MIT Technology Review (2017). https://www.technologyreview.com/10-breakthrough-technologies/2017/, accessed 19 January 2020.

Miller, D. (1988) 'Appropriating the state in the council estate', *Man* 23: 353–372.

Miller, D. and H. Horst (2012) 'The digital and human: a prospectus for digital anthropology', in H. Horst and D. Miller (eds.) *Digital Anthropology*. London: Bloomsbury, 3–35.

Moore, H (1994) *A Passion for Difference*. Bloomington and Indianapolis: Indiana University Press.

Osz, K., A. Rydström, S. Pink, V. Fors and R. Broström (2018) 'Building collaborative testing practices: doing ethnography with WOz in autonomous driving research', *IxD&A Journal* 7: 12–20.

Pink, S. (2017) 'Ethics in a changing world: embracing uncertainty, understanding futures, and making responsible interventions', in S. Pink, V. Fors and T. O'Dell (eds.) *Working in the Between: Theoretical Scholarship and Applied Practice*. Oxford: Berghahn.

Pink, S., E. Ardevol and D. Lanzeni (2016) 'Digital materiality: configuring a field of anthropology/design?' in S. Pink, E. Ardevol and D. Lanzeni (eds.) *Digital Materialities: Anthropology and Design*. Oxford: Bloomsbury.

Pink, S. and V. Fors (2017) 'Being in a mediated world: self-tracking and the mind-body-environment', *Cultural Geographies* 24(3): 375–388. DOI: 10.1177/1474474016684127.

Pink, S., V. Fors and M. Glöss (2017) 'Automated futures and the mobile present: in-car video ethnographies', *Ethnography*. https://doi.org/10.1177/1466138117735621.

Pink, S., V. Fors and M. Glöss (2018) 'The contingent futures of the mobile present: beyond automation as innovation', *Mobilities*. https://doi.org/10.1080/17450101.2018.1436672.

Pink, S., H. Horst, J. Postill, L. Hjorth, T. Lewis and J. Tacchi (2016) *Digital Ethnography: Principles and Practice*. London: Sage.

Pink, S., D. Lanzeni and H. Horst (2018) 'Data Anxieties: finding trust and hope in digital mess', *Big Data and Society* 5(1). https://doi.org/10.1177/2053951718756685.

Pink, S. and K. L. Mackley (2013) 'Saturated and situated: rethinking media in everyday life', *Media, Culture and Society* 35(6): 677–691. DOI: 10.1177/0163443713491298.

Pink, S., K. Osz, V. Fors and D. Lanzeni (2021) 'Simulating and trusting in automated futures: anthropology and the wizard of Oz', in S. Abram and M. Kazubowski-Houston (eds.) *Unimaginable Worlds*. London: Bloomsbury.

Pink, S. and J. F. Salazar (2017) 'Anthropologies and futures: setting the agenda', in J. Salazar, S. Pink, A. Irving and J. Sjoberg (eds.) *Future Anthropologies*. Oxford: Bloomsbury.

Salazar, J. F., S. Pink, A. Irving and J. Sjoberg (eds.) (2017) *Anthropologies and Futures: Techniques for Researching an Uncertain World*. Oxford: Bloomsbury.

Samimian-Darash, L. and P. Rabinow (eds.) (2015) *Modes of Uncertainty: Anthropological Cases*. Chicago: University of Chicago Press.

Smith, R. C. and T. Otto (2016) 'Cultures of the future: emergence and intervention in design anthropology', in R. C. Smith, K. T. Vangkilde, M. G. Kjærsgaard, T. Otto, J. Halse and T. Binder (eds.) *Design Anthropological Futures*. London: Bloomsbury, 19–36.

Sneath, D., M. Holbraad and M. A. Pedersen (2009) 'Technologies of the imagination: an introduction', *Ethnos: Journal of Anthropology* 74(1): 5–30.

Stoller, P. (2018) 'Turbulence on the anthropological path', *Blogpost*. https://paulstollersblog.com/2018/07/06/turbulence-on-the-anthropological-path/, accessed 10 July 2018.

Index

Note: Page numbers in *italics* indicate figures; page numbers in **bold** indicate tables.